The Art of Bloomsbury

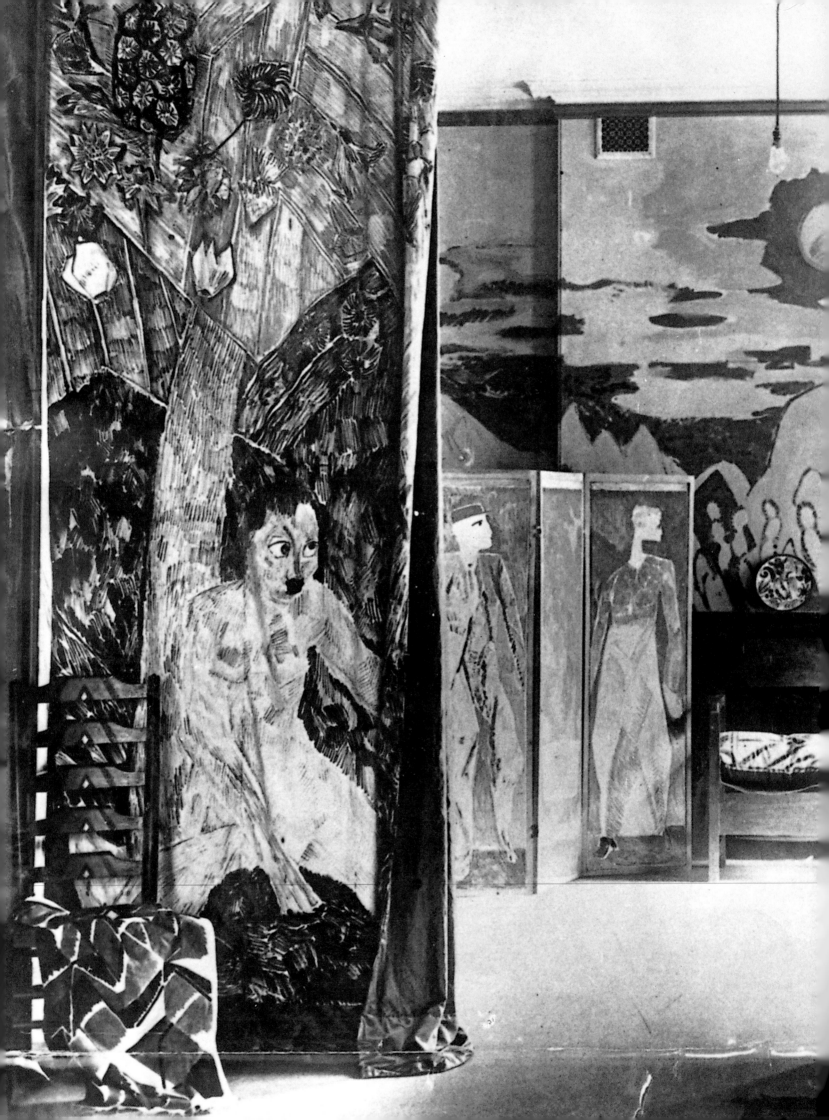

The Art of Bloomsbury

Roger Fry, Vanessa Bell and Duncan Grant

RICHARD SHONE

with essays by James Beechey and Richard Morphet

Princeton University Press

cover:
Duncan Grant, *Omega Paper Flowers on the Mantelpiece, 46 Gordon Square*
*c.*1914–15 (detail, no.50)

frontispiece:
Detail of photograph of the Omega Workshops on opening day, 8 July 1913,
showing Duncan Grant's *Omega Screen* (no.65). First reproduced in
Daily News, 7 August 1913; reproduced here as fig.99

First published by order of the Trustees of the Tate Gallery by
Tate Gallery Publishing Ltd, Millbank, London SW1P 4RG

Published in North America by Princeton University Press,
41 William Street, Princeton, New Jersey, NJ 08540

This catalogue is published to accompany the exhibition at the
Tate Gallery, London, 4 November 1999 – 30 January 2000
and touring to
The Huntington Library, Art Collections, and Botanical Gardens,
San Marino, California, 4 March – 30 April 2000
Yale Center for British Art, New Haven, Connecticut,
20 May – 2 September 2000

Second printing, and first paperback printing, 2002
Paperback ISBN 0-691-09514-0
Cloth ISBN 0-691-04993-9

Library of Congress Catalog Card Number: 99-75244

Designed and typeset by Caroline Johnston
Printed and bound in Hong Kong by South Sea International Press

Contents

Foreword

The past thirty years or more have seen an unprecedented interest in the circle of friends and relations known as the Bloomsbury Group who flourished in the early years of the twentieth century, most of them living in Bloomsbury – in the squares and streets east of London's Tottenham Court Road. With their roots in the nineteenth-century professional world of the law, education, colonial administration and literature, they inherited some of the confidence and advantages of their ancestry but rebelled against what they saw as the unnecessary conventions and moral double standards of an earlier generation. They started afresh. In their rebellion, they were, of course, by no means alone and many of their ideas about social conduct, politics, the arts and personal relations were prevalent across Europe in the new century. The painters and art critics of the group – Roger Fry, Clive Bell, Vanessa Bell and Duncan Grant – were the first of these friends to come to public attention as leading figures in the introduction into Britain of Post-Impressionism, through the two famous exhibitions in London of 1910 and 1912. Fry's essays (later collected in *Vision and Design*) and Clive Bell's *Art* were the most influential critical writings on art of their time. A few years later Lytton Strachey published his most notable book *Eminent Victorians* and John Maynard Keynes his *The Economic Consequences of the Peace*, the first of several texts which made him one of the most influential economists of the century. Shortly afterwards, Virginia Woolf's *Jacob's Room* appeared, the first in a sequence of novels that includes *To the Lighthouse* and *The Waves* which are among the most celebrated contributions to twentieth-century fiction. Among others closely associated with Bloomsbury, E.M. Forster's novels and the complete translation of Freud by James and Alix Strachey are prominent. Also with their origins in Bloomsbury are the Contemporary Art Society (thriving to the present); the Omega Workshops which brought together several leading figures in London's avant-garde and made a definite impact on applied design between the wars; the Hogarth Press which became a notably individual publishing house of contemporary literature and political comment; and the Arts Council of Great Britain in whose foundation Keynes played a crucial role.

This exhibition is the first to take a comprehensive look at the work of the painters of Bloomsbury. It surveys their easel painting and focuses on the period 1910 to 1920 when they produced some of their most exuberant works. An opening section deals with the artists' earlier work, establishing the themes and subjects that preoccupied them for the rest of their careers. There follow more detailed representations of their Post-Impressionist period in portraiture, still life and abstraction, and products of the Omega Workshops are shown in relation to the artists' contemporaneous painting. The final parts take a highly selective look at the painters' later work. No attempt has been made to survey Bell's and Grant's prolific output between the wars as commercial designers and decorators; these have been examined in several recent exhibitions. To provide context, sections of a more documentary nature looking at early and later Bloomsbury, include portraits, photographs and publications.

The exhibition has been devised and selected by Richard Shone, the writer on art and author of *Bloomsbury Portraits* (1976), the first comprehensive study of the three artists shown here. We are most grateful to him for his enthusiasm and the dedication that he has given to the successful realisation of this project. He has written much of the catalogue which contains a wealth of new information as well as valuable essays by Richard Morphet and James Beechey. We would also like to thank Richard Morphet for the advice, ideas and enthusiasm he contributed to the shaping and selection of the exhibition in its early stages. When *The Art of Bloomsbury* was in its initial planning stage it was discovered that the Courtauld Gallery was proposing a substantial exhibition on the work of Roger Fry to be held at the same time as the Tate's show. We are most grateful to Christopher Green and the Courtauld for the cooperative spirit shown in early discussions over loans to the respective exhibitions. Of the many others both inside and outside the Gallery who have worked on the project we would particularly like to thank Paul Williams of Stanton Williams architecture who has designed the exhibition for the Tate, and his assistant Reiko Yamazaki.

We should like to offer our warmest thanks to all the lenders, public and private. It is their generosity that has made possible this survey of so interesting a chapter in the history of modern British art. It is particularly gratifying to see a number of paintings at the Tate Gallery lent from abroad which have not been seen in Britain for many years. A particular thank you must go the Charleston Trust which administers the house in Sussex of Vanessa Bell and Duncan Grant and which has generously agreed to several indispensable loans.

We are delighted that the exhibition will be seen in the USA, at The Huntington in San Marino, California, and then at the Yale Center for British Art, New Haven. It has been a pleasure to work with colleagues

in both places and we would like to thank both Edward Nygren in San Marino and Patrick McCaughey in New Haven for their enthusiasm for the exhibition, and Patrick McCaughey particularly for his commitment to making it possible for it to be seen on the other side of the Atlantic.

In London the exhibition has been sponsored by Prudential who previously sponsored *Grand Tour* in 1996 and *The Age of Rosetti, Burne-Jones and Watts* in 1997–8. We greatly value their continued support. The Huntington and Yale Center for British Art offer special thanks to BP Amoco for generously sponsoring the exhibition in both San Marino and New Haven.

Nicholas Serota
Director

Acknowledgements

When I first studied the painters of Bloomsbury, the bulk of Vanessa Bell's and Duncan Grant's papers were still in private hands. Although Roger Fry's daughter Pamela Diamand preserved an important archive relating to her father, much else was housed at King's College, Cambridge, where it remains. The greater part of Bell's and Grant's papers as well as Fry's letters to Vanessa Bell are now held by the Tate Gallery Archive (TGA). For this exhibition, I have re-read much of them and benefited from further documents, letters and photographs held there. I thank Adrian Glew and other members of the Archive staff for their help. I am most grateful to Angelica Garnett, Henrietta Garnett, and Annabel Cole as the copyright holders of published and unpublished texts and photographs by Bell, Grant and Fry, and for their generosity in allowing works by these artists to be reproduced here. Olivier Bell has kindly permitted quotations from Clive Bell's unpublished letters and I thank her warmly for answering several questions with her customary attention to detail. I am most grateful to James Beechey who has generously shared with me his research on the life of Clive Bell (a biography to be published in 2000 by John Murray) and for many hours of enjoyable discussion. Peter Miall, curator at Charleston, has been helpful from the start of this project and I thank him and his colleagues at Charleston, especially the director, Alastair Upton. I take pleasure in thanking many private collectors, several of whom I visited in the company of Caroline Cuthbert of the Tate Gallery; her knowledge of the whereabouts of key works has been especially important. This is also true of Robin Vousden of the Anthony d'Offay Gallery: he and his colleagues have helped me at many points. Susannah Pollen and Mark Adams of Sotheby's and Rachel Hidderley of Christie's have also helped secure loans for which I thank them. Many private galleries have been extremely helpful in showing me works and tracing owners; I thank particularly Andrew Murray of the Mayor Gallery, James Holland-Hibbert of Spink-Leger, Tony Bradshaw of the Bloomsbury Workshop (unfailingly helpful on several matters), Deborah Gage (who secured some important exhibits), and Julian Agnew and Christopher Kingzett of Agnew & Sons for showing me invaluable sales ledgers and photographs. I have looked at works in over fifty public collections in Britain and warmly thank the curators in all of them; I must especially mention Christine Hopper of Bradford City Art Galleries; David Scrase of the Fitzwilliam Museum; Terence Pepper of the National Portrait Gallery; Hilary Diaper of the Art Collection, University of Leeds; and the Bursar and staff of King's College, Cambridge. Archivists and Librarians at Newnham College, Cambridge, Somerville College, Oxford, University House, University of Birmingham, and the British Medical Association, London, were all most helpful. I greatly enjoyed visiting collections in Canada, the United States and elsewhere and wish to thank for their help Michael Parke-Taylor, Art Gallery of Ontario, Toronto; Michael Pantazzi of the National Gallery of Canada; William Lieberman of the Metropolitan Museum of Art, New York; and, in correspondence, Angus Trumble of the Art Gallery of South Australia, Adelaide. A further pleasure in cataloguing several works in this show has involved 'field-research' visits and I wish to express my thanks to the occupants of Lane End House (formerly 'Eleanor'), West Wittering; Elm Lodge, Streatley-on-Thames; Birkbeck College, University of London (46 Gordon Square); Little Talland House, Firle; the Mas d'Angirany, St Rémy; and M. Brando of the Château de Fontcreuse, Cassis. Visiting the last two I had the good company and help of, respectively, Francis Wishart and Katrine Boorman. In this connection I would like to thank Anne Dunn and Daniel Moynihan for their hospitality in France. I am grateful to many other friends and colleagues who have helped me in a variety of ways: Frances Spalding, Simon Watney, Judith Collins, Wendy Baron, David Sylvester, Mark Lancaster, Bryan Ferry, Stephen Keynes, Lord Hutchinson of Lullington, Henrietta Garnett, Cressida Bell, Matthew Marks, Frances Partridge, Angelica Garnett, Richard Morphet, David Brown, Alison Bagenal, Jeremy Greenwood, and Michael Parkin.

I extend my appreciation to Caroline Elam, the Editor, and Kate Trevelyan, the General Manager, of *The Burlington Magazine* for their patience in allowing me two sabbatical periods during the last two years and to Merlin James for stepping into the breach. At a critical early moment I was greatly helped by Honey Luard in the organisation of this catalogue. At a later stage Mira Hudson heroically pulled things together with good sense, an eye for detail, hard work and encouragement. I thank them both. At the Tate Gallery I record my gratitude to Carolyn Kerr of the Exhibitions department and her colleagues Tim Batchelor, Rachel Meredith, Christine Riding and Helen Sainsbury; to Celia Clear, Tim Holton and Judith Severne of Tate Gallery Publishing; and Kate Burvill of the Press Office. All have contributed to the realisation of this exhibition from the first moment I jotted down lists of possible exhibits in July 1997.　　　　RS

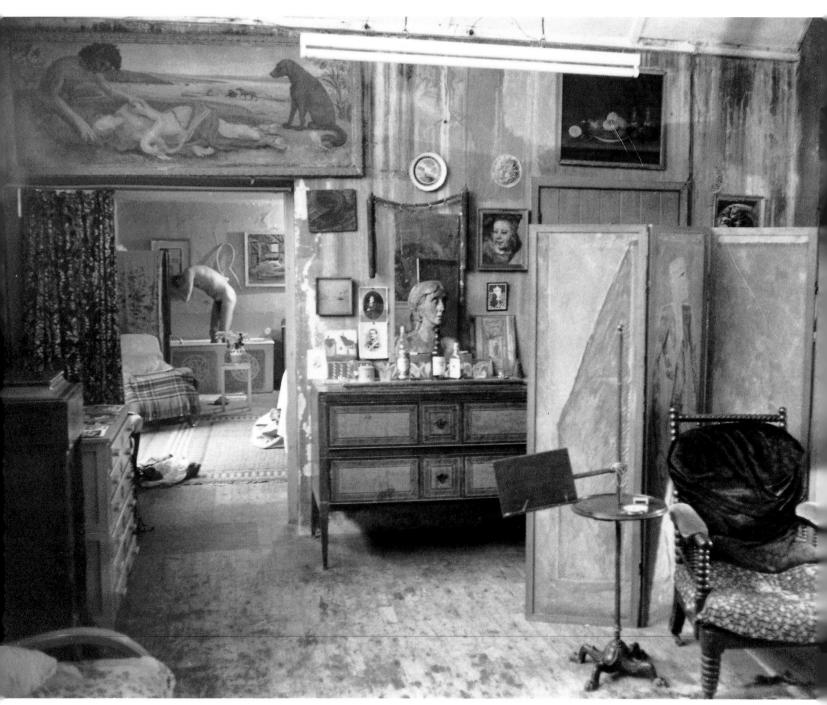

The studio and downstairs bedroom, Charleston, *c.*1980.
Photograph by Andrew Graham. To the right of the bust of
Virginia Woolf (no.195) is Duncan Grant's Omega screen (no.65);
above the doorway, Grant's copy of Piero di Cosimo's
Mythological Subject

The Artists of Bloomsbury: Roger Fry, Vanessa Bell and Duncan Grant

Richard Shone

No single exhibition has previously explored the achievements of the three painters of Bloomsbury, Roger Fry, Vanessa Bell and Duncan Grant, with the purpose of clarifying their similarities and differences of style, temperament and ambition. Their personal and social common ground has been minutely dissected in innumerable publications but in most histories of the art of their time, they are lumped together as some indissoluble three-in-one, the Holy Trinity of formalism. Seen in a long perspective, this has some truth to it: they came together at a particular moment in British art and were energised and excited by many of the same influences and ideas. Their work was viewed by commentators as variations on the same theme, an opinion strengthened by the homogeneity of style they achieved in products designed for the Omega Workshops and in their habit of painting the same subjects, side by side. Much later, when Bloomsbury had become a distinct cultural entity, it was assumed that the painters of the group must have shared the same beliefs and outlook. But, as I hope this exhibition makes clear, their work is easier to characterise individually than it is as the manifestation of an aesthetic theory or a group enterprise.

Of course, Fry, Grant and Bell had no idea they were Bloomsbury painters or that they were producing Bloomsbury art. It was only from the 1960s onwards that the name began to be used as an art-historical category in line with other named groups of the period such as Camden Town and Vorticist. But whereas these last had a definite membership and even at moments a corporate approach, the Bloomsbury painters shared their appellation with non-painters, issued no manifesto, paid no fees and never exhibited as a discrete triumvirate (paradoxically allowing Grant, for example, to show with the Camden Towners and the Vorticists). Constantly they looked outwards. Organisations

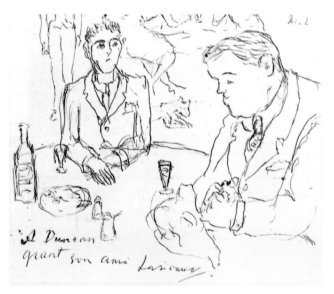

fig.1 Mikhail Larionov, *Massine and Diaghliev at Supper* c.1919, ink on paper 16.5 × 19.7 cm. The Charleston Trust
The drawing is dedicated 'A Duncan Grant son ami Larionov'

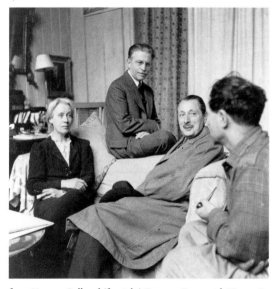

fig.2 Vanessa Bell and (far right) Duncan Grant with Homer St Gaudens (centre) and ?Arnold Palmer (seated) at 8 Fitzroy Street, London, c.1932 discussing the Carnegie International. Photograph courtesy Carnegie Institute, Pittsburgh

whose origins were within Bloomsbury – the Friday Club, the Grafton Group, the Omega Workshops – were, in fact, broad-based and inclusive, and artists as different as Stanley Spencer and Wyndham Lewis, Spencer Gore and Mark Gertler, Henri Gaudier-Brzeska and Paul Nash were associated with one or more of these groups in which Bell, Fry and Grant were prominent. Nor did they feel that the English art world was their only seat of activities. They were conspicuously cosmopolitan in outlook, feeling that English culture had for too long been split from the Continent; the painters of Bloomsbury went to Paris at every opportunity, exhibited there, published in French and American periodicals and had numerous Paris-based friends who, in their turn, visited them in London (fig.1); they showed in Zürich, Berlin and at the Venice Biennale; in New York, Pittsburgh (fig.2) and Chicago. It is surprising to read in a scholarly publication as recent as 1997 that Britain was 'effectively severed by the criticism of Roger Fry and Clive Bell' from 'the international mainstream of art'; this is exactly the opposite of what happened.[1] These two writers on art may have been disparaging about the achievements of the British school – misty-eyed patriotism played no part in their aesthetic evaluations – and certainly found no contemporary homegrown talent to place beside Matisse and Bonnard or Braque and Picasso (not even Duncan Grant) but they had no desire to prolong the drift into provincialism that allowed John Singer Sargent to be venerated as, in Sickert's memorable phrase, 'the *ne plus ultra* and high-water mark of modernity'.[2]

Like other national schools, British art has been shaped by a multitude of social, political and economic pressures but perhaps more than most it has developed in a state of disequilibrium between indigenous practice and influences from abroad. In the early years of the twentieth century, a paradoxical reaction of John Bullish repugnance and eager receptivity greeted the cross-Channel bombardment of new art and ideas. Although Britain was not as isolated from the Continent as some accounts propose, foreign influence was slow to show its hand, restricted by natural British caution, social expediency and the lack of any pronounced internal dynamic. By the early 1900s even those artists who had shown intelligent reflections of recent French art, such as Wilson Steer and Charles Conder, had failed to follow through the implications of their earlier discoveries; Bastien Lepage was still viewed as a more exemplary figure than Monet. There were, however, several young painters – among them Harold Gilman, Duncan Grant and Henry Lamb – who, although they admired Impressionism, did not feel impelled to practice it and found themselves treading water. For them and many others, aspects of Post-Impressionism and Fauvism acted as both release and impetus. These younger artists responded with alacrity, some of them overwhelmed by the invasion, others prompted to produce their most enduring works. 'Here was a possible path', wrote Vanessa Bell of the impact of the first Post-Impressionist exhibition in 1910, 'a sudden liberation and encouragement to feel for oneself, which were absolutely overwhelming'.[3] As both apologists and practitioners, the Bloomsbury painters and critics were essential figures in this unprecedented moment, contributing if not to a change in human character, as Virginia Woolf famously suggested, then to a far-reaching change in taste. They became a centre of cultural authority in the period 1910 to 1930, influencing aspects of museum purchasing and policy, the activities of private collectors, the foundation of exhibiting groups and a wide section of public opinion through their books and journalism.

The aesthetic viewpoint of Bloomsbury is perfectly encapsulated in the words of Virginia Woolf written to Roger Fry who, as she tells him in the same letter, had helped to keep her 'on the right path, so far as writing goes, more than anyone':

> I meant *nothing* by The Lighthouse. One has to have a central line down the middle of the book to hold the design together. I saw that all sorts of feelings would accrue to this, but I refused to think them out, and trusted that people would make it the deposit for their own emotions – which they have done, one thinking it means one thing another another. I can't manage Symbolism except in this vague, generalised way … directly I'm told what a thing means, it becomes hateful to me.[4]

As we now know, the lighthouse of her novel (fig.3) has been made to stand for almost anything – unattainable desires, the enduring life of art, male tyranny, past experience flashing its illumination

on the present moment. But Woolf's plea for the lighthouse as a formal device and not as a symbol to be interpreted in reductionist terms, is both sympathetic and consonant with the attitudes of her own circle – with E.M. Forster's refusal to 'explain' the notorious incident in the Marabar Caves in *A Passage to India* or T.S. Eliot's 'benign neglect' of the 'multiple interpretations' of *The Waste Land* and the mockery implicit in his appended notes.[5] In their stress on formal autonomy, Roger Fry, Vanessa Bell and Duncan Grant are in tune with the chief proposition of Clive Bell's *Art* of 1914 (and, of course, with much of Fry's own, though less rigid, theory) that the artist's aim is to discover expressive form in order to reveal an underlying reality that is parallel with or equivalent to the reality of daily life. They were resistant to symbolic accountability, giving only formal reasons for their choice of subject matter and rarely straying into self-interrogation. Take the example of Duncan Grant's *Venus and Adonis* of *c.*1919 (no.118), a painting of a voluptuous and watchful goddess, languishing for her lover who appears as a tiny, naked figure, errant in the distant landscape. Years later when taxed for an 'explanation' of the painting, Grant acknowledged only the most minimal relation of his painting to the myth, denying it was an 'illustration of the subject, but a rhythm which *came out of the subject*'.[6] With everything we now know of Grant's life with Vanessa Bell at that time – her protective domesticity endangered by his lightly-worn affairs – it is impossible not to read the painting as in some respects psychologically autobiographical, the facts of the myth employed as a conduit of self-perception. Again, Roger Fry, seen as the arch-exponent of formal values and aesthetic decorum, was frequently drawn in his painting to the most romantic and picturesque aspects of the landscape – to the jagged profiles of unpopulated hillsides, to ravines and mountain pools (fig.4). Recognising this 'taste', he nevertheless ruled out its psychological import as 'irrelevant'.[7] The scientific rationalism that characterises much of Fry's thought obviously found an alternative release in these wilder aspects of nature, even when he was intent on taming them (no.127). Several of his later portraits, too, show an obsessive feeling for the sharps and flats of physical appearance that might seem incommensurate with a purely formalist approach.

Vanessa Bell was perhaps the most adamant of the Bloomsbury artists in her relegation of the importance of subject matter. She left no specific statements about her work; the few allusions to it that exist in her correspondence concentrate on formal relations and their complex organisation. In a letter to her sister, Virginia Woolf, she gives her reactions to reading *The Waves* and how the

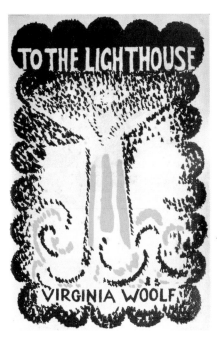

fig.3 Vanessa Bell, dustjacket of *To the Lighthouse* by Virginia Woolf, published by the Hogarth Press 1927

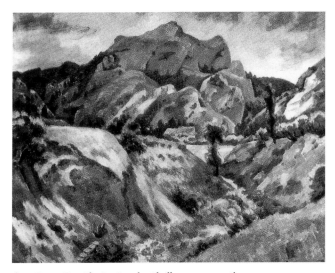

fig.4 Roger Fry, *The Ravine, the Alpilles* *c.*1932–3, oil on canvas 53 × 66 cm. Private Collection

emotions she felt about the death of their brother Thoby (Percival in the novel), strong though they be, are accidental and only move her because of the art of the writing: she commends the depersonalisation of human feelings and recognises that a language must be found that is suggestive rather than illustrational, containing rather than overflowing. This she followed in her own painting, purifying it of, as she saw it, irrelevant facts and didactic accents. It comes as no surprise that the handful of extant abstract works by her attain an extreme degree of non-referentiality. Conversely she later admitted that she did not pursue abstraction after 1915 because of the added interest subject matter gave her, secondary though it was. With the passing of time, however, and the re-evaluation of the formalist premises of Bloomsbury art, a richer and more inclusive picture has emerged.

These artists' works encompass an unexpected range of formal means, psychological content and subject matter. We move between an advanced geometric abstraction (no.83) and an informal extension of the Victorian subject picture (no.7B); between tightly controlled realism (no.8) and swift, lyrical spontaneity (no.86); between erotic longing (no.120) and familial tranquillity (no.136). There are vivid depictions of some of the lasting personalities of the early twentieth-century (nos.32, 41) and interpretations of archetypal European iconography (no.118). We move from bacchanalian fantasy (no.187) to a brooding transformation of the day-to-day materials of existence (no.144). In portraiture there are moments of fastidious self-appraisal (no.147) and others of a near-caricatural immediacy (no.35). Such variety is contained, however, within the parameters of a pacific and celebratory outlook with, at the centre, personal affections and domestic peace. This is not to say the artists were insensible to other subjects and modes of feeling, only that early on they staked out the ground most suited to their preferences and sensibilities. In the face of public events and private tragedies, which erupted into lives devoted to hard work and unambitious pleasures, the painters maintained their own vision, one that was circumscribed yet accessible.

The shared subject matter of Bloomsbury painting is inflected by the individuality of their response. Bell is the least distracted from the unity of her theme, its visual seemliness and overall emotional tone. Fry structures his work with a detachment from its subject that allows the slow disclosure of its tenor of feeling. Grant is more restless and inclusive, often yoking together unexpected elements and allusions – in a still life or an interior – to vivify objective transcription. Only at rare moments do Grant and Bell become nearly indistinguishable in their work; in paintings of the same subject, particularly still life, differences in handling of paint and degrees of linear speed are clues to attribution. Their paintings of the same mantelpiece, for example, provide an instructive comparison (nos.51 and 48). Bell achieves a more monolithic statement, fragile though her components are; she is unimpeded by detail and draws together the various elements into a single chord. Grant is more idiosyncratic, with a nervous, wayward use of contour, here underlined by his use of collage. Bell plants her impression before us with measured clarity; Grant is on a tightrope stretched between fact and fantasy. In Fry's comparable still life on a mantelpiece (no.60), the concourse of personal objects assumes, through interval, shape, accent and proportion, an expressive significance beyond the mundane.

★ ★ ★

When in 1910–11 Roger Fry was welcomed into the circle gathered around Clive and Vanessa Bell at 46 Gordon Square, he found congenial and intellectually adventurous people who, as yet, had made little or no mark in the world. The University of Cambridge was an all-important common ground between these friends; there were family connections; and there was the double attraction of the two contrasting households of the Stephen sisters, Vanessa, a promising painter, married to Clive Bell and the mother of two sons, and Virginia, as yet unmarried, sharing a house with her brother Adrian in Fitzroy Square and working on her first novel, *The Voyage Out*. Their friends included Lytton Strachey (aspiring critic), Saxon Sydney-Turner (civil servant at the Treasury), Sydney Waterlow (Diplomatic Service), Desmond and Molly MacCarthy (both writers), Hilton Young (later

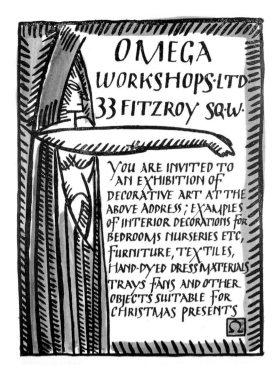

fig.5 Omega invitation card designed by Duncan Grant with lettering by Roger Fry, December 1913, lithograph and watercolour on card 21.6 × 14.6 cm. Private Collection

fig.6 Roger Fry in 1912, photographed by Alvin Langdon Coburn. Courtesy Fry family

a Liberal MP), H.T.J. Norton (Cambridge mathematician), the painter Duncan Grant (cousin of Lytton Strachey and his siblings who included James and Marjorie) and the economist and teacher John Maynard Keynes. Leonard Woolf, who had known several of these people at Cambridge, only returned to England in mid 1911 after seven years in the Ceylon Civil Service; and E.M. Forster, the only one with any public reputation, consolidated in 1910 with the publication of his novel *Howards End*, was an 'elusive familiar in Bloomsbury' who, unlike the others, did not then live in London. Although writing and painting were central to the circle, academic life and politics were also to the fore. Conversation, an all-consuming activity, was as likely to turn to women's rights or sexual tolerance as it was to literature, the arts or the nature of 'good' as propounded by G.E. Moore. Their lives were neither indolent nor luxurious; everyone worked; only Clive Bell could be termed wealthy and although most had some private money, Leonard Woolf and Duncan Grant, for example, did not.

It says much about the fluidity of this circle that Roger Fry, older than the others and already a well-known writer and art historian, was so soon accommodated within it. To find a welcome there was a godsend for him at a particularly dispiriting moment of his life, when he had recently faced the termination of his affiliation to the Metropolitan Museum in New York, seemed unable to gain any official recognition in England and had realised that the mental illness of his wife Helen, the mother of his two young children, was incurable. At the same time, his relatively new interest (late in the day) in Cézanne and contemporary French art chimed with the Bells' and Duncan Grant's increasing awareness of cross-Channel developments (also late in the day). Few among Fry's own generation of friends shared his new enthusiasm and there was no accepted intellectual framework in which it could flourish.

Fry galvanised Bloomsbury. Within two years he organised the two Post-Impressionist exhibitions in London and a show of modern British painting in Paris, was a leading figure in the newly founded Contemporary Art Society, formed the Grafton Group and opened the Omega Workshops (fig.5); he was the prime mover behind Bloomsbury's travels to see Byzantine mosaics in Turkey and Italy; he took the Bells to the studios of Matisse and Picasso; he introduced new Russian artists into the second of the two Post-Impressionist shows; made contacts with dealers and collectors and established

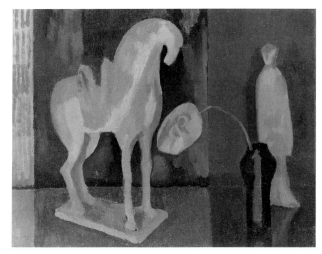

fig.7 Roger Fry, *Still Life with T'ang Horse* c.1919–21, oil on canvas
35.6 × 45.7 cm. Tate Gallery

an international network of friends and acquaintances, from Gertrude Stein and Alvin Langdon
Coburn (fig.6) to Jacques Copeau and Ambroise Vollard. The breadth of his sympathies is reflected
in his own private collection which, within a relatively short period, contained works by Picasso,
Kandinsky, Rouault, Brancusi, Larionov, Derain and Gaudier-Brzeska as well as objects and sculp-
ture from China (fig.7), Korea, Peru and Equitorial Africa. His ceaseless activity changed forever
Bloomsbury's hitherto culturally restricted profile.

In all this, Vanessa Bell and Duncan Grant were willing acolytes; their painting, until *c.*1909–10,
was still relatively conservative even if demonstrably at odds with the work of most of their contem-
poraries. Fry not only boosted their confidence as painters but widened the stage of their activities,
placing them on a more professional footing in the London art world. In their turn, Bell and Grant
provided Fry with a congenial social atmosphere, an audience for the ideas and theories that tumbled
from his mind. They thought him a lucid, suggestive writer and he was one of the few critics that
either of them could bear to read, even when they disagreed with him. But his painting was a different
matter. Bell, on the whole, disliked it and, unhappily, Fry knew this; it became the one painful strand
in an otherwise intimate friendship (fig.8). Bell was notoriously honest but she could never quite
admit to Fry himself, eager for her good opinion, that she generally found his work 'a dead drab
affair'. Grant was notoriously generous and gave praise where he genuinely could. Even so, after
seeing some of Fry's paintings in the 1922 Salon des Indépendants, he told Bell 'I must write him a
postcard to tell him I really thought they looked very good, before you come and disillusion me'.[8]
Clive Bell was under no illusion; he preferred Fry's early work (pre-1910) to the Post-Impressionist
and later phases and thought the pottery he made for the Omega was his most enduring achievement.
In his turn, Fry was clearly biased in favour of Grant's more lyrical and fantastic paintings and
criticised his move from *c.*1919 onwards to a solid and ample realisation of form. And while greatly
admiring Vanessa Bell's personal sense of colour and her directness of response to her theme, he saw
her as relatively lacking in formal invention. It is necessary to keep these dissenting views in mind
when considering the so-called mutual admiration of Bloomsbury.

In their early years of friendship, the three artists frequently worked together on the same or similar
motifs and collaborated on various decorative schemes. Fry encouraged this – a harmonious guild
was perhaps his ideal – and he enjoyed the easy companionship of fellow painters, something that
had been absent from his life for a decade or more. The Omega Workshops was the most substantial
fruit of this alliance. But with the growing intimacy of Grant and Bell from *c.*1915 onwards (fig.9),
this collaborative spirit broke down and Fry rarely painted alongside them again. While lamenting
this loss of companionship, Fry paradoxically advised the two others not to work so closely together
and offered criticisms of both artists' paintings whenever the opportunity arose.

While personally beneficial, Grant and Bell's association with Fry publicly had its drawbacks. Their work came to be measured by the received opinion of Fry's formalist aesthetic (erroneously termed 'significant form') and when his reputation was at its lowest, in the 1950s and 1960s, they were frequently dismissed as theoretical conspirators whose early adherence had backfired (though Fry's own painting received the fiercest denunciations). Again, Fry's falling out in 1913 with Wyndham Lewis, a quarrel which became the fault line of English modernism, dragged Bell and Grant along in its unfortunate wake. Although Grant cared little for Lewis's character or views (and was later 'appalled' by his warm exegesis of Hitler), they were by no means enemies and Grant paid Lewis a studio visit at the latter's request. In 1912 Lewis was a familiar figure at 46 Gordon Square. Bloomsbury and Lewis might never have become intimate but a respectful cooperation could have prevailed if Lewis had not conceived so violent an antipathy to Fry. When this came to a head and Lewis stormed out of the Omega Workshops in autumn 1913, Bloomsbury failed to retaliate, finding no evidence to corroborate Lewis's complaints of Fry's domineering, self-seeking role. Thus, in later years, anyone sympathetic to Lewis's account of events was almost certain to take his side against Bloomsbury. John Rothenstein did this in the respective chapters on Grant and Lewis in his *Modern English Painters* (1952), doing disservice to both artists and making the Omega quarrel a doctrinal point in the history of modern British art. More salient, in fact, was the nationalist thrust and rabid anti-Europeanism of *Blast* with its broadside against 'the abasement of the miserable intellectual before anything coming from Paris'. This was certainly a red rag to Fry and his circle.

In disparaging accounts of the work of Grant and Bell, their friendship with Fry has led to a 'guilt by association'. But how did their own long partnership affect each other and their subsequent reputations? From about 1915 onwards they were professionally and personally inseparable (fig.10), although they were rarely considered as equals. Grant's work invariably received closer attention, especially when the two painters were bracketed together. He was seen to be more ambitious and diverse. This gave the impression that Bell was a pliant imitator, one of several members of a high-profile Ecole de Grant. This was perhaps even more apparent when the critic in question was careful to distinguish between them, though rarely failing to place Bell after Grant and introducing her as one of England's foremost women painters, a categorisation she disliked. That Bell herself was self-deprecatory about her painting in relation to Grant's, there is ample evidence; and for her, everything by Grant was acceptable. After the mid-1920s they seem to have ceased to criticise each other's work in any incisive way, eventually dependent on mutual silent approval. By then Bell was sure of the general direction of her painting and less open than Grant to outside stimuli. She did not, for example, share his predilection for subjects from classical mythology or figurative invention (save occasionally in specifically decorative work); these gave him opportunities to express a playful eroticism (as in his

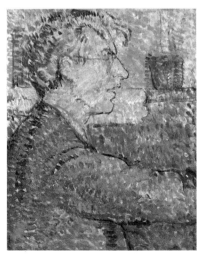

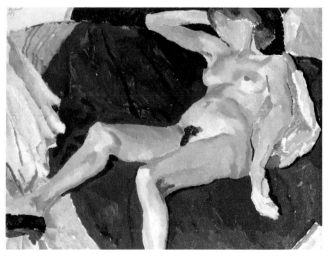

fig.8 Vanessa Bell, *Roger Fry* 1912, oil on wood 29 × 23.4 cm. Private Collection

fig.9 Duncan Grant, *Reclining Nude (Vanessa Bell)* 1919, oil on canvas 61.6 × 81.9 cm. Whereabouts unknown

two *Bathers* paintings, nos.120 and 121) which has no part in her work, though sensual allure is by no means absent from it. Grant's temperament was more receptive than Bell's. His experiences as a student were more cosmopolitan and he developed a vein of free invention that ran in tandem with a sure economy of feeling. In his early years he moved without apparent disjunction between the worlds of Poussin and of Chardin; to unite the two, the poetics of mythological dream and the palpable reality of solid objects, was the impossible task of his career. Bell's subject matter was resolutely domestic – her family and friends, her immediate surroundings or places on whose familiarity she could count. 'I don't think I'm nearly as enterprising as you (or Duncan)', she wrote to Fry, 'about painting anything I don't find at my door.'[9] This reassurance was necessary for behind a seemingly composed and tranquil exterior there was 'an extreme sensitivity, a nervous tension', wrote her brother-in-law, 'which had some resemblance to the mental instability of Virginia'.[10] In the last two decades of her life, Charleston, her home in Sussex from 1916 to her death in 1961, became her province – its inhabitants, interiors and garden, the flowers and fruit grown there, the accumulated objects and memories of a lifetime. All these components come together in her last major composition *The Garden Room* (on loan to Birkbeck College, University of London) painted for the Festival of Britain exhibition *60 Paintings for '51*. Richly coloured and pitched emotionally between intimacy and self-absorption, the painting is conspiratorial in mood as the elderly artist views the women of her family with both warmth and detachment in a manner reminiscent of the photographic tableaux of her great-aunt Julia Margaret Cameron (see fig.27). In the modestly conceived, ruminative works of her last decade the wit, boldness and transgressions of her early work give way to paintings of an almost claustrophobic world, self-effacing in execution yet in their extreme quietude, redolent of her single-minded integrity.

Grant was a willing participant in this circumscribed life in which both artists 'froze defensively into the safety of the known and trusted in their art'.[11] Grant's personal needs were to a great extent satisfied by the domain Bell had created for herself and her family (fig.12); he was both anchored and

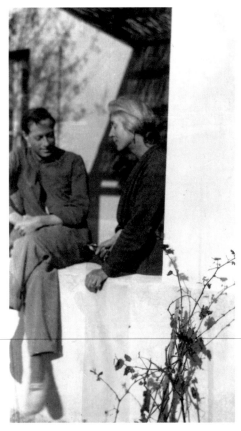

fig.10 Duncan Grant and Vanessa Bell at La Bergère, Cassis, 1928. Tate Gallery Archive

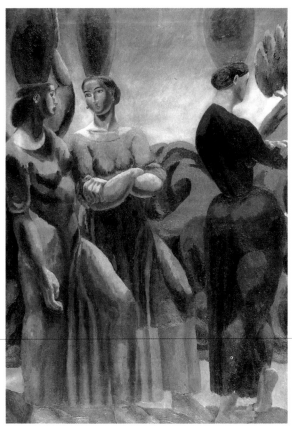

fig.11 Duncan Grant, *Study after 'The Lemon Gatherers'* c.1920, oil on canvas 48 × 34 cm. Private Collection

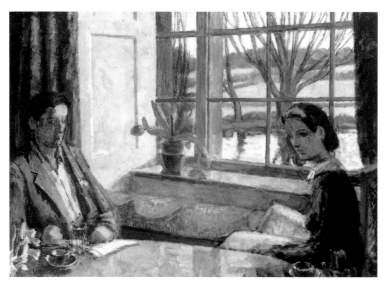

fig.12 Vanessa Bell, *The Dining Room Window, Charleston* c.1940, oil on canvas
55.8 × 78.7 cm. Reader's Digest Association Inc.

free. She in turn found satisfaction in his dependence; and there was the almost daily delight, working closely together, of 'creating something that was unforeseen and original, giving them the magic power to produce a world of their own'.[12] In most ways it was a remarkable relationship. Its disadvantages are seen in repetitive routine and the closing down of possibilities. Bell's assurance wobbled and in the 1950s a soft-focus sentiment bathed gardens and granddaughters and Italian views. In the same period, Grant's brimming imaginative world became further estranged from the reality of his day-to-day existence, producing an unresolved schism of intent.

<p align="center">★　　　★　　　★</p>

The supposedly tight-knit circle to which Fry, Bell and Grant belonged, and their own entwined relationships within it, have tended to limit the terms of discussion of their work. It is frequently assumed that one, perhaps uncharacteristic, remark on a particular subject by one member of Bloomsbury, must automatically signify wholesale agreement from all the others. But the more Bloomsbury is studied, the more apparent becomes the uselessness of the term in any critical evaluation and the less it exemplifies a culturally and intellectually coherent unit. In part this is attributable to its being a publicly manufactured entity growing out of a fortuitous set of private circumstances. These included familial and geographical connections and some shared beliefs as is necessary in any group of friends who maintain their intimacy over an extensive period. But Bloomsbury was not organised; it did not come together to form a club, worship a god, found a movement or inspire social action. Because of its so-called social exclusivity, it is frequently seen as having no theoretical points of contact or shared enthusiasms with other groups or individuals. For example, the painters and critics of Bloomsbury have long been seen as being in direct opposition to the aesthetics of D.H. Lawrence. But a recent investigation has shown the closeness of their ideas and assumptions, going as far as to say that Lawrence's famous attack on formalism in art in his *Introduction to These Paintings* 'reveals what barely falls short of substantial plagiarism, on Lawrence's part, of Fry's argument [in his *Cézanne*], both on a general and on a more detailed level'.[13] Again, because of the antipathetic tone of Fry's and Bell's comments on much nineteenth-century British art, it is assumed that Bloomsbury must have abhorred the work of Burne-Jones. Such a *reductio ad absurdum* flies in the face of the facts – Grant's late statement affirming both his early infatuation for the painter (an enthusiasm he was surprised and delighted to find was shared by Picasso)[14] and his continuing admiration are important in assessing Grant's early influences (see Richard Morphet's essay, p.24). Fry's praise of Burne-Jones's

unity of design and 'magnificent decorations' contrasts sharply with his contemporaneous dismissals of late Millais or Alma-Tadema. Received notions of Bloomsbury, friendly ones as well as hostile, invariably wilt under close inspection: personal prejudice makes do for historical accuracy and the word Bloomsbury is tossed about, proteiform on a sea of misapprehension, assuming whatever shape and colour suits the writer's own agenda.[15]

One further accusation levelled at Bloomsbury as a whole and the painters in particular, is that they were aloof and out of touch with contemporary life and currents of thought. Some were and some were not. If Lytton Strachey's relative aloofness in later years is taken as typical then so must the political engagement of Leonard Woolf or the far-reaching theoretical and practical interventions in the modern world of Maynard Keynes. Additionally, the record of Bloomsbury, its friends and relations, in matters of women's suffrage, higher education and penal reform is well documented. As far as the painters are concerned the accusation is difficult to uphold. If by not painting, on the one hand, seedy lodging houses or tarts on beds or, on the other, images of mechanised war and industrial production, they were out of touch then so be it, although that kind of iconographical enquiry leads to stale debates. On a professional level, the painters were central to the London art world as practitioners, apologists and mentors, working on behalf of other artists – from the Friday Club (1905) and the Omega Workshops (1913) to their roles in the London Artists' Association in the 1920s – and sitting on committees, fostering relations between applied and fine artists and providing inspiration for Maynard Keynes's vision of an Arts Council of Great Britain. In the 1930s Grant and Bell gave invaluable support to anti-fascist exhibitions and initiatives. They were not the inhabitants of the ivory tower of popular conception.[16] If they were not politically active it was not through indifference or ignorance. By the 1930s, when they were middle-aged and Bloomsbury had ceased to exist, they clung to the hard-won freedom, in an era of increasing aesthetic repression, of being allowed to paint without interference alongside similarly free fellow-artists.

Of the Bloomsbury painters, only Grant had an appreciable influence on British art between the wars. This was most notable among his fellow members in the London Artists' Association and the younger generation of painters who were to form the Euston Road School. His fluent calligraphy in paint and fully orchestrated palette made their impact in the 1920s, but were repudiated during the 1930s when painterly euphoria gave way to the subdued mapping of the 'age of anxiety'. His work from before c. 1920 was seen only in occasional examples, the bulk of it stored at Charleston. Vanessa Bell's Post-Impressionist work was even less visible. When a dozen or so canvases from that period

fig.13 Duncan Grant, *Abstract Collage* c.1914 (no.76)

fig.14 Ben Nicholson, *1924 (painting – trout)*, oil on canvas 56 × 58.5 cm. Private Collection

fig.15 Ivon Hitchens, 30 *Pink Star* 1933–4, oil on canvas 85 × 154.9 cm. Private Collection

fig.16 Duncan Grant, *Two Men* c.1920, ink on paper 19 × 22 cm. Private Collection

fig.18 Patrick Heron, *Yellow Painting with Four Discs: 1964*, oil on canvas 152 × 182.9 cm. Fundaçao Calouste Gulbenkian, Lisbon

fig.17 Duncan Grant, *Still Life with Plaster Torso* 1918, oil on canvas 97.5 × 63.7 cm. Private Collection

fig.19 Vanessa Bell, *Abstract Composition* 1914, oil on canvas 92.8 × 62.3 cm. Private Collection

were shown in 1961, just after her death, the disfavour in which her circle in general and her later work in particular were held, spelled critical silence and only two of those paintings were sold (nos.34, 35). Affinities however do exist that relieve the tendency to see the Bloomsbury painters as distinct and apart. There are links, for example, between Grant's and Bell's abstraction and that of Ben Nicholson a decade later, with its similarly collage-like overlapping of geometric and linear elements (figs.13, 14). Nor should one forget the young Henry Moore's enjoyment of Grant's *Venus and Adonis* (no.118) nor the pioneering homoerotic content of some of his work (fig.16) in relation to Keith Vaughan, David Hockney and even Francis Bacon. Nearer to Grant in sensibility and enthusiasms was Ivon Hitchens, some of whose still lifes such as *30 Pink Star* of 1933–34 (fig.15) bear a close relation to Grant's 1914–15 mantelpiece still lifes (no.50) and to the contrast of firm modelling and decorative exuberance in, for example, Grant's *Still Life with Plaster Torso* of 1918 (fig.17). Almost certainly neither Nicholson nor Hitchens knew Grant's early work but such affinities are a further confirmation of John Piper's words about Grant that 'no British artist has ever preached less or prophesied more'.[17] Again, the current reappraisal of Patrick Heron's work (e.g. fig.18) has revealed unexpected similarities of vocabulary with, for example, Bell's *Abstract Composition* (fig.19).

How best, then, to represent the Bloomsbury painters whose output was prolific, uneven and wide-ranging in style and content and who appear in different guises as decade follows decade? What shape and position do they assume at the end of the twentieth century? It should not be forgotten that taken together their careers spanned nearly a hundred years, that with Fry we reach back to the high game of Victorian academicism and the Arts and Crafts movement and go forwards to Grant in old age admiring the work of Richard Long and Howard Hodgkin, painting a portrait of Gilbert and George (fig.165) and regarding Jackson Pollock as 'an old master'. This is the same person who in his youth had been taken the round of studios on Sunday afternoons to meet Briton Rivière, William Holman Hunt and Lawrence Alma-Tadema. The Vanessa Bell of this exhibition is the Miss Stephen who poured tea for George Meredith, James Russell Lowell and Henry James and a decade or so later was proclaiming Picasso as 'one of the greatest geniuses that has ever lived'.[18]

This chronological span and its diversity frame the moment of the ascendancy of the Bloomsbury painters in the years before the First World War, a moment compounded of excitement, liberation, destruction and revision. It is then that they produced some of their most memorable paintings and contributed a vivid unbuttoning of pictorial language and content to British art of that time. Such liberalisation and innovation were crucial and although their work carries little of the weight and resonance of some of their pre-eminent European contemporaries, it is conspicuously adventurous in Britain. If their later works (post-1920) appear less immediately exhilarating, they have felicities of response and qualities of enjoyment – sensuous, meditative, pacific – that look increasingly inviolable as time passes.

Notes

1 Foreword, *The Age of Rossetti, Burne-Jones and Watts: Symbolism in Britain 1860–1910*, exh. cat., Tate Gallery, London 1997, p.7.

2 'Sargentolatry', *A Free House! The Writings of Walter Richard Sickert*, ed. O. Sitwell, London 1947, p.80.

3 V. Bell, *Sketches in Pen and Ink* , ed. L. Giachero, London 1997, p.130.

4 V. Woolf to R. Fry, 27 May 1927, Woolf *Letters*, 3, London 1977.

5 P. Ackroyd, *T.S. Eliot*, London 1984, p.309.

6 *Tate Gallery 1970–72*, 1972, p.111.

7 Letter from R. Fry to V. Bell from St Rémy, 17 June 1927; TGA.

8 D. Grant to V. Bell from Paris, 30 Jan. 1922; TGA.

9 V. Bell to R. Fry, 16 Sept. 1921; TGA.

10 L. Woolf, *Beginning Again*, London 1964, p.27.

11 S. Watney, *Duncan Grant*, London 1990, pp.68–9.

12 A. Garnett, *The Eternal Moment*, Orono, Maine 1998, p.38.

13 A. Fernihough, *D.H. Lawrence: Aesthetics and Ideology*, Oxford 1993, p.117.

14 'I remember being delighted when he [Picasso] told me of his admiration for Burne-Jones and that as a boy he had wanted to come to England to see the works of the master.' (D. Grant to the author, 5 Sept. 1970)

15 For a brilliant analysis of this particular critical 'method', see C. Reed, 'Critics to the Left of Us, Critics to the Right of Us', *Charleston Magazine*, 10, Autumn/Winter 1995, pp.10–16

16 See, for example, the reference to 'the sneering, elitist, ivory-tower attitudes encouraged by the Bloomsbury generation' in Mark Bostridge's review of Adrian Wright's *John Lehmann: A Pagan Adventure* in *Independent on Sunday*, 20 Dec. 1998.

17 *The Listener*, 24 June 1931, quoted Watney 1990, p.63.

18 V. Bell to D. Grant [29 Jan. 1914], *Selected Letters of Vanessa Bell*, ed. R. Marler, London 1993, p.161 where misdated 25 March 1914.

Image and Theme in Bloomsbury Art

Richard Morphet

Bloomsbury painting is often criticised on the one hand for an alleged dull uniformity of manner and on the other for its marked stylistic diversity. The first of these observations flies in the face of the facts; the second identifies a tendency that in the hands of Fry, Bell and Grant became a strength. This essay examines these artists' painting in terms of some of its chief categories of image and of theme. Its aim is to demonstrate that, for all the variety in its outward aspect, unchanging, shared impulses were at work that give Bloomsbury art a unity at once distinctive and enriching.

In their very different ways, Roger Fry and Vanessa Bell each contributed to Bloomsbury art a steadiness of disposition[1] to which the inventiveness and free imagination of Duncan Grant forms a crucial complement. All three artists, however, accorded a central role in painting to directness of sensuous response. A new freedom in this respect was one of their chief contributions to British art in the decade 1910–20. In the work of those years the delight they showed in painterly touch has an expressive character that is fused, in the evident passion of discovery, with other qualities which were startling in their day and that remain arresting when compared with other British art of the period. These include exuberance of colour, idiosyncracies of artistic 'handwriting' and forceful simplification of appearance in the interest of insistent unity of design.

Bloomsbury art represents less of a rupture with that of the nineteenth century than is often claimed. Yet in terms of idiom and of social attitude much of their work in this most innovatory decade had a challenging character that in the context was almost wild. At times it is as though, whatever a picture's motif, part of its very subject is the artist's exhilarated sense of the collapse of restraints on what is permissible. When the two younger artists, in particular, applied paint in slabs or scribbles or accentuated the frontality of their images, the freedom of the act was like a slap in the face to established notions of what made a proper painting.

Another aspect of this liberation was the exceptional diversity of approach that a single artist could adopt within a short period of time. For example, only two years separate Grant's statuesque *The Dancers* of 1910–11 (no.10), who tread their other-worldly round, from the dashed brushwork and exigent glare of his almost provocative *Head of Eve* 1913 (fig.20). Among his still lifes of 1914, the powerful firmness of *The Modelling Stand* (no.49) may be compared with the wandering lines and patches of free colour in the almost Kandinsky-like *Omega Paper Flowers on the Mantelpiece* (no.50). The same months also saw the climax, in one sense, of these artists' willingness to explore extremes of idiom, namely their pure (and sometimes purely rectilinear) abstracts (nos.76, 83, 84).

But if Bloomsbury art of the years around the First World War had a confrontational side, this was entirely secondary to a resolve central to each work, to create an active harmony between the elements of which it is composed. The inseparability of their conception of harmony from the strength of their drive to articulate relationships of colour-in-form led naturally to their exploring abstraction. By a concentrated deployment of the simplest elements they aimed, successfully, to make their abstract works embodiments of a positive emotion. But at the same time the artists were examining the capacity of form and colour alone to yield a result wholly satisfying to both intellect and emotions. They seem quickly to have concluded that pure abstraction could not meet this need. The immediacy of the depicted subject in Bloomsbury art both before this abstract moment and for decades after it should not, however, allow us to disregard the unusual degree to which a composition, when contemplated more than fleetingly, insists on its character as a pictorial *structure*.

The Bloomsbury preoccupation with harmony is a clue to understanding the distinction between their abstract works and the near-abstracts painted in the same period by the also structure-conscious

fig.20 Duncan Grant, *Head of Eve* 1913, oil on board 75.6 × 63.5 cm.
Tate Gallery

artists of the Vorticist circle. As its critics never fail to stress, Bloomsbury art's attraction to a kind of universality differed sharply from Vorticist celebration of the dynamism of specifically modern industry and speed. Two features of the Vorticist aesthetic specially elucidate the difference. In some respects the Vorticists were stimulated by the idea of modern warfare. The Bloomsbury painters abhorred such a prospect and on the level of broad predisposition there is a link between their quest for an art in which all parts of a work are in creative harmony and their pacifist position when hostilities developed. Secondly, the Vorticist attitude to the past was ambiguous to say the least, Wyndham Lewis writing in *Blast* No.1 that 'Our vortex is not afraid of the Past; it has forgotten its existence'.[2] By contrast, the Bloomsbury painters drew continual inspiration from the great art of previous centuries (not to mention from that of contemporary masters in Paris, another connection denigrated by the Vorticists). While in many ways they reacted as strongly as the Vorticists against those parts of nineteenth-century British art favoured by established taste, their art nevertheless extends certain of its preoccupations. Hence the paradox that the very phase of Bloomsbury art that presented the sharpest offence to artistic convention also revealed close links with some of the art most approved of by such taste.

Grant's kinetic scroll painting of 1914 (no.78) is a wholly abstract work designed slowly to expose to view, through a rectangular aperture, a sequence of seventeen different arrangements of a cluster of coloured rectangles (most of them executed in collage), to the accompaniment of the music of J.S. Bach. The effect is of a calm unfolding, a gentle kaleidoscopic tumbling. Appealing to several senses simultaneously, it has a markedly spiritual character. *The Golden Stairs* (1872–80, Tate Gallery) by Sir Edward Burne-Jones, whose work Grant had admired since childhood[3] has been described as 'one of the great celebrations of music in Symbolist art'.[4] Despite its outward dissimilarity it can be seen as connected to Grant's kinetic scroll painting in being 'an essay in a form of abstraction, a pictorial evocation of the rhythms and counterpoint of music'.[5] As Christopher Newall has written, his 'fondness for the infinity of abstract variation allows Burne-Jones … to be regarded as … unconsciously engaging with issues that would, after his death, galvanise a new generation of progressive artists'.[6] Grant's kinetic painting is, of course, peculiarly of the twentieth century. It showed knowledge both of

the work of the Russian composer Aleksander Scriabin and of synthetic Cubism. Yet if even here, at its most abstract, Bloomsbury art reveals affinities with High Victorian art, it is hardly surprising that such parallels are still clearer in its representational work. Again, the connection hinges on the importance to the younger group of imagination, fantasy and the spiritual.[7]

Before Fry knew Bell or Grant, he published a text strongly praising the art of G.F. Watts[8]; two years later, Grant copied a portrait by the recently dead painter.[9] Vanessa Bell knew Watts personally as a family friend of the Stephens and, although she was later hostile to his art,[10] his portrait of her father hung in her house when Grant first became a visitor there (it became a conspicuous feature of her sister's drawing room at 29 Fitzroy Square after 1907). Awareness of Watts's work was pervasive. It is not difficult to see parallels between the more classical side of Watts (fig.21) and the work of Grant (no.10), and the generalised yet authentic sentiment of some of his allegorical pictures must have struck a chord, even though neither its Victorian idealism nor its intimations of a possible form of abstraction more misty than theirs can have spoken to Bloomsbury.

A characteristic which both Watts's celebrated *Hope* (1886; fig.22) and his *The Genius of Greek Poetry* (late 1850s–c.1878, Harris Museum and Art Gallery, Preston) share with Pre-Raphaelite painting is a curious angular awkwardness of posture in the principal figures. An expressive strength of such images, this quality is also seen in one of Grant's best-known paintings, *The Queen of Sheba* 1912 (no.20). Here, too, the parallels with Burne-Jones are close, but in Bloomsbury's figurative work such affinities are most evident when a painting's theme is music. A picture such as Burne-Jones's *The Hours* (fig.23) combines preoccupations with music, bodily gesture and the arrangement of other-worldly figures in a row that, transfigured, finds an echo some forty years later in Grant's and Bell's murals for J.M. Keynes's rooms in Cambridge (fig.24).

Like many Bloomsbury works, these suggest a vision of life conceived in terms of ritual or ceremony; indeed, Bell and Grant brought such an approach to bear on several everyday activities, for example taking a bath (fig.25). But when in these early years instruments are shown being played, or dance is in progress, it is as though the sound is audible, though reaching us from another and a more rarefied world. Such is the case both in the slow, stately movement of Grant's *The Dancers* 1910–11 (no.10) and in the sequence of images of angels on the four sides of the log box at Charleston (fig.26).

fig.21 G.F. Watts, *The Judgement of Paris* c.1865–72, oil on canvas 80 × 65.4 cm. The Faringdon Collection Trust

fig.22 G.F. Watts, *Hope* 1886, oil on canvas 142.2 × 111.8 cm. Tate Gallery

fig.23 Edward Burne-Jones, *The Hours* 1882, oil on canvas 77.5 × 183.4 cm. Graves Art Gallery, Sheffield

fig.24 Duncan Grant and Vanessa Bell, *Studies for Mural in J.M. Keynes's Rooms, Webb's Court, King's College, Cambridge* 1920, oil on canvas, each panel 84 × 36.8 cm. Private Collection, USA

fig.25 Duncan Grant, *The Tub* 1916, oil on panel, size unknown. Destroyed. Reproduced from R. Fry, *Duncan Grant*, 1924

fig.26 Duncan Grant, *Log Box* 1917, oil on wood 34.3 × 34.3 × 31.8 cm. The Charleston Trust

This work, too, is concerned with formal progression, since each dancing figure seems to be responding to the music we see being made on the surface that precedes its own. In such images it is as though something of the vision of High Victorian art has been transmuted, lightened and somehow aerated by Grant's strong and frequently expressed response to the work of Piero della Francesca.[11] Music, very much in the act of being performed, 'sounds' through Piero's work and Grant must also have drawn inspiration from him for the tall, vase-like hats seen in several of his imaginary figure groups (fig.11). But the influence is more than a matter of iconography; it lay equally in Piero's combination of strongly articulated form with a quality of dreamlike and yet lucid other-worldliness.[12]

A presence still more pervasive than Watts's in Vanessa Bell's and Duncan Grant's lives was that of Bell's great-aunt, the highly original photographer Julia Margaret Cameron (1815–79). Cameron created the definitive images of the strange and again almost unworldly beauty of her niece Julia Jackson (later Stephen), the mother of Bell and of Virginia Woolf, which in turn were copied by both Bell and Grant on both canvas and paper. Photographs by Cameron hung in the family's home even after its 'liberation' from the parental house and among those who wrote about her art was Roger Fry.[13] Although the attitude of this younger generation towards Cameron's high-minded vision had strong elements of satire, as evidenced by Virginia Woolf's play *Freshwater: A Comedy*, it is impossible not to see a curious continuity between Cameron's fantastic, contrived and mood-pervaded figure

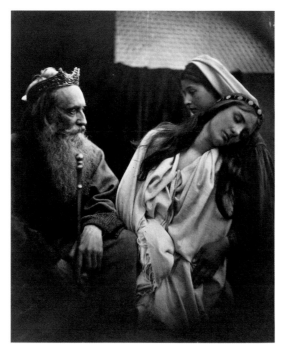

fig.27 Julia Margaret Cameron, *Queen Esther before King Ahasuerus*, registered 1865, albumen print The Royal Photographic Society

fig.27A Eve Younger (centre) as Charmian and Angelica Bell (foreground) as Cleopatra in Shakespeare's *Antony and Cleopatra*, late 1930s. From Vanessa Bell's photograph albums. Tate Gallery Archive

groups (fig.27) and the later artists' propensity to create just such tableaux of their own, whether in fine or applied art or in family theatricals in both London and Sussex (fig.27A).

These various modes form a single tissue, so that it is impossible to make hard and fast distinctions between genres of Bloomsbury art in terms of imagery. Echoes of the strange intensity of Cameron's imagination can be found not only in the work of Grant with its repeated inclination towards fantasy, but also in that of Bell, for example in her enigmatic figure group *A Conversation* (fig.28). But it is suggested, too, in a quality of the exotic and the near-excessive that recurs in Bloomsbury art up to the mid 1930s. This was specially manifest in the heightened emotional climate of their art of the decade from 1910, as in the image of a lily – the emblem of aestheticism – on one side of Grant's painted signboard for the Omega Workshops of 1913 (fig.29). In that period, flowers painted by both Bell and Grant often had exaggeratedly long stems, which extended in improbable yet expressive arcs beyond the confines of their conceptual vases to culminate in spectacular blooms (no.67). The atmosphere of these images is not inconsistent with that of a passage in a letter to Alfred, Lord Tennyson in which Mrs Cameron wrote of:

> 'that consummate flower' the Magnolia – a flower which is, I think, so mysterious in its beauty as if it were the only thing left unsoiled and unspoiled from the garden of Eden. A flower a blind man would mistake for a fruit too rich, too good for Human Nature's daily food. We had a standard Magnolia in our garden at Sheen, and on a still summer night the moon would beam down upon those ripe, rich vases, and they used to send forth a scent that made the soul faint with a sense of the luxury of the world of flowers.[14]

Cameron and her circle would have regarded the Garden of Eden as soiled by Bell and Grant's several interpretations of life there, not least in the latter's large painting *Adam and Eve*, in which a gargantuan full-length Eve advances alarmingly towards the viewer between Matisse-like palm trees, while Adam stands on his hands (fig.30). They would also have been outraged by what they would have considered the crudeness of representation and touch in Bell's *Nude with Poppies* (1916, no.86), and above all by the overt sensuality that pervades these and so many other Bloomsbury works of the

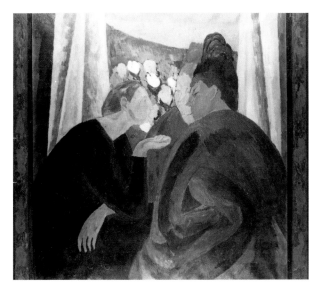

fig.28 Vanessa Bell, *A Conversation* 1913–16, oil on canvas
86.6 × 81 cm. Courtauld Gallery, London

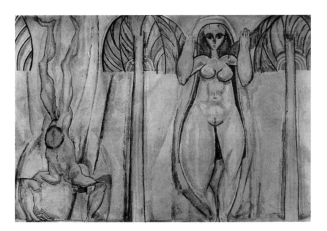

fig.30 Duncan Grant, *Adam and Eve* 1913, oil on canvas
approx. 213 × 335 cm. Lost or destroyed

fig.29 Duncan Grant, *Lily* side of Omega Workshops
signboard 1913, oil on wood 104.1 × 63.2 cm. Victoria
and Albert Museum, London

period. But the languor ordained by the near animate heads of Bell's poppies[15] has an almost
hot-house quality that links Cameron's vision and that of much of her era's art with the ambience of
Bloomsbury painting, for all the latter's liberation.

Important among the means by which Bloomsbury art gives access to a world not quite of the here
and now are the use of gesture and of the figures' glances or gaze. Gestures 'speak' to the viewer, as if
to impart an enigmatic meaning. Paintings focus with unusual insistence on eyes and their arresting
expressions. This, too, is a feature of the work of Piero, though in Bloomsbury art eyes hint, some-
times disconcertingly, at more secular mysteries and relationships. They are significant, for example,
in all Grant's early self-portraits (e.g. fig.31, and nos.9 and 27), in most of his intimate pre-1920 por-
traits of Vanessa Bell (e.g. nos.39, 115 and 116), in his *Head of Eve* (fig.20) and in Bell's portrait of
Mary Hutchinson (no.35). Not only the look that eyes give is accentuated, but also their shape.
Examples of works which combine the meaningful stare with the Delphic gesture include the larger of
Grant's two self-portraits in a turban (no.9) and the poster, of 1912, for the Second Post-Impressionist
Exhibition (fig.69). In other works, not least in Bell's portraits of Virginia Woolf (no.32), who disliked
being looked at, eyes are significant by their absence. They are crucial when, their shape enhanced,
they are left actively blank in Grant's *Head of Morpheus*, the god of sleep, on a headboard at
Charleston (fig.32). The power of this image derives from the fusion of at least four elements — its

striking design; its glowing, inner-lit colour; its hieratic centralisation, in tension with insistent asymmetry; and the sheer variety of its unorthodox means. Paint is applied as modelling, as *écriture* and by spattering, while the crucial nose and brow are of unpainted wood, blatantly screwed on.

A further ingredient in the strange imaginative power of Bloomsbury figure painting in this early period is the sense conveyed by so many ostensibly fanciful pictures that they reflect simultaneously the actual lives the painters led. In some cases this is because the models were friends or relations of the artist. Grant's *The Queen of Sheba* represents not only her and King Solomon but also Pernel and Lytton Strachey, his two paintings of *Nude with Flute* (no.80) are of their sister Marjorie and *Standing Nude with Bird* (fig.104) is Molly MacCarthy, while Grant's turbaned self-portraits recall his participation in the Dreadnought Hoax of 1910 (see no.27). Conversely, despite its response to particulars of a given time and place, the very character of Bell's celebrated *Studland Beach* (no.26) invites speculation as to whether this scene may not also represent real inward experience.[16] Such ambiguities are complicated by the importance for the artists in these years not only of the intense personal relationships so wrongly considered by many to be the sole preoccupation of their circle but also of costume parties and an abundance of vivid theatre and dance performances on the London stage. Engagement with the theatre continued in Grant's work into the 1950s. One cannot overlook the parallel concern of Virginia Woolf, especially in *Orlando* (1928), with the merging of the real with the imagined, of present time with past, and of one identity with another.

Grant's *Le Crime et le Châtiment* (no.7B) is a strange but telling combination of close observation of a setting with a concern to register strength of emotion. This family 'portrait' is far removed from the sense of the fantastic yet, as with *Studland Beach*, the unconventionality of its conception and its interest in heightened human experience interlink with the purely imaginative side of Bloomsbury art. A key genre for these painters, however, was more direct forms of portraiture and here, too, a chief concern was to communicate the immediacy of the sitter's presence. The intimate portraits of Vanessa Bell made by Fry and Grant (the latter a long and extraordinary sequence) are specially charged with feeling. In the searching observation on which they depend there is a seriousness in

fig.31 Duncan Grant, *Self-Portrait* 1910, oil on canvas on board 41 × 30.5 cm. The Charleston Trust

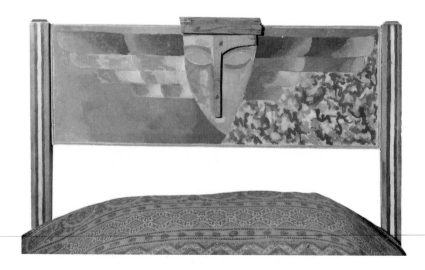

fig.32 Duncan Grant, *Head of Morpheus bedhead* c.1916, oil on wood 30 × 94 cm. The Charleston Trust

fig.33 Duncan Grant, *David Garnett at a Table* c.1919, oil on canvas 44.7 × 59.7 cm. Private Collection

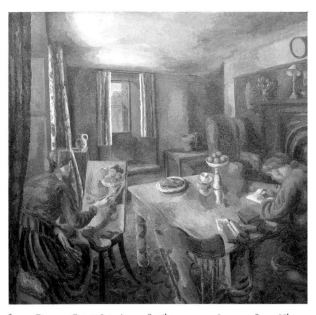

fig.34 Duncan Grant, *Interior* 1918, oil on canvas 163 × 174.8 cm. Ulster Museum, Belfast. Vanessa Bell at left, David Garnett at right

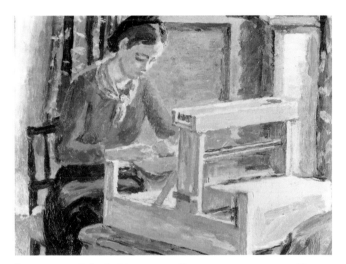

fig.35 Vanessa Bell, *The Weaver* 1937, oil on canvas 40.5 × 30.5 cm. The Charleston Trust. A painting of Angelica Bell

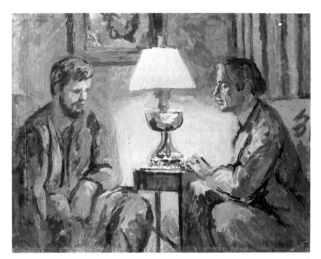

fig.36 Vanessa Bell, *Julian Bell and Roger Fry Playing Chess* c.1933, oil on canvas 61 × 81.3 cm. The Provost and Fellows of King's College, Cambridge

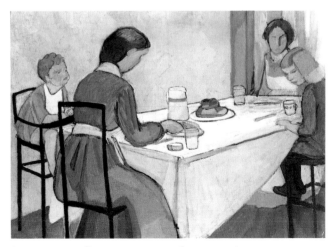

fig.37 Vanessa Bell, *Nursery Tea* 1912, oil on canvas 76.2 × 105.4 cm. Private Collection

which love is fused with admiration and with a kind of continuous surprise. In all three artists' self-portraits scrutiny reveals a marked honesty, evident from an early date but never more so than in the sombre self-images of each in old age (e.g. nos.141, 147). These should be prominent in any consideration of Bloomsbury's emotional range.

As portrait painters they were also concerned to bring out the circumstances in which the sitter is found. For Bell and Grant the setting was increasingly Charleston which, for painters and writers alike, was a place of creative work as much as of relaxation. It is therefore not surprising how many of the images of their family and friends represent concentrated activity (fig.33). This theme is embodied in Grant's *Interior* 1918 (fig.34) in which a writer works side by side with a painter (or actually with two, since the presence of the picture's creator is implicit), while the facing window looks onto a working farm. Even the children are shown at work (no.116), and concentration is the theme of Bell and Grant's paintings of them performing music, weaving (fig.35) or playing chess (fig.36). In the art of Vanessa Bell, in particular, images of the life of the family, of meals (fig.37) and of conversation among friends (no.22) convey a quiet but profound emotion.

Paintings of life at Charleston hand down to us the character of an existence and a combination of circumstances the equivalent of which would be difficult to create today. The life was not as easy as hostile critics suggest, yet such settled conditions, allied to strong professional motivation, beauty of surroundings and liveliness and intelligence of companionship, formed in themselves a compelling subject for painting. Thus in a more all-embracing sense than Monet's environment at Giverny, Charleston itself *generated* art. There is a partial parallel with the home-centred painting of Bonnard and of Vuillard. The latter's small pictures of the 1890s have been described, comparably, as being 'remarkable as depictions of individuals *within* their environment, surrounded and explained by the spaces they have created for themselves'.[17]

In such works by Vuillard the unusual prominence of pattern is an obvious link with Charleston's decorated walls. But when Charleston is described as a 'riot of decoration' and references are made to the painters' handiwork being on 'every available surface', its character is misunderstood. It was in fact exceptionally ordered. Among the elements the artists employed to create what Angelica Garnett has described as 'an atmosphere of untroubled serenity'[18] were not only space, colour and light but also many walls left undecorated. A process of continuous, undramatic change, involving spaces, things, people and their activities, constantly revealed subjects for paintings. While celebrating specific motifs, these also carried a sense of the totality of their context. As the same author records

> living there was rather like living on a stage where the set is being constantly changed or modified … But it would be a mistake to suppose that this search for visual satisfaction led to a state of self-conscious exhibitionism … If [Bell and Grant] kept their eyes open all the time, if they changed and adjusted things, it was always in relation to what was already there, and it is for this reason that we … feel a sense of unity and wholeness.[19]

In Charleston, European art of the past seems alive, both through actual images from earlier centuries and through their indirect presence in Bloomsbury paintings and decorations. At the same time, the house has a French feel. When an environment merges these qualities with those already described, the result is a world that seems quite other. The paintings of that world by the artists who created it not only reflect its particular character but also give their idea of it a more concentrated expression. Thus such works are not only a valuable form of record but also, through the devices of art, encapsulations of a vision.

Between the wars, that vision had its real-life parallel in France, when the Bloomsbury artists lived for periods in a landscape that descended through fertile fields to the nearby Mediterranean. In these years a convention much favoured in British and French art was the view looking out through an open window or door. In such Bloomsbury views of Charleston or of Cassis (figs.38, 40) it is no exaggeration to say that both the view and the implication are of a kind of paradise. These works speak of total

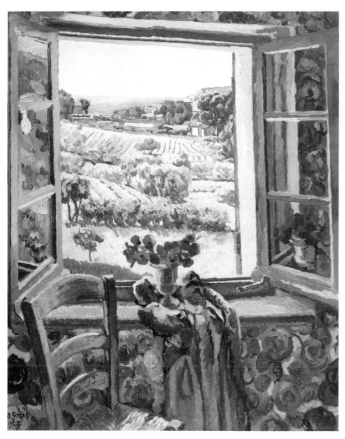

fig.38 Duncan Grant, *Window, South of France* 1928 (no.131)

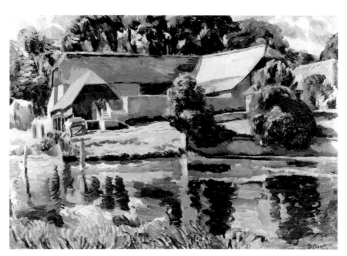

fig.39 Duncan Grant, *The Barn by the Pond* 1925, oil on board 60.1 × 83.5 cm. City of Aberdeen Art Gallery and Museums Collections

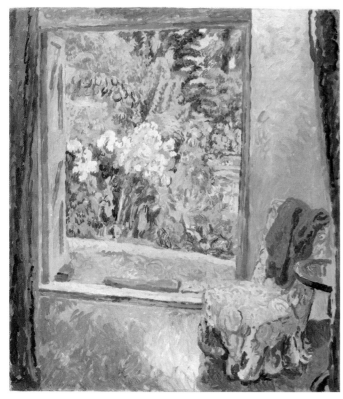

fig.40 Duncan Grant, *The Doorway* 1929 (no.132)

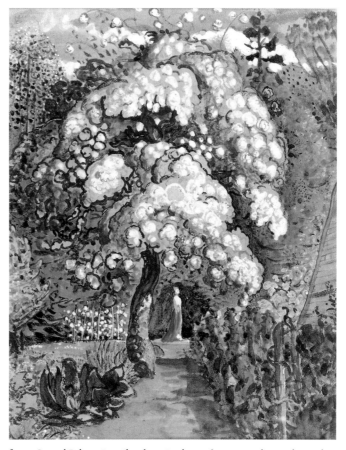

fig.41 Samuel Palmer, *In a Shoreham Garden* c.1829, watercolour and gouache on paper 28.1 × 22.2 cm. Victoria and Albert Museum, London

harmony between man and nature. Everything is ordered, beneficially. In the paintings of Charleston, the sense of benign control is enhanced by the fact that each of the principal outdoor 'zones' the pictures record (garden, pond, barnyard) is an enclosure (fig.39). The reassurance this gives is strengthened by the interconnectedness of these spaces, and by that between each and the house interiors. One scene leads to the next with natural ease. The paintings confirm both the functionality of the farm and the way in which a garden or the surrounding land are continually tended, even constructed, suggesting an equivalence between the practicality of their making and that of a painting. On more than one level the subject of these images is a state of integration.

In views into the garden, such as Grant's *The Doorway* (no.132, fig.40), the enclosed world we glimpse, with its sense of promise and with its sheer natural abundance, sometimes seems to link with the world represented by Samuel Palmer, as in his *In a Shoreham Garden* (fig.41); even Palmer's tutelary woman has her parallels in other Charleston garden paintings. In the context of the grim realities of life in the inter-war years it is often objected that Bloomsbury art is escapist. It is no more so than Palmer's visionary images or Stanley Spencer's of Cookham, and in any case the objection can detract neither from the peculiar intensity of the work itself nor from its power to nourish those who see it.

The reassuring nature of these paintings of Charleston or the South of France has a counterpart in Roger Fry's vision of landscape. He was always responsive to both the functional and the natural structures of the French countryside, not least those of Provence, to which he was drawn also by particular qualities of colour.[20] His landscape paintings lend themselves unusually readily to spatial exploration in detail. Steps, statues, roads and paths all operate as markers or conductors, giving the viewer a satisfying sense of being able to find their way, stage by stage, always knowing exactly where they are, through every part of a contained environment in which the reassurance derived from the clarity and openness of every element is enhanced by a strange sense of familiarity. The latter is in part the result of Fry's ability simultaneously to suggest both the immediate materiality and the endurance through time of the phenomena he represents. All three artists' interpretations of the landscapes they loved sprang from the instinct to give lasting form to a state of active harmony. The harmony established in a painting's internal relations parallels the artist's lived experience of its motif.

As the Bloomsbury artists grew older, intensity in their art took different, less overt forms. The later the artists were born, the longer they lived. The interval of nearly thirty years between the deaths of Roger Fry at sixty-seven and of Vanessa Bell at eighty-one enlarges the contrast between his later work and that of his younger colleagues, already evident in his lifetime owing in part to Bell and Grant's greater intimacy. For them, searching study of the motif grew in importance. The resulting prized immediacy was enriched by the depth of their engagement with past art.

It is perhaps in still life, above all, that the work of Bell and Grant shows the closest affinity. This side of their art developed an increasingly meditative quality. A concern with the dialogue between the parts of a picture's design came together with a feeling for the context in which the painter apprehended each depicted object, whether in terms of taste, of function or of history of ownership. Such connections augmented the closeness of their vision to the past. The sense increased of each picture as a contained world, rich in its particular combination of associations, transmitting delight in the direct material realities of the motif, yet simultaneously exposing the painter's means of brushstroke, accent, hue. As with the also quiet, direct yet sensuous still lifes of Braque or Morandi, such pictures brought the viewer close to the artist's mind at work. They also seemed to trap the passage of time during their making.

In many of the still lifes of Bell and Grant the familiar firm vertical in the design represents the edge of a frame or canvas, often seen from the back. Their motifs, especially Grant's, had long referred to the studio and its apparatus, but as their preoccupation with still life deepened a significant part of a painting's subject, with or without depicted brushes or stretchers, seems to become the painter's *métier* itself, its processes and the sense of wellbeing that it brought. Characterisations of the Bloomsbury painters as superficial ignore this central feature of their calling. Critics may recog-

nise it more readily in the case of Vanessa Bell, the frequent austerity of whose demeanour in old age is well known, but it was no less important for Grant, who from his teacher Simon Bussy 'learnt an attitude to work that was humble, attentive, scrupulous and self-denying',[21] which he maintained till he died.

A recent review listed Vanessa Bell among the artists who 'give us pleasant, thoughtful paintings … but every stroke and dab of the brush, every little decision between, say, mauve and pink, every glimpse of … the South Downs beyond the sitting room window … all these things proclaim the unadventurous status quo of the English middle classes … Whatever Bacon's faults, he was never provincial'.[22] One of many texts which imply that in order to be significant art must 'develop', this seems to overlook the quiet strength of painting that draws on long experience, slows the viewer down as the means of disclosing its content, both plastic and affective, and has greater stamina in the long run than much work that is more 'progressive' (figs.132, 144). Bloomsbury's finest still lifes reflect the artists' increasing indifference to the demands of idiomatic advance. While certain qualities were thereby lost (a problem compounded by a degree of overproduction) others, associated with the very inwardness of the works, were gained. Today's is not perhaps the most propitious climate for the recognition of these lasting qualities.

The most widely admired aspect of the late work of Bell and Grant is the final flowering of the latter's art in the late 1960s and early 1970s. This surprising phase is explained not only, perhaps, by the loss of constraint so often associated with extreme age but also by the greater ease of travel and the renewed contact with avant-garde art that were made possible for Grant by Vanessa Bell's death, by the help of his companion Paul Roche and by friendship with a range of very much younger people. Interwoven with these factors was the dramatic revival of interest, beginning soon after Vanessa Bell died, in Bloomsbury's most advanced art of some fifty years earlier. Grant's initial reaction to this was delight qualified by a degree of puzzlement. This underlay the slight time-lapse between the onset of this change in climate and its impact on Grant's new art. When this took effect the work gained a renewed quality of freedom and of imaginative strangeness which make one curious as to the course Grant's art might have taken had his relative isolation in terms of generation and of taste ended sooner than it did.

Conversely, it would have been gratifying had more of the younger generation who now entered Grant's life been sufficiently independent of the prevailing perspective of that most vanguardist of eras to enter more fully into the vision that directed Bloomsbury art of the period c.1945–68. In

fig.42 Vanessa Bell, panel for RMS *Queen Mary*, oil on canvas. Photograph from *RMS Queen Mary*, published by Cunard White Star 1934. Cunard Archive, Special Collections and Archives, University of Liverpool

fig.43 Duncan Grant, *The Arrival of the Italian Comedy* 1951, oil on canvas 182.9 × 228.6 cm. Artist's Estate

retrospect the task of judging Bloomsbury art from the 1930s on is rendered more difficult by so much of it being lost or unsurveyed. Should this lack be remedied, it will be easier not only to distinguish the peaks from the troughs within the later decades but also to explain and illuminate individual works that may too readily be dismissed, by seeing them in the framework of the sequences within which they emerged. Answers may then be easier to such questions as how Grant's large output of erotic art relates to his own work (and Bloomsbury art) as a whole, or how we should judge the grand machines which Bell and Grant produced from time to time. Calling for rehabilitation, for example, is work such as Vanessa Bell's large painting of the mid 1930s for the RMS *Queen Mary* (fig.42). The 'artificiality' of its scene of the avenue in a park, with a fountain, children, nursemaid and strolling couple seen beyond a ledge which supports a large vase of flowers, a dish of fruit and a fan, is far from being a weakness. I also suspect that a work such as Grant's *The Arrival of the Italian Comedy* (fig.43), produced for the Festival of Britain project *Sixty Paintings for '51* and currently widely regarded as an embarrassing pastiche, will likewise reveal over time an authenticity of feeling and a liveliness of structure that call for greater exposure. It would be surprising were this not so, considering the context from which both pictures sprang.

Grant is the only Bloomsbury artist who could have conceived the latter work and it is to be hoped that this exhibition will enable visitors more fully to perceive how distinct a sensibility underlies the achievement of each of its three chief figures. The paintings of Fry, a writer of genius, may understandably be discussed in terms of aesthetic theory but should be judged by their intrinsic qualities. Of Fry the artist it can be said, as he himself did of G.F. Watts, that 'fortunately, he seems to have lived by the dictates of a sound instinct rather than by self-conscious theories'.[23] Fry's painting is consistent with his view, also expressed about Watts, that 'beauty cannot exist by itself; cut off from life and human realities it withers'.[24] (fig.44). His pictures have a workmanlike quality: they present the depicted subject with a down-to-earth directness. Their simultaneous subject, which shares this directness, is the exposure, at once intellectual and sensuous, of the way the image has been constructed in terms of both flatness and depth (fig.45).

The directness of Fry's paintings and their aversion from anything showy are among their close affinities with the work of Vanessa Bell, but her art is marked by a greater bluntness and a more uncompromising quality. In Fry's lifetime this could often include a more ruthless instinct towards simplification, which probably forms one of the strands of her (and Grant's) unflattering view of much of his work. After Bell's death a contemporary, the painter André Dunoyer de Segonzac, observed perceptively that

> never in her work does one meet with … affected prettinesses …, nor yet with the facile but seductive picturesque: all is purity, frankness and perfect simplicity both in what is expressed and the means of expression. This accent of sincerity and truth has nothing to do with dull realism; it is stamped with a grand, natural distinction without a trace of affectation.[25]

A further distinguishing feature of Bell's work is an implicit gravity, evident even in some of the most outspoken images of her most avant-garde years. When these qualities are seen in conjunction with the nurturing love of family manifested repeatedly in her work it is easy to see how she represents, in a sense, a moral centre in Bloomsbury art.

The Bloomsbury painters continually surprised one another by the new works they created, but of the three Duncan Grant was the least predictable and the most inventive. The range of past and current art to which his own responded was also wider. He had a gift for translating a given manner in painting into his own vision, not pretending to have done otherwise yet not producing a pastiche (fig.46). Taking his career as a whole, the variety of his approaches is not only remarkable but is often evident within quite narrow time-spans. Close together in the early 1920s, for example, were small landscapes and townscapes reminiscent of early Corot in their simplicity and in their lightness of tone, yet also some of his darkest and most solidly realised table-top still lifes. The late 1940s could produce townscapes as dissimilar as an architectural vista in Copenhagen in his recurrent, skilfully

fluid manner of 'drawing' in paint with seeming speed, ease and lightness of touch, and a dignified elevation of St Paul's Cathedral in the manner of the mid-eighteenth century.

Grant's verve and his earnestness can come together in a single work, as in *Still Life with Matisse* (1971, no.149). Most of his re-charged late works, of which this is an example, also consolidate his longstanding preoccupation with combining references to different worlds and different times into a quiet but rich new celebration. In work of this kind by the Bloomsbury painters, 'eclecticism' is a source of strength. Even in the most generically ordinary of still lifes the formal qualities of a picture and the freshness with which paint is applied are made interdependent with its imaginative dimension in such a way that to isolate any of these aspects seems unreal. The same can be said of many other artists, but it is its consistent flavour that makes Bloomsbury art unmistakable – free to move across a variety of manners yet always itself, controlled but engaging, alert and nourishing.

Bloomsbury art is frequently taken to task for all the things it is *not* – for example, directed towards issues of social concern, rigorous, stylistically single-minded, wholly independent of applied art, consistently advanced, and so on. One of the most frequent criticisms is that it does not attain to the heights of the modern art – Cézanne, Matisse, Picasso – to which it owes so much.[26] Surely, however, the task for our later generation should be to appraise their work for what it *is*. Its satisfactions are numerous. A generous, humane art, it succeeds, through its concentration of expression, in transmitting to the future the love of life by which it was impelled.

fig.44 Roger Fry, c.1919. Title and date unknown. Probably a scene in France

fig.45 Roger Fry, *The White Road by the Farm* c.1912, oil on canvas 64.8. × 80.6 cm. Scottish National Gallery of Modern Art, Edinburgh

fig.46 Duncan Grant, *Zurburán* c.1928, oil on canvas 50.8 × 141 cm. Private Collection

Notes

1 These artists' work is analysed more closely in the author's 'The Art of Vanessa Bell' in *Vanessa Bell : Paintings and Drawings*, exh. cat., Anthony d'Offay Gallery, London, Nov.–Dec. 1973 and his 'Roger Fry: The Nature of his Painting' in *The Burlington Magazine*, 122, July 1980, pp.478–9.

2 Quoted in R. Cork, *Vorticism and Abstract Art in the First Machine Age*, 1, London 1975 (p.254).

3 As recorded in detail in F. Spalding, *Duncan Grant*, London 1997, p.13. See also R. Shone's essay above p.19 and note 14.

4 *The Age of Rossetti, Burne-Jones and Watts: Symbolism in Britain 1860–1910*, Tate Gallery, Oct. 1997 – Jan. 1998, p.186.

5 Ibid.

6 Ibid., p.190.

7 As used here, the term 'spiritual' does not denote religious belief, though all these artists engaged with Christian imagery in various ways, conveying a feeling that is anything but hostile.

8 'Watts and Whistler' in *The Quarterly Review*, 202, April 1905, pp.607–23; reprinted in C. Reed, ed., *A Roger Fry Reader*, 1996, pp.25–38.

9 Spalding 1997, p.65 and entry on no.6 in present catalogue.

10 Recounted in F. Spalding, *Vanessa Bell*, 1983, p.2.

11 Spalding 1997 records (p.33) that among Grant's copies from Piero's *The Nativity* (National Gallery, London), was one (destroyed in the Blitz) of the angel musicians. They, too, stand in rows. She also reproduces in colour his variation of 1919 (private collection, London) on Piero's *Baptism of Christ* (also National Gallery).

12 While such preoccupations distinguish Bloomsbury sharply from the Camden Town and Vorticist art with which theirs overlaps stylistically, they connect it with the work of Stanley Spencer, especially before the hiatus of the First World War. Both Grant and Spencer combine influences from Pre-Raphaelitism and from the Italian Renaissance, in figure paintings that seem vividly real and unreal at once.

13 V. Woolf and R. Fry, *Victorian Photographs of Famous Men and Fair Women by Julia Margaret Cameron*, London 1926.

14 Quoted in B. Hill, *Julia Margaret Cameron*, 1973, p.90.

15 Elizabeth Mortimer records that in a letter to Roger Fry, Vanessa Bell wrote of this image as representing 'a woman asleep, rather like "Flaming June" by Lord Leighton, with poppies and waves (I think) all very symbolical'. Mortimer goes on to explain that 'the poppies as a source of opium represent sleep, and the waves through their rocking motion are also conducive to it' (*The Swindon Collection of Twentieth Century British Art*, Swindon, 1991, p.10). See also no.86 in the present catalogue.

16 As amplified by Lisa Tickner in her Paul Mellon lecture given at the National Gallery, 27 Nov. 1996, 'Vanessa Bell: *Studland Beach*, Domesticity and "Significant Form"', published in *Representations*, 65, Winter 1999, pp.63–92. See also no.26 in the present catalogue.

17 G.H. Hamilton, *Painting and Sculpture in Europe 1880–1940*, Harmondsworth, 1967, p.65.

18 A. Garnett, 'House Painting' in *The Eternal Moment*, Orono, Maine 1998, p.104.

19 'The Restoration of Charleston', ibid., p.120.

20 e.g. 'I don't think I ever had such a sensation of colour in my life: it was so rich and yet so sober – all earth colours' (Fry to his daughter Pamela from Aix-en-Provence, 9 Nov. 1919, in D. Sutton (ed.), *Letters of Roger Fry*, II, 1972, p.468).

21 Spalding 1997, p.26.

22 T. Hilton, 'Who's the Subject, You or Me?', *Independent on Sunday*, 26 April 1998, p.24.

23 In the essay 'Watts and Whistler': see note 8 above.

24 Ibid.

25 Foreword to catalogue of memorial exhibition, Adams Gallery, London, Oct. 1961.

26 The Bloomsbury artists did not, of course, claim that it did.

Defining Modernism: Roger Fry and Clive Bell in the 1920s

James Beechey

In a vividly imagined evocation of artistic life in London between the wars, Myfanwy Piper pictured the rooms of a cultivated amateur of modern painting:

> I think of a house in the twenties. In one room there is a curved green sofa and a small round table with curved feet, through the French window the iron curves of the balcony echo them; beyond it, a green and London brick density stops the eye. The walls have settled, no line of the yellowish window frame or wainscot is quite straight; there is some pink somewhere. On the sofa there is a woman with a white triangle of face, narrow and angular. It is a painting, half Matisse in its scale and layout, half Derain in its mixture of boldness and blunt-edged mystery. Another room has books with their dust covers still on and many French ones, cadmium yellow and white and a deeper yellow. Under their weight the crowded shelves sag. There is a high backed chair. I look for Monsieur Jeffroye [*sic*] – he is not there, but Cézanne is there all the same.[1]

The conceit was quite deliberate. The cult of Cézanne reached its apogee in England in the 1920s. Although his own works were absent from national collections until the Courtauld Fund pictures went on show in the new galleries of modern foreign art at the Tate Gallery in 1926, his imprint, even at one remove, was manifest everywhere. A school of English painters for whom every native tree cast a blue shadow and every village roofscape rose in a pattern of rectangles, filled the walls of London galleries with their apings of French Post-Impressionism, 'lowering essays in plasticity in which the Home Counties were transformed into the Bouches du Rhône'.[2] In support of this prevalent obsession with formal values, Cézanne's authority was unceasingly invoked. Above all, it was pervasive in the pronouncements of the two high priests of modernism, whose voices were heard above all others after the war. In Bloomsbury, Cézanne was the household god. Conspicuous among the handbooks on the

fig.47 Clive Bell's sitting room, 50 Gordon Square, showing (centre) Juan Gris's *Les Oeufs*, 1911 (Staatsgalerie, Stuttgart). Decorations by Vanessa Bell and Duncan Grant, 1926

art amateur's shelves were Clive Bell's *Art* and Roger Fry's *Vision and Design*, Fry's *Cézanne* and Bell's *Since Cézanne*. 'In so far as one man can be said to inspire a whole age,' Bell had written in the first of these, 'Cézanne inspires the contemporary movement'.[3]

The story of how England met modern art is well known. It combines all the best ingredients of the *succès de scandale*, so familiar in the history of the avant garde – a derisive public, a jeering press, an outraged artistic establishment, ruptured friendships. What is less readily appreciated is how promptly the legitimacy of Post-Impressionism and Cézanne's status within it was accepted – at least by those best-positioned to lead public taste. When Cézanne died in 1906, it was barely noticed in England. George Moore published his *Reminiscences of the Impressionist Painters* (his excursions into art history were taken quite seriously at the time) and confused him with Van Gogh as the painter of 'crazy cornfields peopled with violent reapers'.[4] In 1908 two paintings by Cézanne were shown at the annual exhibition of the International Society, and Roger Fry – who had himself discovered the artist only in 1906 – boldly averred in a letter to the editor of *The Burlington Magazine* that: 'There is no need for me to praise Cézanne – his position is already assured.'[5] In 1910 Fry translated Maurice Denis's essay on Cézanne for the same magazine, a vital step in the formulation of him as a 'classic' artist.[6] But he had some reason to regret the complacency of his earlier declaration when he staged the exhibition *Manet and the Post-Impressionists* at the Grafton Galleries later in the year, and the triumvurate of Cézanne, Gauguin and Van Gogh, whom he had selected equally to represent the new trends in painting, was wildly abused for incompetence and insincerity. By the time of Fry's Second Post-Impressionist Exhibition in 1912, a crucial change of emphasis had occurred in his approach to Cézanne whom he now presented, alone of the 'old masters', as the precursor of a modern movement whose leaders were Picasso, Matisse and Derain. The metamorphosis of Cézanne from peripheral Impressionist to seminal Post-Impressionist had been effected in four short years by Fry – the unlikeliest of revolutionaries – with the support of one or two allies, the most vocal of whom was Clive Bell. Fry was already distinguished as an expert on the early Italian Renaissance; he had also published an edition of Reynolds's *Discourses*, and had been a curator and advisor of the Metropolitan Museum, New York. Bell had dabbled in literary journalism, but his enthusiasm for modern art was known only to his immediate circle of friends. Neither was an obvious candidate to proselytise for the new religion of Cézanne; and in a series of four marvellously facetious drawings on the theme of 'The Conversion of St Roger', Henry Tonks later made great play of Fry's transformation from the 'genteel scholar of saints and madonnas'[7] to the apostle of Post-Impressionism. In one, a wild-eyed Fry is shown in supplication before a statue of Cézanne; in another, *The Unknown God* (fig.48), he is depicted as a ranting St Paul, holding up a skinned cat as a model of pure form before an incredulous audience including his former associates Walter Sickert, Philip Wilson Steer, George Moore, John Singer Sargent and D.S. MacColl, while from the wings Bell, as the attendant Timothy, chants the Post-Impressionist mantra: 'Cézannah! Cézannah!'

Bell may have displayed all the brashness of the *arriviste*, but his first book, *Art*, published in 1914 and continuously in print until the 1930s, was that rarest of successes, a treatise on aesthetics that was also a bestseller. He promised a universal theory of art for a public bewildered by competing notions of the avant garde, and offered an exhilarating ride across the 'slopes' of art history, beginning at Byzantium and ending with the maturity of Cézanne. Bell never attempted the masterly descriptive analyses of his paintings that completed the apotheosis of Cézanne in Fry's later study of the artist, one of the happiest examples of a critic perfectly in rapport with his subject;[8] but he asserted a potent vindication of Cézanne as both a type of the exemplary artist and the pioneer of the modern movement – 'the Christopher Columbus of a new continent of form',[9] in a phrase bagged from Apollinaire. Of the various sources for Bell's premise of the autonomy in art of imaginative and actual life – including G.E. Moore's *Principia Ethica*, the Cambridge bible of embryonic Bloomsbury – the most immediate was Fry's 'An Essay in Aesthetics', published in the *New Quarterly* in April 1909, which Bell recognised as 'the most helpful contribution to the science that has been made since the days of Kant'.[10] In Fry's essay the seeds were sown for Bell's rejection of the sentimental clutter of

fig.48 Henry Tonks, *The Unknown God (Roger Fry Preaching the New Faith and Clive Bell Ringing the Bell) c.*1923, oil on canvas 40.6 × 54.6 cm. Private Collection. Among the audience, Steer, Sickert and Sargent

fig.49 Walter Sickert, Major Armstrong, Henri Doucet, Clive Bell, Ethel Sands and Roger Fry at Newington House, Oxfordshire 1912. Tate Gallery Archive

emotional or literary association and for his notorious claim that the representative element in art was irrelevant to aesthetic contemplation. In his preface to *Art,* he acknowledged his immense debt to Fry, while noting that they disagreed profoundly about many of the principles of aesthetics. Historians of twentieth-century English art lazily assume a straightforward master–pupil relationship between Fry and Bell. Yet they were men of quite distinct backgrounds and temperaments, and with very different aims and ambitions.

Fry belonged to an older, more austere generation, with its roots in the late nineteenth-century Arts and Crafts movement. His writing evinced all the open-mindedness of the Quaker and betrayed all the doubts of the trained scientist. Fry was a connoisseur as well as a painter, but above all a supreme teacher who convinced his readers (and his audience – for his lectures were famously brilliant) to see a work of art as he saw it, partly because his passion for communication was so intense, but also because he readily conceded his own equivocations and refused to fall back on dogma. Bell shared none of his caution. He was unconstrained by any allegiance to art history. He was the pace-maker. He oozed self-confidence. He bullied his readers into taking his generalisations as irrefutable certainties, and he did so with a swagger that his mentor could only envy. Bell, Fry observed, 'walks into the holy of holies of culture in knickerbockers with a big walking stick in his hand, and just knocks one head after another with a dextrous back-hander that leaves us gasping'.[11] When he likened the quarrel among the Romantics and the Realists to a dispute between those 'who cannot agree as to whether the history of Spain or the number of pips is the most important thing about an orange',[12] he introduced a new and disarmingly irreverent tone to the language of art criticism. Fry never accepted Bell's notion that significant form was the sole property of aesthetic experience, and he became increasingly distrustful of Bell's insistence on the dissociation of form and content. The nuances of Fry's and Bell's approaches to formalism have been laboriously treated by professional philosophers,[13] and the personal differences between them can easily be traced in the published editions of Fry's letters and Virginia Woolf's diaries, as well as in Bell's sharp reminiscences of Fry in his memoir *Old Friends.* In the 1920s their social and intellectual interests diverged more starkly than before the war. But this was also the decade in which together, through their books, through their extensive journalism, predominantly in the *Nation and Athenaeum* and the *New Statesman* and, in Fry's case, through his executive role in several exhibiting societies, they exerted an unprecedented sway over the reception and production of contemporary art in England.

Douglas Cooper, in his introduction to the first catalogue of the Courtauld Collection, questioned why neither Fry nor Bell had demonstrated their devotion to Cézanne by buying his pictures.[14] In

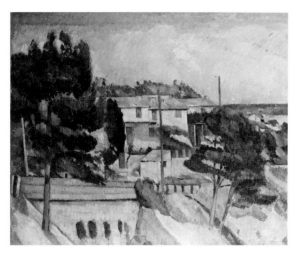

fig.50 Paul Cézanne, *Viaduct at L'Estaque* c.1883, oil on canvas
53 × 63.5 cm. Finnish National Gallery, Helsinki

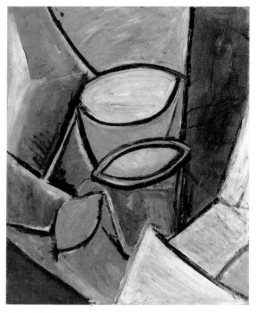

fig.51 Pablo Picasso, *Pots et Citron* 1907, 55.2 × 45.7 cm.
Ex collection Clive Bell; Private Collection, Germany

fact, Bell had made a bid for Cézanne's *The Viaduct at l'Estaque* (fig.50) at *Manet and the Post-Impressionists*, but the asking price (which he later remembered as £400) was beyond his pocket, and it was sold for double that figure to the National Gallery of Finland, Helsinki. Instead he began to assemble a small collection of contemporary French pictures, including two landscapes by Maurice de Vlaminck and proto-cubist still lifes by Juan Gris and Picasso; the latter's *Pots et Citron* (fig.51) was the first painting by the artist in an English private collection. Fry's collection, though it embraced many of his more eclectic enthusiasms, was similarly built around his admiration for early French modernism. His purchases at this time included Derain's *Le Parc des Carrières* (1909; Courtauld Gallery, London), which became something of a talisman for his own experiments in Post-Impressionist painting, and, more adventurously, Picasso's barely figurative *Tête d'homme* (1913; private collection).[15] However, in the years immediately following the two Grafton Galleries exhibitions, the French painter who was bought and acclaimed most faithfully by Fry and Bell, as well as by their friends such as St John and Mary Hutchinson, Hilton Young and Percy Moore Turner, was Jean Marchand. (He was also the first modern artist, with Renoir, to enter Samuel Courtauld's collection.) By 1919 Fry owned five paintings by Marchand, which he relied on for the compositional devices of several of his own still lifes; and Bell had purchased Marchand's impressive townscape *La Ville* (c.1912; private collection) from the Second Post-Impressionist Exhibition. Bell contributed a preface to the catalogue of Marchand's exhibition at the Carfax Gallery in 1915 in which he hailed the Frenchman as the foremost practitioner of significant form; Fry's review of Marchand's 1919 show at the same gallery was the only essay on a living artist included in his anthology *Vision and Design*, published the next year. Marchand, Fry declared, was assured of a continually growing fame. Fry did not meet Marchand until he journeyed to the south of France in the winter of 1919; but painting alongside him at Cagnes and in the following spring at Vence confirmed him in this belief. In a letter to a friend, Fry explained that Marchand's attraction for him lay in 'that austerity and solidity of construction which, for me, are the greatest qualities of the French tradition from Poussin to Cézanne. These are particularly what we lack in England where fantasy and lyricism are all in favour'.[16]

When Marchand is remembered today, it is usually as a joke against Fry and Bell. So sure a touchstone did he become for Bloomsbury's understanding of Cézanne's legacy that, as Simon Watney has commented, 'if Marchand had not existed, it seems that Fry could have invented him'.[17] Between 1906 and 1912 he moved through a brisk exploration of modern styles, briefly adopting the heightened

colours of Fauvism, flirting hesitantly with Cubism and fleetingly with Futurism. In 1912 he partic-ipated in the first Salon de la Section d'Or, conceived to demonstrate the scope of the cubist movement at the height of its influence. Even in an exhibition that did not include Picasso or Braque, Marchand's cubified landscapes and still-lifes appeared tame beside Duchamp, Léger and Gris. A theoretical justification of Cubism had seemed implicit in Fry's and Bell's early pronouncements; indeed, Cubism was defined by one of its principal champions in France, Pierre Reverdy, in language analogous to Fry's celebrated claim in his introduction to the catalogue of the Second Post-Impres-sionist Exhibition that Cézanne and his heirs sought not an imitation but an equivalence of life, 'not to imitate form but to create form'.[18] 'Cubism', Reverdy wrote, 'is an eminently plastic art; but an art of creation and not of reproduction or interpretation.'[19] Fry allowed a very broad interpretation of Cubism – 'like S. Paul, [it] has been all things to all men … To some it has been a doctrine and a reve-lation; to some it has been a convenient form of artistic journalism; to some it has been a quick road to notoriety, to some an aid to melodramatic effect. To M. Marchand it was just a useful method and a gymnastic'.[20] It was just this appropriation of Cubism as little more than a modern pictorial manner-ism, a useful post-Cézannesque constructive discipline, which prevailed in England. For a while Bell was ready to accept Cubism as the epitome of Cézanne's example – 'Nothing could be more logical. Art is not representation, but expression'[21] – but he never loved it, and he struggled to achieve an adequate explanation of it. Emphasising Picasso's and Gris's Spanish heritage, he concluded that Cubism was alien to the French temperament.

Fry's and Bell's misunderstanding of Cubism has to be held against them, but it was also shared by many French critics closer in touch with its origins. Marchand assumed only briefly a role as the exemplar of Fry's New Movement in Art (the title of an exhibition he arranged in Birmingham in 1917); later Fry found him 'almost entirely dull'.[22] Bloomsbury's eulogising of him was, to an extent, born of circumstance. (Bell and Fry wrote about him in 1915 and 1919 because there was no one else to write about – Marchand and Maurice Asselin were the only two contemporary French artists given exhibitions in London during the war.) But it was also suggestive of their preference for a strand of modernism that maintained a direct concern with the experience of nature, a tendency which led them to exaggerate the achievements of artists such as Vlaminck, Othon Friesz and André Dunoyer de Segonzac, for whom the implication of Cézanne's model was a renewed commitment to naturalism rather than an encouragement to abstraction.

Bloomsbury's Francophilia was widely advertised. When Osbert Sitwell and the dealer Leopold Zborowski staged the first post-war show of modern French art in London at the Mansard Gallery in 1919, Fry found ten times as many pictures worthy of careful study there than in a typical exhibition of the London Group. Bell was more blunt. 'At any given moment the best painter in England is unlikely to be better than a first-rate man in the French second class',[23] he declared on his return from a visit to Paris the following year. That outburst ensured Wyndham Lewis's undying enmity. Both Bell and Fry had been supporters of Lewis before 1913. They had included his work in the Second Post-Impressionist Exhibition and in the first Grafton Group show, they had praised him in print – particularly his *Kermesse* (1912; destroyed), a landmark in the history of the pre-war English avant garde – and Bell had commissioned his *The Laughing Woman* (c. 1912; destroyed) for the Contempo-rary Art Society. But after the infamous walk-out of Lewis and his friends from the Omega Work-shops and the establishment of the Vorticist group with its origins in Futurism (a movement Fry and Bell scorned), relations between Lewis and Bloomsbury were virtually severed. Lewis's posture as the helmsman of radical modernism was adopted in direct opposition to Bloomsbury, and particularly to its equation of modernism with the contemporary French school. The English Post-Impressionists, Lewis's ally R.H. Wilenski protested, 'watch the Parisian cat, note where he jumps to and what effect it makes. If the cat is applauded our artists follow suit'.[24] Lewis looked instead to Northern European influences, while justifying Vorticism with nationalistic rhetoric: the result, Bell objected, was 'as insipid as any other puddle of provincialism'.[25]

The home-grown artist who most clearly reflected Bloomsbury's Mediterranean preferences was

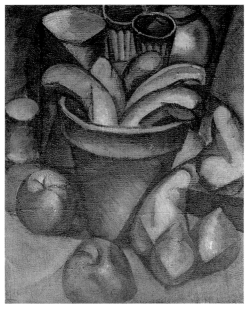

fig.52 Jean Marchand, *Still Life with Bananas and Apples*
c. 1910, oil on canvas 40.5 × 38 cm. Ex-collection Roger
Fry; The Charleston Trust

fig.53 Pablo Picasso, *The Artist's Living Room, rue la Boëtie: Jean
Cocteau, Olga Picasso, Erik Satie, Clive Bell* 21 November 1919,
pencil on paper 49 × 61 cm. Musée Picasso, Paris

Duncan Grant. But while he undoubtedly absorbed the talk of formalism which flowed around him,
he was never inhibited by theory. Fantasy and lyricism – the two traits in English art which Fry had
regretted in 1919 – were just the qualities which distinguished Grant's best work, as Fry himself
acknowledged in his 1924 monograph on the artist.[26] Grant's inventive imagination reminded Bell of
the Elizabethan poets; his combination of a delicious sensibility with intellectual and artistic integrity,
of Gainsborough. Certainly Grant was 'of the movement', but he was also 'in the English tradition
without being in the English rut'.[27] In Bloomsbury, household loyalties sometimes exerted an unfortu-
nate but irresistible pull. The relentless puffing, by Bell in particular, of Grant as the only British
artist who stood comparison with his French contemporaries, demeaned both critic and artist. 'It
wearied a whole generation with his name,' John Rothenstein commented; 'worse still, it sowed the
suspicion in the minds of other artists that they were belittled in order that his reputation might be
enhanced.'[28]

Only after the war did Fry and Bell establish a foothold in the French art world. Before 1919 they
had made sporadic sorties across the Channel and had formed friendly relationships with several
Parisian dealers such as Ambroise Vollard, Daniel-Henry Kahnweiler, Clovis Sagot and Charles
Vildrac, as well as making the acquaintance of Matisse and Picasso. Fry did manage one wartime
visit to Paris in 1916 and brought back to England the first report of Picasso's transition to neo-classi-
cism. For the duration of the war, Fry and Bell were acutely aware of their estrangement from the
vital centre of avant-garde activity, and they both hurried to Paris in the autumn of 1919. Throughout
the next decade they were conspicuous figures there in the artists' quarter. As their intimacy with
French artists grew, so their critical practice was increasingly allied to current developments in Paris.
Their reconnection to the French movement had come, in fact, in the first summer of peace, when
Diaghilev's Ballets Russes played a long season in London. Bloomsbury was terrifically excited by
its encounters with Derain and Picasso (who had travelled with the Ballet, for which they were pro-
viding the decor and costumes of two new productions) and led the popular acclaim for Diaghilev's
dancers and artists. [29] In *Parade*, the ballet for which Picasso supplied an astonishing cast of Cubist
characters, first staged in 1917, the failure of a troupe of circus entertainers to entice an audience into
the tent where they were performing had enacted a parable of the existing relationship between the
avant garde and the public. That relationship was inverted by the Ballet itself; and the willingness of
artists such as Matisse, Gris, Léger, Mikhail Larionov and Nathalia Gontcharova to work for it was a

mark of the popular triumph of modern art in the 1920s. Vanessa Bell's account of the ecstatic reception of *Parade* at its London première in November 1919 was conveyed first hand by Clive Bell to Picasso and his collaborators Jean Cocteau and Erik Satie (see fig.53).

From their earliest acquaintance with his work, both Fry and Bell had been thrilled, but also perturbed, by Picasso's genius. Nowhere is Fry's natural diffidence more overt than in his published writings on Picasso. In 1912, he conceded that 'it is dangerous and difficult to speak of Picasso';[30] nine years later 'to say what I think about Picasso is a task from which I shrink'.[31] That Picasso was the most gifted and original, 'the most incredibly facile'[32] artist, Fry never doubted, even when in 1912 he could only take his latest works on trust. By 1921, as Fry inched his way towards a greater acceptance of representation, he had very nearly lost all faith in the potential of abstraction: 'there is nothing inherently impossible in the venture to create expressive form out of the minimum of representation possible, but when we come to consider the quality of what is thus expressed I confess that personally I feel some disappointment … We are intrigued, pleased, charmed, but hardly ever as deeply moved as we are by pictures in which representation plays a larger part.'[33] It was with palpable relief that Fry reported to Vanessa Bell Picasso's preoccupation with figurative painting when he saw him in Paris later that year. The new works were just what he had hoped for: 'Vast pink nudes in boxes. Almost monochrome pinkish-red flesh and pure grey *fonds* which enclose it. They're larger than life and vast in all directions and tremendously modelled on academic lines almost.'[34] Fry and Bell were quick to celebrate a return to literal subject matter which did not entail sacrificing the purity of form. Their accent on the role of form in Picasso's art appears excessively restrictive today; they were, however, the two English writers who consistently put his name before the British public. In the 1920s Bell regularly visited Picasso in his studio and his friendship with him lasted to the end of his life (fig.54). His 1920 essay on Picasso and Matisse was reprinted as the introduction to the catalogue of Picasso's first post-war London exhibition at the Leicester Galleries the following year, and his assertion then that Picasso's restless spirit would dominate his age was one of the earliest instances of a later commonplace in writing about the artist.

Picasso rather than Matisse, Bell insisted, was the master of the modern movement, 'a born *chef d'école*'. 'Picasso is the liberator. His influence is ubiquitous … His is one the most inventive minds in Europe.'[35] But it was Matisse whose influence was more thoroughly felt in England. The spectacular display of his masterpieces – *Dance I*, *La Luxe I* and *The Red Studio* – at the Second Post-Impressionist Exhibition was of essential importance in the theoretical and practical conception of English Post-Impressionism. Vanessa Bell paid specific homage in her view of the Matisse room at the

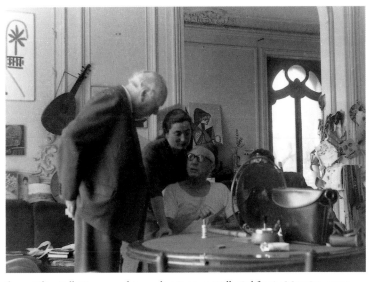

fig.54 Clive Bell, Picasso and Jacqueline Roque at Villa Californie, Mougins, *c.*1959.
Photo courtesy Alison Bagenal

Grafton Galleries (fig.55), itself a conscious echo of *The Red Studio*. The evolution of Grant's painting during the next two decades, from *The Dancers* (1910–11; no.10) to *The Doorway* (1929; no.132) is unthinkable without the example of Matisse. Perhaps because his personal contact with Matisse was more limited than with Picasso or Derain, Bell devoted comparatively little critical attention to him. From 1920 until 1950 – when he published his lecture on modern French art given at the opening of the Cone Collection at Baltimore – he made only passing mention of him in his journalism.[36] When he did it was often, significantly, to extol his sculpture, in which he found the most complete realisation of plastic form. Neither he nor Fry indulged in glib adulation of Matisse's sensuality and they preferred the austerity of his pre-1918 work to the more alluring charm of his 1920s odalisques. Fry was always an elucidatory critic of Matisse, never more so than in his 1930 monograph. Its prologue – almost one third of the entire text – is given over to a compressed history of western art in which he delineated his new aesthetic of the 'dual nature of painting'. Matisse emerges as the Post-Impressionist who has reconciled the conflicting impulses for abstract and narrative art. His style is based on '*equivoque* and ellipsis' and the essence of his achievement has been 'to recover for the painted canvas … the quality of an *objet d'art*'.[37]

If, in Matisse, Fry found the archetype of a living artist who expressed the classic spirit, Bell's hero in the 1920s was Derain. Like many others, Bell was in awe of the immense force of his character, and his capacity for intellectual detachment – his willingness to draw inspiration from the past, appropriating as he liked from the primitive and classical traditions, to create an art at once modern and worthy of the museums. To his detractors this parasitic tendency was proof of his inconsistency, to Bell it underlined the seriousness of his purpose. 'Here was an artist who had refused nothing and feared nothing. Could anyone be less of a reactionary and at the same time less of an anarchist?'[38] In England Bell was Derain's staunchest advocate. In France, where he enjoyed enormous success in the art market, Derain's reputation came under repeated fire. In May 1922, having been shown Derain's work of the previous winter which, he said, had taken his breath away, Bell was treated to a rare confessional from the artist:

> I had the nearest approach to a scene of emotion that I certainly, and perhaps any *man* is? … am? likely to have with Derain. He tried to explain what he wanted to do, said that since the war he had felt, as an artist, very lonely because he thought that no one else was after the same thing, that his painting had ceased to be 'modern' and that when he saw his pictures so utterly unlike those of his contemporaries whom he most admired, he couldn't help mistrusting himself and wondering whether his work wasn't all nonsense; that it was the enthusiasm of a few people, of whom I was one, that had continued to give him confidence in himself, and that now he couldn't help believing that his art had a certain valeur, and that he had never seen so clearly or felt so happy in his life.[39]

Bell, like Fry, lamented Derain's later lapses into easy imitation – 'mere five-finger exercises in brilliant technique'[40] – but he noted with approval the propensity of young French painters to seek protection in his 'unconscious nationalism',[41] a phrase picked up and re-used by Derain's supporter André Salmon in his 1923 monograph on the artist. In turn Bell adopted Salmon's dialectical theory of contemporary painting which proposed Picasso as the 'animator' and Derain as the 'regulator' of the modern movement[42] – a characteristically ample generalisation, but one which contained a pinch of truth.

Considering the ardent nature of Fry and Bell's Francophilia, and the volume of their writing on modern French art, it is surprising how little attention has been given to their connexions with contemporary French criticism. Several of the most prominent critics were among their friends in Paris. Georges Duthuit, Matisse's son-in-law and the early historian of Fauvism, was a popular Anglophile, much favoured in Bloomsbury. Duthuit, Salmon, the most energetic apologist for non-academic art, Waldemar George, editor of *L'Amour de l'Art*, and Florent Fels, editor of *L'Art Vivant*, were four of Bell's regular companions in the 1920s. Fry contributed a survey of modern French painting to one of

fig.55 Vanessa Bell, *A Room at the Second Post-Impressionist Exhibition*, 1912, oil on panel
51.3 × 62.9 cm. Musée d'Orsay, Paris. Gift of Mrs Pamela Diamand 1959

fig.56 André Derain, *Still Life on Table* 1910, oil on canvas 92 × 71 cm. Musée
d'Art Moderne de la Ville de Paris

fig.57 Clive Bell, Alice Derain, André Derain, Moïse Kisling, Florent
Fels and Georges Gabory at the Foire de Monmatre, Paris, c. 1923

the first issues of *L'Amour de l'Art* under George's editorship; and George originally commissioned his study of the Cézannes in the Pellerin Collection for the same magazine. An abbreviated version of his 1930 essay on Matisse was translated the following year for Christian Zervos's review *Cahiers d'Art*. Bell's last and most substantial assessment of Derain, a rigorous defence of the artist against his numerous detractors, was published in the magazine *Formes* in 1930, and he contributed a sketch of the English art scene to *L'Art Vivant* in 1932. Ten years earlier he had undertaken a similar exercise for *Valori Plastici*, the short-lived but influential journal of Italian Neo-Classicism.[43]

In his 1919 review of Sitwells' and Zborowski's exhibition in London of modern French art, Fry had for the first time explicitly recognised the division of the modern movement into two counter-flowing streams, one dedicated to the artificial construction of an abstract pictorial vision, the other to the naturalistic representation of appearances in three-dimensional space.[44] This dichotomy in the progress of modernism provided the context for fierce debates in Paris in the 1920s, in which Salmon and George (with whom Fry and Bell had most in common), as well as Reverdy and Louis Vauxcelles, were the most prominent voices. Fry's initial distaste for the new naturalism soon gave way to an accord with the prevalent concern in France for authority and tradition. A 'return to first principles'[45] was prefigured in Bloomsbury's writings long before Bell's friend Jean Cocteau announced a universal 'call to order' in 1926. As early as 1910 Bell and Fry were beginning to provide a historical justification of Post-Impressionism. Their earliest theses were peppered with references to 'the great tradition', in which allusions to Piero, Raphael, Poussin, Chardin, Ingres were liberally scattered. For instance, Matisse was one artist whom Bell credited with significant form when he first propounded the theory in *The Burlington Magazine* in 1913; when he utilised a passage from this article the following year in *Art*, he quietly substituted the example of Piero.[46] 'And how traditional they are!' Fry exclaimed in his essay for *L'Amour de l'Art*; 'I like to think that Rubens would recognise his grandson in Matisse, just as Matisse should recognise his heritage, that Fra Bartolommeo would have understood immmediately what Picasso wanted ... that the great designers of the seventeenth century, and Poussin most of all, would have perceived with what clearsightedness Derain has divined their secret.'[47] Even Cézanne was now discussed more in relation to the old masters than to the modern movement. 'What surprised me,' Fry recorded as he began his study of the Pellerin Collection, 'was the profound difference between Cézanne's message and what we have made of it. I had to admit to myself how much nearer Cézanne was to Poussin than to the Salon d'Automne'.[48] Historical events, as well as aesthetic prejudices, were an important stimulus. In 1920 the Louvre was rehung, and among its new acquisitions was Courbet's *The Artist's Studio* which Bell, perhaps prompted by the admiration of Derain and Segonzac for the painting, rushed to praise in *The Burlington Magazine*.[49] In the same year the quatercentenary of Raphael's death was celebrated in several exhibitions which brought to the fore debates about the relationship of modern painting to the Renaissance.

Of even greater significance was the death of Renoir at the end of 1919. The acceptance of *The Umbrellas* (always one of Bell's favourite paintings, and one on which he published a short monograph in 1945) by the National Gallery in 1917 had rekindled English interest in Renoir and, months before the French painter's death, Bell had proclaimed him the greatest living artist. For him and for Fry, Renoir was the model of a modern artist who renewed his vision through a prolonged study of the past. Fry published three articles on Renoir in 1920 alone, on each occasion stressing his accomplishment in fusing sensibility and construction. The vigorous sensuality and monumental volume of Renoir's late nudes was an inspiration for the neo-classicism of Derain and Picasso, as it was in England for the different approaches to modernism of Mark Gertler and Matthew Smith. Gertler's elaborate still lifes aspired to the precision of seventeenth-century Spanish or Dutch examples, but were realised with spatial devices derived from Picasso and Derain; Smith's sumptuous nudes, redolent of the opulence of Rubens, depended upon a unity of colour and form suggested by Fauvism. Both achieved great critical and commercial success in the late 1920s, not least because they found consistent favour with Fry and Bell.

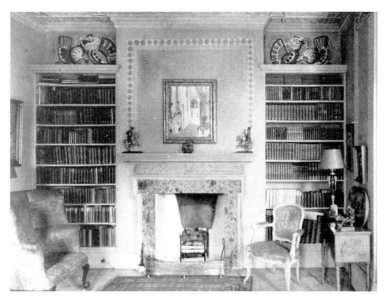

fig.58 St John and Mary Hutchinson's drawing room, 3 Albert Gate, Regent's Park, showing Matisse's *Interior at Nice* (1920; Saint Louis Art Museum). Decorations by Vanessa Bell and Duncan Grant, 1926–8

'We are not yet clear,' Bell wrote in 1914, 'of the Victorian slough. The spent dip stinks on into the dawn.'[50] By the end of the 1920s Bell and Fry had effected a phenomenal transition in artistic taste – the decisive shift in Britain in the twentieth-century. Their version of the history of modernism was established as the critical orthodoxy. It was filtered through the more mundane journalism of Alan Clutton-Brock and Charles Marriott in *The Times*, T.W Earp in *Studio* and their protégé Raymond Mortimer in the *New Statesman*. It was enshrined in the prospectuses of the London Group and the London Artists' Association, in whose activities Fry was instrumental and in which his stylistic preferences predominated. And it was reflected in the taste of collectors such as Montague Shearman, Frank Hindley Smith and, most notably, Samuel Courtauld. Bloomsbury was more coherent and more prolific than any other contemporary grouping. Fry and Bell grasped opportunities to reach audiences beyond the readership of *The Burlington Magazine*, or even the *New Statesman and Nation*. Bell, for instance, contributed regular defences of modernism to the New York paper the *New Republic*; his influence in America was considerable and long-lasting and can be detected in the more systematic formalism of Clement Greenberg. He was also a contributor to *Vanity Fair*, and in England he and Fry both wrote for *Vogue* in the mid-1920s when, for a brief moment, it flourished as a magazine which devoted as much attention to high culture as to *haute couture*. Despite Fry's sincere resistance to cultural élitism, Bloomsbury critics helped to make modern art *chic*. Bloomsbury's supremacy in the 1920s did not go unchallenged, but its more radical rivals lacked both its energy and its manpower. Periodic blasts from Wyndham Lewis's camp were made without their originator's scalding conviction, and the counter-objectives of Neo-Realism faded with the death of Harold Gilman in 1919. Conservative opposition, from D.S. MacColl – still abusing Cézanne after the Second World War – and Sickert – mischievously insisting in 1924 that 'Picasso is certainly not a patch on Poulbot, or Genty, or Métivet, or Falke or Arnac, or Kern, or the amazing Laborde'[51] – was easily deflected. Under Bloomsbury's hegemony the vocabulary of formalism ('plasticity', 'classic', 'volume', even the derided slogan 'significant form') entered common discourse, and the names of its tribal deities, from Manet to Picasso, became widely familiar – so that it was ridiculous for Patrick Heron to maintain that by the end of the 1930s 'to meet anyone in Britain who knew who Matisse and Bonnard were was a bloody miracle'.[52]

A consideration of Bloomsbury's critics confined only to their activity in the sphere of contemporary art is a necessarily partial assessment. It is especially unfair to Fry, the most compelling writer

on art in the Anglophone world since Ruskin. Recent re-evaluations of his critical practice have gone a long way towards demolishing the sterile formalist of so many myths. During the last decade of his life he was constantly revising, and in many cases overturning, his earlier opinions before arriving at his eventual resolution of the dual nature of painting which synthesised form and content, outlined in his late essays on Matisse and Rembrandt. He never rejected the possibility that his first impressions might be mistaken and the hallmark of his critical practice was, as Benedict Nicolson put it, his 'glorious refusal ever to make up his mind'.[53] Less than a quarter of the newspaper articles and reviews he published between 1918 and his death in 1934 were concerned with living artists. Many of his most perceptive comments on modern art were buried in unpublished letters to his friends: they never fail to impress in their acuity. Bell was less agile. After Fry's death, he continued to enliven the back pages of the *New Statesman and Nation* for another ten years. His focus was directed more specifically than Fry's on current developments, but he was also busy rectifying his early and abrupt dismissal of the Impressionists and extolling the virtues of Bonnard, for the purity of whose painting he had an instinctive sympathy. He was generally contemptuous of Surrealism, though he sometimes found an encouraging word for its more elegant English practitioners such as John Banting and John Tunnard. The straightforward naturalism of the Euston Road School (which name he coined), and the lyrical landscapes of Victor Pasmore in particular, were more to his liking in the 1930s and 1940s. He publicly praised Henry Moore's shelter drawings during the war, and privately expressed some admiration for the early work of Francis Bacon after it. And as late as 1952 he could admit his interest in the first appearance of Abstract Expressionism in London when Jackson Pollock's work was included in an exhibition, *Opposing Forces*, at the Institute of Contemporary Arts.

Such evidence of genuine discrimination needs to be mustered, for the accusation that Fry and Bell stifled every vital movement in England between the wars has gained much ground in recent years. These claims conveniently overlook the debt freely acknowledged to the aesthetics of Post-Impressionism by the leaders of a new school in the 1930s such as Paul Nash and Moore – as well as the emergence, in Herbert Read, of a critic quite as persuasive on their behalf as Fry and Bell had been a generation before. Certainly some did feel let down by Bloomsbury. John Russell remembers Ben Nicholson saying of Clive Bell: ' "He got so near to the point of what we were doing, and then he didn't carry it through …" '.[54] And by 1929, according to Robert Medley, a painter who in the early years of his career was greatly helped by Bloomsbury, many of his contemporaries regarded Fry as 'a potential traitor to the cause of modernism'.[55] The very success of their campaign to convert England to modern art bred a smugness among critics and dealers (if not among museum officials) which lingered long after the original battle was won. As an element in Bloomsbury's inheritance, it cannot be ignored, though it often relied on the crude assimilation of a doctrine never as rigid as is usually supposed. In the 1930s, Myfanwy Piper wrote, 'There were two sets of enemies for artists: those who hated all art since Manet and those who blindly idolised the Ecole de Paris. The latter were the most dangerous.' ' "You don't want to look at that stuff" ', Duncan Macdonald at the Lefevre Gallery advised her when she asked to view their exhibition of Ivon Hitchens. ' "Come up and see my Derains." ' [55]

Notes

1 M. Piper, 'Back in the Thirties', *Art and Literature*, 7, Winter 1965, pp.136–7.

2 R. Shone, 'The Arrival of Cézanne in England', *Charleston Magazine*, 14, Autumn/Winter 1996, p.26.

3 C. Bell, *Art*,1914, p.199.

4 G. Moore, *Reminiscences of the Impressionist Painters*, London 1906, p.35.

5 R. Fry, 'The Last Phase of Impressionism', *The Burlington Magazine*, 12, March 1908; reprinted in *A Roger Fry Reader*, ed. C. Reed, Chicago 1996, p.73.

6 M. Denis, 'Cézanne', *L'Occident*, Sept. 1907; translated by Roger Fry in *The Burlington Magazine*, 16, Jan. and Feb. 1910, pp.207–19 and 275–80.

7 B.H. Twitchell, *Cézanne and Formalism in Bloomsbury*, Ann Arbor, Michigan 1987, p.62.

8 R. Fry, *Cézanne: A Study of his Development*, London 1927.

9 Bell 1914, p.207.

10 Ibid., p.xi.

11 R. Fry, 'A New Theory of Art', *Nation*, 7 March 1914; reprinted in Reed 1996, p.161.

12 Bell 1914, p.212.

13 Among the more lucid considerations of Fry's and Bell's aesthetics are the relevant chapters in S.R. Fishman, *The Interpretation of Art: Essays on the Art Criticism of John Ruskin, Walter Pater, Clive Bell, Roger Fry and Herbert Read*, Berkeley and Los Angeles 1963; and Twitchell 1987.

14 See D. Cooper, *The Courtauld Collection: A Catalogue and an Introduction*, London 1954, p.73.

15 For a fuller account of Fry's collecting activities, see C. Reed, 'The Fry Collection at the Courtauld Institute Galleries', *The Burlington Magazine*, 132, Nov. 1990, pp.766–72.

16 R. Fry to M. Mauron, 12 Dec. 1919, *Letters of Roger Fry*, II, ed. D. Sutton, London 1972, p.474.

17 S. Watney, *English Post-Impressionism*, London 1980, p.115.

18 R. Fry, 'The French Group', catalogue of the Second Post-Impressionist Exhibition, 1912; reprinted in R. Fry, *Vision and Design*, London 1920, p.167.

19 P. Reverdy, 'Sur le cubisme', *Nord-Sud*, 1, 15 March 1917; quoted in C. Green, *Cubism and its Enemies: Modern Movements and Reaction in French Art 1916–1928*, New Haven, Connecticut, 1987, p.159.

20 R. Fry, 'Jean Marchand', *Athenaeum*, 11 April 1919; reprinted in Fry 1920, p.197.

21 C. Bell, 'Aesthetic Truth and Futurist Nonsense', *Outlook*, 7 May 1924, p.21.

22 R. Fry to V. Bell, [Oct. 1921], TGA.

23 C. Bell, 'Wilcoxism', *New Republic*, 3 March 1920; reprinted (with revisions) in C. Bell, *Since Cézanne*, London 1922, p.190.

24 R.H. Wilenski, 'London Art Chronicle', *Transatlantic Review* 1, 1924 (p.488).

25 C. Bell, 'Contemporary Art in England', *The Burlington Magazine*, 31, July 1917, p.37; reprinted in C. Bell, *Pot Boilers*, 1918, p.229.

26 R. Fry, *Duncan Grant*, 1924.

27 C. Bell, 'Duncan Grant', *Athenaeum*, 6 Feb. 1920; reprinted in Bell 1922, p.112.

28 J. Rothenstein, *Modern English Painters*, II, London 1956, p.62.

29 It has often been claimed (most recently in M. Amory, *Lord Berners*, London 1998) that Bloomsbury was converted to the Russian Ballet only with the involvement of Picasso and Derain after 1917. They had been admirers since Diaghilev's first London season in 1911 and contemporary letters and later reminiscences put their attendance and enjoyment at that time beyond doubt.

30 R. Fry, 'The Grafton Gallery: An Apologia', *Nation*, 9 Nov. 1912; reprinted in Reed 1996, p.115.

31 R. Fry, 'Picasso', *New Statesman*, 29 Jan. 1921; reprinted in Reed 1996, p.343.

32 See n.30.

33 See n.31 (p.345).

34 R. Fry to V. Bell, 15 March 1921, in Sutton 1972, p.504.

35 C. Bell, 'Matisse and Picasso', *Athenaeum*, 14 May 1920; reprinted (with revisions) in Bell 1922, p.84.

36 See C. Bell, *Modern French Painting: The Cone Collection*, Baltimore 1951. Bell's praise for Matisse's drawings in a review 'Black and White', *New Statesman and Nation*, 15 Feb. 1936 did elicit an appreciative letter from Matisse (TGA).

37 R. Fry, *Henri-Matisse*, London 1930, pp.22–3, 29.

38 C. Bell, 'The Authority of M. Derain', *New Statesman*, 5 March 1921; reprinted in Bell 1922, p.208.

39 C. Bell to M. Hutchinson, 12 May 1922 (Harry Ransom Humanities Research Center, University of Texas at Austin).

40 R. Fry to H. Anrep, 11 Nov. 1925, in Sutton 1972, p.584.

41 See n.38 (p.205).

42 See A. Salmon, 'Picasso', *L'Esprit Nouveau*, 1, Oct. 1920; and Bell 1922, p.4 and p.205.

43 C. Bell, 'Derain', *Formes*, 1, Feb. 1930, pp.5–6; 'Peintures et sculpteurs vivants', *L'Art Vivant* 8, May 1932, pp.246–7; 'L'odierna pittura inglese' in *Valori Plastici*, 15, 1921, pp.114–15.

44 R. Fry, 'Modern French Art at the Mansard Gallery', *Athenaeum*, 8 Aug. 1919; reprinted in Reed 1996, pp.339–42.

45 C. Bell, 'Post-Impressionism and Aesthetics', *The Burlington Magazine*, 22, Jan. 1912, p.228.

46 Ibid., and Bell 1914, p.8.

47 R. Fry, 'La Peinture moderne en France', *L'Amour de l'Art*, May 1924, pp.144–6. Original French text: 'Et comme ils sont traditionnalistes! ... J'aime à penser que Rubens reconnaîtrait son petit-fils en Matisse, tout comme Matisse doit reconnaître son heritage, que Fra Bartolommeo aurait compris tout de suite ce que voulait Picasso ... que les constructeurs de XVIIe siècle, et Poussin tout le premier, auraient perçu avec quelle clairevoyance Derain à deviné leur secret.'

48 Fry 1927, p.2.

49 See C. Bell, 'L'Atelier de Courbet', *The Burlington Magazine*, 36, Jan. 1920, p.3. When Bell's article was published, Courbet's picture was in the hands of the Barbazanges Gallery, Paris; the Louvre was inviting subscriptions from the public to buy it for the State.

50 Bell 1914, p.221.

51 W. Sickert, 'Modern French Painting', *The Burlington Magazine*, 44, Dec. 1924; reprinted in *A Free House!*, ed. O. Sitwell, London 1947, p.297.

52 P. Heron interviewed by M. Gayford in *Patrick Heron*, exh. cat., Tate Gallery, London 1998, p.22.

53 B. Nicolson, 'Post-Impressionism and Roger Fry', *The Burlington Magazine*, 93, Jan. 1951, p.15.

54 J. Russell, 'Clive Bell', *Encounter*, 23, Dec. 1964; reprinted in *Reading Russell*, London 1989, p.147.

55 R. Medley, *Drawn from the Life: A Memoir*, London 1983, p.56.

56 Piper 1965, p.136.

Catalogue Note

MEASUREMENTS

Height is given before width, centimetre size before inches (the latter in parentheses); for irregularly shaped exhibits, the maximum extent is cited.

PROVENANCE ('*Prov*')

Three full points indicate lacunae in the present knowledge of the history of a work.

EXHIBITION HISTORY ('*Exh*')

Abbreviations are used in the catalogue entries. For full references see Bibliography on p.287.

LITERATURE ('*Lit*')

Exhibition catalogues are not cited under 'Lit' if the exhibitions in question have already been cited under 'Exh'. Abbreviations are used in the catalogue entries; see Bibliography on p.287 for full references.

GENERAL ABBREVIATIONS

b.	bottom
c.	centre
l.	left
r.	right
t.	top
bt	bought
exh. cat.	exhibition catalogue
repr.	reproduced

EXHIBITED WORKS

Four catalogued works, no.53, no.80, no.92 and no.98, are unfortunately unavailable for exhibition.

The following works will be exhibited at the Tate Gallery only: nos.2, 5, 10, 11, 14, 18, 25, 29, 34, 40, 41, 43, 48, 49, 52, 55, 62, 76, 77, 78, 81, 85, 87, 88, 104, 105, 106a, 106b, 107a,107b, 107c, 113, 119, 129, 134, 143, 149, 152, 153, 156, 157, 163, 164, 167, 173, 174, 175, 176, 177, 178, 179, 180, 181, 182, 183, 184, 185, 186, 187, 188, 189, 190, 192, 195

For documentary material see p.274

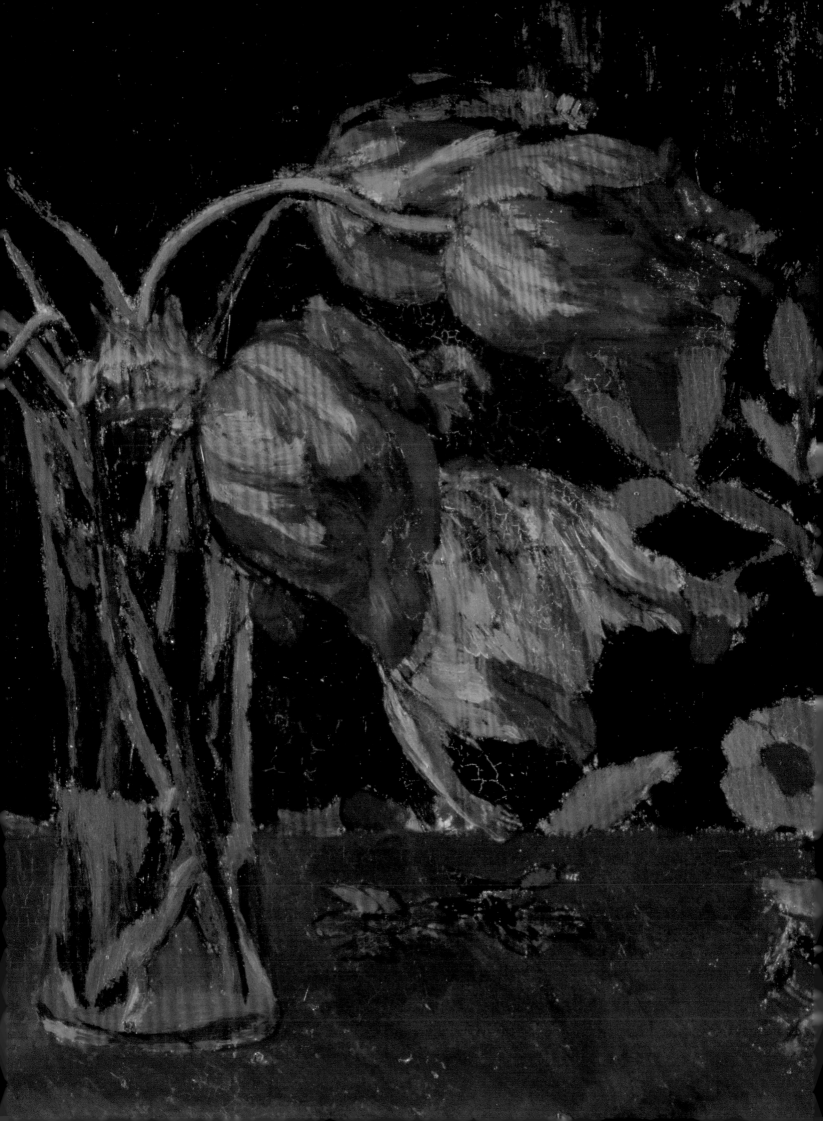

Some Early Impressions

Paintings 1892–1911

Distinct in background, temperament and aspirations, the three artists of Bloomsbury, Roger Fry, Vanessa Bell and Duncan Grant, did not become close friends and collaborators until 1911–12. They arrived at that state of mutual sympathy and shared interests by different routes but all three held in common a rejection of several aspects of contemporary British art and a strong attraction to recent French art and literature.

Although Roger Fry's early work derives much from the English landscape school, particularly Gainsborough, Cotman, Girtin and Bonington, the infiltration of French art, above all of Claude and Corot, had become substantial by the 1890s. Fry's dislike of late Impressionism and his distrust of facile naturalism left him, as he said, 'out of touch with his generation' although there are affinities between his landscapes and those of Wilson Steer and William Rothenstein, his fellow exhibitors in the New English Art Club. His discovery, as a painter, of the 'grave and impressive' art of Chardin in 1902 and of the work of Cézanne over the following years, led to a gradual rethinking of his painting, an overhaul that coincided with a reformulation of his aesthetic theories as adumbrated in 'An Essay in Aesthetics' (1909; reprinted in *Vision and Design*, 1920).

Vanessa Bell's early years as a painter were dominated by the work of G.F. Watts, a friend of her parents, but by 1905 she found his painting 'beastly' and transferred her allegiance to Whistler and J.S. Sargent whose teaching at the Royal Academy Schools she greatly enjoyed. She was soon alert to French Impressionism, mainly through the murky illustrations in Camille Mauclair's *The French Impressionists*, a copy of which she acquired in 1903, the year it was published in England. Even so, she seems to have lacked any one strong direction. The few paintings by her that survive from before *c.*1910, although they establish her lifelong preoccupation with still life and interiors, reveal little of the adventurous spirit that was beginning to stir some of her contemporaries. On the other hand she had decided what to avoid – the watery Impressionism of the New English Art Club, socially accept-

 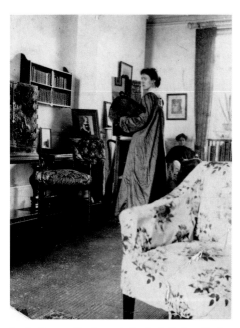

fig.59 Roger Fry painting at Studland Bay, *c.*1911. Tate Gallery Archive

fig.60 Vanessa Stephen painting Lady Robert Cecil, 1905. Tate Gallery Archive

fig.61 Duncan Grant painting in Sicily, 1911. Tate Gallery Archive

opposite detail from Duncan Grant, *Parrot Tulips* 1911 (no.11)

able portraiture and the polished drawing of her Slade School friends such as Henry Lamb. In 1905, aware of a gap in communication between young painters, she founded the Friday Club for meetings, lectures and exhibitions. In the following year she married Clive Bell whose stimulating first-hand knowledge of recent French art was greater than her own or of any of her circle of friends.

At one of the early meetings of the Friday Club in 1905, Vanessa Bell was introduced to Duncan Grant who had just left the Westminster School of Art and was about to embark on two years' study in Paris. In his teens, his heroes were Edward Burne-Jones and Aubrey Beardsley and he had met, through his aunt Lady Strachey, some of the eminent figures of late Victorian art such as Watts and William Holman Hunt. But at the Westminster School he found his fellow students 'all admired Degas and Whistler enormously and despised much of the contemporary painting in England'. At the same time, the French painter, Simon Bussy, through his marriage to Grant's cousin, Dorothy Strachey, became an exacting and fruitful influence on Grant. Bussy urged him to copy Piero della Francesca, introduced him to Japanese prints and recommended Jacques-Emile Blanche's school in Paris, La Palette. While there, Grant worked extremely seriously but remained relatively ignorant of the latest developments in French painting. His early portraits of his friends and Strachey relations (nos.6–8) encapsulate the sound technical accomplishment he had achieved by his early twenties as well as the bookish world of early Bloomsbury.

(*Some Early Impressions* by Sir Leslie Stephen, 1903)

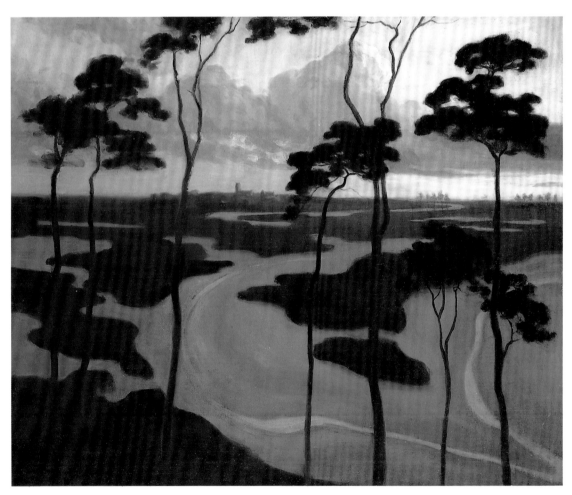

1

1 *Blythburgh, the Estuary* 1892

Oil on canvas 61 × 74 (24 × 29)
Private Collection

'I am repainting most of my Suffolk pictures' wrote Roger Fry to his father in late 1893, 'as I found they were too detailed and literal and that for the final effect I must get away from Nature' (Fry to Sir Edward Fry, Fry, *Letters*, 1, 1972, p.155). This may or may not refer to the present work, painted in the previous year in Suffolk but it suggests almost for the first time in Fry's correspondence a change of direction in his approach to his painting. Fry and his great friend, Nathaniel Wedd, the scholar and Fellow of King's College, Cambridge, stayed in the summer of 1892 in Blythburgh, a small village on the River Blyth, five miles west of Southwold in Suffolk. It is noted for its magnificent fifteenth-century church which is situated above the marshes and estuary of the Blyth and can be seen on the horizon in Fry's painting. Landscape was Fry's main subject in his early years as painter; his chief influences were Nicolas Poussin and Claude as well as the English watercolourists, Thomas Girtin above all (fig.62). He was aware at first hand of new developments in France but his natural caution and an antipathy to the structural looseness of late Impressionism, as exemplified by Claude Monet, made his careful, detailed landscapes appear remarkably backward-looking, especially in comparison with the work of contemporaries such as his friends William Rothenstein and Philip Wilson Steer. But in no.1 Fry introduces a new note, the colour showing greater invention, the composition bearing similarities to work by some of the Pont-Aven artists of the 1890s such as Maurice Denis, particularly in the sinuous rythmns of the estuary crossed by the pine trees whose dark foliage echoes the cloudy islands in the water below. Submitted to the New English Art Club jury in 1893, the painting was rejected as being too Post-Impressionist. 'I gave in to what I thought were wiser counsels, and my next rebellion against the dreary naturalism of our youth lay in the direction of archaism' (Fry to D.S. MacColl, 3 February 1912, in *Letters*, 1, 1972, p.353).

Prov: The artist; P. Diamand to present owner
Exh: *Post-Impressionism*, RA 1980 (290, repr.)
Lit: Spalding 1980 (pp.45–6; pl.14)

fig.62 Roger Fry, *Verona, Misty November Day* 1902, pencil and watercolour on paper 28.8 × 42.4 cm. British Council Collection

2 *Studland Bay (Black Sea Coast)* 1911

Oil on canvas 71.1 × 91.4 (28 × 36)
Swindon Museum and Art Gallery

Recent inspection shows that this painting is a view of Studland Bay, Dorset, and not the Turkish Coast as previously catalogued. Fry's May 1911 visit to Turkey, where he saw Byzantine mosaics and was excited by the landscape around Brusa, made an immediate impact on his painting. After his return, several large canvases were carried out from sketches made in Turkey which emphasise linear structure and schematic form at the expense of representational detail and local colour. In September 1911 Fry subjected the English coastline to his new style.

In the early 1900s Studland was a small, unspoilt, picturesque village just under four miles from the town of Swanage. Mild tides meant safe bathing; there were spacious views towards the Isle of Wight; pretty cottages, a Norman church and no seaside 'front' – 'it declines to be maritime' as one guidebook noted. It was popular with Bloomsbury and Cambridge intellectuals – Bertrand Russell was there in spring 1910 with, among others, Gerald Shove (see no.29); Russell paid a very different visit there in 1911, alone with Lady Ottoline Morrell. The Bells and Stephens, several Stracheys, Desmond and Molly MacCarthy, Sidney Waterlow and Roger Fry gathered there in the summers of 1910 and 1911 (only Duncan Grant is absent from the roll-call).

Two substantial paintings by Fry of Studland are known – this one and *Studland Bay* (fig.63) – as well as several *pochades* (such as a study for fig.63, Christie's 9 November 1984 (77)). In no.2 Fry has resumed some of the ideas deployed in his Blythburgh painting (no.1), after a long intervening period of mostly *retardataire* landscapes. There is the same distant horizon seen between foreground trees, similar sinuous rhythms and an invented rather than naturalistic palette, though in the Studland painting this assumes a much bolder and more expressive range. The twisting pines and thrusting rock add to the lurid effect of the whole as though it were a theatrical backdrop waiting for dancers (almost certainly Russian) to emerge from the wings.

Prov: Artist's estate to P. Diamand from whom bt 1969
Exh: *Edwardian Reflections*, Cartwright Hall, Bradford, 1975 (50); Barbican 1997 (44; p.18 repr. in reverse)
Lit: Naylor 1990 (p.82, repr. in reverse); *The Swindon Collection of Twentieth Century British Art*, 1991 (pp.48–9, as *The Black Sea Coast*)

2

fig.63 Roger Fry, *Studland Bay* 1911, oil on canvas 58.5 × 90 cm. Rochdale Art Gallery

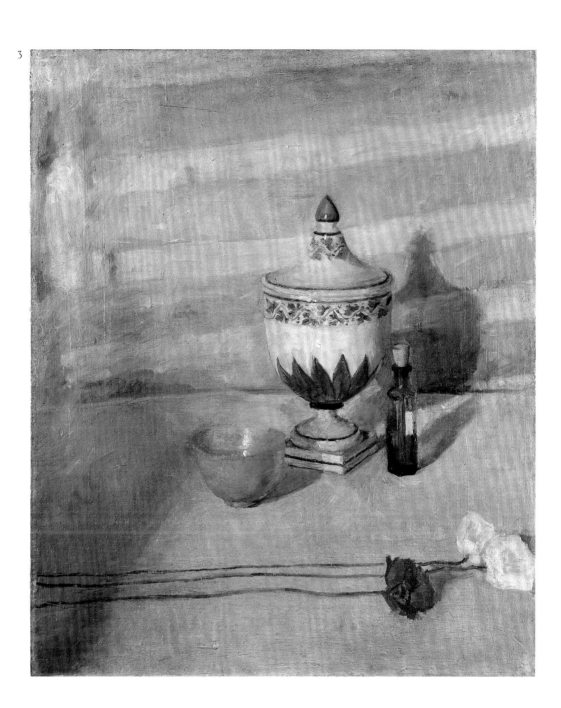

VANESSA BELL

3 *Iceland Poppies* c.1908–9

Oil on canvas 53 × 44 (20⅞ × 17¼)
Inscribed on verso
Private Collection

When Vanessa Bell's studio in London was burnt out following an air-raid in September 1940, apparently a good deal of her early work was destroyed. Very few paintings and almost no drawings from before about 1911 are extant but luckily this painting, then at Charleston, has survived. It was first exhibited in 1909 and already shows characteristics that remained hallmarks of Bell's subsequent work, particularly the way in which she extracts something grave and substantial from comparatively simple components. The subtext of this still life is medicinal for, apart from the obvious presence of the medicine bottle, the lidded pot is an eighteenth-century French pharmacist's jar (still at Charleston), and the poppies (*papaver nudicaule*, a spring-flowering variety of the yellow Arctic poppy), whose long stalks here echo the banded wall or fabric at the back, carry overtones of opium and narcotic drugs. Almost certainly Bell was conscious of these associations when she arranged the objects but it seems unlikely that they had any particular autobiographical significance. Her reticence was already evident, as much in the unsensational attitude to her subject as in its modest arrangement and her unemphatic handling of paint.

In a list of Bell's paintings made c.1945 by Grant, no.3 is called *Poppies and Poison*.

Prov: The artist to D. Grant; to A.V. Garnett 1978; to present owner
Exh: NEAC, Summer 1909 (146, as *Still life*); Adams 1961 (1, repr.); ACGB 1964 (4, repr.); Bristol 1966 (56); FAS 1976 (1); Sheffield 1979 (3); New York 1980 (1); Canterbury 1983 (1); Dallas and London 1984–5 (1, repr.)
Lit: 'G' [Duncan Grant], *Spectator*, 19 June 1909 (p.977); Shone 1976 (pl.6); Watney 1980 (pl.25); Spalding 1983 (pl.1; pp.82, 113, 171); Shone 1993 (pl.13)

4

4 *Apples: 46 Gordon Square* c.1909–10

Oil on canvas 71 × 50.8 (28 × 20)
The Charleston Trust

The vague early exhibition history of this painting makes it difficult to date precisely but late 1909 or, more likely, early 1910 seem most probable, taking into account the season depicted (winter or early spring). Additionally, the more impasted paint surface and unusual composition suggest a move forwards from the restrained fluidity of *Iceland Poppies* (no.3) or *Hotel Garden, Florence* of late spring 1909 (Charleston Trust). Although the influence of recent French painting was shortly to transform Bell's work, no.4 has affinities with her English contemporaries. Walter Sickert's encouragement after he had seen *Iceland Poppies* ('Continuez!' he admonished her) increased her confidence and momentarily aligned her work with that of Sickert's Fitzroy Street circle which included Spencer Gore (e.g. *Woman in a Flowered Hat*, exh. NEAC 1908) or Harold Gilman (e.g. *The Kitchen*, c.1908). (For an illuminating discussion of Bell's and Sickert's modernism in relation to this painting see Reed 1989.)

The railed garden of Gordon Square, Bloomsbury, is seen through the balconied first-floor window of the Bells' house at number 46. On a low table or box, three apples rest on a blue and white Nankeen dish, part of a set from the Stephen family home (several similar dishes are still at Charleston). The combination here of interior still life and a view through a window, with its concomitant balance of emphatic verticals and shorter horizontals, is the earliest extant example of a theme to which Bell returned throughout her career. Variations include *Interior with a Table, St Tropez* (no.124) and the late *Still Life with Bust by Studio Window* (no.144) and, by extension, *The Open Door* (no.127); note too the layered bands of the garden, road and pavement, seen through the open French windows, in relation to the view in *Frederick and Jessie Etchells Painting* (no.24). Here, careful realism and a sober attention to the cool light from outside, and the play of warm creams, greys and browns, establish a slow, meditative intimacy which is Bell's most characteristic mood of self-revelation.

This room with three French windows was the Bell family's drawing room but was later used as a studio by Vanessa Bell up to late 1915; in the following year it became Maynard Keynes's room, was decorated by Bell and Grant in 1918 (door panels in the Keynes Collection, King's College, Cambridge) and remained his until his death in 1946. Along with adjacent houses, 46 was ruthlessly converted by the University of London (Birkbeck College currently occupies the house) but the curtained window, balcony and view are much the same today (July 1998).

Prov: The artist to D. Grant; to A.V. Garnett 1978
Exh: ?FC, June 1910 (as *Still Life*) or ?FC, 1911 (138, as *Apples*); Adams 1961 (3); ACGB 1964 (5); Bristol 1966 (70); Sheffield 1979 (4); New York 1980 (3); Canterbury 1983 (2)
Lit: Shone 1976 (pl.27); Watney 1980 (pl.16, reversed); C. Reed, 'Apples: 46 Gordon Square', *Charleston Newsletter*, 23, June 1989 (pp.20–4); Naylor 1990 (pl.96); Shone 1993 (pl.16)

5

DUNCAN GRANT

5 *The Kitchen* c.1904–6

Oil on canvas 50.8 × 40.6 (20 × 16)
Inscribed 'Duncan Grant 1902' on back
Tate Gallery, London. Presented by the Trustees of the Chantrey Bequest 1959

Duncan Grant put on record (Tate 1959, no.2) that this was a view inside Elm Lodge, a house rented by his parents at Streatley-on-Thames, and in later years he dated the work 1902 on the back. It is unlikely that he painted something so accomplished at the age of seventeen. However it is known that the Grants were at Elm Lodge in 1902–3 and evidence exists that they were there again for the summer of 1904 when Grant's training at the Westminster School of Art was well underway and when a drawing by him of an ancient dovecote at Streatley was published in the June issue of *The Country Gentleman*. There are few oil paintings of this early period with which to compare it (a small Streatley landscape dated 1903 was at the New Grafton Gallery, autumn 1974 (8), and a landscape sketch of Streatley, 1902, is at Charleston). The still life on the table shows an awareness of Chardin whom Grant only came to revere in 1906 in Paris.

This modest, luminous painting announces many of Grant's later preoccupations, notably the theme of a view from one room through to another (here from the kitchen to the scullery), the patterned floor and wallpaper and the domestic objects grouped on the table. Similar viewpoints are taken in several of his other paintings, such as his near-abstract *Interior, 46 Gordon Square* (1914; no.74). The figure of the

cook in the doorway, caught as though unawares by the artist, is also highly characteristic of later work in which people going about their daily occupations add human presence to interiors and landscapes.

A visit to Elm Lodge (1999) confirms the location for no.5 although interior changes have partly obscured Grant's view.

Prov: The artist; Chantrey Purchase by Tate Gallery 1959
Exh: *Painter's Progress*, Whitechapel Art Gallery, 1950 (1); *Paintings by Edwardian Artists*, Graves Art Gallery, Sheffield, 1952 (16); Tate 1959 (2); Summer Exhibition, RA 1960 (690, as a Chantrey Purchase); Tate 1975 (1)
Lit: Shone 1976 (pl.16); Watney 1980 (pl.76); Watney 1990 (p.113); Naylor 1990 (p.76, repr.); Shone 1993 (pl.23); Spalding 1997 (p.22 and note)

DUNCAN GRANT

6 *John Maynard Keynes* 1908

Oil on canvas 80 × 59.5 (31½ × 23½)
Inscribed 'Duncan Grant' b.l.
The Provost and Scholars of King's College, Cambridge

In September 1908, when this portrait of John Maynard Keynes (1883–1946) was begun, the future economist had resigned two months previously from his clerkship in the India Office and was working on the revision of his dissertation, 'Treatise on Probability', which had failed to win him a prize fellowship at King's College, Cambridge, in March that year (resubmitting it in March 1909, he was elected). Before assuming an interim position as lecturer in economics at King's, Keynes spent a long summer holiday with the new love of his life, Duncan Grant, in the Orkneys, more specifically in rented rooms at Orgil Farm in the north-east corner of the island of Hoy. Grant had arrived on Hoy in late July and stayed with friends at Melsetter while looking for suitable accommodation for Keynes's arrival in early August. Grant attempted several landscapes before beginning this portrait on 13 September while Keynes was revising his dissertation. It was continued intermittently until October and finally finished in London by mid-December when the sitter's father Neville Keynes bought it for his wife Florence. She bequeathed it to King's College on her death in 1958.

While surviving landscapes from this visit to the Orkneys are conventional and modest, Grant's portrait begins to show a personal quality in its integration of a full-length figure in an interior, in its direct informality and its differentiation of textures. It is a considerable advance, especially in its handling of the side-illumination, on his portrait of John Peter Grant (Scottish National Portrait Gallery, Edinburgh; Shone 1976, pl.20) painted in Scotland a year earlier to hang beside his own copy (1906, untraced) of G.F. Watts's portrait of John Peter's father (National Portrait Gallery, London). It is not difficult to detect the influence of some of Jacques-Emile Blanche's male portraits of about this period which Grant knew from visits to his studio as a pupil, and from exhibitions; and the composition has similarities with Simon Bussy's 1904 pastel of Grant's cousin Lytton Strachey (no.156).

The painting of Keynes has always been judged a sympathetic likeness and the sitter's attitude and gaze are remarkably close to Lady Ottoline Morrell's impression formed a few years later of her friend's 'detached, meditating and yet half-caressing interest in those he is speaking to, head on one side, a kindly tolerant smile and very charming eyes wandering, searching and speculating, then probably a frank, intimate and perhaps laughing home-thrust' (*Ottoline at Garsington: The Memoirs of Lady Ottoline Morrell*, ed. R. Gathorne-Hardy, 1974 [p.50]).

Prov: Mrs J.N. Keynes (sitter's mother) by whom bequeathed 1958
Exh: Tate 1959 (7); Wildenstein 1964 (14); ACGB 1969 (1)
Lit: R.F. Harrod, *The Life of John Maynard Keynes*, 1951 (p.132); Holroyd 1967, 1 (p.345); R. Lekachman, *The Age of Keynes* (Penguin ed.) 1967, repr. cover [detail]; *Essays on John Maynard Keynes*, ed. M. Keynes, 1975 (repr. opp. p.139); R. Skidelsky, *John Maynard Keynes*, 1983, 1 (pp.198, 200–1, repr. opp. p.73); Naylor 1990 (p.71, repr.); Shone 1993 (pl.37); Spalding 1997 (repr. opp. p.304)

DUNCAN GRANT

7A *Lytton Strachey* c.1909

Oil on canvas 53.3 × 66 (21 × 26)
verso no.7B
Tate Gallery, London. Purchased 1947

This portrait of Grant's cousin Lytton Strachey (1880–1932) was begun in March 1909 in Strachey's study–bedroom at 67 Belsize Park Gardens, Hampstead, the house into which Lady Strachey and her children had moved in 1908 after the death of Sir Richard Strachey. Work on the painting was fitful and, as the flowers in the vase testify, not completed until later in the year. At this time Strachey was leading an increasingly frustrated existence, finding no solution to his wish to escape from family life (a spur-of-the-moment proposal of marriage the year before to Virginia Stephen epitomised his frustration); his dissatisfaction with regular reviewing for the *Spectator* led to his resignation in April 1909 but he had no substantial literary project in view. Added to this, the place in his affections vacated in 1908 by Grant, in favour of Maynard Keynes, had yet to be filled (not until 1910 did the painter Henry Lamb become the focus of his attentions).

Hanging in the Stracheys' house was Simon Bussy's portrait of Sir Richard Strachey (fig.64) which obviously provided Grant with a model for the composition of no.7A in which Lytton is also seen reading, in profile, legs crossed, the light coming from behind him, a small table in front of his armchair; an adjustable library table on the other side supports the volume of *State Trials* on which Lytton rests his notoriously thin, long-fingered hands. The flowers and drooping, disembodied gloves pick up the rhythms of his chair's chintz cover. Through a number of assured but unemphatic details Grant has captured something of Strachey's studious, gloomy life at this period in the family home he found increasingly claustrophobic.

Prov: Bt from the artist by the Tate Gallery 1947
Exh: Tate 1959 (9); ACGB 1969 (3); Tate 1975 (3); Liverpool 1996–7 (14; repr.)
Lit: Holroyd 1967, 1 (repr. opp. p.280); Shone 1976 (pl.15); Shone 1993 (pl.30, p.49)

6

7A

7B

7B *Le Crime et le Châtiment* c.1909

Oil on canvas 53.3 × 66 (21 × 26)
Painted on the reverse of no.7A
Tate Gallery, London. Purchased 1947

Little is known of the origins of this arresting work or why Grant chose to paint it on the same support as no.7A. It is possible he began it as a submission to the Royal Academy Summer Exhibition of 1910 and tentatively called it *Despair*. It is unique in Grant's work in being a scene depicting the psychological state of the sitter. It shows the artist's cousin Marjorie Strachey (1882–1964) in the family drawing room, overcome with gloom after reading Dostoevsky's novel, the paper-covered French translation of which lies on the sofa beside her. The painting seems to embody the emotional shock afforded by Dostoevsky as his works infiltrated the unprepared sensibilities of cultured Edwardians. In Grant's own circle, the Russian novelist was read avidly (see, for example, Leonard Woolf's praise of *Les Frères Karamazov* in a letter to Lytton Strachey, 2 August 1911, in *The Letters of Leonard Woolf*, ed. F. Spotts, 1989, p.166). A few years later, Virginia Woolf wrote that Dostoevsky's books 'have become an indestructible part of the furniture of our rooms, as they belong to the furniture of our minds' (*The Essays of Virginia Woolf*, ed. A. McNeillie, 2, 1987, p.83).

Marjorie Strachey was principally a teacher and writer. She was an integral figure of early Bloomsbury, high-spirited, bawdy and erratically erudite. Her ungainly plainness made her lewd party-turns grotesquely comic but her exquisite reading aloud of Racine impressed the French theatre producer Jacques Copeau. In later years she lived at 1 Taviton Street, Bloomsbury, her flat providing a pied-à-terre for Duncan Grant in the later 1940s. One of her two published novels, *The Counterfeits* (1927), a somewhat ludicrous and romantic love story partly based on her own thwarted affair with the politician Josiah Wedgwood, casts a satirical eye on Bloomsbury, evoking

fig.64 Simon Bussy, *Sir Richard Strachey* 1902, pastel on paper 45.7 × 50.8 cm.
National Portrait Gallery, London

Grant's later studio at 8 Fitzroy Street as well as Charleston and, incidentally, mentioning the power of Dostoevsky. Grant probably planned this work as a definite commercial proposition, to appeal to the Royal Academy public's enjoyment of narrative images and domestic detail; but he seems not to have finished it in time for submission. For another image of Marjorie Strachey, see no.80.

Prov: Bt from the artist by the Tate Gallery 1947
Exh: ? FC, London, June 1910 (as *Interior*); Tate 1959 (9); ACGB 1969 (3); Tate 1975 (3); Liverpool 1996–7 (14, repr.)
Lit: Shone 1976 (pl.23); Watney 1990 (pl.16); Naylor 1990 (p.77); Shone 1993 (pl.36); Spalding 1997 (pp.84, 91, 94–5)

8 *James Strachey* c.1909–10

Oil on canvas 63.5 × 76.2 (25 × 30)
Tate Gallery, London. Purchased 1947

James Strachey (1887–1967) was the youngest of the five sons of Sir Richard and Lady Strachey and was a close companion of his cousin Duncan Grant: both attended Hillbrow preparatory school, Rugby, and St Paul's, London. James was at Trinity College, Cambridge (1905–9) and then worked as a reviewer and assistant at the *Spectator*, edited by his cousin St Loe Strachey. An early, protracted and painful infatuation for Rupert Brooke gave way to two long-lasting relationships with women: Noel Olivier and Alix Sargant-Florence. With Alix, whom he married in 1920, he formed an extraordinary working partnership for the rest of his life. After analysis with Sigmund Freud in Vienna in the year of their marriage, they were among Freud's chief English apologists and became his accredited English translators, a position that culminated in the monumental Standard Edition (1953–66 and 1977) which has been described as 'unquestionably the greatest achievement of its kind in the twentieth century. It surpasses in completeness and accuracy any Freud in any language, including German' (*Bloomsbury/Freud: The Letters of James and Alix Strachey 1924–1925*, ed. P. Meisel and W. Kendrick, 1986, p.313). Strachey's early letters reveal him as studious, rational, a lover of music and the theatre, subject by turn to sullen moods and forced hilarity, impatient of accepted behaviour and with an implacable hatred of Christianity. From Bloomsbury's early days to *c.*1920 he was an essential ingredient of its social life.

A letter from Rupert Brooke to Edward Marsh of 10 December 1909 mentions how he 'went to the New English and saw the famous picture of James' legs'. This almost certainly refers to no.8 although the catalogue for the NEAC Winter show of 1909 lists only two watercolours exhibited by Grant, nos.222 and 243. The first was entitled *Merrily, merrily shall I live now / Under the blossom that hangs on the bough* and the Tate Gallery NEAC catalogue is anonymously annotated 'gifted w.c. sold'; the second was *Burford High Street* ('charming') which was bought by Maynard Keynes. It is possible that Grant, often late in finishing works to a deadline, submitted this painting of James Strachey after the catalogue had gone to press. Alternatively, Brooke's remark refers to another work altogether and Grant exhibited no.8 at the Friday Club exhibition in June 1910 as *Portrait*; he was painting

8

James Strachey early that month (Grant to James Strachey, 3 June 1910, Strachey Papers, BM) though this could refer to a full-length nude painting of Strachey made at this time.

The setting is the drawing room at the Stracheys' Hampstead house (the same carpet is seen in no.7B), an oriental screen placed behind the figure (the pose wittily echoing the screen's four panels) in what was to become one of Grant's favourite compositional devices. An obvious delight in texture and arabesque is kept in check by the sober solidity of the elegant reader who looks up momentarily from his book. Although by this date Grant was well aware of Impressionism, it did not answer the question of what direction his work was to take (a position similar to Roger Fry's a few years earlier). With such paintings as this he appears as a highly accomplished but stranded figure in the contemporary English scene.

Prov: The artist to his mother Ethel Grant; bt from the artist 1947
Exh: NEAC, Dec. 1909 (?ex.cat.); Tate 1959 (10); ACGB 1969 (7); Columbus 1971 (38; fig.91); Edinburgh and Oxford 1975 (3); *An Aesthetic Dialogue, 1850–1930*, Barbican Art Gallery, London, and Setagaya Art Museum, Tokyo, 1992 (363); Liverpool 1996–7 (no.15, repr.)
Lit: Mortimer 1944 (pl.3); C. Hassall, *Rupert Brooke*,1964 (repr. opp. p.97); Holroyd 1967, 1, (repr. opp. p.280); Q. Bell, *Bloomsbury*, 1968 (p.35); Shone 1976 (pl.22, p.52); Watney 1980 (pl.77, p.86); Spalding 1986 (pp.39–40, repr. pl.24); Shone 1993 (pl.34, p.49); *Friends and Apostles: The Correspondence of Rupert Brooke and James Strachey 1905–1914*, ed. Keith Hale, 1998 (pl.4)

DUNCAN GRANT

9 *Study for Composition (Self-Portrait in a Turban)* 1910

Oil on board 76 × 63.5 (30 × 25)
Private Collection

Pentimenti reveal that originally Grant held a basket of some kind on his head in a manner similar to figures in his mural of grape-pickers in J.M. Keynes's Cambridge rooms (for which see no.10). As the title suggests, he may have had a large figure composition in mind but if so this is the only portion to survive. Grant's enjoyment of fantastic head-dress and fancy-dress plays and parties no doubt contributed to this startling image of himself but hats and turbans of varying exoticism appear in abundance in English art of this period — from the gypsy feathered hats in Augustus John's portraits of Dorelia and the straw boaters in Walter Sickert's costerwomen to Edward Wadsworth's self-portrait in a turban of 1911. Grant found professional nude models relatively expensive to hire and so frequently inveigled friends to pose for paintings and drawings at this time, including James Strachey, George Mallory and Philip Noel Baker; he also posed naked himself for photographs to be taken in his studio.

Prov: The artist; bt Wildenstein by present owner 1964
Exh: Wildenstein 1964 (15, repr.); ACGB 1969 (6); Edinburgh and Oxford 1975 (2, repr. on cover); *A Homage to Duncan Grant*, Harvane Gallery, London, 1975 (10); Crafts Council 1984 (P28, repr. frontispiece)
Lit: Shone 1993 (pl.44)

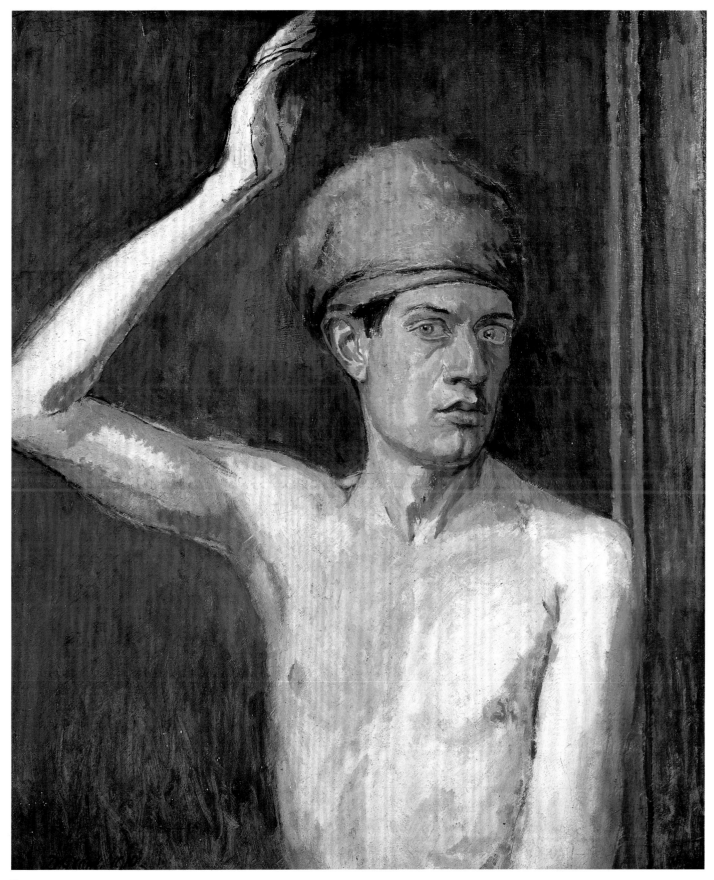

9

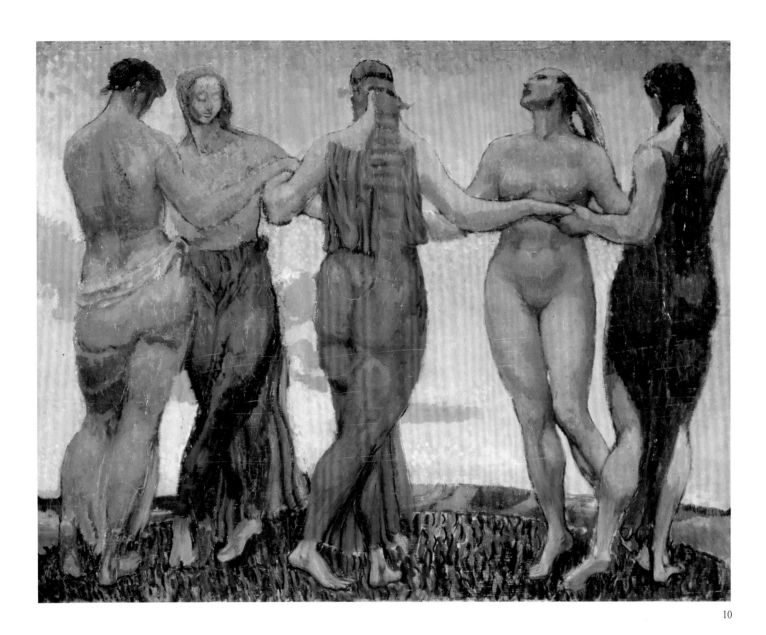

DUNCAN GRANT

10 *The Dancers* c.1910–11

Oil on panel 53.3 × 66 (21 × 26)
Tate Gallery, London. Bequeathed by Sir Edward Marsh through the
Contemporary Art Society 1953

Establishing a detailed chronology of Grant's early work, especially during the period 1910–12, is hampered by his eclectic approach to painting at this time, the impetuous effect on him of new art from abroad, his habit of employing different styles at a given moment and of reworking paintings at various stages. *Dancers*, which exists in two versions, began as a painting steeped in Italian renaissance influences (from Lorenzetti to Botticelli's *Primavera*, as Simon Watney has noted) filtered through Edward Burne-Jones (e.g. the group of three female dancing figures in clinging skirts in *The Mill*, Victoria and Albert Museum); at the same time it evolved directly from a drawing of c.1909–10 (fig.65) which owes much to Grant's passion for Poussin, whose drawings he studied in Paris in 1907. Additionally, the influence of Gauguin is easy to detect in contour and palette, especially in

relation to the *Three Tahitians* (shown at the First Post-Impressionist Exhibition in late 1910; now National Gallery of Scotland, Edinburgh). But Grant's amalgamation of these sources produced a highly personal piece, the grave, stately movement of the five figures against the sky establishing a mood that recurs throughout his work. The handling and colour of no.10 suggest a date of late 1910 – early 1911 (the artist told the present author it was painted in Fitzroy Square, an address he left in November 1911). The second, larger version shown at the Second Post-Impressionist Exhibition in autumn 1912 (fig.67) is a succinct restatement of the composition in which the dark contours of the dancers are broken by strong, square-ended vertical brushstrokes. A similar transformation took place in the closely related mural Grant painted on a wall of J.M. Keynes's study in King's College, Cambridge (fig.66), its central area showing four energetically dancing nude figures seen against a pointillist blue sky, the horizon kept very low as in no.10. Some photographs of this mural taken in 1911 show that Grant, who experienced considerable difficulty bringing the work to a conclusion ('I remember throwing down my brushes in tears' he told the author), later in the year 'primitivised' the heads of his figures and added the foliage of the vines that run along the top. In the heads

fig.65 Duncan Grant, Study for *The Dancers* c.1909–10, ink and wash on paper 14.3 × 18.2 cm. Private Collection

fig.66 Detail of mural by Duncan Grant in J.M. Keynes's rooms at King's College, Cambridge, c.1910–11. Photographed by Grant while work in progress. Tate Gallery Archive

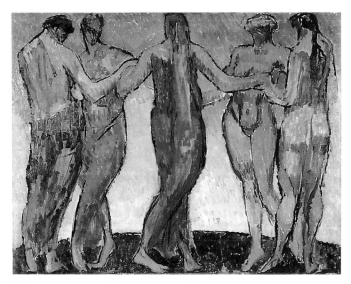

fig.67 Duncan Grant, *The Dancers* 1912, oil on canvas 71 × 92 cm. Private Collection

he was undoubtedly influenced by Picasso, particularly by such a work as *Nude with Drapery* (1907) and studies for it, then owned by the Steins, and not by Henri Matisse's *Dance* which he had not yet seen. The theme of a chain of figures in action continued to preoccupy Grant in such works as *Bathing* (no.71) and *Dancers* c.1916–17 (Britten-Pears Foundation, Aldeburgh).

Prov: Bt Adrian Stephen c.1911–12 by whom sold to Edward Marsh by whom bequeathed through CAS to Tate Gallery 1953
Exh: (?) *Paintings and Drawings*, CAS, Grosvenor House, 1923 (144); *Retrospective Exhibition*, NEAC, London, and Manchester City Art Gallery, 1925 (109 and 137 respectively); Guillaume Davis 1929 (3); *Anthology of English Painting*, French Gallery, 1931 (16); Venice Biennale 1932 (29 or 35); *Empire Exhibition*, British Council, Johannesburg, 1936 (445, repr.); *Franco–British Exhibition of Contemporary Art*, Melbourne, 1939 (160); *The Collection of the Late Sir Edward Marsh*, Leicester Galleries, 1953 (61); Tate 1959 (15); Tate 1975 (5)
Lit: *Studio*, 97, 1929 (p.178, repr.); Watney 1980 (pl.78, p.86)

DUNCAN GRANT

11 *Parrot Tulips* 1911

Oil on canvas 52 × 49 (20½ × 19¾)
Inscribed 'D. Grant.1911' b.l.
Southampton City Art Gallery

Modest in size and intention, this painting of parrot tulips against a floral textile nevertheless occupies a significant place in Grant's career. The work was his sole exhibit at the second Camden Town Group exhibition during his brief membership of what was the most progressive artists' group in London at that time. It was bought by Edward Marsh, the collector, writer and private secretary to Winston Churchill at the Admiralty. It was one of the first contemporary pictures in what became one of the most extensive collections of modern British art, containing notable works by Sickert, Mark Gertler, Lamb, Gilbert and Stanley Spencer and John and Paul Nash, as well as several further paintings by Grant. The purchase of no.11 occasioned a violent and final quarrel between Marsh and his friend, the Hon. Neville Lytton, a painter who denigrated it as a 'disgraceful picture'. Although *Parrot Tulips* is conventional enough, its obvious lack of refinement in colour and setting would have offended someone such as Neville Lytton who exhibited with the New English Art Club (as, of course, had Grant in the previous year).

It is known that Grant was working on a still life of tulips in early 1909. There is just a possibility that no.11 may have been begun then and finished or reworked in 1911 for the Camden Town exhibition in December that year. It is curious that Grant should have chosen as his only exhibit a painting almost wholly innocent of contemporary developments when he had, by then, painted *Bathing* (no.71), a large study of wrestlers with totemic heads, and the Gauguinesque *Dancers* (no.10, bought by Marsh). However, these more radical works might well have clashed with the work of his fellow Camden Town exhibitors.

A letter from Clive Bell to Edward Marsh of about November 1911 (Berg Collection, New York Public Library) suggests that Marsh should come to see the works by Grant which the Bells owned at 46

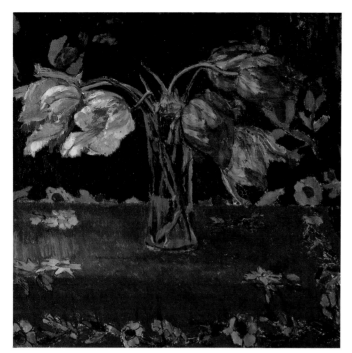

11

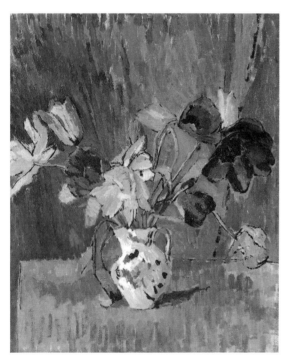

fig.67A Duncan Grant, *Tulips* c.1912, oil on board 56.4 × 45.5 cm.
Queensland Art Gallery, Brisbane

Gordon Square before they went to Manchester for a Contemporary Art Society exhibition (December 1911 – January 1912). It appears that Marsh took the tip and purchased no.11 at the Carfax Gallery or soon afterwards. In a portrait of Marsh by Neville Lewis (c.1937, Royal Society of Literature, London) no.11 is clearly visible on the wall behind the sitter.

Sir Edward Marsh, as he became, also owned Grant's *Still Life with Bread and Carrots* (Tate Gallery) and *Acrobats* (Montreal Museum of Fine Arts; see no.138). A similar painting of parrot tulips of c.1912 is

in Queensland Art Gallery, Brisbane, also with a Carfax provenance (fig.67A).

Prov: Bt by Edward Marsh 1911, by whom bequeathed through CAS to Southampton City Art Gallery 1954
Exh: CTG, Carfax Gallery, Dec. 1911 (53); Twentieth-Century Art, Whitechapel Art Gallery, 1914 (365); CTG Southampton City Art Gallery, 1951 (75); CTG, Plymouth Art Gallery, 1974 (18); *An Honest Patron: A Tribute to Sir Edward Marsh*, Bluecoat Gallery, Liverpool, 1976 (p.32); Camden Town Recalled, Fine Art Society, 1976 (71)
Lit: E. Marsh, *A Number of People*, 1939 (p.355); C. Hassall, *Edward Marsh*, 1959 (p.179); W. Baron, *The Camden Town Group*, 1979 (p.243; pl.89); Watney 1980 (pl.8); Southampton City Art Gallery Collection 1980 (p.37, repr.); Shone 1993 (pl.48)

DUNCAN GRANT

12 *Virginia Woolf* 1911

Oil on board 56.5 × 41 (22¼ × 16⅛)
Inscribed 'D. Grant 1911' b.l. (later inscription)
The Metropolitan Museum of Art, Purchase, Lila Acheson Wallace Gift, 1990

This work was painted at 46 Gordon Square when the sitter was visiting her sister Vanessa Bell in whose studio Grant was temporarily working. There is no evidence for the date of 1911 save that given by Grant in the Tate 1959 catalogue; the painting was inscribed by the artist in 1964. It was certainly painted before she was married to Leonard Woolf (so she is in fact Virginia Stephen) and sometime in early 1911 is stylistically appropriate (compare the handling with *Pamela*, no.17, and the 1911 portrait of G.H. Luce at King's College, Cambridge).

Virginia Woolf notoriously disliked sitting for her portrait; Grant knew he had to work swiftly or 'she might just get up and walk out' (Grant in conversation with the author, August 1965). The painting shows all the signs of having been done in one sitting; its vivid immediacy catches something of Virginia Woolf's intensely observant presence (if not her physical beauty). Grant told the present author that the painting was done after the sitter had experienced an extensive period of mental instability and ill-health and indeed Virginia Stephen had needed several holidays and rest cures in 1910. Nuances of this in the painting have even been seen as premonitory. This is Grant's only portrait of Woolf. He had intended to make a large painting in 1910 of her seated in the drawing room of her home in Fitzroy Square but the project got no further than an ink drawing of the composition (collection Olivier Bell).

Prov: Vanessa Bell; to A.V. Garnett 1961–82; to Nerissa Garnett by whom sold to Metropolitan Museum of Art, New York 1990 (on loan to National Portrait Gallery, London, 1983–90)
Exh: *Fitzroy Street Retrospective 1910–20*, Artists International Association Gallery, 1955 (19); Tate 1959 (19); Wildenstein 1964 (17, repr.); *Vision and Design* 1966 (23); ACGB 1969 (12, repr. on cover); Columbus 1971 (39, fig.88); Edinburgh and Oxford 1975 (5); *The Bloomsbury Group*, National Book League, 1976 (54)
Lit: Q. Bell, *Virginia Woolf*, 1972, paperback ed. 1976 (cover); Shone 1976 (pl.9); Watney 1980 (pl.64); *Illustrated Report 1982–3*, National Portrait Gallery (p.21, ill.23); Naylor 1990 (p.79, repr.); Shone 1993 (pl.41; cover)

12

The Voyage Out

Paintings 1911–13

In 1910 Roger Fry's position as Curator of Paintings at the Metropolitan Museum of Art, New York, was terminated and he returned permanently to England. It was then that he became part of the inner circle of Bloomsbury, lectured to the Friday Club, helped launch the Contemporary Art Society and planned the explosive exhibition *Manet and the Post-Impressionists* at the Grafton Galleries (November 1910 – January 1911). Works in this show had an immediate impact: 'here was a sudden pointing to a possible path', Vanessa Bell later recalled, 'a sudden liberation and encouragement to feel for one-self, which were absolutely overwhelming' (V. Bell, 'Memories of Roger Fry', *Sketches in Pen and Ink*, ed. L. Giachero, 1997, p.130). The ferment caused by the exhibition meant that the Bloomsbury painters were by no means isolated within the broader picture of avant-garde British art, as is some-times claimed. Cordial relations existed bewteen them and Sickert's Fitzroy Street circle (Grant was briefly a member of the Camden Town Group), with Slade School graduates such as Mark Gertler (who exhibited with the Friday Club) and with Wyndham Lewis, Edward Wadsworth and Frederick Etchells (see no.24). They also came to know personally the French artists they admired, visited the Stein family collections in Paris and made useful contacts with, for example, the dealer Ambroise Vollard, the theatre producer Jacques Copeau and several of the artists associated with Diaghilev's Russian Ballet.

Fry was undoubtedly the animator, as writer, lecturer (see no.165), and exhibition organiser; his greater age and experience brought about opportunities which, without him, would have seemed unavailable to Grant and Bell. An example of this was his securing an important commission to deco-rate a room at the Borough Polytechnic in south London where the chairman was Basil Williams, an old Cambridge friend. The murals by Fry, Etchells, Grant (see no.71) and others formed the first Post-Impressionist collaboration in London, the precedent for several subsequent schemes such as the

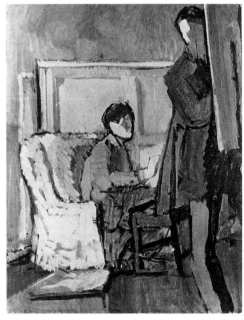

fig.68 Vanessa Bell, *The Studio: Duncan Grant and Henri Doucet Painting at Asheham* 1912, oil on board 58.4 × 50 cm. Private Collection

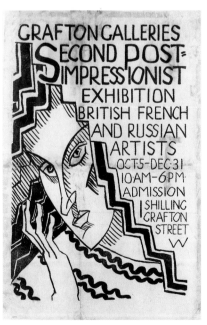

fig.69 Poster, 1912, for the Second Post-Impressionist Exhibition 119.4 × 93.8 (47 × 37). Collaborative design by Bell, Etchells, Fry and Grant. Victoria and Albert Museum, London

opposite detail from Roger Fry, *Fort St André, Villeneuve-lès-Avignon* 1913 (no.16)

Cave of the Golden Calf Cabaret Club, decorations carried out by the Omega Workshops and the Vorticist room at the Restaurant de la Tour Eiffel. Grant's *Queen of Sheba* (no.20), one of his best-known works, is a further example of a commissioned, site-specific painting. Several of the artists involved in these schemes exhibited together at the Galerie Barbazanges in Paris in May 1912, a trial run for the English section of the Second Post-Impressionist Exhibition of 1912–13 which included, besides the Bloomsbury painters, work by Spencer Gore, Wyndham Lewis, Eric Gill and Stanley Spencer.

In 1911–12 Vanessa Bell's painting matured rapidly in this intoxicating atmosphere; *Studland Beach* (no.26) is one of the most radical works produced at that time in Britain and shows Bell more in step with some of her French and German contemporaries than with her fellow exhibitors in England. Her singleminded development can be traced in several works painted at Asheham House in late summer 1912 (no.25). Grant's work of 1911–12 reveals the impact not only of the Post-Impressionists but of his discovery of Byzantine mosaics, romanesque decoration and African sculpture. His painting is restless and eclectic, the influences often ill digested; but he is a conspicuously adventurous colourist while at the same time more ready than Bell or Fry to embrace a wide range of subject matter, from the quotidian to the fantastic. Fry's landscapes of 1912–13 are among his most memorable works, conveying his taste for dramatic viewpoints translated into powerfully schematic form; compared with Grant and Bell (or with the landscapes of Spencer Gore and Harold Gilman), his palette remains relatively subdued, influenced by André Derain and Jean Marchand.

Fry, Grant and Bell were the first members of Bloomsbury to gain a measure of public recognition at this time (though it frequently took the form of abuse); the writers in their circle, Virginia Woolf and Lytton Strachey, for example, had yet to make their mark but the painters left records of them (nos.23, 33) that are key works in the development of English Post-Impressionism.

(*The Voyage Out*, Virginia Woolf's first novel, 1915)

13 *River with Poplars* 1912

Oil on panel 56.5 × 70.8 (22¼ × 27⅞)
*Tate Gallery, London. Presented by Mrs Pamela Diamand, the artist's
daughter 1973*

In October 1911 Fry went to Paris, primarily to see the Salon d'Automne, and then, joined by Clive Bell and Duncan Grant, proceeded to tour by bicycle the countryside around Poitiers and Chauvigny. In between strenuous inspections of romanesque churches and abbeys, Fry made a number of small oil studies and drawings. These were used as the basis for several later paintings after his return to London (e.g. *Chauvigny*, Leeds University Art Collection). No.13 shows the river at Angles-sur-l'Anglin, a picturesque village near Poitiers with a twelfth-century church, ruined castle and wide shallow river. A smaller oil study on board is at Monk's House, Rodmell; almost certainly this was the painting which George Bernard Shaw gave to Virginia Woolf in 1940. Its composition is the same but the heightened colour and more schematised form of no.13 give, in fact, a more vivid apprehension of the scene. Fry made at least three other paintings of Angles-sur-l'Anglin and one was shown at the Second Post-Impressionist Exhibition in 1912 (as no.120), possibly the present work. Some years later Fry included a woodcut of Angles-sur-l'Anglin in his *Twelve Original Woodcuts* (Hogarth Press, 1921). Richard Morphet (who discovered the place depicted in no.13) has written about Fry's landscapes in general, but could easily be referring specifically to *River with Poplars* as 'articulated unusually clearly into horizontally disposed ranks in the foreground, middle ground, distance and sky, the latter occupied by cloud formations, treated as an important element of the picture in their own right' (Morphet 1980, p.487).

Prov: Margery Fry; to P. Diamand by whom presented to the Tate Gallery 1973
Exh: Colchester 1959 (55) and Luton 1960 (55, as *Garsington, Pond and Poplars*, as also at Colchester); *Vision and Design* 1966 (68, repr.)
Lit: *The Tate Gallery 1972–4: Biennial Report*, 1975 (p.137, repr.); Shone 1976 (pl.53); Shone 1993 (pl.65, repr. in reverse, corrected in reprint 1996)

fig.70 View of the river Anglin at Angles-sur-l'Anglin. Photograph by Richard Morphet 1986

14 *Landscape at Asheham* c.1912

Oil on panel 59.5 × 73.5 (23½ × 29)
*Monk's House, Rodmell, The Virginia and Leonard Woolf Collection
(The National Trust)*

Fry stayed with the Bells at Asheham House in August 1912; no.14 was presumably painted on that visit and was either left there or given to the Woolfs soon afterwards. It shows a walled area of grass to one side of the house and the steeply rising bank of trees at the other (out of the picture on the left). Fry's increasingly confident painting is experienced here in the internal rhythms of the trees and their relation to the schematised sky which is echoed in turn by the sharp segment of garden wall on the right – a favourite compositional device of Cézanne. No.14 also reminds us of Fry's (and Bell's) affinities at this moment with Spencer Gore whose Letchworth paintings of late 1912 show a similarly architectonic stylisation and warm colour.

For Asheham House, see nos.22, 24 and 25.

Prov: The artist to L. and V. Woolf; L. Woolf to Trekkie Parsons 1969; to University of Sussex; to National Trust 1980
Exh: Not previously exhibited
Lit: Monk's House, East Sussex, guide, 1987 (no.17)

15 *Farm-buildings, France* 1913

Oil on canvas 65 × 81 (25⅝ × 31⅞)
University of Hull Art Collection

This was almost certainly painted in the autumn of 1913, when Fry spent most of October in the region of Avignon with the French painter Henri Doucet (1883–1915) whom Fry had met in 1911 and who worked at the Omega Workshops in 1913 (see fig.68). Fry's correspondence from this holiday is scanty and what remains is mostly taken up with the defection of Wyndham Lewis from the Omega. He seems to have painted only landscapes including this work, no.16 and *White Road with Farm* (fig.45), as well as a study of a 'wonderful valley Doucet and I have found' which he later used as the basis for a large painted screen for the Omega Workshops. This was Fry's first substantial visit to Provence (he had stopped at Avignon on his honeymoon in 1896), an area he came to know in detail in the years after the First World War and where he eventually bought a house at St Rémy.

The contemporary French influence is most marked in Fry's landscapes of c.1912 to 1915. If Cézanne's shadow hovers in the background, more immediate influences include the younger generation of Derain, André Lhote, Maurice de Vlaminck and Othon Friesz, all of whom had been well represented in the Second Post-Impressionist Exhibition. Vlaminck's *Buzenval*, Lhôte's *Port of Bordeaux* and Friesz's *Composition*, all shown at the Grafton Galleries, provide ample evidence of Fry's assimilation of what was essentially a development from Cézanne, inflected by aspects of Cubism, particularly in the way a design, as Fry wrote in 1911, is held together 'by that insis-

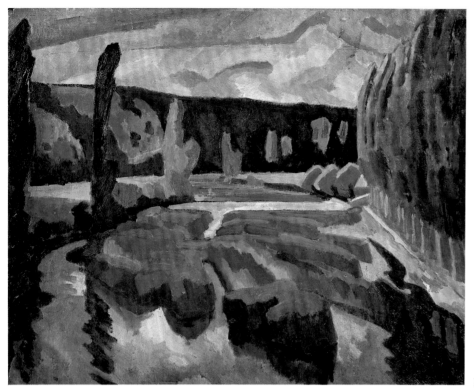

13

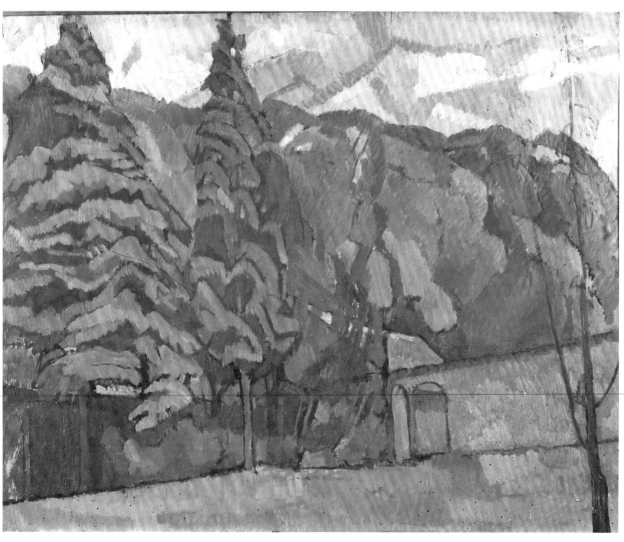

14

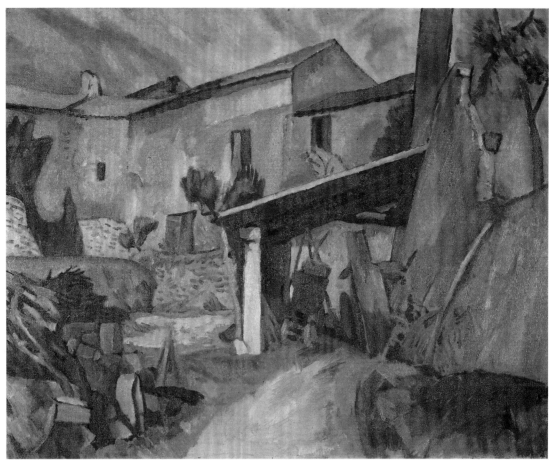

15

16

tence throughout on a single geometric measure of all the forms'. (Fry, 'The Autumn Salon', *Nation*, 11 November 1911, p.236)

Prov: Bt from the artist by his sister Isobel Fry; to P. Diamand by whom presented to University of Hull, 1964
Exh: 2nd GG, 1914 (as *Farmyard*); ACGB 1952 (4, as *French Farm Yard*); Colchester 1959 (49) and Luton 1960 (49, as *Provençal Farmyard*); *Art in Britain 1890–1940*, University of Hull, 1967 (4, repr.)
Lit: Shone 1977 (pl.17)

undemonstrativeness (see his essay 'Claude' of 1907 in *Vision and Design*, 1920) remained the *sine qua non* of the genre, we find him here in a mood of captivating diffidence closer, for example, to the early work of Sisley than to the monolithic statements of Cézanne.

Prov: The artist; Helen Anrep; Adams Gallery from whom purchased by Mayor Gallery 1973; to Belgrave Gallery 1977, where bt by present owner
Exh: *British Paintings*, Mayor Gallery, June 1973 (no cat.); FAS 1976 (53)
Lit: Shone 1976 (pl.54); Shone 1993 (pp.84–5; pl.66)

ROGER FRY

16 *Fort St André, Villeneuve-lès-Avignon* 1913

Oil on canvas 62.3 × 80.7 (24½ × 31¾)
Private Collection

The town of Villeneuve-lès-Avignon lies immediately across the Rhône from Avignon and is dominated by the fourteenth-century stronghold Fort St André. Fry has positioned himself on a quiet road leading out of the town, the Alpilles visible in the background. 'I try to turn my back on the medieval castle and the distant towers of Avignon', he wrote to Duncan Grant, 'but the beastly things will get into my composition somehow or another.' (Fry, *Letters*, 2, 1972, p.373). In this painting, the late afternoon light enmeshing the buildings in soft yellows and pinks, he seems to have faced the fact that, strictures notwithstanding, such architectural subjects drew from him his most personal work. The geometric structuring of the painting is less insistent than in no.15 and there is a more subtle attention to the quality of light. Although for Fry the landscapes of Claude in their purity and

DUNCAN GRANT

17 *Pamela* 1911

Oil on canvas 49.5 × 75.1 (19½ × 29⅝)
Yale Center for British Art, Paul Mellon Fund

This portrait of Roger Fry's daughter Pamela was one of the most popular exhibits in the English section of the Second Post-Impressionist Exhibition. It was warmly commended in the press although some reviewers pointed out that it seemed to belong more to an *intimiste* approach to painting than to a Post-Impressionist one (P.G. Konody in the *Observer* even saying it was 'quite out of place in this gathering', 27 October 1912).

The setting is the recently made rectangular lily pond in the lawn of Fry's new house, Durbins, near Guildford, into which he had moved in late 1909. Fry commissioned Grant and Henri Doucet to paint his daughter (1902–85) at Durbins in June or July 1911. The sitter (later Mrs Diamand) recalled that Grant's work was mainly done during a rest between posing: 'I … had sat down at random by the big pond,

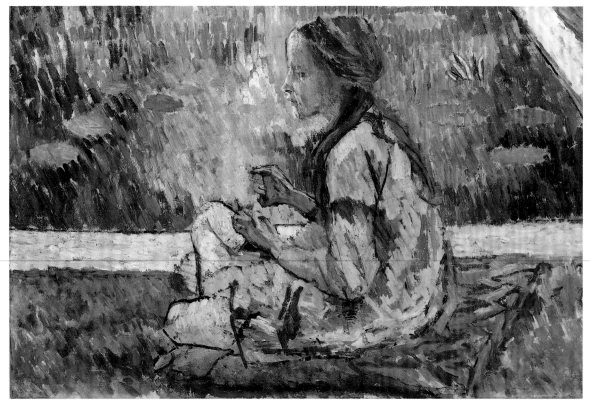

17

with my legs out straight in front of me ... a most tiring position to hold' (Diamand 1985, p.28). Fry was disappointed by Doucet's painting (and possibly by Vanessa Bell's, for Mrs Diamand in later years thought she too was of the party) and acquired Grant's work. The parallel, thick brushstrokes, seen especially on the girl's dress and the pond, combined with the black outline drawing, closely relate to Grant's 1911 style as seen in his mural for Keynes at Cambridge (see no.10). The delicate detail in the painting of the head may owe something to the use of photographs, for Adrian Stephen in a letter to Grant of 14 July 1911 (Charleston Trust) mentions photographs he had taken of Pamela at Durbins for Grant's use.

The painting possibly played an important though obviously unintended role in the modern movement in England. Pamela Diamand related that Grant was two days late in arriving at Durbins to fulfil Fry's commission because he had been unable to raise the train fare from London to Guildford. She felt this may well have contributed to

her father's plans for an organisation that would benefit impecunious artists and was thus instrumental in the founding of the Omega Workshops in early 1913. The lily pond in no.17 was the inspiration for Grant's lily pond design for the Omega used on screens and tabletops (see no.64).

Prov: R. Fry by 1912; P. Diamand; d'Offay from whom bt by Yale Center for British Art 1984
Exh: Second Post-Impressionist Exhibition 1912 (102; lent by Fry); ?*The New Movement in Art*, Royal Birmingham Society of Artists, Birmingham, summer 1917, and Heal's, Mansard Gallery, Oct. 1917 (no.37); Tate 1959 (18); *CTG*, Minories, Colchester, 1961 (33); Rye 1967 (4); ACGB 1969 (11); Edinburgh and Oxford 1975 (4); Fredericton 1977 (2, repr.); *Post Impressionism*, RA, 1979–80 (303, repr.); d'Offay 1984 (42, repr.)
Lit: J. Laver, *Portraits in Oil and Vinegar*, 1925 (p.145); Mortimer 1944 (pl.13); R. Shone 1976 (p.79); Shone, *The Post-Impressionists*, 1979 (pl.190); Spalding 1980 (pl.54); Watney 1980 (p.88, pl.79); P. Diamand, 'Durbins', *Charleston Newsletter*, 10 March 1985 (pp.21–29); Shone 1993 (pl.53)

18

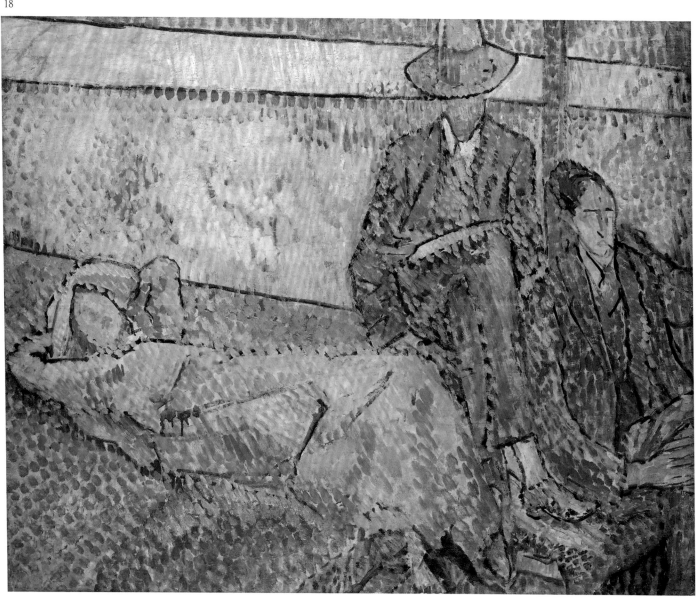

18 *On the Roof, 38 Brunswick Square* 1912

Oil on panel 96.5 × 118.7 (38 × 46¾)
Private Collection

When the lease of her house at 29 Fitzroy Square expired at the end of
1911, Virginia Stephen decided on an experimental plan of communal
living for herself, her brother Adrian and selected friends. She found
38 Brunswick Square, a spacious eighteenth-century house on the
north side of the square (since demolished, the terrace now being
occupied by the Coram Foundation and the University of London).
Accounts differ as to which floors were occupied by whom and when,
but Maynard Keynes (who signed the lease of the house) and Duncan
Grant used the ground floor; Virginia and Adrian Stephen each had
separate floors above and Leonard Woolf, back earlier in the year from
Ceylon, took rooms at the top. The Cambridge economist Gerald
Shove (see no.29) became a lodger in summer 1912.

The house was notable for two striking mural paintings. Duncan
Grant and Frederick Etchells (see no.24) transformed the curved back
wall of the ground-floor sitting room with an extensive street scene
which included a fallen cab horse and an attendant crowd of onlookers.
Upstairs Grant painted for Adrian Stephen a radically simplified ten-
nis game – athletic figures in motion painted in scarcely modelled
colour (mainly red and yellow) and probably inspired by the tennis
games played on a court in Brunswick Square, outside the windows of
number 38 (fig.71). The Grant/Etchells collaboration was at its closest
in 1912 following their work the previous year on the Borough Poly-
technic murals (see no.71).

For some time in the 1950s and 1960s, *On the Roof* was attributed to
Etchells but Grant himself (learning Etchells had refused authorship
when shown a photograph of the painting) eventually agreed it was
his. 'It's extraordinary how indistinguishable they become', Vanessa
Bell commented. 'I suppose their general colour schemes have a great
deal in common' (Bell to Fry, 5 June 1912, TGA).

This painting shows Virginia Stephen, Adrian Stephen and Leonard
Woolf, probably in early summer 1912 on the mezzanine roof at the
back of number 38. (It is worth noting that Virginia Stephen accepted
Leonard Woolf's proposal of marriage on 29 May, about the time no.18
was painted.) Grant's rapid use of mosaic-like patches of colour, fre-
quently overlaying or interrupting his preliminary, drawn lines, sug-
gest both light and movement in this informally posed group of
friends. It is perhaps the last substantial work in which Grant used his
personal adaptation of a pointillist technique.

Prov: The artist; d'Offay by 1970; to present owner 1987
Exh: d'Offay 1975, 2 (no cat.); Edinburgh and Oxford 1975 (9); FAS 1976 (35);
d'Offay 1984 (47); d'Offay 1986 (no cat.); Barcelona 1986 (18; repr.); New York
1987 (125; repr.)
Lit: Shone 1976 (pl.1); Shone 1993 (pl.50)

fig.71 Duncan Grant, *Tennis Players* c.1912,
mural at 38 Brunswick Square (destroyed).
Photo: Tate Gallery Archive

19 *Woman at a Window* c.1912

Oil on canvas 127 × 101.6 (50 × 40)
Inscribed 'D. Grant' b.r. and 'D. Grant' on stretcher, t.r.
Mrs Stanley Berwin

Nothing is known about the inspiration 'for this painting, which has
the title *German Lady looking at the Alps* in Vanessa Bell's 1951 inven-
tory of Grant's paintings stored at Charleston. In 1912 Grant had not
recently been either to Germany or to the Alps; there is a slight possi-
bility the work was based on someone seen on his travels elsewhere,
for example, on his return from Italy to England in 1911. It further
expands the repertory of Grant's subject matter in this period and
belongs to a number of works originating in brief on-the-spot sketch-
es – a man holding a greyhound, a figure throwing slops from a pail,
a carpenter and his assistant in a room in Brunswick Square, a prosti-
tute in a window, revellers at a Post-Impressionist dance. There is a
faint suggestion here of those unmarried, well-to-do female 'compan-
ions' found in E.M. Forster's novels and in Grant's own family. The
upright figure in her yellow coat and blue and green hat stands at an
open window looking across a lake or meadow towards the mountains
which fuse with the sky. Although Grant's pointillist-derived style of
1911–12 is still in evidence, it is used here less emphatically; along
with the obvious exaggerations in the drawing of the figure, this
points to a date in mid-1912.

Prov: The artist; to Crane Kalman Gallery from whom bt by present owner 1973
Exh: Not previously exhibited

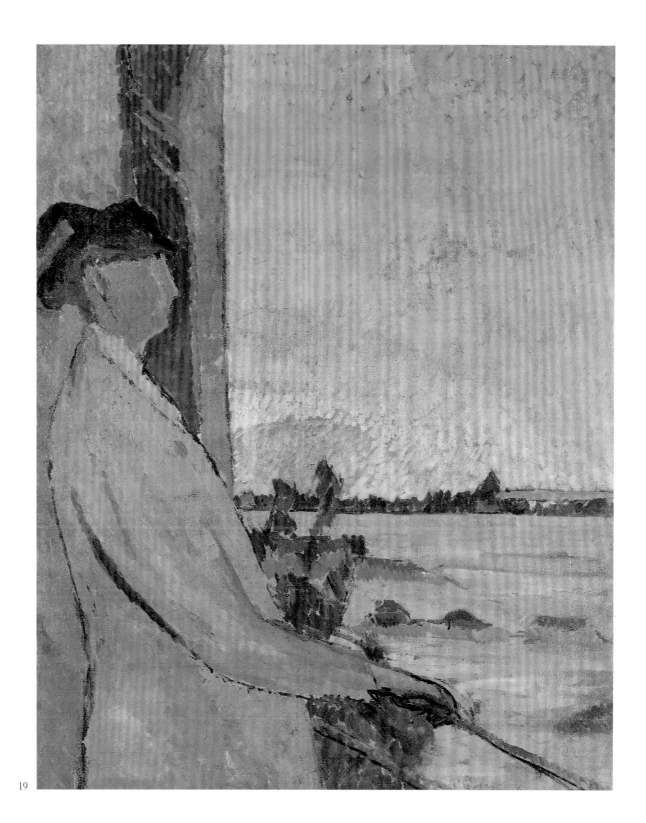

19

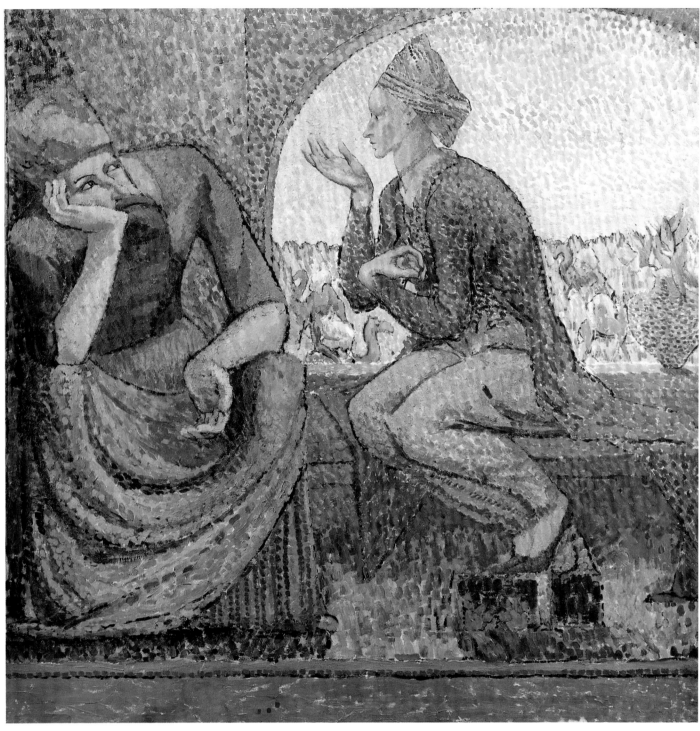

20

20 *The Queen of Sheba* 1912

Oil on board 120 × 120 (47¼ × 47¼)
Tate Gallery, London. Presented by the Contemporary Art Society 1917

This is one of Grant's most celebrated early works in which he fuses brilliant colour, striking design and an engaging subject – the Queen of Sheba finding that King Solomon, on her visit to him in Jerusalem, was even wiser and richer than she had heard. It was included in the Second Post-Impressionist Exhibition and shown several times elsewhere before becoming his first work to enter a public collection. In 1959 (see Tate 1959) Grant suggested it was painted as a proposed mural decoration for a cloister at Newnham College, Cambridge, at the invitation of Jane Harrison, the great classical scholar and lecturer at Newnham. In fact the wall in question was a lecture-room passage (there is no cloister at Newnham) and the proposal, supported by Miss Harrison, came through the 'Committee for the Exhibition of Designs and Mural Painting and Decoration of Schools and other Institutions' on which sat Miss Clough, Miss Tuke, Mr Rackham and Mrs Verrall (Council Minutes, Newnham College, 17 February 1912). Having visited Keynes's rooms at King's to see Grant's mural there of grape-pickers and dancers, Miss Harrison suggested, with advice from Maynard Keynes, that Duncan Grant ('the coming genius' as she referred to him) should submit a design (see Spalding 1997, pp.121–22). In May she urged Grant to send in a design based on a smaller, completed sketch of *The Queen of Sheba* (probably also seen in Keynes's rooms). There was further discussion at Newnham on 11 May 1912 in which a sketch by Mrs Bernard Darwin (Elinor Monsell, a Friday Club exhibitor) was seen and won Council approval and it was noted that Grant's design had been submitted but was unavailable for inspection. Nothing more was heard of the scheme, nor was Elinor Darwin's proposal carried out. Years later Grant recalled that some members of Newnham were against his proposal (Watney 1990, p.85). The earlier oil sketch for no.20, smaller and more freely painted, remained with Keynes but has in recent years gone missing from his collection bequeathed to King's College, Cambridge.

Frances Spalding has suggested two possible sources for the subject matter of no.20, besides the more general inspiration of Piero della Francesca's *Solomon and Sheba* in Arezzo – a performance in London in late 1911 of Goldmark's 1875 opera *The Queen of Sheba* and an obscure episode in Strachey family history. The latter is lent some substance by the legend that Lytton Strachey and his sister Pernel posed for the two figures but there is no evidence for this beyond the fact that Solomon sports a reddish beard (Strachey had recently acquired his), and that Pernel was a tutor at Newnham. It is not impossible, then, that a family joke accounts for the origins of the painting. Grant's experience of North Africa in 1911 was also relevant; photographs he took of camels at Tunis were used for the animals seen here through the arched window. The vein of exoticism in Grant's figurative compositions such as *Idyll* (Charleston Trust), *The Dancers* (no.10), *Lemon Gatherers* (fig.158) and the King's College mural for Keynes, finds its fullest expression in *The Queen of Sheba*, in subject and colour as well as exaggerated gesture (the necks of the camels echoing the hands and arms of Solomon and Sheba). This last was undoubtedly influenced by the revelation of the Russian Ballet, seen by Grant

in their two Covent Garden seasons in 1911 in which *Schéhérazade* and *Le Pavillon d'Armide* thrilled him – the latter was 'more perfect in scenery, clothes, precision and beauty of movement than anything I'd seen' (Grant to author, 21 June 1965). At the same time, there seems a direct link with the Byzantine mosaics in Ravenna, especially the scene of the *Three Wise Men* in Sant'Apollinare Nuovo. Grant would have known this from reproduction: the full impact of the mosaics themselves did not become apparent to him until his visit to Ravenna in spring 1913.

Grant's 'pointillist' phase culminated in *The Queen of Sheba*, the closely woven texture of spots of paint directing the movement within clearly defined contours. These two elements – linear definition and the pulsation of areas of pure, divided colour – began to war with each other and Grant abandoned his method soon afterwards. Here, however, they do not diminish, in Rupert Brooke's words, the 'exquisite wit and invention' of the whole.

Prov: R. Fry; bt CAS 1912; to Tate Gallery 1917
Exh: ? *Exposition de quelques indépendants anglais*, Galerie Barbazanges, Paris, 1912 (no.1); CAS, Cardiff, 1912; Second PIE 1912 (74, repr.); CAS, Sandon Society, Bluecoat Chambers, Liverpool, 1913 (24); CAS exhibition, Goupil Gallery, April 1913 (17); *Twentieth-Century Art*, Whitechapel Art Gallery, 1914 (364); Tate 1959 (24, repr. on cover and poster); Tate 1975 (8)
Lit: *Tate Gallery Illustrations*, 1928 (pl.108); Mary Chamot, *Modern Painting in England*, 1937 (p.48); J. Rothenstein, *The Tate Gallery*, 1962 (p.253); R. Morphet, *British Painting 1919–1945*, 1967, pl.7; Shone 1976 (pl.46); Shone 1977 (pl. 36); Watney 1980 (pl.75); P. Roche, *With Duncan Grant in Southern Turkey*, 1982 (back jacket); Watney 1990 (fig.20); Naylor 1990 (p.86, repr.); Shone 1993 (pl.45); Spalding 1997 (btw. pp.144–5)

VANESSA BELL

21 *Monte Oliveto* 1912

Oil on cardboard 48.5 × 36.2 (19⅛ × 14½)
Inscribed 'VB' (studio stamp) and title on back
Art Gallery of South Australia, Adelaide. South Australia Government Grant 1963

This work belongs to a group of small paintings on board carried out during a visit to Italy in May 1912. Bell was with her husband and Roger Fry; for the early part of the month she was ill with measles and confined to their hotel in Bologna where Fry gave her some coloured papers with which she made mosaic collages. Later they moved to Florence and it was from there the party made a day visit to San Gimignano and nearby Monte Oliveto Maggiore, the great hilltop Benedictine monastery reached by cypress-bordered roads. The view chosen here is the village below, a woman and child pausing by the well. It is almost an exact equivalent of her sister's 1908 Italian diary describing 'the brown and grey landscape ... curved vineyards, groves of olives ... the ground is singularly bare, and stony ... trees now green, now black against the sky, are full of lines' (V. Woolf, *A Passionate Apprentice*, 1990, p.393). Although Bell's palette in no.21 and other works (see fig.72) from this holiday remains relatively subdued, she displays a more radical sense of form than hitherto, introduces an emphatic vertical at the edge of her painting (a continuing stylistic hallmark) and organises it on a schematic basis, eliminating detail and

fig.72 Vanessa Bell, *Haystacks in Italy* 1912, oil on board 34.1 × 24.1 cm. Private Collection on loan to Charleston Trust

the subtle effects of illumination which were characteristic of her earlier work. A number of studies, in oil on card, have survived from this Italian visit: two are at Monk's House, Rodmell, one of Siena is in a private collection, two of a Tuscan town were in d'Offay 1973 (5 and 6) and a landscape near Pisa (fig.72) is at Charleston. Years later, Roger Fry wrote to Bell, remembering the holiday: 'Do you remember Pisa and our excursion to S. Piero a Grado where you painted a haystack and I a romanesque church (symbolic I suspect)?' (RF to VB, 17 May 1930 from Italy; TGA). While Fry had no hesitation in tackling tourist sites and picturesque views, Bell generally eschewed them, choosing modest even featureless subjects through which she conveyed her response to mood, local colour and sense of place.

Prov: Artist's estate to A.V. Garnett from whom bt by Art Gallery of South Australia 1963
Exh: AAA 1912 (800, priced at £10); Adams 1961 (5); *Bohemian London: Camden Town and Bloomsbury Paintings in Adelaide*, Art Gallery of South Australia, Adelaide 1997 (3, repr.)
Lit: Bulletin of the National Gallery of South Australia, 25, no.3, 1964 (pp.2–3)

VANESSA BELL

22 *Conversation at Asheham House* 1912

Oil on board 67.5 × 80 (26⅝ × 31½)
Inscribed 'Galerie Barbazanges … par Vanessa Bell (Mme)' on back in ? R. Fry's hand
University of Hull Art Collection

The setting of this conversation piece presents a problem. It was long thought to have been painted at Asheham, Virginia Stephen's rented country house near Lewes, but a similarly early work with the same dimensions is listed in Vanessa Bell's 1951 inventory of her paintings as *Group at Little Talland House*. Little Talland was a semi-detached red-brick house in the main street of Firle village which Virginia Stephen rented from January 1911 to January 1912 before she took a lease of the larger and more isolated Asheham House a few miles west of Firle. It is possible that, forty years later, Bell confused the location of her painting. The evidence for its being Asheham, besides Grant's statement to that effect (exh. cat., Hull 1967), is supported by the fact

that there appears to have been no weekend party at Little Talland with the cast as shown here – the painter's brother Adrian Stephen on the left, her future brother-in-law Leonard Woolf and her husband Clive Bell (part visible, in blue socks) – as well as the artist herself. Such a grouping, however, was possible at Asheham between 9 and 11 February and again between 24 and 26 February 1912. But a report from the present occupant of Little Talland House (to the author, 1 July 1998) shows that the front first-floor room (almost certainly designed as a sitting room rather than a bedroom) contains features that exactly correspond to no.22 whereas an inspection of Asheham House, before its demolition in 1995, showed no such possible arrangement of fireplace and alcove.

No.22 is one of several paintings of casually grouped figures from this period, including *The Bathers* (private collection), *The Post-Impressionist Ball* (private collection), the Asheham interior with Frederick and Jessie Etchells (no.24) and *Street-Corner Conversation* (1913, private collection). Duncan Grant later wrote of Bell's work at this period, 'it amused her to take things as they came', in reference to

the figure of Clive Bell cut at the edge of the board, his head reflected in the overmantel mirror. Here she has swiftly encapsulated a typical Bloomsbury gathering of friends among startlingly vivid loose-covered chairs: the impact of Post-Impressionism was beginning to take effect beyond the canvas.

Prov: Bt from artist's estate by University of Hull 1966
Exh: ?*Exposition de quelques indépendants anglais*, Galerie Barbazanges, Paris, 1912; ACGB 1964 (9); *Art in Britain 1890–1940*, University of Hull, 1967 (1, repr.); *Post-Impressionism*, RA 1979–80 (275, repr.); Canterbury 1983 (13); *The Friday Club 1905–1922*, Michael Parkin Gallery, 1996 (6, repr. on cat. cover)
Lit: Watney 1980 (p.82, pl.71); Shone 1993 (frontispiece); *A Bloomsbury Group Reader*, ed. S.P. Rosenbaum, 1993 (repr. on cover)

22

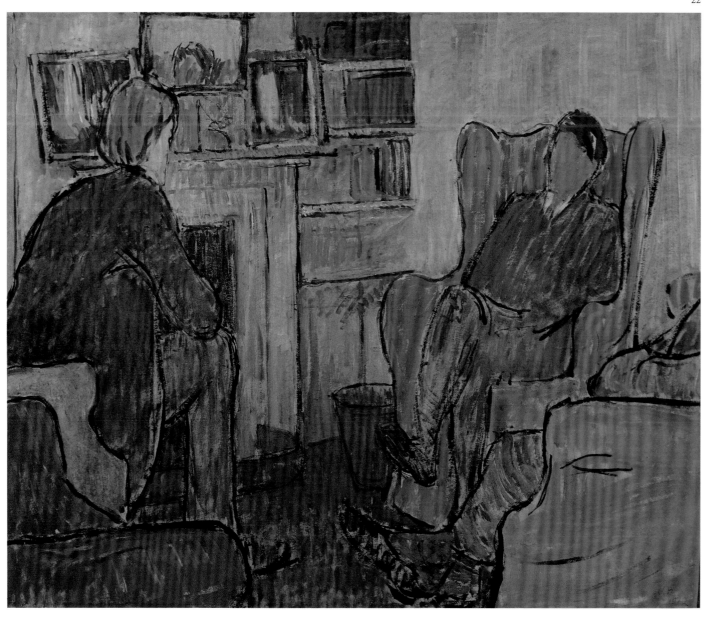

23 *Virginia Woolf* c.1911–12

Oil on canvas 40 × 34 (15¾ × 13⅜)
National Portrait Gallery, London

Four early portraits of Virginia Woolf by her sister are known – this one and no.32, one now at Monk's House, Rodmell (National Trust) and an oil sketch in a private collection. All were painted between late 1911 and mid-1912, when the sitter was still Virginia Stephen at either Little Talland House, Firle, or Asheham House (see no.22). Although the National Trust painting is the only one of the four that attempts a detailed likeness, all are revealing. This one shows a moment of quiet intimacy between the sisters, Virginia either sewing or crocheting, Vanessa working indoors on a small board which was probably propped on the seat of a wooden chair – there was no studio at Little Talland House where no.23 was probably painted (compare the orange loose cover and wall colour with no.22). Bell is already moving towards the linear simplifications, absence of detail and firm colour contrasts of works such as *Studland Beach* (no.26) painted some months later.

In 1911–12, Virginia Stephen was working on her first novel *Melymbrosia*, published as *The Voyage Out* in 1915, and writing regularly for the *Times Literary Supplement*. She was already aware of Leonard Woolf's feelings for her, which were to lead to their marriage in August 1912. It was also at this time that Virginia Woolf began to take a sharper interest in contemporary painting as a result of her frequent visits to Friday Club meetings and her guarded pleasure in the First Post-Impressionist Exhibition in late 1910. But, as a writer, she soon began to feel upstaged by the conspicuous success of the painters and critics in her circle and the ousting of literary discussion in favour of art-talk whenever she and her friends met. By late 1912 she had become impatient with the 'furious excitement of these people all the winter over their pieces of canvas coloured green and blue' (V. Woolf to

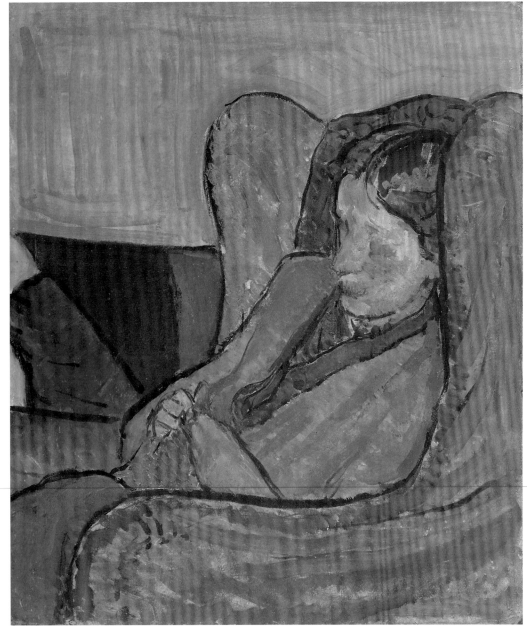

23

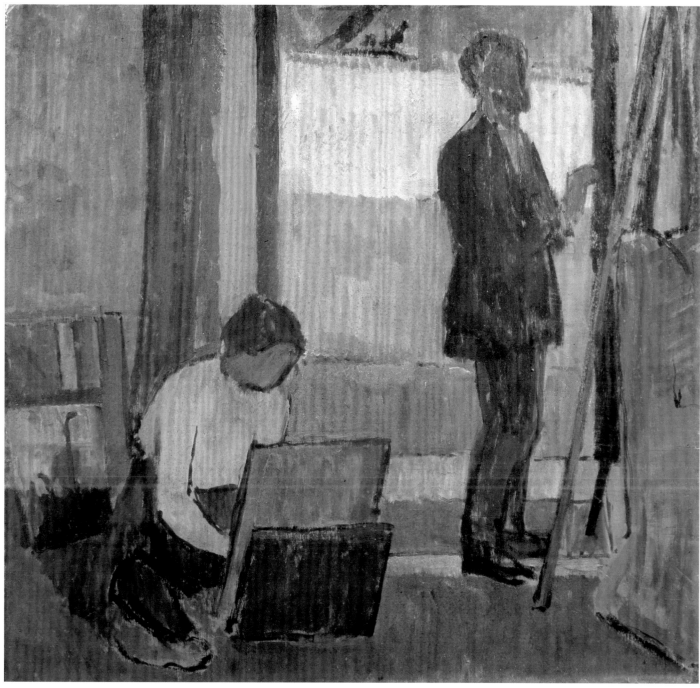

24

Violet Dickinson, *Letters*, 2, p.15, 24 December 1912). Nevertheless, the new painting and her aesthetic discussions with Roger Fry had a profound impact on her writing, although this was only to emerge later in the decade.

Prov: The artist to Leonard Woolf; by whom bequeathed to Trekkie Parsons 1969; to d'Offay, from whom bt 1987
Exh: ACGB 1964 (10); Barcelona 1986 (1); Barbican 1997 (6; repr. p.89); *The Sitwells*, NPG, 1994 (no.2.46, repr.)
Lit: Shone 1976 (pl.59); R. Shone, 'Virginia Woolf by Vanessa Bell', *Art at Auction*, Sotheby's, 1985 (pp.58–62); 'Acquisitions', *NACF Review*, 1988 (p.119, repr.); J. Hayes, *The Portrait in British Art*, NPG, 1991 (pl.61; p.158); Naylor 1990 (p.83, repr.); Shone 1993 (pl.57)

VANESSA BELL

24 *Frederick and Jessie Etchells Painting* 1912

Oil on board 51 × 53 (20⅛ × 20⅞)
Inscribed with monogram 'VB' b.l.
Tate Gallery, London. Purchased 1971

The setting is a room at Asheham House in a single-storey 'pavilion' attached to the south side of the house (and matched by another on the north); this room, curved at one end with French windows opening onto a narrow terrace and lawn edged by a typical Sussex flint wall, served as a light, spacious studio from 1912 to 1914 (fig.74). During Bell's two-month stay at Asheham in late summer 1912 (see no.25) she

fig.73 Frederick and Jessie Etchells at Asheham, 1912, photographed by Vanessa Bell. Tate Gallery Archive

fig.74 Interior view of studio at Asheham prior to demolition in 1995. Photograph by the author

managed, in spite of the distraction of her children and many visitors, a sustained period of painting.

Among her guests were Frederick Etchells (1886–1973) and his sister Jessie (1893–1933), both painters, who stayed at Asheham from 28 August to 4 September. Etchells, who had studied at the Royal College of Art, had come to know the Bloomsbury painters in early 1911. He collaborated on the Borough Polytechnic murals (see no.71) and in 1911–12 worked closely alongside Duncan Grant; together they painted a large mural for Adrian and Virginia Stephen at 38 Brunswick Square (see no.18 and Shone 1993, pl.51) and in 1913 Etchells made a significant contribution to the Omega Workshops, where his sister also worked. Taking Wyndham Lewis's side against Fry, Etchells left the Omega and his brief but important liaison with Bloomsbury was over. He later practised as an architect from the 1920s onwards, translated books by Le Corbusier and became a noted expert on ecclesiastical architecture. His sister showed, along with her brother, at the Friday Club and in the Second Post-Impressionist Exhibition; there are two paintings by her (as also there are two by her brother) at Charleston and a still life in Rochdale Art Gallery. She left the Omega in late 1914 and married David Leacock the following year in Canada. She made a brief return to the Omega in 1916. She was, wrote Vanessa Bell, 'a nice character … and very silent'. Etchells made a less favourable personal impression: Molly McCarthy, the wife of Desmond McCarthy, found him 'dirty and dull'; 'dull and uncouth' was Clive Bell's opinion (though he admired his painting). Bell herself found the visit a strain and there is perhaps a tinge of unconscious sympathy in her portrayal of Jessie, who makes do with working on the floor in contrast to her brother, who has appropriated an easel. When no.24 was catalogued for the Tate Gallery, Etchells wrote to the compiler: 'It is startling to come across so authentic a representation of oneself at a so much younger period, and Jessie is equally true to one's recollection' (Tate 1970–72, p.81).

Although the painting has all the appearance of having been carried out with swift spontaneity, alterations were made as Bell worked on it: for example, at first the French doors were closed, the overpainted vertical visible immediately to the left of Etchells's figure. It is possible that Jessie's facial features were initially indicated but, as Duncan Grant commented (Tate 1970–72, p.81), Bell 'purposely avoided very often any definition'. Her reductive treatment of the view through the doorway is characteristic (see no.4), showing (from bottom to top) stone step, red-tiled terrace, grass, wall and elm trees beyond. Inside, the scene is subdued in colour, the high notes being the orange and purple-bordered curtain (made by Bell), Jessie Etchells's red stocking and the warm tones of the section of armchair on the right. The painting is imbued with a sense of contented release as well as communal purpose on the eve of the Second Post-Impressionist Exhibition.

Photographs of the Etchellses at Asheham are in the Tate Gallery Archive (fig.73); a photograph reproduced in Nina Hamnett's *Laughing Torso*, 1932, p.67, shows Etchells in similar three-quarter profile as in no.24, standing near Amedeo Modigliani at a Paris fancy-dress dance.

Prov: A.V. Garnett; d'Offay Couper Gallery from whom bt by Tate Gallery, London 1971
Exh: Crafts Council 1984 (p.18); Liverpool 1996–7 (1, repr.; pp.6–8)
Lit: Tate Report 1970–72, 972 (p.81); Shone 1976 (pl.43; p.77); Watney 1980 (pl.70, p.82); Naylor 1990 (p.104); Shone 1993 (pl.54); R. Shone, 'Asheham House', *Charleston Magazine*, 9, Spring/Summer 1994 (pp.36–40, repr.)

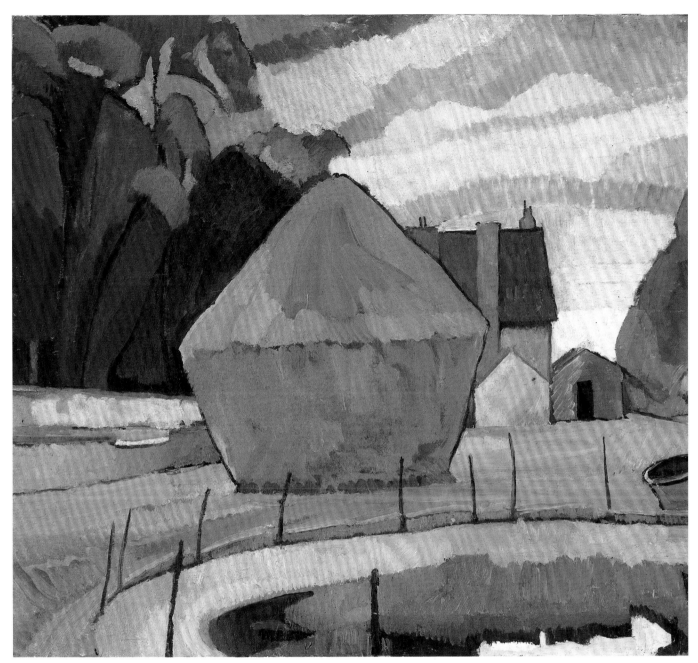

25

fig.75 Haystack at Asheham, 1916, photographed by Barbara Bagenal. Alison Bagenal

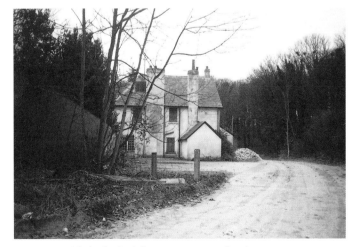

fig.76 View of the back of Asheham House prior to demolition in 1995. Photograph by the author

25 *The Haystack, Asheham* 1912

Oil on board 60.3 × 65.7 (23¾ × 25⅞)
Smith College Museum of Art, Northampton, Massachusetts. Gift of Anne Holden Kieckhefer (class of 1952) in honor of Ruth Chandler Holden (class of 1926), 1989

Vanessa Bell stayed at Asheham House from mid-August to mid-October 1912 while her sister Virginia (who leased the house) was on a prolonged honeymoon abroad with Leonard Woolf. Portraits, interiors with figures, still lifes and landscapes were painted in quick succession and two, at least, of her four exhibits at the second Post-Impressionist Exhibition (which opened on 5 October that year) were the fruit of these two months in the country. Although her palette remained relatively muted (the ascendancy of primary colour came early in 1913) there is a notable increase in formal simplification, the scarcely modelled colour contained in succinctly drawn contours. Most of the Asheham paintings are on lightly primed board and the application of thinned paint on this absorbent surface gives an internal rhythm to the flat areas of colour.

In no.25 Bell's viewpoint is taken from the farmyard behind Asheham House near to a rough track that continued into a hollow in the hill at the back of the house. Typically, her principal subject is a conical corn stack, its form echoed in the dark tree to the left and the two small extensions to the house, on the right. The chief colours of the painting are brought together in the reflections in the farm pond in the foreground. Earlier in the year Bell had painted a similarly shaped haystack while in Italy (fig.72). From then onwards rural buildings such as barns and outhouses, as well as corn stacks, augmented her range of subject matter, not in order to record this particular aspect of country living but because, as here, the often utilitarian and unadorned shapes satisfied formal criteria. It is to this work, presumably, that Bell refers when she tells Roger Fry that 'yesterday I began another slightly higher painting of the corn stack' (Bell to Fry, 4 September 1912; TGA). Photographs (fig.75) taken in 1916 show a corn stack prominent at the back of the house. Two such stacks also appear in a drawing of Asheham by Dora Carrington in a letter to Lytton Strachey, 29 January 1917 (*Carrington. Letters and Extracts from her Diaries*, ed. D. Garnett, 1979, p.54).

Prov: A.V. Garnett; d'Offay; Anne Holden Kieckhefer to present collection 1989
Exh: ACGB 1964 (12); Bristol 1966 (78); Rye 1967 (18); New York 1980 (12); *Landscape in Britain 1850–1950*, Hayward Gallery, London, and ACGB tour 1983 (no.134, repr.); Barcelona 1986 (13, repr.); *100 Years of Art in Britain*, Leeds City Art Gallery, 1988–9 (25, repr.)
Lit: Spalding 1983 (repr. btw. pp.80–1)

26 *Studland Beach* c.1912

Oil on canvas 76.2 × 101.2 (30 × 40)
Verso: oil sketch of 3 male nude figures by D. Grant
Tate Gallery, London. Purchased 1976

Studland Beach is the masterpiece of Bell's early period: in its radical formal simplification through suppression of detail and minimal modelling of discrete areas of colour, it is an outstanding contribution to modernism in Britain.

With a changing cast of family and friends, Bell made at least four visits to Studland on the Dorset coast (see no.2): in September–October 1909; March–April 1910; September–October 1910; and September 1911. Although there is some evidence (see Tate 1979) that there was a further visit, no written or photographic documentation exists whereas all the other visits are well recorded. There are five extant paintings of the beach and coastline: a small dark study of the bay belongs to c.1909 (Sotheby's 6 February 1985, 419, repr.); secondly, an initial oil sketch for no.26 (fig.77) almost certainly belongs to September 1911 – it compares in size, support and style to a portrait of Lytton Strachey at Studland of 1911 (wrongly dated 1912 in Shone 1993, pl.33) and a third view of Studland Bay of c.1911 (Sotheby's 22 November 1995, 20, repr.). A large painting of eleven figures on the beach, *The Bathers* (private collection), was also most likely begun on the same visit and finished later that year in London: indebted to the example of Maurice Denis and Gauguin (see Spalding 1983, p.100, and Barbican 1997, p.104), the work is ambitious but unresolved. The smaller, simpler sketch of September 1911, with its fluid drawing of wet on wet, was then taken up, perhaps in early or mid-summer 1912 in London, as the basis for the present work. It shows considerable advance on Bell's *Nursery Tea* of early June 1912 (fig.37) in which she attempted 'to paint as if I were mosaicing – not by painting in spots but by considering the picture as patches each of which has to be filled by the definite space of colour' (Bell to Fry, 5 June 1912, TGA). No.26 fuses contemporary subject matter (the two foreground figures are almost certainly Bell's son Julian and his nurse Mabel Selwood) with, as Lisa Tickner has previously argued, the distilled memories of Bell's own childhood holidays in St Ives centered on her mother. At the same time, Bell's caressing vision of women and children is presented in a setting of extreme spatial simplicity and restricted colour. The resulting impression of other-worldliness is embodied in the standing woman by the bathing hut, gazing at a horizonless sea.

Prov: Artist's estate; d'Offay to private collection 1973; d'Offay from whom bt 1976
Exh: d'Offay 1973 (4, repr.); Barbican 1997 (4, repr.)
Lit: Shone 1976 (pl.40); Shone 1977 (pl.16); *Tate Gallery 1976–8: Illustrated Catalogue of Acquisitions*, 1979 (pp.32–3 repr.); Watney 1980 (pl.66, pp.81–2); Spalding 1983 (repr. btw. pp.80–1); F. Spalding, *British Art Since 1900*, 1986 (pl.25); Naylor 1990 (p.105); Shone 1993 (pl.55); Marler 1993 (pl.VIII); L.Tickner, 'Vanessa Bell: *Studland Beach*, Domesticity, and "Significant Form"', *Representations*, 65, Winter 1999 (pp.63–92 repr.)

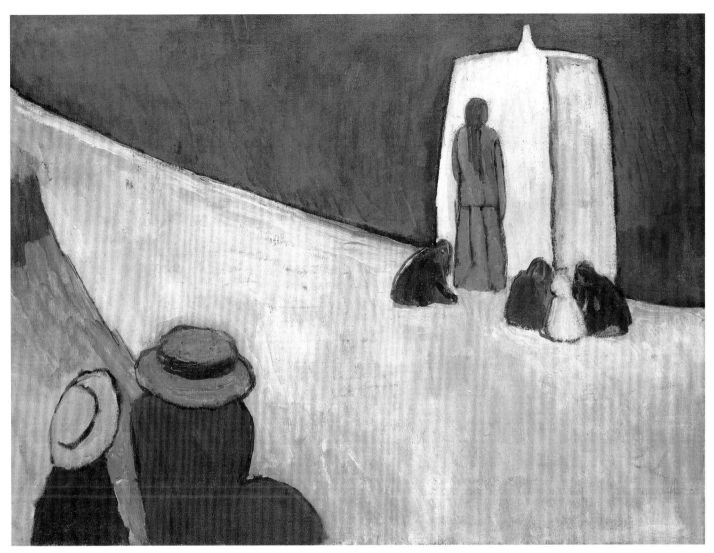

26

fig.77 Vanessa Bell, Study for *Studland Beach* 1911, oil on board
25.4 × 34.5 cm. Private Collection

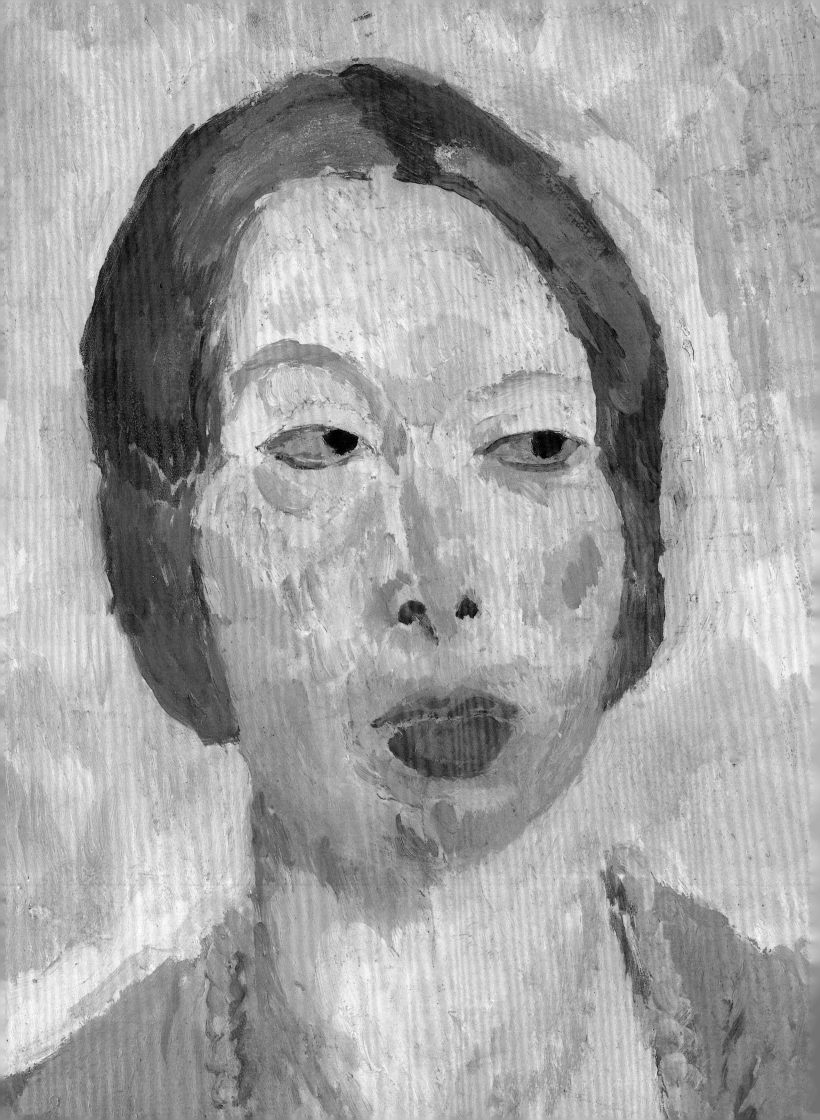

Essays in Biography

Portraits 1910–25

Portraiture of an informal, non-commissioned kind runs through the work of the Bloomsbury artists. Several early paintings such as Fry's *Edward Carpenter* (NPG), Bell's *Lady Robert Cecil* (private collection) and Grant's *James Strachey* (no.8), though they impart convincing likenesses of their subjects, are essentially figures in interiors; this remained their favoured convention. In 1912–15 Grant and Bell (sometimes joined by Fry) frequently painted the same model – Iris Tree, Henri Doucet, Mary Hutchinson or Lytton Strachey, for example. Vivid personal presence characterises the best of these; sittings were friendly and informal and a likeness was not always a prime requirement. Bell, for example, sometimes left her sitter's face nearly or completely devoid of features (no.32). Grant often concentrated on the whole figure, a freely imaginative response to the sitter but which nevertheless, touches on an essential element in their look or attitude – Pamela Fry's self-restraint (no.17), David Garnett's bullish attractions (no.37) or Katherine Cox's reliable amplitude (no.30). Bell is invariably witty, even teetering on the edge of caricature (no.35). Until *c.*1911–12 portraiture played a minor role in Fry's output but it came to mean more to him during the First World War when the human contact of painting someone was invaluable to him. His sitters included Nina Hamnett (see no.173), Iris Tree (no.40) and her sister Viola, Edith Sitwell (no.41), Lalla Vandervelde, Maynard Keynes and André Gide (fig.88).

Grant's long series of portraits of Vanessa Bell began in 1911 (no.158) and continued until shortly before her death in 1961. Most depict her in lapidary repose (no.115) or reverie (fig.78). The small painting of Bell wearing an exotic sunhat (no.39) is one of Grant's most compact and eloquent images of her, epitomising the intimacy of the two painters who from 1914–15 spent the rest of their lives together.

Bloomsbury portraiture, unpompous, unrhetorical, relaxed in mood, embodies the importance the painters attached to personal relationships and their essentially pacific if not always uncritical view of their fellow human beings.

(*Essays in Biography* by John Maynard Keynes, 1933)

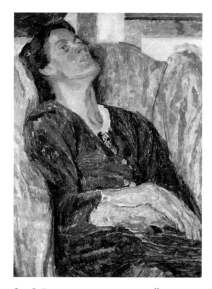

fig.78 Duncan Grant, *Vanessa Bell at Eleanor* 1915, oil on canvas 76 × 55.9 cm. Yale Center for British Art, New Haven

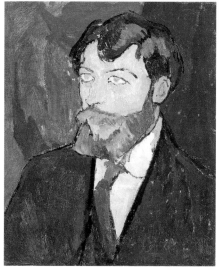

fig.79 Vanessa Bell, *Henri Doucet* 1912, oil on board 41.6 × 34.6 cm. Private Collection

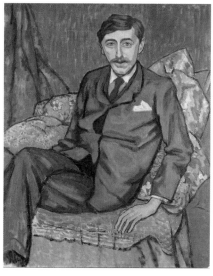

fig.80 Roger Fry, *E.M. Forster* 1911, oil on canvas 72.4 × 59.7 cm. Private Collection

opposite detail from Vanessa Bell, *Mrs St John Hutchinson* 1915 (no.35)

27 *Self-Portrait in a Turban* c.1909–10

> Oil on panel 27 × 19.5 (10⅝ × 7⅝)
> *The Charleston Trust*

This self-portrait has been variously dated to between 1909 and 1911; on stylistic grounds the earlier date is convincing. It belongs to a group of youthful self portraits, such as one of *c.*1908 in the National Portrait Gallery, and another of 1910 also at Charleston (fig.31). No.27 is the most intimate and direct; it shows the painter at the age of about twenty-four and is one of his first works to include exotic or unusual headwear. In February 1910 Grant wore a turban for his role in the celebrated Dreadnought Hoax when he, Virginia and Adrian Stephen and others dressed up as the Emperor of Abyssinia and his suite and visited, without detection, HMS *Dreadnought* anchored in Weymouth Bay. Grant's personal attractions as a young man were widely commented on and by no one more enthusiastically than his cousin Lytton Strachey who wrote to Leonard Woolf in 1905: 'His face is outspoken, bold … the full aquiline type, with frank gray-blue eyes, and incomparably lascivious lips' (Holroyd 1967, 1, p.262). Although Grant was not unaware of his physical charms (and D.H. Lawrence later characterised him in *Lady Chatterley's Lover* as having 'a weird Celtic conceit of himself'), he was quite without personal vanity, often appearing in a grotesque assortment of other people's cast-off clothes.

Prov: V. Bell to A.V. Garnett 1961; F. Garnett from whom bt by Charleston Trust 1996
Exh: *Painter's Progress*, Whitechapel Art Gallery, 1950 (2); Tate 1959 (13, pl.1); ACGB 1969 (10); Tate 1975 (A)
Lit: Mortimer 1944 (pl.32); Watney 1990 (pl.2); Shone 1993 (pl.17); *National Art Collections Fund Review*, 1996 (no.4295, p.98, repr.)

27

28 *Adrian Stephen* c.1910

> Oil on panel 34.4 × 25.5 (13½ × 10)
> Inscribed 'Adrian Stephen by D. Grant about 1910' on back in the artist's hand
> *The Charleston Trust*

Adrian Leslie Stephen (1887–1948) was the fourth and last child of Leslie and Julia Stephen and was the model for the young, patricidal James Ramsay in his sister's novel *To the Lighthouse* (1927). Overshadowed in his youth by his older brother Thoby (and especially after the latter's premature death in 1906), Adrian's life after going down from Trinity College, Cambridge, was spent with his sister Virginia with whom he had a volatile, uneasy but close relationship. They lived at 21 Fitzroy Square, as he searched for a suitable profession, considering both the law and the stage. By turns high-spirited and humorous and listlessly depressed, and growing to an immense height, Adrian was stirred from his torpor by a love affair with Duncan Grant which lasted from 1909 to *c.*1912. It proved to be his one affair with a man (his escapades with women are detailed in his letters to Grant) and in 1914 his natural uxoriousness led to his marriage to Karin Costelloe, a

fig.81 Adrian and Karin Stephen at about the time of their marriage in 1914. Tate Gallery Archive

young Newnham graduate and step-daughter of Bernard Berenson (fig.81). Along with his brilliant, deaf, socially unsettled wife, he took a degree in medicine in order to practise as a Freudian psychoanalyst and in 1925 became a member of the British Psychoanalytical Society. Although he remained geographically in Bloomsbury (and had consulting rooms in Gordon Square), he gradually withdrew socially although he remained on intimate terms with Duncan Grant and in touch with his sister Vanessa whom he visited at Charleston in later years. He once told Grant he had read none of Virginia's books.

There are four extant portraits of Stephen by Grant from the period 1910–12. A head and shoulders (without hat) is at Charleston, an earlier three-quarter length in profile was on the London art market in 1996 and a seated, 'pointillist' portrait of late 1911 is in the sitter's family (and is the frontispiece to Stephen's biography *There's the Lighthouse* by Jean MacGibbon, 1997, which also reproduces a drawing of the young Adrian by G.F. Watts). Grant catches Stephen's frank, unsuspicious gaze as well as the marked family likeness with his sister Virginia (see no.12). The delicate greens, blues and mauve-pinks of the face suggest a date of late 1910 and can be compared to Grant's self-portrait in *Study for Composition* (no.9).

Prov: The artist; A.V. Garnett; to Charleston Trust 1984
Exh: Wildenstein 1964 (16); ACGB 1969 (5)
Lit: Shone 1976 (pl.25, p.57); Shone 1993 (pl.42 and cover)

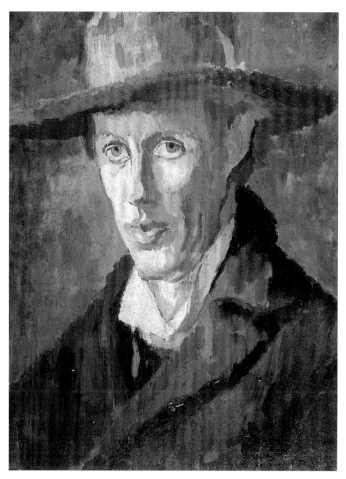

28

DUNCAN GRANT

29 *Gerald Shove* 1911

Oil on canvas 28.5 × 28.7 (11⅛ × 11⅜)
The Provost and Scholars of King's College, Cambridge

Gerald Frank Shove (1887–1947) was at King's College, Cambridge, 1907–10 and was introduced into Bloomsbury by Maynard Keynes. He had rooms in 38 Brunswick Square (see no.18) from July 1912 as a tenant of Virginia and Adrian Stephen. After a period of homosexual dalliance, he married Fredegond Maitland, a cousin of the Stephens, in 1915, and as a confirmed pacifist, he worked as an agricultural labourer during the First World War, mainly at Garsington Manor, Oxford. Later he became a fellow of King's and Reader in Economics. His obituary in *The Times* mentions his 'rock-like integrity of mind and character' and refers to him as of a 'severe' and 'passionate disposition', a superb teacher and an active, valued member of the university. His friendships in Bloomsbury (save with Maynard Keynes) petered out after about 1920.

Although previously dated to 1912 or 1913, no.29 was painted in Cambridge in summer 1911 (letter from Adrian Stephen to Grant, 9 June 1911, Charleston Trust Archives). Grant's familiarity with earlier Italian renaissance portraiture, particularly of heads seen from slightly below as in Mantegna and Piero, informs this and other portraits of the period. An unfinished oil sketch of Shove reading outside a tent (1913) is in a London private collection.

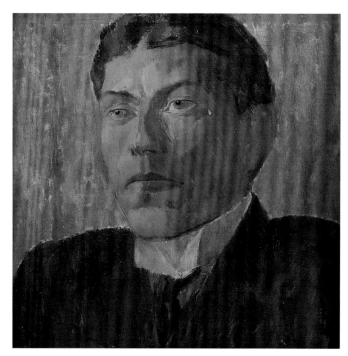

29

Prov: J.M. Keynes by whom bequeathed 1947
Exh: *French and English Paintings*, Miller's, Lewes, 1943 (21); Tate 1959 (27); ACGB 1969 (13); Cambridge 1983 (24, repr.); on loan to Charleston, 1995 season

30 *Katherine Cox* 1912

Oil on canvas 73.7 × 59.7 (29 × 23½)
Inscribed 'D. Grant Portrait of Ka Cox' on back in Grant's hand
Private Collection

Katherine ('Ka') Cox (1887–1938), the daughter of a stockbroker with literary and socialist interests, was educated at Newnham College, Cambridge, where she became an ardent Fabian. She was squarely and amply built, short-sighted and dressed unconventionally: 'She chose bright pure colours for her clothes; wore a coloured handkerchief round her hair … an individual looking woman; derived partly from a John painting' (V. Woolf, *Diary*, 5, 1984, pp.143–4). She was also practical, kind, natural in manner and consoling in a crisis: 'To be with her was like sitting in a green field of clover' (Frances Cornford quoted in C. Hassall, *Rupert Brooke*, 1964, p.271). Cox was an essential ingredient of the Neo-Pagans (Brooke, Frances and Francis Cornford, Gwen and Jacques Raverat, the four Olivier sisters) and for several years from early 1911 was a close friend of Virginia Woolf, Duncan Grant and Maynard Keynes. Her love affair with Rupert Brooke ended in 1912 with her refusal to marry him. In 1918 she married Will Arnold-Forster (1885–1951), a painter, and went to live in Cornwall where she became a pillar of local life.

Duncan Grant met Ka Cox in 1911 and painted her on several occasions. There are two open-air studies made at Grantchester (1911), the *Seated Woman* of 1912 (shown at the Second Post-Impressionist Exhibition; Fry Collection, Courtauld Gallery), and a head-and-shoulders made as a study for both no.30 and its remarkably similar second version (National Museum of Wales, Cardiff). Mention of a portrait of Ka Cox by Grant occurs in a letter of mid-1911 from Rupert Brooke to the sitter; but this date is stylistically incompatible with no.30 which belongs to mid-1912 (Ka Cox to D. Grant, 26 March 1912, refers to sit-

fig.82 Katherine Cox, Asheham, 1912, photographed by
Vanessa Bell. Charleston Trust

tings but most likely for the *Seated Woman*; Duncan Grant Papers). The Cardiff version was dated 1913 in 1964 but in notes made in 1959 Grant lists both paintings as 1912 and painted at Brunswick Square. Cox appears to be seated against a red screen, her clothes echoing Virginia Woolf's description, quoted above. This is one of Grant's strongest portraits from this early period, its brilliant colour and formal consolidation deployed with a confidence lacking from paintings of even a few months before.

In the spirit of the Neo-Pagans, Ka Cox was a willing nude model for both camera (fig.82) and brush.

Prov: The artist; bt from Wildenstein by present owner 1964
Exh: Wildenstein 1964 (ex cat.)

31 *Lady Ottoline Morrell* 1913

Oil on panel 83.2 × 64.1 (32¾ × 25¼)
Inscribed 'D Grant –/13' t.r. (late inscription in Grant's hand)
Private Collection

Lady Ottoline Morrell (1870–1938) was one of the most celebrated hostesses of the early decades of the twentieth century. Although there was often a political element to her entertaining, she was conspicuous for her encouragement of writers and painters. She was born Lady Ottoline Cavendish-Bentinck, the half-sister of the 6th Duke of Portland, and in 1902 married Philip Morrell, a Liberal MP. In London, she entertained at 44 Bedford Square, from 1915 to 1927 at Garsington Manor, near Oxford, and afterwards at 10 Gower Street; over the years her guests included Nijinsky, T.S. Eliot, W.B. Yeats, Picasso and Charlie Chaplin. Although the Morrells remained a devoted couple, Lady Ottoline engaged in a succession of love affairs with, among others, Augustus John, Henry Lamb and Bertrand Russell. Her romantic sensibility and religious yearnings disqualified her from becoming closely integrated within the Bloomsbury circle although she knew all its members, their friendship strengthened through the Morrells' unequivocal support of conscientious objectors in the First World War. Her meddlesome interventions and sometimes imperious manner allied to her unforgettable looks and a high-handed disregard for contemporary fashion made her the frequent butt of ridicule, most spectacularly expressed in print in D.H. Lawrence's *Women in Love* (1920) and Aldous Huxley's *Chrome Yellow* (1921) and, privately, in waspish Bloomsbury letters. She was a significant patron of painters such as Mark Gertler, Stanley Spencer, Augustus John and Henry Lamb; the Contemporary Art Society held its first meeting in her house in 1910; and she supported the Omega Workshops (though the decorative exuberance of Léon Bakst was more to her taste).

With Duncan Grant, Lady Ottoline maintained a miraculously trouble-free friendship for thirty years. She owned several paintings by him though never acquired no.31 (she would not pay the £40 Grant asked for it in 1918; see Bell to Fry, 22 January 1918, TGA). A series of lively sittings took place in Grant's studio at 38 Brunswick Square in early 1913. At some point towards the completion of the work Grant added a string of imitation pearls, the indented marks of which are still visible near to the painted pearls, and intended to add (and may even

30

31

have briefly done so) a piece of wood to further emphasise Lady Otto-line's prognathous chin. Her sartorial extravagance is seen in the plumage of her hat, emphasising Grant's unmistakably avian conception. But the dark tone of her dress and the heavy shadow behind her contribute to the overall note of romantic melancholy in what is one of Grant's most sympathetic and striking portraits.

A head-and-shoulders of c.1914 in Leicester Art Museum (Naylor 1990, repr. p.103) has long been mistakenly catalogued as being of Lady Ottoline; it is probably of Vanessa Bell.

Prov: The artist; bt from Wildenstein by present owner 1964
Exh: *Englische Moderne Malerei*, Kunsthaus Zürich, 1918 (39); Wildenstein 1964 (23, pl.3); ACGB 1969 (17); Columbus 1971 (40, fig.87); *Bloomsbury, IV, A Summing Up*, Harvane Gallery, London 1973 (33); Edinburgh and Oxford 1975 (13)
Lit: D. Garnett, *The Flowers of the Forest*, 1955 (p.34); *The Early Memories of Lady Ottoline Morrell*, ed. R. Gathorne Hardy, 1963 (pp.238–9); D. Gadd, *The Loving Friends*, 1974 (repr. opp. p.131); Shone 1993 (pl.76; p.99)

VANESSA BELL

32 *Virginia Woolf in a Deckchair* 1912

Oil on board 34.8 × 24 (13¾ × 9½)
Mimi and Peter Haas

This compact, swiftly executed work was almost certainly painted in the garden of Asheham House in the first half of 1912 before the sitter's marriage. The featureless but slightly modelled face, though in part a result of Bell's increasing avoidance of detail in her work, also suggests Woolf's impatience with being scrutinised and her elusive mobility of expression. The image would have been instantly recognised by those who knew her. 'It's more like Virginia in its way than anything else of her' (Leonard Woolf talking to the present author in front of this work, August 1965). For further portraits of Virginia Woolf by Bell see no.23.

Prov: The artist to L. Woolf c.1955; to Trekkie Parsons 1969; Sotheby's 15 May 1985 (98, repr.); bt Ivor Braka; to present owner
Exh: ACGB 1964 (13); New York 1980 (14); Canterbury 1983 (11)
Lit: V. Woolf, *Mrs Dalloway*, Penguin 1964 (repr. on cover); L. Edel, *Bloomsbury: A House of Leions*, 1979 (repr. opp. p.128); D.F. Gillespie, *The Sisters' Arts*, 1988 (p.182, repr.)

32

33 *Lytton Strachey* 1913

Oil on board 91.5 × 61 (36 × 24)
Private Collection

fig.83 Duncan Grant, *Lytton Strachey* 1913, oil on board
91.5 × 59.1 cm. Charleston Trust

When Lytton Strachey spent several days with the Bells at Asheham House in the first week of September 1913, he was persuaded to sit to the resident contingent of artists — Vanessa Bell, Duncan Grant and Roger Fry — in a chair against the curving flint wall at the end of the terrace in front of the house (fig.84). Grant's full-length portrait (fig.83) is owned by the Charleston Trust; Fry's unhappy production is in the collection of the University of Texas, Austin (cut down from its original full-length); Bell's is by far the most vivid and successful painting, showing the future author in his Augustus John phase which included a red beard and long hair. As contemporary photographs show, Bell faced Strachey a little more head-on than her painting partners and grasped the opportunity to produce a more bold and spontaneous image than Grant's or Fry's. Touches of violet, rose madder, magenta and cadmium yellow are offset by the darker tones of Strachey's jacket and trousers and the cooler grey-blues of his hat and the pages of his book. The painting is hardly elaborated beyond the first swift application of paint and in fact Bell listed this work in her Charleston inventory as 'Lytton unfinished'.

The painting remained with the artist and was first exhibited in 1964 after her death. In his catalogue introduction to the Memorial Exhibition (ACGB 1964) Ronald Pickvance scooped its importance: '[It] points to the road she was then to take … There are no hesitations, no half-measures; she now combines her simplified schemata of shapes with a new effusion of colour, arbitrary and expressive. Here … is a more truly *fauve* Strachey than Henry Lamb's now canonical image' (for which see no.155).

It is worth noting, if only as a further nail in the coffin of Bloomsbury's reputation for mutual admiration, that Strachey disagreed with Clive Bell's theories on form in art, was greatly distressed by Grant's painting over the following few years and thought Bell's work 'pathetic'.

Prov: The artist to A.V. Garnett 1961; bt Richard Carline 1964; by descent to Hermione Hunter; sold Christie's, 12 June 1987 (lot 207) where bt Ivor Braka by whom sold to present owner
Exh: ACGB 1964 (20); *Contemporary Portrait Society Exhibition*, Oxford University Press Gallery, London, 1968; Portraits 1976 (9)
Lit: Holroyd 1968, 2 (p.96; repr. frontispiece) and cover of one vol. ed., 1994 (repr. jacket); Shone 1976 (pl.77; pp.126–9); Naylor 1990 (p.75); Shone 1993 (pl.95)

fig.84 Lytton Strachey at Asheham House. Clive Bell and Julian Bell at right, 1913. Tate Gallery Archive

33

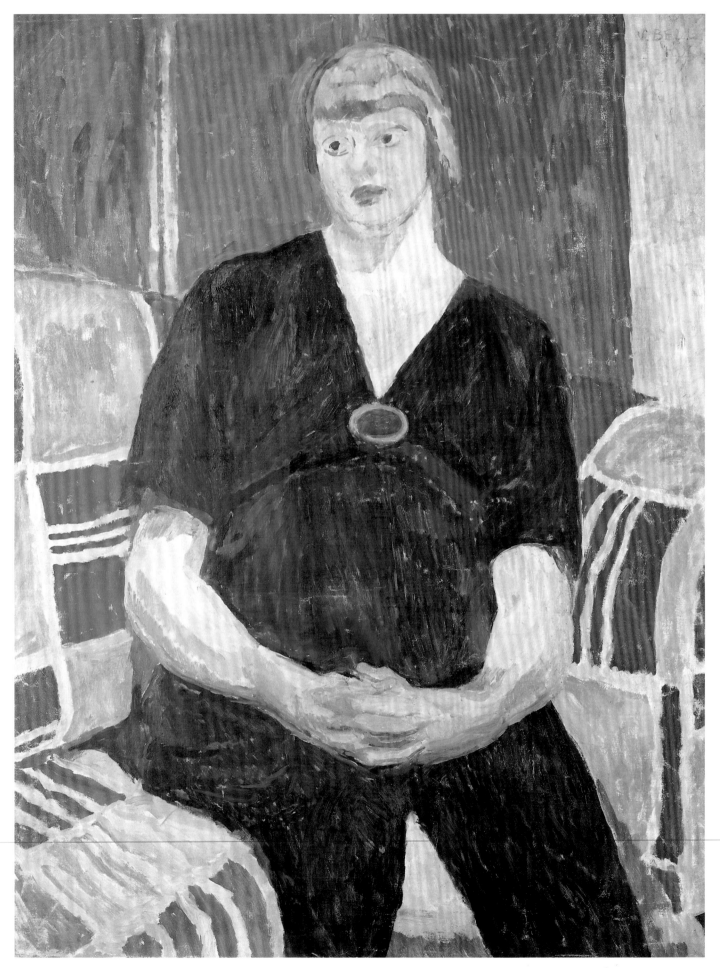

34

34 *Iris Tree* 1915

Oil on canvas 122 × 91.5 (47 × 36)
Inscribed 'V Bell 1915' t.r.
Private Collection

Iris Tree (1897–1968) was a poet and actress, daughter of the great actor-manager Sir Herbert Beerbohm Tree and his wife Maud. With her lifelong friend Lady Diana Cooper (née Manners), she briefly attended the Slade School of Art and after the First World War toured with her in Europe and North America in Max Reinhardt's spectacularly popular *The Miracle*. She contributed to Edith Sitwell's anthology *Wheels* and published *Poems* in 1920. She first married Count Friedrich Ledebur and later the interior designer and photographer Curtis Moffat. She lived for many years in the United States and latterly in Rome where she made a memorable appearance in Fellini's *La Dolce Vita*. She was beautiful, high-spirited and enterprising, was sculpted by Jacob Epstein (Tate Gallery), painted by Augustus John, Henry Lamb and Alvaro Guevara and photographed by Man Ray. She sat to Duncan Grant, Vanessa Bell and Roger Fry (see no.40) on various occasions in 1915 when she was a plump, gauche eighteen-year-old with daringly cropped hair and little sense of punctuality. In a letter to Grant of 31 January 1915 Lytton Strachey enquired: 'Have you been painting Iris lately?' which suggests no.34 and Grant's portrait (fig.85), carried out on the same occasion, were underway or completed (Strachey Papers, British Library).

This is one of Bell's most vivid and successful Post-Impressionist portraits, relying for effect on the bold contrast of Iris Tree's black clothes and the brilliant checked rug on the sofa, its colours echoed in the yellows and pinks of Tree's face and arms and repeated in the rec-

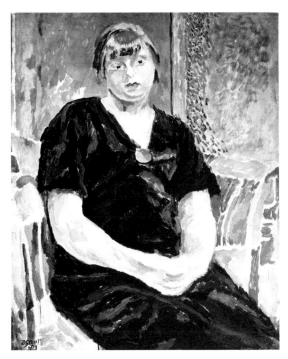

fig.85 Duncan Grant, *Iris Tree* 1915, oil on canvas 75 × 62 cm. Reading Museum and Art Gallery

tangles of colour on what appears to be a painted screen in the background. Grant's portrait is more restless in handling and slightly more subdued in tone suggesting adolescent complexities; Bell has gone for a full-frontal image that is witty and audacious.

Prov: Bt Adams Gallery by present owner 1961
Exh: Adams 1961 (11); ACGB 1964 (27, pl.2); FAS Edinburgh 1975 (34); *Word and Image: The Bloomsbury Group*, National Book League, 1976 (72); *Women Artists: 1550–1950*, Los Angeles County Museum of Art and touring 1976–7 (122, repr.); Sheffield 1979 (19); Canterbury 1983 (33); Crafts Council 1984 (P24); *The Sitwells*, NPG, 1995 (2.25; repr.); Barbican 1997 (10, repr. p.154)
Lit: W. Gaunt, *Concise History of English Painting*, 1964 (pl.179, p.219); Shone 1976 (pl.v, pp.146–7); Spalding 1983 (repr. opp. p.208); Naylor 1990 (repr. p.228); Shone 1993 (pl.108, p.144)

35 *Mrs St John Hutchinson* 1915

Oil on board 73.7 × 57.8 (29 × 22¾)
Inscribed 'VB' (studio stamp) b.l., inscribed on back 'Mrs Clive Bell / The Grange / Bosham'
Tate Gallery, London. Purchased 1973

Mary Barnes (1889–1977) was born in Quetta, India, a great-niece of Sir Richard Strachey and a first cousin once removed of Duncan Grant and the Strachey children; much of her early life was spent in Italy. In 1910 she married the barrister St John Hutchinson (1884–1942) and was hostess to a number of painters and writers of an older generation such as Henry Tonks and George Moore (friendships commemorated in Tonks's *Saturday Night in the Vale*, 1928–9, Tate Gallery). The Hutchinsons had two children, Barbara and Jeremy (now Lord Hutchinson of Lullington), but before the birth of her second child in 1915 she had already met Clive Bell whose lover she remained until the late 1920s. Slim, poised, fashionably dressed, well read, she was introduced by Clive Bell to avant-garde painting and literature; she became a patron of the Omega Workshops, owned paintings by Gertler and Grant (no.73), Marchand, Derain and Matisse. Her taste for recent art was shared with her husband who was a valued supporter of the Contemporary Art Society. She was the friend and confidante of T.S. Eliot, Aldous Huxley, Osbert Sitwell and, years later, Samuel Beckett. Her book of sketches and stories *Fugitive Pieces* was published by the Hogarth Press in 1927.

Mary Hutchinson's relations with Bloomsbury were not plain sailing; her social life was luxuriously fashionable compared with Bloomsbury's more unadorned society. But she maintained cordial friendships within the circle and with Virginia Woolf developed a curiously passionate if wary friendship which intensified in later years: she was, in Hermione Lee's words, 'the main inspiration for the febrile socialite Jinny in *The Waves*' (H. Lee, *Virginia Woolf*, 1996, p.383).

With Vanessa Bell, her relations were more tricky. Bell was happy to decorate rooms for her in her successive London homes River House, Hammersmith (see no.86), and later 3 Albert Gate, Regent's Park; she entertained her as Clive's mistress; and there were early moments of confessional intimacy. But they were such fundamentally different characters that their relations remained cool, suspicious and even hostile. Bell's controlled impatience is evident in two vividly realised and

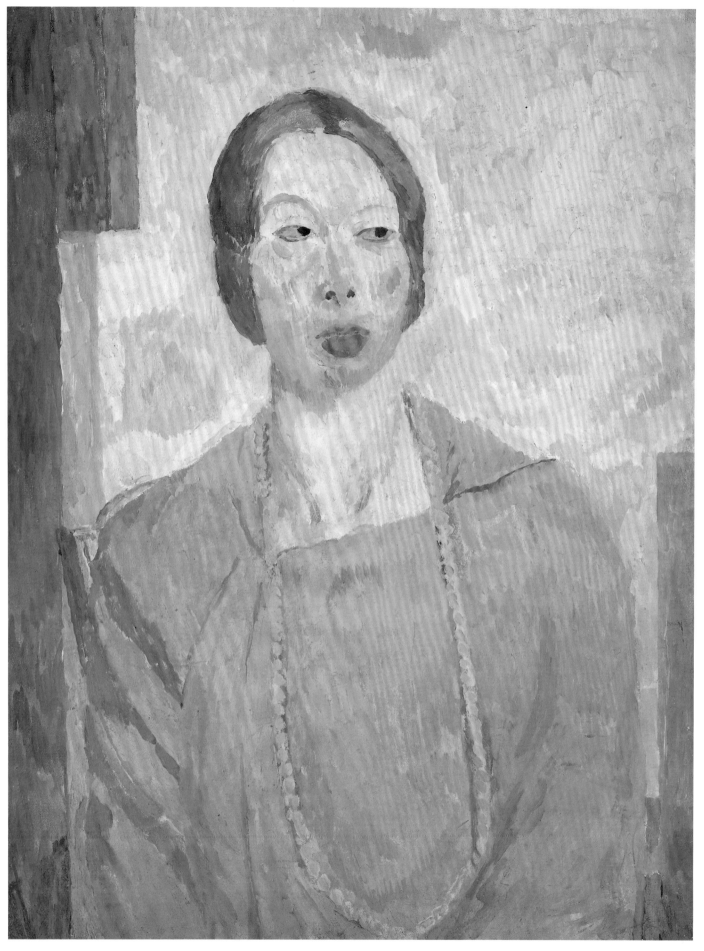

35

unflattering portraits of Mary Hutchinson begun in 1915 – no.35 and a very similar version which was owned by Roger Fry (now private collection; Shone 1976, pl.107). The sittings given to Bell and Duncan Grant by Mary Hutchinson in February 1915 at 46 Gordon Square are detailed in the *Tate Biennial Report* (see below); she sat again to the artists in April 1917 at Charleston (fig.86) but it is not certain whether the artists continued with their earlier attempts or painted new (and so far untraced) versions. The painting in Roger Fry's collection was included in *The New Movement in Art* in October 1917 to which it was lent by Fry. This would suggest that either a 1917 portrait or no.35 was the painting of Mary Hutchinson that Bell sent to the London Group show of 1919, as detailed in a letter from Bell to Fry, in November 1919 (TGA).This letter suggests that she had continued with the painting some time after it was first begun. Its conspicuous place in the London Group show evidently upset the sitter for, as Bell wrote, 'it's perfectly hideous now and yet quite unmistakable'. The rectilinear abstract background, also seen in Grant's more finished portrait (private collection), suggests that Mrs Hutchinson sat in front of a non-figurative painting or wall-decoration in Bell's Gordon Square studio. The portrait's brilliant colour and vivid physical presence make it one of Bell's outstanding early paintings.

Prov: Artist's estate; bt from Adams by Edward le Bas 1961; le Bas estate; Mrs J. Hadley; Christie's 13 July 1973 (222, as *Portrait of a Lady*) where bt Tate Gallery
Exh: ? *Paintings by Vanessa Bell*, Omega Workshops, Jan. 1916 (7gns.); ? LG, Mansard Gallery, Heal's, November 1919 (10, as *Portrait*); Adams 1961 (9, as *Portrait of a Lady*); *A Painter's Collection*, RA 1963 (18, as *Portrait*); ACGB 1964 (28, as *Portrait of a Lady*); Barcelona 1986 (35, repr. p.24)
Lit: *The Tate Gallery Biennial Report 1972–74*, 1975 (pp.85–6); S. Wilson, *British Art from Holbein to the Present Day*, 1979 (p.126, repr.); Watney 1980 (pl.15); Naylor 1990 (p.74); Shone 1993 (pl.123); D. Bradshaw, '"Those Extraordinary Parakeets". Part One: Clive Bell and Mary Hutchinson', *Charleston Magazine*, no.16, Autumn/Winter 1997 (p.11, repr.)

fig.86 Mary Hutchinson at Charleston, 1917, photographed by Vanessa Bell. Private Collection

36 *David Garnett* 1915

Oil on board 76.4 × 52.6 (30½ × 20¾)
National Portrait Gallery, London

Painted at the same sitting as Grant's portrait, see no.37.

Prov: From the artist's estate to d'Offay; private collection, London; Christie's 3 March 1989 (lot 354) where bt NPG
Exh: d'Offay 1973 (15); FAS Edinburgh 1975 (36); FAS 1976 (19); Sheffield 1979 (17); Canterbury 1983 (34); d'Offay 1984 (16); *D.H. Lawrence and the Visual Arts*, Nottingham Castle Museum, 1985 (6); Barcelona 1986 (27); New York 1987 (111, repr.)
Lit: Q. Bell, *Bloomsbury*, 1974 ed. (repr. btw. pp.48–9) and 1986 (fig.18); Shone 1976 (pl.97); Spalding 1983 (p.141); Naylor 1990 (p.239, repr.)

DUNCAN GRANT

37 *David Garnett* 1915

Oil on canvas 61 × 53.3 (24 × 21)
Private Collection

At the time of this portrait, David ('Bunny') Garnett (1892–1981) was a young man in search of a career. His father was the celebrated publisher's reader and critic Edward Garnett, and his mother Constance was the pioneer translator from the Russian, particularly of Tolstoy, Dostoevsky and Chekhov. Garnett began by studying botany at the Royal College of Science, London. Through his father he already knew writers such as Conrad, W.H. Hudson and D.H. Lawrence and he began to write and read widely. Initial unfavourable impressions of Duncan Grant changed rapidly in early 1915 and, although Garnett was predominantly heterosexual, he embarked on an affair with Grant which lasted until 1918 or 1919, four years during which they shared their lives as conscientious objectors working on the land in Suffolk and, from 1916, at Charleston in Sussex. Although retaining the warmest feelings for Grant, Garnett's passions were directed increasingly towards women and in 1921 he married Ray Marshall. In the following year he published his best-selling first novel *Lady into Fox*. There followed a long career as novelist, editor and autobiographer; in 1942 he married Angelica, Vanessa Bell's and Duncan Grant's daughter at whose birth in 1918 Garnett had been present. He was broad-shouldered and blue-eyed, full of powerful but not always comprehended feelings; a practical man, versed in country pursuits since his childhood in Kent, he became an expert beekeeper and angler. He spoke notoriously slowly, his pauses, Lytton Strachey wrote 'long enough to contain Big Ben striking midnight – between every two ... words' (Holroyd, 2, 1968, p.139).

No.37 is probably the first of several portraits Grant made of Garnett over the next few years, among them no.38, as well as a number of nude studies and many drawings. It was painted at Eleanor House, West Wittering (see no.85), when Garnett posed for both Grant and Bell. Grant's sexual attraction is evident in an image that emphasises the sitter's masculinity; it also suggests a certain brutality of tem-

37

36

perament from which Grant was to suffer in the later stages of their affair. Bell's version (see no.36) shows a much more boyish Garnett, almost wrily comic in its fusion of the innocent and the hobbledehoy.

Prov: The artist to d'Offay from whom bt *c.*1979
Exh: d'Offay 1, 1975; FAS Edinburgh 1975 (3); *British Paintings 1900–1975*, Agnew's, 1975 (40); FAS 1976 (46); Toronto 1977 (19, repr.)
Lit: Shone 1976 (pl.96); Watney 1990 (fig.33)

DUNCAN GRANT

38 *David Garnett in Profile* 1915

> Oil on canvas 67 × 38.8 (26⅜ × 15¼)
> Inscribed 'D Grant 1914.' b.r. (late inscription)
> *Private Collection*

This is almost certainly a painting of 1915, made after the other portrait of Garnett shown here (no.37). The profile format is reminiscent of Grant's portrait of Lytton Strachey (no.7A) but here a relaxed, sensuous uninhibited atmosphere has replaced the restrained and scholarly image found in the earlier work. The section on the wall of a painting of a female nude – a homage to Garnett's predominant heterosexuality perhaps – provides sustaining colour and change of pace.

Prov: The artist by whom given to present owner 1964
Exh: *Twentieth Century British Art*, Agnew's, 1972 (12); on loan to Charleston Trust 1997 season
Lit: Q. Bell and V. Nicholson, *Charleston*, 1997 (pp.102–3, repr., detail)

DUNCAN GRANT

39 *Vanessa Bell in a Sunhat* *c.*1913

> Oil on canvas 34.3 × 25.4 (13½ × 10)
> *Private Collection*

The long series of Grant's portraits of Bell, painted over fifty years, began in 1911 (see no.158). The distinctive shape of her features – the heavy-lidded eyes and full mouth, the oval head set on a generous neck – also formed the prototype of the stately, often protective goddesses in innumerable imaginative compositions (see for example, *Venus and Adonis*, no.118). Bell was careless of her beauty and rarely followed fashion in her clothes or in her make-up (which she scarcely used). Leonard Woolf, her brother-in-law, wrote of her as 'usually more beautiful than Virginia, the form of her features was more perfect, her eyes bigger and better, her complexion more glowing … in her thirties [she] had something of the physical splendour which Adonis must have seen when the goddess suddenly stood before him' (L. Woolf, *Beginning Again*, 1964, p.27). Grant painted her clothed and nude, reading, sewing, nursing their child Angelica, listening to music, bathing and, of couse, painting. In the more consciously posed portraits her expression runs to the resigned and inscrutable (no.114). In this compact, vivid head, a white marguerite tucked into the pink band of her sun hat, Grant catches the look seen in contemporary photographs, head slightly bowed, eyes looking up with the steadfastness of the contem-

fig.87 Eleanor House, West Wittering, Sussex. Postcard, *c.*1920. Private Collection

39

38

40

plative painter. At the same time he touches on a mood of exoticism which characterised the period just before the First World War, underlined by the 'foreign' conical shape of her hat with its Gauguinesque flower.

Prov: The artist to d'Offay from whom bt by present owner 1986
Exh: FAS 1976 (ex cat.); d'Offay 1984 (56); d'Offay 1986 (no cat.)

ROGER FRY

40 *Iris Tree in a Sombrero* 1915

Oil on canvas 98.4 × 71.1 (38¾ × 28)
Inscribed 'R.F.1915' on verso
Private Collection

Although Fry was one of the group who painted Iris Tree in early 1915 (see no.34), his contribution does not survive and he asked her sit to him again some months later. Grant also painted her on this occasion (his unfinished work is reproduced in Naylor 1990, p.114). She wears different clothes, sporting a Bohemian sombrero and black scarf, providing Fry with one of his most dramatic portraits and one of the most successful of a whole series, including Edith Sitwell (no.41), Nina Hamnett (fig.136A; unavailable for exhibition), Madame Vandervelde, J.M. Keynes, Viola Tree (Iris's sister, an actress and writer), and André Gide (fig.88), all painted between 1915 and 1919. None was commissioned, all were drawn from Fry's large circle of friends. After about 1920, commissions were more forthcoming, especially from Oxford and Cambridge colleges. But it was the more private, social activity of painting a friend, without the constraints of satisfying committees, that found him at his most penetrating.

Prov: P. Diamand; to d'Offay by whom sold to present owner 1984
Exh: ?*Paintings by Roger Fry*, Alpine Club Gallery, 1915 (4); Colchester 1959 (10); *Portraits* 1976 (15); Dallas and London 1984 (30, repr.); d'Offay 1984 (29)
Lit: Shone 1976 (pl.93, p.150); Spalding 1980 (pl.80; p.215)

ROGER FRY

41 *Edith Sitwell* 1918

Oil on canvas 61 × 45.7 (24 × 18)
Inscribed 'Roger Fry 1918' b.l.
Sheffield Galleries & Museums Trust

The young poet Edith Sitwell (1887–1964) was probably introduced to Fry by her brothers Osbert and Sacheverell Sitwell towards the end of the First World War. She was editor of *Wheels*, the anti-Georgian poetry anthology (1917–21, 6 vols.), which reproduced drawings by William Roberts and Lawrence Atkinson; in 1922–3 she received wide notoriety for *Façade*, an entertainment in which she collaborated with her brothers and William Walton and Frank Dobson.

Fry makes no mention in his correspondence of painting Sitwell and she in her autobiography gives no details, save that she 'wore a green evening dress, the colour of the leaves of lilies, and my appearance in this, in the full glare of the midsummer light of midday, in Fitzroy Square, together with the appearance of Mr Fry, his bushy, long grey hair floating from under an enormous black sombrero, caused great joy to the children of the district as we crossed from Mr Fry's studio to his house for luncheon' (Sitwell 1965). Her memory is a little at fault – Fry lived and worked in one apartment in 21 Fitzroy Street; perhaps she visited the Omega Workshops around the corner in Fitzroy Square. Fry's 'black sombrero' is suspicious though not impossible.

This fine portrait with its sensitive delineation of Sitwell's features is valuable as a painted record of the poetess's unadorned early appearance. Later, she proved a godsend to a succession of painters and photographers, among them Nina Hamnett, Alvaro Guevara (*The Editor of Wheels* 1919, Tate Gallery), Wyndham Lewis, Tchelitchew and Cecil Beaton. Another portrait by Fry, his sitter in profile, is in a private collection.

Edith Sitwell's relations with the Bloomsbury artists were slight; her brothers Osbert and Sacheverell were much closer in the immediate post-war period, especially when they organised an important exhibition of modern French art in 1919 at Heal's Mansard Gallery.

fig.88 Roger Fry, *André Gide* 1918, oil on canvas 48 × 63.5 cm.
Private Collection

41

Osbert entertained Grant, Clive Bell, Strachey and others at his house in Chelsea and he stayed at Charleston in 1919.

Prov: …; John George Graves (? bt LAA 1931) by whom presented to Sheffield City Art Gallery 1935
Exh: (?) LG, Mansard Gallery, Heal's, April 1919 (6); *Roger Fry*, LAA 1931 (32); *British Painting 1890–1960*, Mappin Art Gallery, Sheffield, and Aberdeen Art Gallery, 1975–6 (46, repr.); *Portraits* 1976 (14; pl.5); *Images of Edith*, Sheffield Polytechnic Gallery and touring, 1977 (p.7; p.3); *The Sitwells*, NPG 1994 (2.22, repr.)
Lit: E. Sitwell, *Taken Care of*, 1965 (p.83); *Concise Catalogue*, Sheffield City Art Galleries, 1981 (p.21, pl.19); F. Spalding, *20th Century Painters and Sculptors*, 1990 (pl.40); Shone 1993 (pl.109; p.144)

HENRY LAMB

42 *Leonard Woolf* 1912

Oil on canvas 51.1 × 40.6 (20⅛ × 16)
Private Collection

During the period *c*. 1908–12 it seemed that Henry Lamb (1883–1960) might become part of the Bloomsbury circle through his close friendship with Lytton Strachey and his professional ties with its painters and critics. He had known Grant and the Bells for some years, partly through his brother Walter Lamb and partly through his founder-membership of the Friday Club. He drew and painted Strachey (see

nos.43 and 155), Leonard Woolf, Clive Bell (see no.154), Duncan Grant and Saxon Sydney-Turner. But during 1912–13 when his friendships with Strachey and Lady Ottoline Morrell noticeably cooled, he gradually withdrew; in later years he seemed to have only embittered memories of this early phase of his life. But in 1912 he was sufficiently in favour to have been included in the second Post-Impressionist Exhibition. Vanessa Bell, however, disliked his work almost from the start: 'academic drawing niggled and polished up to the last point without life or interest, very skilful, and utterly commonplace and second-hand in idea' (Bell to Fry, 23 November 1911, TGA). The portrait of Woolf, carried out in March 1912 in Lamb's studio at the Vale Hotel, Hampstead Heath, shows him at his freshest with its almost startling human presence (the sitter called it a 'successful, accurate portrait') and lightly brushed, warm colour. Lamb and Woolf rode together on Hampstead Heath and attended Russian lessons (along with Sydney-Turner) at this time. Lamb called Woolf 'an unfinished sketch of a great passionate character' (Clements 1985, p.136).

Prov: Richard Carline 1961; Mark Glazebrook; Sotheby's, 22 July 1964 (lot 139) where bt by present owner
Exh: *Memorial Exhibition of Paintings and Drawings by Henry Lamb, R.A.*, Leicester Galleries, London, 1961 (59); *Henry Lamb, 1883–1960*, Manchester City Art Gallery and touring, 1984 (36; repr. in col. p.28)
Lit: Q. Bell, *Bloomsbury*, 1974 (p.32, repr.); L. Woolf, *An Autobiography*, 1, 1980, paperback (repr. jacket); K. Clements, *Henry Lamb: The Artist and his Friends*, 1985 (pp.136–7)

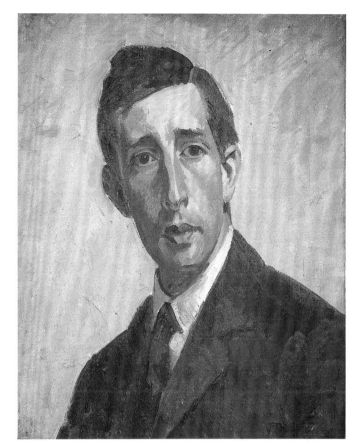

42

HENRY LAMB

43 *Lytton Strachey* 1913–14

Oil on canvas 50.8 × 37.8 (20 × 14⅞)
Private Collection

This is a small study for the large painting of Lytton Strachey (Tate Gallery) which Lamb had begun in 1912; a full version was finished by April 1913 and completely repainted in 1914 with 'more frank colours and solid forms'. A few details were added later including, according to Clements (Manchester 1984) the figures of Florence Nightingale and Dr Arnold walking outside, two of the four subjects of Strachey's *Eminent Victorians* (1918); Holroyd more persuasively suggests these are Mrs Humphrey Ward and St Loe Strachey (1967, p.46).

A comparison of Lamb's work with Vanessa Bell's painting of Strachey (no.33), carried out a few months apart, points to the radical divergence between Lamb and his recent fellow-exhibitors in the Second Post-Impressionist Exhibition (in which Lamb had shown a head-and-shoulders of Strachey). The sitter himself found the portrait of great interest but 'rather shattering' and his brother James saw it as a vulgar and superficial caricature, the general view among Strachey's close friends – Fry called it 'that horrid vulgar picture by Henry' (Virginia Woolf, *Diary*, 4, 1982, p.70). It remains however the most famous image of the writer and is undoubtedly Lamb's finest portrait although its colour in recent years has considerably darkened.

Prov: Siegfried Sassoon 1923 by whom given to Lady Ottoline Morrell; to Julian Vinogradoff; bt from Leicester Galleries by Lord Cottesloe; ...; d'Offay 1971; present owner

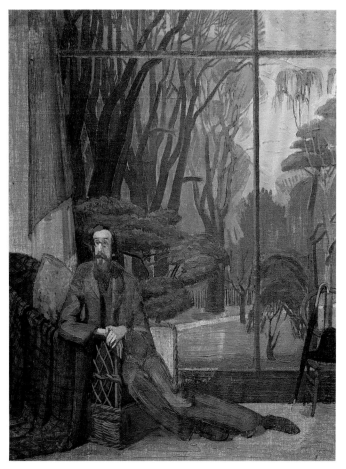

43

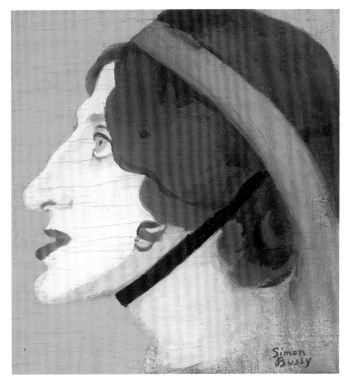

44

fig.89 Simon Bussy, *Lady Ottoline Morrell* c.1918–20, woodcut 19 × 14.8 cm. The Provost and Scholars of King's College, Cambridge

Exh: *Pictures from Garsington*, Leicester Galleries, London 1956 (32); *Memorial Exhibition of Paintings and Drawings by Henry Lamb, R.A. (1883–1960)*, Leicester Galleries, London 1961 (3, repr.); *British Painting, 1700–1960*, British Council exhibition, Moscow and Leningrad 1960 (103)
Lit: Holroyd 2, 1967 (pp.45–6); *Henry Lamb 1883–1960*, Manchester City Art Gallery and touring, 1984 (under no.46)

SIMON BUSSY

44 *Lady Ottoline Morrell* c.1920

Oil on canvas 31.7 × 29.2 (12¼ × 11½)
Inscribed 'Simon Bussy' b.r.
Tate Gallery, London. Presented by Clive Bell and Duncan Grant 1951

Bussy attempted a portrait of Lady Ottoline Morrell (for whom see no.31) in pastel in 1913 but abandoned the work. The present profile was almost certainly painted from memory and is based on a woodcut by Bussy known only from a single example (fig.89) which probably dates from c.1918–20. Bussy and his wife Dorothy stayed with Lady Ottoline at Garsington in August 1920 (when Gide was a fellow guest) and again in September 1921. Bussy's profile portraits (see no.162) have their origin in his admiration for Piero della Francesca's *Federico da Montefeltro* and *Battista Sforza*, the former copied by Duncan Grant in 1904–5 on Bussy's recommendation. The present work combines attested likeness with satiric aplomb.

Prov: Bt from artist by D. Grant and C. Bell, 1947, by whom presented to the Tate Gallery 1951
Exh: *Simon Bussy*, Galerie Charpentier, Paris 1948 (4); *Word and Image: The Bloomsbury Group*, National Book League 1976 (61); Dallas and London 1984 (27); Barcelona 1986 (29); *Simon Bussy (1870–1954)*, Musée départemental de l'Oise, Beauvais, and touring 1996 (31, repr.)
Lit: Q. Bell, *Bloomsbury*, 1968 (p.36, repr.) and 1986 (pl.17); L. Norton, 'Simon Bussy: Channel Painter', *Apollo*, September 1970 (p.220; fig.2); R. Alley, *Tate Gallery's Collection of Modern Art*, 1981 (pp.90–1, repr.); *Correspondence André Gide – Dorothy Bussy*, ed. J. Lambert, III, Paris 1982 (p.491); M. Seymour, *Ottoline Morrell*, 1992 (pp.72–3); F. Spalding, *The Bloomsbury Group*, NPG 1997 (p.45; repr.)

DORA CARRINGTON

45 *E.M. Forster* c.1924–5

Oil on canvas 50.8 × 40.6 (20 × 16)
National Portrait Gallery, London

Although usually listed as a 'member' of Bloomsbury, the writer Edward Morgan Forster (1879–1970) was, in fact, a tangential figure: 'I don't belong automatically' he once noted. However, most of his beliefs and values coincided, through Cambridge University and the Apostles, with those of 'Old Bloomsbury'. In early years he was closely attached to Fry, who painted his portrait (fig.80) and designed the jacket for his stories *The Celestial Omnibus*, and later, he greatly admired and came to rely for advice upon Leonard Woolf. He was a founding member of the Memoir Club and appears in Bell's painting of it. In his mother-dominated and sexually repressed early years he

clung, outwardly at least, to a late-Victorian sense of propriety whose overturning provides much of the meat and most of the comedy of his first novels such as *A Room with a View*, 1908. Forster did not live in Bloomsbury until the mid-1920s, but he enjoyed warm personal relations with several individuals within the group without ever wanting any closer involvement (see, for example, his hostile estimate in a letter to W.J.H. Sprott, 16 July 1931, in *Selected Letters of E.M. Forster*, eds. M. Lago and P.N. Furbank, 2, 1985, p.105).

Forster stayed with Lytton Strachey and Dora Carrington on several occasions at the Mill House, Tidmarsh, and after 1923, at Ham Spray, their house in Berkshire. Carrington's portrait is difficult to date and Jane Hill suggests, though gives no evidence, that it was painted from memory. This is doubtful but it certainly may have taken Carrington some months to finish it once the initial surreptitious drawing was over. The build-up of small dabs of paint and subtle illumination of Forster's profile suggest a date of *c.*1924–5 rather than 1920 to which it is usually assigned.

Dora Carrington (1893–1932) is not represented in depth as a Bloomsbury artist in this exhibition, for although there are obvious points of contact between her work and that of Grant, Fry and Bell, her aesthetic temperament was fundamentally different and the Post-Impressionists had much less impact on her during and immediately after her training at the Slade School of Art. Her work has deeper affiliations with that of John Nash, Mark Gertler and the Spencer brothers, and her style in interior decoration is quite distinct from the Omega artists. It is often repeated that Carrington suffered as a painter from Bloomsbury's refusal to take her work seriously. This seems an increasingly untenable view; her own diffidence about showing her paintings, even to her intimate circle centred on Ham Spray, was the real obstacle in their assessment. Grant, for one, always thought highly of her gifts; Vanessa Bell wrote to Lytton Strachey that she would be 'delighted to help' Carrington exhibit at the London Group (4 October 1920, Strachey Papers, BM); she did and Carrington showed in the October 1920 exhibition. Roger Fry was less encouraging, although he included Carrington in the 'Nameless Exhibition' of 1921 and liked her work for the Omega and for the Hogarth Press. Clive Bell's only written comment on her work was that it 'amounted to nothing' (Clive Bell to Vanessa Bell, 21 February 1932, TGA); in later years he told Frances Partridge that he had been wrong (Frances Partridge in conversation with the author, May 1984). Carrington's reputation, immensely boosted by the publication of her letters and diaries and more recently by the film *Carrington* (1994), has led to a thorough examination of her work, culminating in the large-scale retrospective at the Barbican Art Gallery in 1994.

Prov: The artist to Ralph Partridge 1932; to Frances Partridge by whom given to NPG 1969
Exh: *Carrington*, Barbican Art Gallery 1995 (no.78)
Lit: *Carrington: Letters and Extracts from her Diaries*, ed. D. Garnett, 1970 (repr. opp. p.141); N. Carrington, *Carrington: Paintings, Drawings and Decorations*, 1978 (pl.11); *Complete Illustrated Catalogue: National Portrait Gallery*, 1981 (p.205, repr.); *The 20th Century at the National Portrait Gallery*, 1984 (p.19, repr.); F. Spalding, *The Bloomsbury Group*, NPG, 1997 (p.48; repr.)

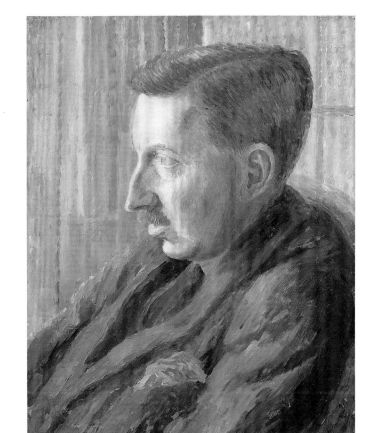

45

fig.90 E.M. Forster at Charleston, 1923. Photograph by Vanessa Bell. Tate Gallery Archive

A Room of One's Own

Still-Life Paintings 1914–19

In his monograph on Cézanne (1927), Roger Fry wrote that it is in still-life painting that 'we frequently catch the purest self-revelation of the artist'. He develops this by insisting that the invariably commonplace objects of still life, displayed on a table top, are free of complex human emotions and ideas and that the artist is at liberty to concentrate on the purely visual. In practice, of course, although the chosen motif might be ordinary or even banal, the end result might disclose a note of unmistakable autobiography or social subtext. Fry's own *Still Life with Italian Painting* (no.60), for example, is a key to his life and interests at a specific moment; he has chosen his objects with care, fastidious as to their placing and background. Grant and Bell in their still lifes were more casual: it is doubtful that they would have consciously arranged, for example, the clutter that forms the starting-point for their well-known pair of paintings of a mantelpiece (nos.48 and 51) or that Bell would have tampered with what she saw for her *Flowers in the Studio* (no.53). What mattered was the point of view she herself adopted. Certainly the objects in early still lifes by Grant and Bell were pre-arranged (e.g. Bell's *Iceland Poppies*, no.3) but during their Post-Impressionist period, the accidental element in their choices is matched by their formal and material adventurousness. Subject matter was essentially domestic – flowers and fruit, dining tables, laden coffee-trays, books, shelves and window-sills (figs.91, 93), clothes, their own or other people's paintings. These are frequently offset by parts of the interior in which the objects are found, inclusive roomscapes that result in a complex web of visual and personal associations.

Grant frequently worked in series at this time and there are three or four versions of some still-life subjects (as well as of interiors, e.g. nos.74 and 75) especially after he introduced collage into his work in 1914. He is at his most spontaneously self-revealing in purely painted works, when his inventive colour and rhythmic handling of paint are most in evidence (e.g. no.50). Fry's still lifes are more austere, shorn, in his concentration on essential form, of the lyrical note sounded by Grant and Bell; he succeeds better with the artificial flowers of the Omega than with the natural abundance of real ones. A handful of Vanessa Bell's still lifes, particularly of flowers, are among her most compelling works in which sensuousness, gravity and repose are combined.

(*A Room of One's Own*, by Virginia Woolf, 1929)

fig.91 Duncan Grant, *Still Life on a Windowsill* c.1915, oil on canvas 61 × 50.8 cm. Private Collection

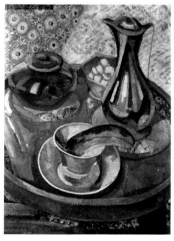

fig.92 Roger Fry, *Still Life with Banana* c.1915, oil, gouache and collage on card 50 × 37 cm. Courtauld Gallery, London

fig.93 Vanessa Bell, *Roses and Carriage Clock* c.1916, oil on board 42 × 33 cm. Private Collection

opposite detail from Vanessa Bell, *Still Life on Corner of a Mantelpiece* 1914 (no.51)

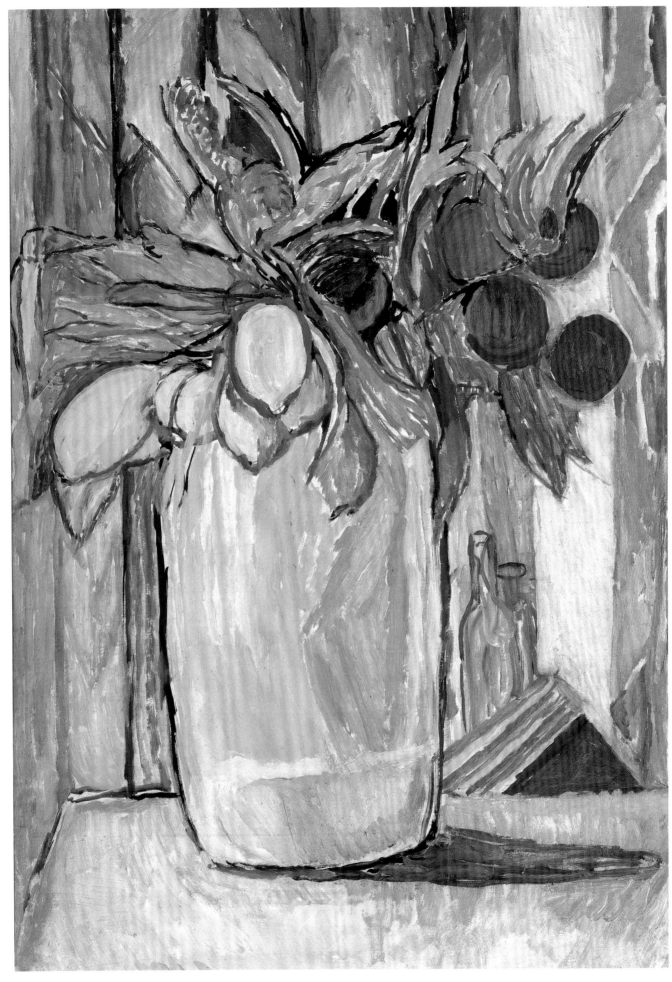

46

46 *Oranges and Lemons* 1914

Oil on cardboard 73 × 51.5 (28¾ × 20¼)
Private Collection

In January 1914 Grant visited Tunis and sent sprays of oranges and lemons to Vanessa Bell in Gordon Square. She wrote to him on 29 January: 'Your basket of oranges and lemons came this morning. They were so lovely that against all modern theories I stuck some into my yellow Italian pot and at once began to paint them. I mean one isn't supposed nowadays to paint what one thinks beautiful ... I took what was left round to the Omega for Roger this afternoon and no doubt he'll soon be doing likewise' (29 January 1914, TGA). Fry seems to have joined Bell at Gordon Square to paint his version, as the same Omega textile, *Maud*, (from which Bell had made curtains for her studio) appears in both paintings as does the Italian pot with similarly arranged fruit. Where Bell's painting conveys the exotic note struck in midwinter London by lemons and oranges still on the branch, Fry's work (fig.94) is more solidly grounded and more sober in colour. The Cézannian tilt of Bell's vase is characteristic of several still lifes of 1913–14 (e.g. *Still Life with Beer Bottle*, 1913, Charleston Trust) but the release of colour she had found that autumn in her portrait of Lytton Strachey (no.33), though still bounded by drawn contours, is maintained, presaging the group of brilliantly coloured still lifes and portraits of 1914–15.

In the letter quoted above, Bell is most obviously making a mocking reference to Clive Bell's *Art*, published shortly after this work was painted. She had read it in typescript and proof and though she agreed with much of its aesthetic argument, she was by no means a slave to its theoretical tenets.

Prov: D. Grant; A.V. Garnett; d'Offay where bt by present owner 1979
Exh: ACGB 1964 (30); d'Offay 1973 (11, repr.); FAS Edinburgh 1975 (33); FAS 1976 (15); Canterbury 1983 (23)
Lit: Shone 1976 (pl.78)

fig.94 Roger Fry, *Oranges and Lemons* 1914, 76.1 × 50.7 cm. Whereabouts unknown

47 *Omega Paper Flowers in Bottle* 1914

Oil on canvas 30.5 × 33 (12 × 13)
Private Collection

A narrow bottle containing several artificial flowers (for which see no.58) and probably one or two natural ones is seen against what appears to be part of the Omega Workshops textile, *Maud*, designed by Bell in early 1913. This abstract textile was produced in more than one colour combination and Bell's painting seems to be an amalgamation of these though she omits, for the most part, the grid of black lines printed over the colour areas and white ground of the fabric. The artificial flowers may well have been made by Bell, thus making much of the painting a reprise of her own decorative design. The work is unusual in Bell's output for the integration of foreground flowers and patterned background; she attempts it here and in *Oranges and Lemons* (no.46) and occasionally in later years. More usually she prefers a plain ground to highlight her principal subject.

Prov: Gift from artist to Joy Brown (of the Omega Workshops); by descent; Sotheby's, 10 May 1989 (69); S. Lummis; private collection, Hong Kong; D. Gage from whom bt by present owner
Exh: Not previously exhibited

48

48 *The Mantelpiece* 1914

Oil and collage on board 45.5 × 39.2 (18 × 15½)
Inscribed 'D. Grant 1914' b.r.
Tate Gallery, London. Purchased 1971

This work and its companion, no.51, form a revealing summary of the differences of approach and sensibility of Grant and Bell when painting the same subject. That the work of the two painters was sometimes confused had more to do with the similarities of subject matter than of style, although at certain moments their tonal range is close.

The marble mantelpiece shown here was in Bell's first-floor studio at the front of 46 Gordon Square; this room's fireplace no longer exists but a similar one, less elaborate and probably not so high, is still *in situ* in the adjoining room at the back. The objects on the shelf include boxes and cartons, handmade paper flowers from the Omega Work-shops in a jug and, visible in Grant's work on the right, an Omega box by Frederick Etchells with swimmers on its sides. The two works, however, are difficult to read in these specific terms and there may be a mirror, a painting or even part of a mural behind the objects. Bell, who painted the subject to Grant's left, has a slightly lower, more oblique view and concentrates on the elements that take up the left side of Grant's work. She radically simplifies the scrolled moulding under the shelf into two rectangles whereas Grant keeps to the double curve. His surface is more restless and inclusive and follows a sinuous under-drawing in pencil. This is emphasised by his use of collage, both of 'found' papers and ones especially painted; these were cut and applied as he worked. Bell is more grave and restrained, drawing the diverse shapes of the subject into a pyramid echoed in the inverted pyramid below the shelf on the left. Grant gives a greater sense of relief through spatial intricacy, more undulating contours and a wider range of colour. There is a visual nervousness in his work whereas Bell's response is carried through in an apparently seamless, single sweep.

51

When no.48 was acquired by the Tate Gallery, Grant wrote that he thought this was among his earliest works in which he used collage. Stylistically both paintings appear to belong to summer 1914.

Prov: The artist; d'Offay Couper Gallery from whom bt by Tate Gallery 1971
Exh: Tate 1975 (10)
Lit: *The Tate Gallery 1970–72*, 1972 (p.110, repr.); Shone 1976 (pl.134); Watney 1980 (pp.95–6, pl.84); Naylor 1990 (p.109, repr.)

DUNCAN GRANT

49 *The Modelling Stand* c.1914

Oil and collage on board 75.6 × 61 (29¾ × 24¾)
Inscribed 'The Modelling Stand 1912' (late inscription by Grant on back)
Private Collection

Grant applied collage in his work from c.mid-1914 to c.1916. As noted in no.48, papers were either especially painted or found, printed ones; pieces of textile, wood, cigarette packet paper and newsprint were also used. Sometimes a collaged version of a subject was made after a painted version had been completed, sometimes collage accompanied paint at the same time in front of the subject (as in no.48); and sometimes collage was used autonomously, away from a subject. It is not known where no.49 was carried out but a sculptor's modelling stand would have been found in the workrooms of the Omega Workshops or possibly was part of the furnishings of Grant's studio at *22* Fitzroy

49

Street which he occupied from October 1914. Obviously the Cubist collages of Picasso and Braque underlie Grant's approach; working on designs for the theatre and at the Omega had also introduced a more flexible, interchangeable attitude to materials. But he seems to have used collage for quite distinct and personal ends, maintaining that it gave works an added dimension of reality, a double-life, without having to 'describe objects' (conversation with the author 1972); it also increased the surface variety he was aiming for.

No.49 is one of Grant's most complex collage-paintings, an elaborate dialogue between the flat surface of the support and spatial depth suggested by contour, between painterly handling and segments of unmodelled colour. It moves rapidly from sharp description (as in the objects towards the front of the stand) to a near-abstract interleaving of elements to the right of the central white bowl. The colour scheme is controlled by the green-striped yellow material that appears at four points above and below the stand. As in other works by Grant (and Bell), a formal touchstone was provided by Picasso's still-life *Pots et Citron* (fig.51) hanging in the Bells' house; the two bowls at the centre of Grant's work are almost a direct quotation from Picasso's painting.

Prov: The artist; to d'Offay by 1975; to present owner 1996
Exh: Liverpool 1980 (26); d'Offay 1984 (59); New York 1987 (130, repr. in reverse)
Lit: *The Burlington Magazine*, 130, Jan. 1988 (fig.59); Watney 1990 (pl.20); Shone 1993 (pl.100)

50 *Omega Paper Flowers on the Mantelpiece, 46 Gordon Square* c.1914–15

Oil on canvas 55.2 × 75.9 (21¾ × 29⅞)
Mellon Bank, Pittsburgh

On the mantelpiece stand a bottle and a terracotta pot, both vessels holding painted artificial flowers, four in the pot, three in the bottle. These flowers, made from scraps of material, wool, paper and wire, were sold at the Omega Workshops from *c.*1914; none appears to have survived. They are present in works by all three Bloomsbury artists from 1914 to *c.*1920 (see nos.47, 50 and 61). They were invariably fantastic in shape and brilliant in colour; Grant obviously enjoyed their release from natural forms and may indeed have designed or painted some of those shown here. Vanessa Bell made flowers for inclusion in her solo show at the Omega in early 1916 (see Collins 1983, p.126) and Grant included artificial flowers in at least two Charleston still lifes of 1917 (Keynes Collection, King's College, Cambridge; and no.58).

In October 1914 Grant offered a painting to his friend George Mallory as a wedding present, adding that he was thinking of painting some paper flowers for him. It is not known if Mallory received such a gift but after Adrian Stephen married Karin Costelloe (31 October

50

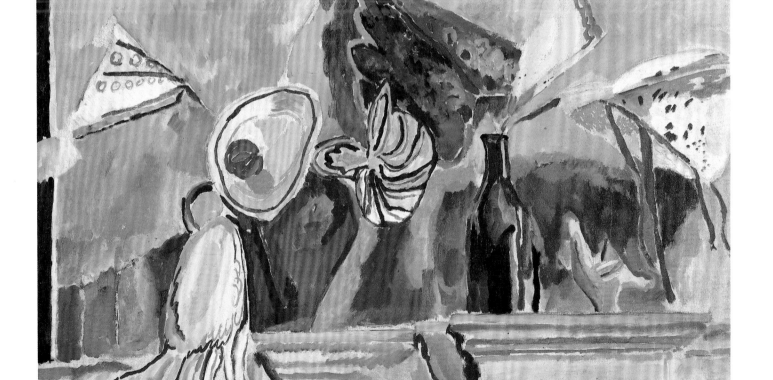

1914), Grant gave them the present work. There is a small study (or possibly independent painting) of the left-hand portion of no.50 (private collection).

The painted stripes and jelly-fish tendrils of the flowers suited Grant's often sinuous lines and contours in paintings up to early 1915 (as in *The Modelling Stand*, no.49). They encouraged a new exuberance in the handling of paint (thinly applied) and a higher key in colour, reflecting the brilliant flowers themselves. It has been suggested (e.g. in Watney 1990, p.35) that Grant saw in April 1913 Matisse's show, at Berheim Jeune in Paris, of his recent Moroccan paintings (which included canvases of flowers) and that this gave impetus to his subsequent work. However, there is no evidence for a trip to Paris during the short run of the show (13–19 April), though Grant was in the French capital for one night in May 1913. By then the flowerpieces by Matisse had left Paris for Russia (via Germany). Grant may have known photographs of them; nevertheless, he comes closest to Matisse in such works as this one and two flowerpieces of *c.*1915 in which an arum lily, prominent in Matisse's Moroccan works, also appears.

Prov: Gift from artist to Adrian and Karin Stephen *c.*1914; to their daughter Judith Henderson; to Nigel Henderson; by whom sold to d'Offay; bt Mellon Bank, Pittsburgh, PA 1984
Exh: d'Offay 1984 (60, repr.)
Lit: Watney 1990 (pl.16); Shone 1993 (pl.98)

VANESSA BELL

51 *Still Life on Corner of a Mantelpiece* 1914

Oil on canvas 55.9 × 45.8 (22 × 18)
Tate Gallery, London. Purchased 1969
[Illustrated on p.121]

See no.48.

Prov: Artist's estate; bt Tate Gallery (Chantrey Purchase) 1969
Exh: Adams 1961 (10); ACGB 1964 (24); Tate 1975 (21); Canterbury 1983 (26)
Lit: Shone 1975 (pl.80);Watney 1980 (pl.86); Naylor 1990 (p.108)

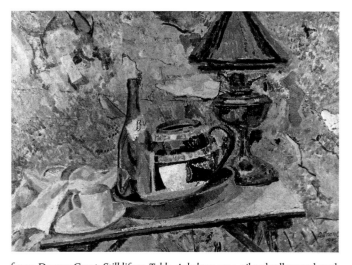

fig.95 Duncan Grant, *Still life on Table, Asheham* 1914, oil and collage on board 54.2 × 78.7 cm. Private Collection

VANESSA BELL

52 *Triple Alliance* 1914

Collage, newsprint, oil and pastel on board 81.9 × 60.3 (32¼ × 23¾)
The University of Leeds Art Collection

Almost certainly this work was completed at Asheham House in late summer 1914 when Bell painted alongside Grant in front of the same subject – a bamboo table placed against the flint wall of the garden. Grant's version (collection Frances Partridge) contains slight collage elements; and at least three further paintings by him of the same table but with different objects on it are known, all dating to late summer 1914 (fig.95). Unlike Grant's paintings, however, Bell's introduces a topical note. The Triple Alliance of the title (it is unknown how or when the work gained the name though it was called this by Fry in 1923) refers not so much to the 1882 secret treaty between Germany, Italy and Austro-Hungary but to the Triple Entente signed by Britain, France and Russia on 3 September 1914 pledging military alliance against Germany and agreeing not to make a separate peace. Bell's collage elements contain both personal and public references, from a cheque made out to herself for 5 guineas, snipped at the corners and partly overpainted to form the white shape of an Appolinari's soda syphon (a further fragment of a cheque is used at the neck of the central bottle) to pages from *The Times* (one fragment carries the date of 1st September) and maps including the valley of the Meuse north of Verdun and the German-French border at Aix-la-Chapelle. This is the only work by Bell to allude to contemporary events – ones that would soon considerably alter her domestic life – but even so the reference is unemphatic: the familiar elements of still life, seen here in almost military formation, contrast with the semi-obliterated news items from abroad such as 'Austrian Generals Killed', as though she were determined to preserve her life as a painter at a time when everything was under threat.

Prov: Bt Michael Sadler 1917 by whom given to University of Leeds 18 Oct. 1923
Exh: *The New Movement in Art*, Royal Birmingham Society of Artists, Birmingham July–Sept. 1917 (16, as 'Bottles on a Table' and Mansard Gallery, Heal's, London (9)); *A Commemorative Exhibition … from the Collection of Sir Michael Ernest Sadler*, Leeds City Art Gallery, 1962–3 (2); ACGB 1964 (ex cat., at Leeds only); *Vision and Design* 1966 (32); Norwich 1976–7 (54); Sheffield 1979 (18); Canterbury 1983 (27); *Michael Sadler*, University Gallery, Leeds 1989 (5, repr.); Barbican 1997 (8); *Art Treasures of England: The Regional Collections*, RA 1998 (378, repr.)
Lit: Fry, *Letters*, 2, 1972 (p.532); Shone 1976 (pl.105); C. Harrison, *English Art and Modernism*, 1981 (pl.28); Collins 1983 (p.153); *Charleston Newsletter*, 24, Dec. 1989 (p.55, repr.); Shone 1993 (pl.125; p.167)

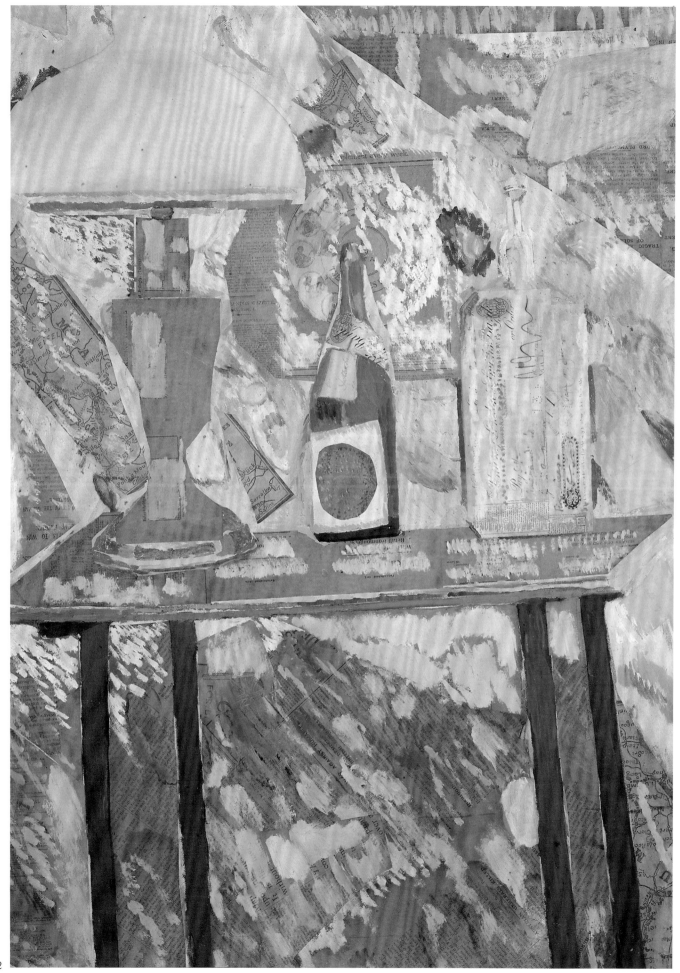

52

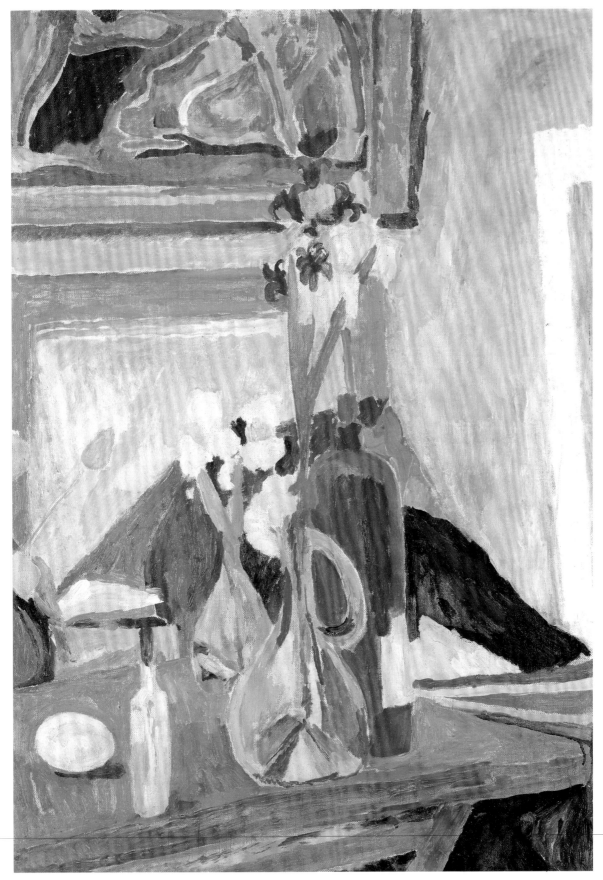

53

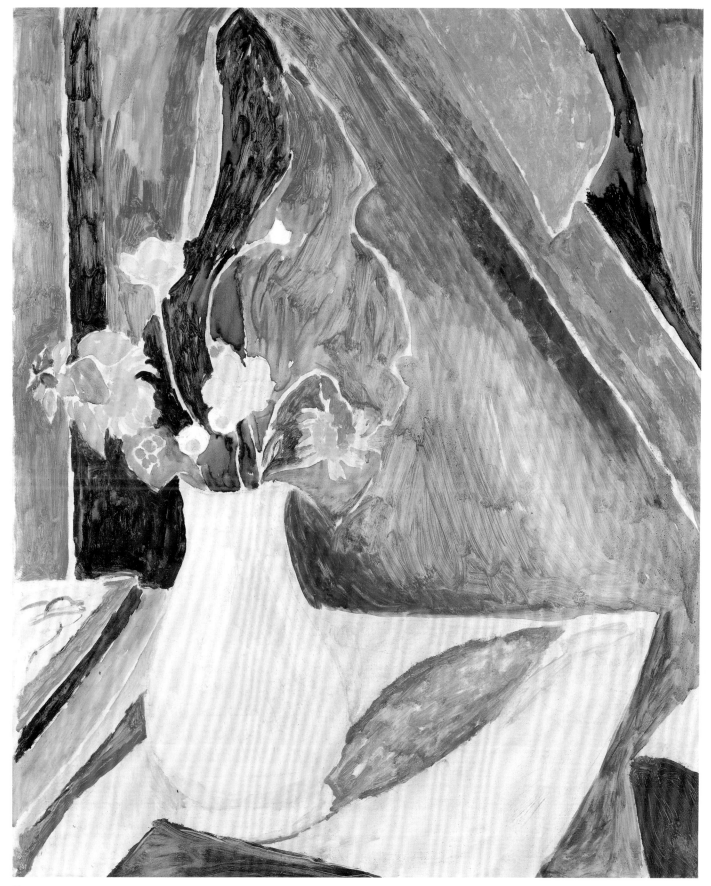

54

53 *Flowers in the Studio* 1915

Oil on canvas 78.7 × 55.2 (31 × 21¾)
Private Collection

The presence of hyacinths and tulips places this work in spring 1915, a date further confirmed by a segment of Grant's panel *Blue Nude with Flute* (see no.80) seen at upper left. It is uncertain where the work was painted; Eleanor House (see no.85) is a possibility, though it is doubtful whether Grant would have painted his sizeable panel there. The setting could be Bell's studio in Gordon Square or Grant's at 22 Fitzroy Street. For a Bell still life of this period it is unusually free in its composition and may have been an unarranged *chose vue* (though the egg on the table on the left looks suspiciously 'placed'). Echoing rhythms are established throughout the work within the geometry of frames, stretcher and trestle table. Although Matisse is an obvious source of inspiration for this painting, still lifes by Cézanne in which foreground objects are seen against the receding perspective of a room (e.g. the Courtauld Gallery's *Still Life with Plaster Cupid*), also influence Bell's subtle, informal composition.

Prov: Given by the artist to Virginia Woolf; to Quentin Bell; to d'Offay; to private collection 1988
Exh: d'Offay 1986 (no cat.); New York 1987 (108, repr.)

54 *Still Life: Wild Flowers* 1915

Oil on canvas 76.8 × 63.5 (30¼ × 25)
Sandy and Harold Price

The wild flowers suggest that the work was painted in the country (probably at Eleanor House; see no.85) rather than in London and although the work is uninscribed, the date of spring 1915 is most likely. The background is difficult to read but the top right shape may be a sloping easel; Bell would often include such accidental elements in her painting at this time but here she emphasises its formal necessity within the composition by an echoing shape in the shadow cast by the vase of flowers. The predominant colours of blue, ochre and pink in the background similarly appear behind David Garnett (no.36) also painted at Eleanor in spring 1915.

Prov: Gift from the artist to D. Grant; sold d'Offay to present owner, 1986
Exh: ?*Paintings by Vanessa Bell*, Omega Workshops, 1916; *An Exhibition of English and French Paintings*, Miller's, Lewes, 1943 (23); Adams 1961 (7); ACGB 1964 (31, repr.); Wildenstein 1964 (9); Bristol 1966 (109); New York 1980 (16); d'Offay 1984 (15, repr.); d'Offay 1986 (no cat.)

55 *The Glass* c.1916

Oil on canvas 25.4 × 35.6 (10 × 14)
Private Collection

The centrally placed glass seems both to absorb and emit a kaleidoscope of variegated colours in this modestly scaled but intensely realised still life. It is the most extreme example of a phase in Grant's development in which objects and background achieve an overall spatial and colouristic synthesis, as elaborated on a larger scale in, for example, *The Modelling Stand* (no.49). The first signs of this appear in a series of still lifes of late summer 1914 painted at Asheham House and contemporary with Bell's *Triple Alliance* (no.52). There the broken and meandering rhythms of a flint wall behind the alfresco still life are picked up in the grouping of the objects (see fig.95). *The Glass* probably dates to 1916 at a transitional moment in Grant's work when his earlier brilliance of colour was applied in patches of closely hatched strokes, seen here especially in the patterned cloth towards the top left. By this time Grant's painting activities were restricted by his agricultural work as a conscientious objector; a number of small still lifes resulted from his being allowed only a few hours a week in which to paint.

Prov: Artist's estate to d'Offay; Christie's, 11 Nov. 1988 (368) where bt S. Lummis; D. Gage where bt by present owner 1997
Exh: d'Offay 1984 (70); d'Offay 1986 (no cat.)
Lit: *Charleston Newsletter*, 23, June 1989 (p.62, repr. as '*The Vase c.1915*');
F. Spalding, *20th Century Painters and Sculptors*, 1990 (pl.7)

56 *Green Jug and Brush Pot* c.1917

Oil on canvas 36.8 × 25.4 (14½ × 10)
Private Collection

As with *The Glass* (no.55), the small scale and local subject matter of this work (a studio corner with canvas backs visible behind the pots and bottle) was dictated by Grant's curtailed opportunities to paint during the war. Without the day to day continuity of the studio, some of his inventive momentum was lost; modestly conceived still lifes such as this characterise his production in 1916–17. In late 1917, his health and nerves undermined, his work as a farm labourer was restricted on medical orders to afternoons only and he gradually entered a more prolific and ambitious period. With its unaffected transcription of the thing seen, this and similar works were practice runs for more solidly realised and larger still lifes of 1918–19.

Prov: The artist; to d'Offay by whom sold to present owner 1986
Exh: d'Offay 1986 (no cat.)
Lit: Naylor 1990 (p.223, repr.)

55

56

57

57 *The Coffee Pot* c.1918

Oil on canvas 61 × 50.7 (24 × 20)
The *Metropolitan Museum of Art, Purchase, Mr and Mrs Milton Petrie Gift, 1981*

Although not immediately legible, the setting for this still life of a metal coffee pot, milk-pan and glass rummer, appears to be one of the fireplaces at Charleston, most likely that in the dining room, with a decorated board around the grate, above which projects a stone slab on which the breakfast coffee and milk were kept warm. Grant seems to have placed a piece of card or paper behind the pot which acts as a sta-bilising rectangle for the high-pitched colour of the whole. Short, close-packed parallel brushstrokes, seen especially in the pot's vibrant reflections and the stripes around the decorated board, make up the tightly controlled surface, established around the dramatic black han-dle of the pot. Grant's earlier, more loosely calligraphic manner of painting had begun to wear unsatisfactorily thin. He had tackled the problem in a large, complex and somewhat lugubrious canvas of Charleston dining room (*Interior*, 1918; fig.34) and continued with a series of still lifes in which generally high colour is tailored to a new formal severity (fig.96).

The charcoal drawing (no.180) for this work clearly demonstrates Grant's realignment – there are relatively few preliminary drawings for still lifes before c.1918; *Interior*, too, was built up from a group of drawings and watercolours. In the notes made in October 1919 for his Carfax Gallery exhibition in January 1920 (Charleston Trust Archive), Grant lists the two coffee pot paintings, one larger than the other; the drawing may have been made between the two.

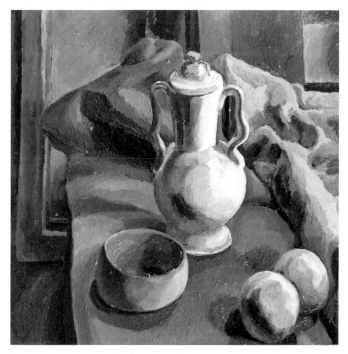

fig.96 Duncan Grant, *Still Life* c.1920, oil on canvas 61 × 61 cm. Private Collection

Prov: …; Christie's, New York, 9 Nov. 1979 where bt Mayor Gallery, London; bt d'Offay 1980; private collection; to Metropolitan Museum of Art, New York 1981
Exh: ?Carfax 1920 (9, as *Coffee Pot. No.1* or 25, as *Coffee Pot. No.2*; both 25 guineas); Dallas and London 1984 (19, repr.); Barbican 1997 (114)
Lit: Shone 1993 (pl.134)

58 *Paper Flowers* c.1917

Oil on canvas 72.8 × 51.2 (28¾ × 20¼)
Inscribed 'Duncan Grant' b.r.
Private Collection

Artificial flowers from the Omega Workshops and possibly a small fan are seen in a glazed terracotta pot on the edge of the sitting-room man-telpiece at Charleston. The distinctive pale green walls of this room formed a revealing background for strong primary colours, especially red and yellow (see the red flower in no.115) and Grant here makes the most of this singing contrast. The off-vertical angle of the shelf and support and of the chimney-breast wall on the right is a characteristic device of both Grant's and Bell's still lifes, a Cézannian tic which even-tually ran deep into their visual vocabulary. Grant's directional brush-strokes and the fact that the flowers are artificial suggest a date in late 1917 and the work is roughly contemporary with *The Coffee Pot* (no.57). A watercolour of the same subject (private collection) may have been painted after rather than before no.58.

Prov: The artist from whom bt by present owner
Exh: Not previously exhibited

ROGER FRY

59 *Chair with Bowl and Towel* c.1917–18

Oil on canvas 58.3 × 48.2 (23 × 19)
The Provost and Scholars of King's College, Cambridge

Fry came relatively late to still life, landscape and portraits having occupied him almost exclusively until c.1911. His first substantial, extant still life is the *Still Life: Jug and Eggs* (1911; Art Gallery of South Australia, Adelaide), the composition of which inspired, two years later, Fry's Omega linen *Amenophis*. There are occasional examples over the following years but it was not until c.1917 that they became numerous. A large group of paintings of flowers had an unexpected success when shown at the Carfax Gallery in November 1917, but there were other, less immediately seductive works, of which this is one of the most radically simplified in form and modest in compo-nents. It was probably painted in Fry's studio at 21 Fitzroy Street; the small watercolour (no.174) may have been done after the painting. 'I am particularly working on still life', Fry wrote to Charles Vildrac on 8 November 1917, 'trying to discover a more absolute construction and the ultimate simplification of all relationships. I find the idea of plas-ticity suggested by flat, or scarcely modelled volumes is much more powerful than that evoked by means of chiaroscuro. But it needs a very

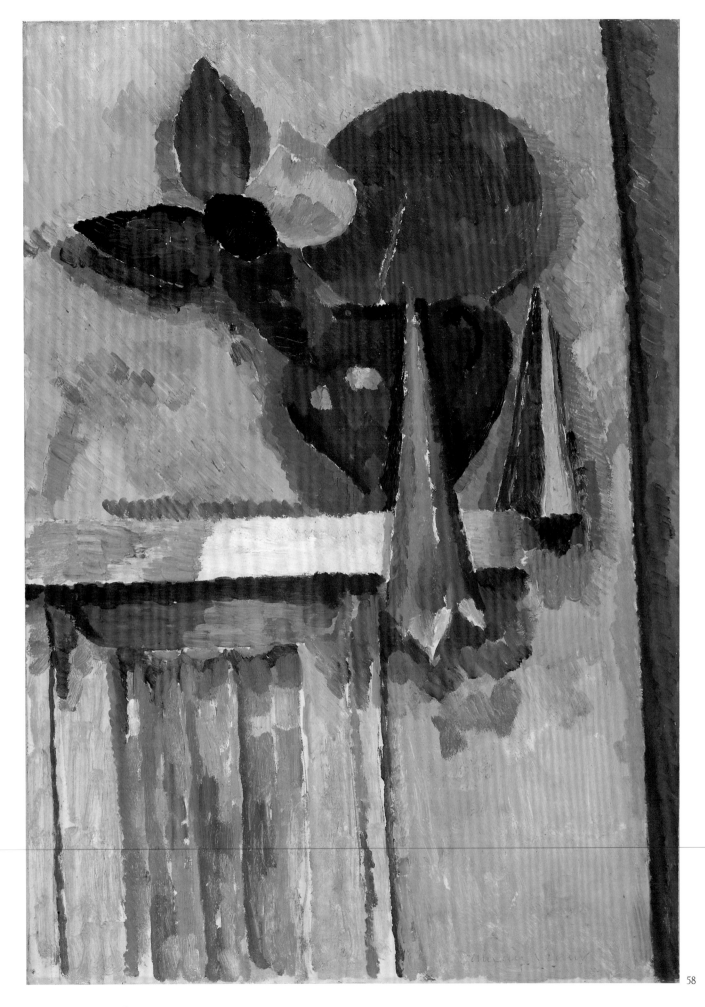

58

59

special drawing to succeed: it needs deformations to give the real idea' (Fry *Letters*, 2, 1972, p.419).

Several still lifes from 1917–18 are boldly simplified, made up of such apparently mundane elements that a note almost of banality is achieved, running parallel with a fastidious grasp of contour and weight. It is also worth noting that Fry was perhaps at his least happy during the latter part of the First World War: his relations with Vanessa Bell were at a low ebb, his health was poor, the Omega was not thriving, foreign travel was impossible and domestic happiness eluded him. The hours spent alone painting still life were a consolation and something of the stoical austerity of his mood at this time informs works such as this.

Prov: Bt J.T. Sheppard, *c.*1918; gift to King's College, Cambridge, 1954
Exh: (?) Omega Workshops, *c.*1918 (Omega label noting purchase on reverse); *Modern English Pictures from Local Collections*, Clare College, Cambridge, 1970

ROGER FRY

60 *Still Life with Italian Painting* 1918

Oil on panel 43.5 × 84 (17 × 33)
South African National Gallery, Cape Town

Fry rarely attempted the kind of unarranged, casual subjects that appealed to Bell and Grant; his still lifes are nearly always consciously determined. Here he comes closer to his colleagues in the apparent informality of his mantel-scape which, nevertheless, contains carefully chosen tokens of his life in 1918. The painting on the left is an early fourteenth-century Venetian *Crucifixion* which Fry owned for many years (it can be seen, for example, in a photograph of his London flat, 48 Bernard Street, in *c.*1930; repr. Fry, *Letters*, 2, 1972, fig.86; it is still in the possesion of the Fry family). It was almost certainly acquired in the early years of the century, probably in Italy and reminds one of Fry's continuing role as a connoisseur, particularly of Italian renaissance painting. The two cartons on the left seem to have been inspired by the two books on a step at the feet of Saints Peter and Paul in Crivelli's panel painting in the Accademia, Venice, which Fry knew well. In the centre is a black-glazed pot, thrown by Fry, containing several paper flowers made at the Omega Workshops; beyond the box on the right are 'two pouches of precious, rationed tobacco' (see d'Offay 1984). Side-lighting throws angular shadows from the flowers onto the chimney-breast. If Chardin is an obvious source for this perfectly spaced reading of domestic clutter, the flowers add a fantastic note often sounded in Fry's work (e.g. artichoke leaves in *Flowers*, *c.*1912, Tate Gallery, *Madonna Lily*, 1917, Bristol City Art Gallery, and *Paper Flowers on the Mantelpiece*, *c.*1919 (fig.97; untraced) similar in conception to no.60).

Prov: The artist to P. Diamand; d'Offay by 1983; bt National Gallery of South Africa 1984
Exh: *London Group Exhibition*, Mansard Gallery, Heal's, May 1918 (2); Colchester 1959, (33); *Vision and Design* 1966 (83); d'Offay 1984 (31); *Focus on Bloomsbury*, National Gallery of South Africa, Cape Town, and touring, 1987–8 (7, repr.)

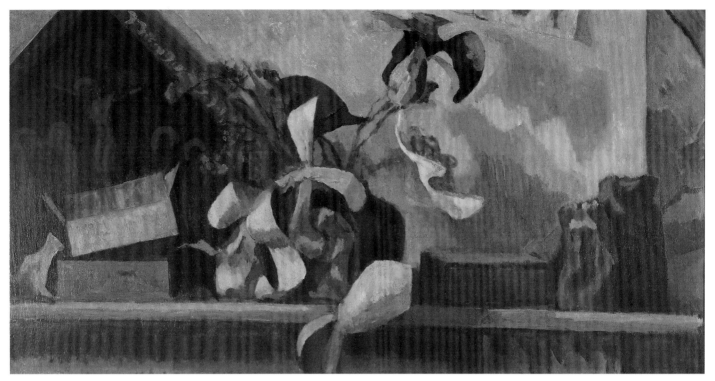

60

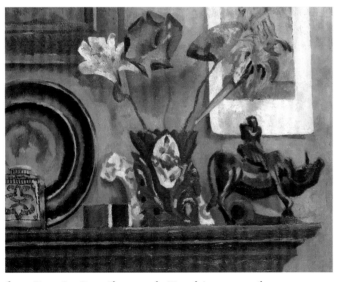

fig.97 Roger Fry, *Paper Flowers on the Mantelpiece* c.1919, oil on canvas on board 42 × 50.8 cm. Present whereabouts unknown

ROGER FRY

61 *Still Life with Omega Flowers* 1919

Oil on canvas 59.9 × 44.2 (23½ × 17⅜)
Inscribed 'Roger Fry 1919' b.l.
Tatham Art Gallery, Pietermaritzburg

In January 1919 Fry wrote to Vanessa Bell about a possible commission for the Omega to design the sets for a new play starring Lillah MacCarthy; he suggested to Bell, who had asked him if she could help the Omega whose staff was devasted by the epidemic of Spanish influenza, that she make some artificial flowers: 'I want some quite monstrous orchid-like flowers for the East African play. They should be phallic and *funeste* but rather by implication than any direct statement' (20 January 1919, TGA). It is not known whether Bell complied (and the play did not materialize) but it is possible that the four extravagant blooms seen here in a black Omega vase, were made by her. Certainly they are different from any of those in paintings noticed so far and, in Fry's detailed transcription, answer to his desire for flowers even more bizarre than those customarily produced at the Omega. The vertical bands of differentiated colour behind the vase and table (with its Archimboldo-like piece of fruit or vegetable) suggest the painting was carried out in Fry's new London home at 7 Dalmeny Avenue, Holloway, into which he moved in February – March 1919: he painted and papered his studio walls in different colours to form varied backgrounds for his work (e.g. fig.7).

Prov: Fry family; ...; bt from d'Offay by present owner 1984
Exh: d'Offay 1984 (32); *Focus on Bloomsbury*, National Gallery of South Africa, Cape Town, and touring 1987–8 (10, repr.)

61

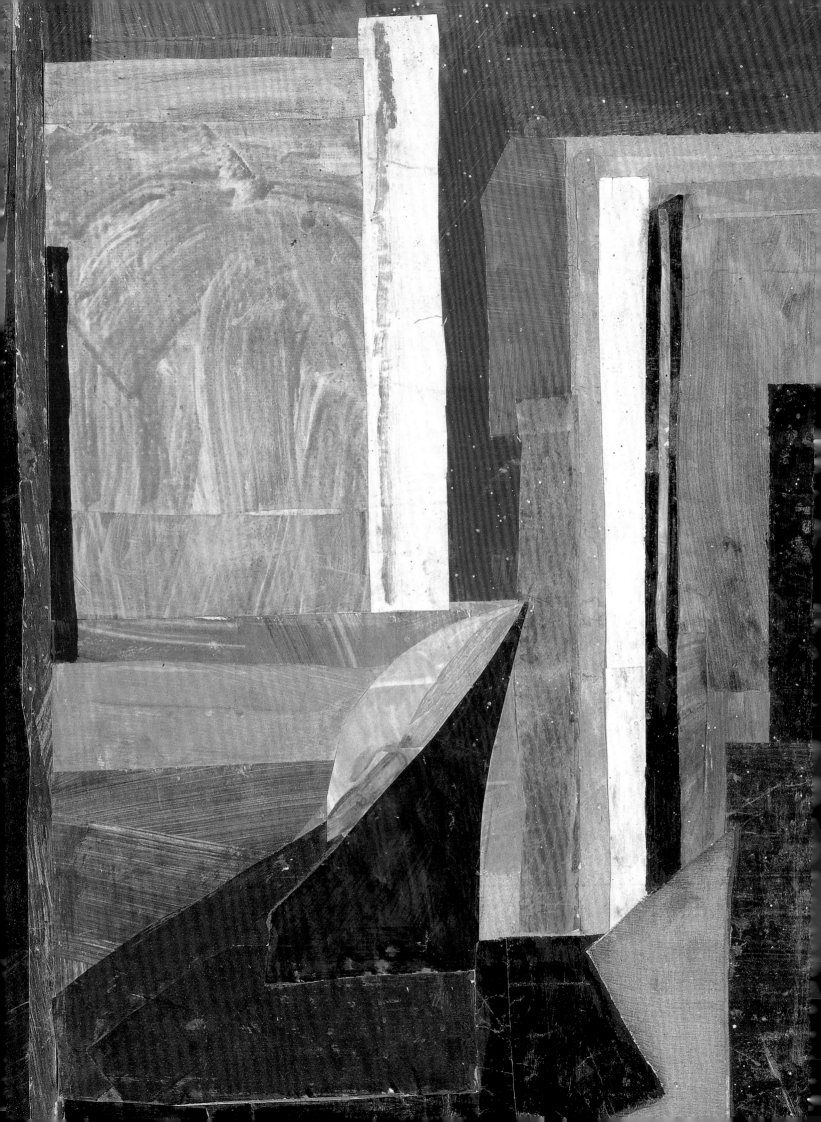

Vision and Design

*The Omega Workshops: furniture, applied art, paintings,
works on paper 1911–18*

The Omega Workshops Ltd opened to the public in July 1913, its showrooms and studios in a house at 33 Fitzroy Square. Fry was its driving force and director; Grant and Bell were shareholding co-directors. Along with these three, the artists principally identified with the opening displays of furniture, wall decorations and textiles were Wyndham Lewis, Frederick and Jessie Etchells (see no.24), Edward Wadsworth, Henri Doucet (fig.79) and Cuthbert Hamilton. Later, a further cross-section of artists was associated with the enterprise, among them William Roberts, Paul Nash, Nina Hamnett (see no.175) and Henri Gaudier-Brzeska. All works were sold anonymously, designs for future items were centrally pooled and artists were paid so much per day (usually seven shillings and sixpence). There was a business manager, accountant, caretaker and a changing cast of assistants in the salesroom and studios. Outside craftsmen and manufacturers were employed for printed fabrics, carpets, furniture and, later, pottery. Whole interiors were undertaken (see nos.63 and 92) and Omega wares were prominent in various fine and applied art exhibitions in London. There was good press coverage, most of it favourable, and eventually the Omega sold work abroad. During the war, concerts, lectures and 'evenings' were organised, as well as theatrical performances, and its activities included a dress-making department and the publishing of books. A series of temporary exhibitions included one-artist shows devoted to McKnight Kauffer, Alvaro Guevara and Mikhail Larionov as well as Vanessa Bell's first solo exhibition (1916); shows of children's drawings and contemporary copies of old-master paintings were also mounted. The clientele was wide-ranging – from curious members of the public and commercial organisations to 'ladies of fashion' and Fry's writer friends such as George Bernard Shaw, W.B. Yeats, Arnold Bennett and most of those associated with Bloomsbury; visitors over the years included Rupert Brooke, Augustus John, Ezra Pound, Gertrude Stein, Derain and Picasso.

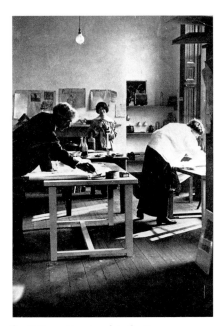

fig.98 Roger Fry at work in the Omega Workshops c.1913

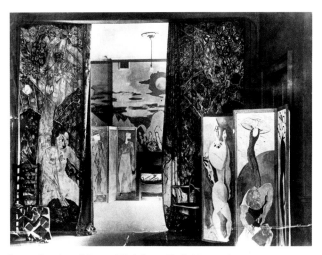

fig.99 Opening of Omega Workshops, *Daily News*, 7 August 1913. At right, screen by Wyndham Lewis; centre background, screen by Duncan Grant; curtains by ?Henri Doucet; on chair on left, textile *Maud* by Vanessa Bell

opposite detail from Duncan Grant, *Interior at Gordon Square* c.1914–15 (no.75)

The years 1913–14 saw the Omega at its most innovative: outstanding are its abstract fabrics and carpets, simple unadorned furniture (no.62 and 64) and pottery (no.95) that was distinctly ahead of its time in Britain. An artist's personal spontaneity of expression formed the keynote within the homogeneous sensibility of the Omega style; good craftsmanship, at least in the early days, was encouraged; professionalism went hand in hand with informality; it was revolutionary yet amenable. Several strands of the London avant garde were brought together in a moment of unprecedented collaboration. However, by the autumn of 1913, Wyndham Lewis felt that Fry's dominance in the enterprise and the Omega's rule of anonymity were oppressive. Taking the mismanaged commission for an Omega room at the Ideal Home Exhibition as the excuse for their dissatisfaction, Lewis, along with Wadsworth, Etchells and Hamilton, seceded, issuing a letter to the press and to patrons of the Workshops which attacked Fry and the aesthetic foundations of the Omega. Some of their complaints were vindicated in the subsequent dissipation of the Omega's house style. After the outbreak of war in 1914 it became increasingly difficult to attract new artists, sales and commissions fluctuated and Fry's stalwart collaborators, Grant and Bell, were in rural retreat. By the later stages of the war, though still prolific, the Omega was producing little of interest and some of its earlier innovations were already being commercially rehashed by mainstream manufacturers. By 1919 Fry was eager to concentrate on his own painting and writing and the Omega was losing money; in June – July that year a clearance sale was held and the company went into voluntary liquidation a year later.

This section shows three groups of works by Fry, Bell and Grant: Omega furniture and objects; designs on paper; and paintings of the Omega period or ones such as Grant's *Bathing* (no.71) or Bell's *Summer Camp* (no.82) which anticipate or relate to the Workshops' style and activities.

(*Vision and Design*, essays by Roger Fry, 1920)

62

62 *Omega Chair* 1914

Painted wood and cane seat and back 130.2 × 50.8 × 54.6
(51¼ × 20 × 21½)
The Charleston Trust

These simple, comfortable dining-room chairs were designed by Fry in 1913 and made by the Dryad Company, Leicester. Most were painted in a red lacquer, others were in grey; originally the cane was gilded; and a few had a wood circle attached to the top of the back but this 'Byzantine' addition was thought unnecessary by Grant and Bell and they were soon discontinued. The chair proved to be one of the Omega's most successful products and a number of them survive. They appear in several paintings including Alvaro Guevara's portrait of Edith Sitwell (1919, Tate Gallery) and Clive Bell's portrait by Roger Fry (*c.*1921–2, NPG).

Prov: V. Bell; A.V. Garnett to Charleston Trust 1984
Exh: *The Omega Workshops*, Miller's, Lewes, 1946
Lit: Collins 1983 (pp.58–9)

63 *Marquetry Desk for Lalla Vandervelde* 1916

Holly and ebony 97.8 × 99 × 53.3 (38½ × 39 × 21)
G.E. and J.A. Hedley-Dent

This writing desk belongs to a whole suite of furniture produced by the Omega for the flat of Mme Lalla Vandervelde in Rossetti Garden Mansions, Flood Street, Chelsea. Although most of the furniture was painted (by Fry and others), this desk was exceptional in that it was the only marquetry item supplied and is completely abstract in idiom. Inlaid furniture and trays (see no.98) were crafted for the Omega by the cabinet-maker Joseph Kallenborn of Stanhope Street, across the Euston Road from Fitzroy Square. An inlaid occasional table by Fry (Art Gallery of Western Australia, Perth) and a cupboard with marquetry doors still exist and a table with drawers designed by Duncan Grant is known from photographs. The present desk however seems to have been the last piece of inlaid furniture made for the Omega.

Lalla Vandervelde (née Speyer) was born in Belgium in 1870; in 1901 she married her second husband Emile Vandervelde, leader of the Belgian Socialist Party. She knew London well and during the First World War was an indefatigable fund-raiser for the Belgian cause in Britain and the United States. She was attractive, adventurous and cultured, and among her friends were Edward Elgar, Arnold Bennett and Roger Fry. She bought paintings from the Omega and was painted by Fry in 1917, after her flat was completed (which is mentioned as 'Omega Flat' in Arnold Bennett's journal for 28 January 1917). She did not stay long

63

in Flood Street and moved to 34 Kensington Square where the Omega reinstalled her furniture and decorations. Between the wars she became an eccentric and flamboyant figure known throughout Europe, especially after she successfully took up motor racing at the age of sixty. She returned to England in the 1950s and died in 1965. She gave her Omega furniture to her brother and sister-in-law, who presented most of it to the Victoria and Albert Museum after her death. Her racy autobiography *Monarchs and Millionaires*, was published in 1925.

Prov: Mme Lalla Vandervelde to Mr and Mrs F.C.O. Speyer; by descent to present owners
Exh: *Vision & Design* 1966 (188); Crafts Council 1984 (F16, repr.)
Lit: *The Journals of Arnold Bennett*, ed. N. Flower, 2, 1932 (p.184); *Illustrated London News*, 26 March 1966 (p.31, repr.); Collins 1983 (p.143)

OMEGA / DUNCAN GRANT

64 *Lily-Pond Table* c.1913–14

Oil on wood 125.5 × 72.5 × 80.5 (49⅜ × 28½ × 31¾)
Art Gallery of South Australia, Adelaide. South Australian Government Grant 1984

The genesis of Grant's lily-pond design is typical of several works which he carried out for the Omega. First came his painting of Pamela Fry (no.17) by the goldfish pond at Fry's home, Durbins, of summer 1911; there followed, perhaps late 1912, a sketch in oil on paper of gold-fish in a lily-pond with a framing border (private collection). The lily-pond table (no.64) probably came next in 1913. Collins records: 'Grant

remembered that as he was working with the pots of warm size colour beside him, Fry urged him to take the pots and pour some colour straight onto the table top so that lilies, leaves, goldfish and water all became random pools of colour' (Liverpool 1980, p.11, no.5). Several table tops and screens (fig.100) and at least one chest of drawers were treated in this manner and were a popular Omega item. The table top is more figuratively based and clearer in colour than the screen (the best version of which is in the Fry Collection, Courtauld Gallery; another lily-pond table is at Charleston). Assistants may have carried out these further versions based on Grant's prototype. The design is the most freewheeling of all those to have survived from the Omega where a more geometric abstraction predominated. It is one of Grant's most spectacular inventions and prefigures the marbling technique he later developed in both easel and decorative works (e.g. *Flowers in a Glass Vase*, no.81).

Prov: C. Bell; to Q. Bell; d'Offay by 1983 where bt Art Gallery of South Australia 1984
Exh: d'Offay 1984 (no.113, repr.); *Bohemian London: Camden Town and Bloomsbury Paintings in Adelaide*, Art Gallery of South Australia, Adelaide, 1997 (p.76, repr.; pp.52, 53)
Lit: Shone 1993 (pl.83, p.104)

fig.100 Duncan Grant, *Lilypond Screen* for Omega Workshops, 1913, oil on wood, each panel 183 × 61 cm. Private Collection

65 *Painted Omega Screen* 1913

Gouache on paper on four wood panels (front); oil and acrylic (back)
174.7 × 50.8 (68¾ × 20) each panel
The Charleston Trust

Grant included screens in many of his paintings of interiors (such as no.8) and painted them at all periods of his life. For the Omega Workshops he and Wyndham Lewis both showed painted screens at the opening of the showrooms in Fitzroy Square; Grant's lily-pond screen was produced several times, a screen with blue sheep on it was painted in early 1913 (Victoria and Albert Museum) and one with horses on it was owned for many years by the Strachey family (though it had disappeared by 1959).

This four-panelled screen, on view at the Omega in July 1913, probably belongs to early that year. Grant employs the schematised drawing and hatched lines found in contemporaneous paintings such as *The Tub* (no.72) and *Slops* (1913, private collection). Two figures (male and female) carry a blue pail of milk (according to the artist) along the edge of a wall or building; they turn their heads to gaze at something beyond the frame. Several of Grant's works of this period are based on local, London incidents. It is possible that these other-worldly milk-carriers were in fact inspired by a common sight at the large dairy in Wakefield Street at the back of Brunswick Square where Grant was then living and which was visible from the house.

The back of the screen had been painted with a rectilinear arrangement of plain colours, but by the late 1960s these had somewhat faded and been damaged. In c.1969–70, Grant repainted the back (after conservation) using thinned acrylics and oil paint, keeping to the original design but changing some of the colours. The screen was in his Fitzroy Street studio (see Bell's *8 Fitzroy Street*, c.1936, Royal West of England Academy, Bristol) before being removed to Charleston in 1939 (see Bell's *The Housemaid*, 1939, Williamson Art Gallery, Birkenhead) and was included in several of his late paintings.

Prov: D. Grant; to A.V. Garnett 1978; to Charleston Trust 1984
Exh: Opening Display of the Omega Workshops, July 1913; Norwich 1976–7 (62); Liverpool 1980 (4); d'Offay 1984 (112)
Lit: Q. Bell and S. Chaplin, 'The Ideal Home Rumpus', *Apollo*, 80, Oct. 1964 (p.287–91; pl.XI, fig.7); Shone 1976 (pl.63); Anscombe 1981 (pl.11); Watney 1990 (fig.27 and pl.11); Shone 1993 (pls.77 and 78)

65 (front)

65 (back)

66

fig. 101 Interior by Omega Workshops in a house in ?Bedford Square, with firescreen by Duncan Grant and sculpture, *Group*, by Roger Fry

67

68

66 *Embroidered Firescreen* 1912–13

Silk on linen 70 × 57 (28 × 23¾)
Bryan Ferry Collection

See entry no.67.

Prov: Lady Ottoline Morrell to her daughter Julian Vinogradoff; London
saleroom where bt d'Offay 1980; to present owner by 1980
Exh: Dallas and London 1984–5 (16, repr.)
Lit: Anscombe 1981 (pl.1)

67 *Design for Firescreen* c.1912

Oil on paper 83 × 75 (32¾ × 29⅝)
Inscribed 'D.Grant 1911' b.r. (in 1970)
Private Collection

In late autumn 1912 Fry was encouraging the artists in his circle –
notably Bell, Grant and Frederick Etchells, all of whom were showing
work in the Second Post-Impressionist Exhibition at the Grafton Gal-
leries – to produce furniture and items of applied art for the First
Grafton Group exhibition (March 1913, Alpine Club Gallery) as a
foretaste of the Omega Workshops opening later that year. Grant
appears to have made two designs for firescreens, related in composi-
tion but highly different in colour. In September 1912 Lady Ottoline
Morrell had written to Grant asking for a design for a firescreen which
she was to carry out in silk. This object is shown here as no.66 and the
design for it (Shone 1993, pl.69) bears an early inscription 'D. Grant
1912'. A sketch for this on the back of a letter was among Grant's
papers at Charleston; a larger preliminary design is in the Fry Collec-
tion, Courtauld Gallery (Naylor 1990, repr. frontispiece).

The second firescreen (no.68), embroidered in silk by Vanessa Bell,
for which this is the design, was in a much cooler colour-scheme and
omits the birds seen among the five flowers in no.66. She seems to have
worked this during 1913 in readiness for the Omega Sitting Room at
the Ideal Home Exhibition in October. She wrote to Fry from Asheham
House, 18 September 1913: 'The size of the screen is 34 in. x 31 in. I am
going on working at it and getting much quicker I think but I certain-
ly shan't have it done in time.' The size she gives here does not include
the striped border which may have been Bell's own invention as it
appears on none of Grant's designs. Further versions of this screen are
known from contemporary photographs, particularly the one seen in
fig.101 which may be painted rather than embroidered; and the design
appears on a silk cloak painted by Grant and worn by Nina Hamnett
in a photograph taken at the Omega which also includes a glimpse of
the screen (repr. Crafts Council 1984, p.16). Both these firescreens are
exceptional for their time. Of no.68 Paul Nash was to write that 'it is a
very beautiful and successful achievement' and, along with Omega
fabrics, heralded, ten to fifteen years in advance, the typical 'art deco'
textile patterns of the 1920s and early 1930s (P. Nash, 'Modern
English Textiles', *Artwork*, January – March 1926, pp.80–7). The
schematic curves, simplified rhythms and striated facets of the back-

ground (seen more especially in no.66) are obviously indebted to
Picasso's work of 1907, e.g. the still lifes *Pots et Citron* (fig.51) which
was owned by the Bells, and *Vase of Flowers* (1907; Zervos II, 30) as
well as *Nude with Drapery* (1907; Zervos II, 47) and its studies then
owned by Gertrude and Leo Stein.

Prov: Bt from the artist by present owner 1970
Exh: Norwich 1976–7 (58B)
Lit: Shone 1976 (pl.62)

68 *Embroidered Firescreen* 1913

Silk on linen 93 × 85.2 (36⅝ × 33⅝)
The Provost and Scholars of King's College, Cambridge

See entry no.67

Prov: J.M. Keynes by whom bequeathed 1946
Exh: ?Omega Workshop, c.1913–14; *Embroiderers' Guild Exhibition*, Walkers
Galleries, 1923; *Modern Designs in Needlework*, Independent Gallery, Oct. 1925;
Miller's, Lewes, c.1943; Tate 1959 (127); Liverpool 1980 (7); Cambridge 1983 (96,
repr.); Crafts Council 1984 (S9)

69 *Painted Omega Screen (Tents and Figures)* 1913

Pencil and gouache on paper on canvas, on four panels,
178 × 208 (70⅛ × 81⅞) overall
Omega symbol b.r.
The Board of Trustees of the Victoria and Albert Museum

For a discussion of this screen see no.82, the painting on which its
design was based. At some point it gained the title *Bathers Screen* and,
although water played no part in its conception, it does share the
theme of women naked in the open air, prevalent in the work of the
French artists Bell admired, including Cézanne, Denis, Matisse and
Derain as well as some of the artists of Die Brücke. It was a subject to
which she returned in the 1950s. For related Omega designs see nos.92
and 93.

Prov: R. Fry; to H. Anrep 1934; Anrep family from whom bt by present owner
Exh: Omega Workshops 1914–15; used on stage for the London run of Israel
Zangwill's *Too Much Money*, 1919; *The Omega Workshops*, Victoria and Albert
Museum 1964 (no cat.); Crafts Council 1984 (S2, repr.); London and Stuttgart
1987 (25, repr.)
Lit: Cork 1976, I (p.88, repr.); Shone 1976 (pl.III); Anscombe 1981 (pl.3); J.W.
Adams, *Decorative Folding Screens*, New York, 1982 (p.155, repr.); Collins 1983
(pl.33; pp.179, 180, 181); Spalding 1983 (repr. btw. pp.80–81); Naylor 1990
(p.244, repr.); Marler 1993 (pl. p.VII); Shone 1993 (pl.64 and p.173)

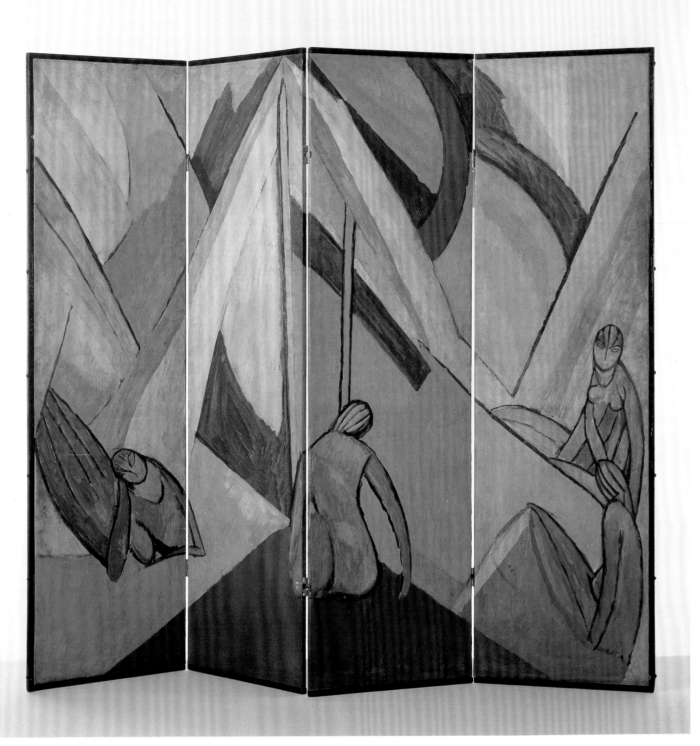

69

70 *Design for Overmantel Mural* c.1913

Oil on paper 76.2 × 55 (30 × 22)
Yale Center for British Art, Paul Mellon Fund

In a group of photographs of c.1913 Vanessa Bell and Molly Mac-Carthy are seen naked in Bell's studio at 46 Gordon Square, standing against an enormous canvas in progress, pinned to the wall behind them. The painting has not survived but its squared-up design is extant (Spink 1991, 5, repr.) and shows that the work was intended as a wall decoration to be fitted around a fireplace. The present work may have been a preliminary idea in which only the space above the mantelpiece has been considered. Both these designs were in Bell's studio at her death which suggests they could have been part of a private project rather than a design for the Omega. In their interior decorations, Bell and Grant made the wall above the fireplace and the surround of the grate itself, the visual focus of the room, just as it was its domestic heart. Firescreens, draught-excluding screens, tiled hearths and grate surrounds occupied an important role in their applied art at a time when few of the old houses in which they frequently worked contained central heating. Grant took the theme of heating to an extreme in his painted volcano above a fireplace in Mary and St John Hutchinson's house (1918). Sometimes they painted the whole chimney breast from shelf to cornice; at other times they decorated around an existing mirror or framed painting using marbling, stippling or simple abstract patterns. Painted decorations that included figures are rarer and this and its related design are Bell's only known examples. Bell's massive nudes, indebted to Matisse, their schematic form related to her own paintings such as *Street Corner Conversation* (1913, private collection), are carried out in a characteristic harmony of grey-greens, blue, ochre and indian red with accents of black.

Prov: Artist's estate; private collection 1967; d'Offay; bt from Spink by present owner 1993
Exh: Folio 1967 (5); New York 1980 (17); d'Offay 1984 (5); d'Offay 1986 (no cat.); Spink 1991 (4, repr.)
Lit: Collins 1983 (p.16; pl.3); Shone 1993 (pl.75)

70

DUNCAN GRANT

71 *Bathing* 1911

Oil on canvas 228.6 × 306.1 (90 × 120½)
Signed indistinctly b.r.
Tate Gallery, London. Purchased 1931

Bathing is Grant's first substantial painting intended for a specific, public interior and the first of a long series of works celebrating the naked male body out of doors, both in action and in repose. It and its companion painting *Football* (1911, Tate Gallery) were his two most advanced works to date, their fusion of pictorial conventions outstripping the relatively restrained language of his easel painting at that time and going beyond his mural for Maynard Keynes in Cambridge of 1910–11 (see no.10). Equally important, they belong to a group of seven paintings by six artists, assembled by Roger Fry for the decora-

fig.102 Model posing for *Bathing*, photographed by Duncan Grant 1911.
Private Collection

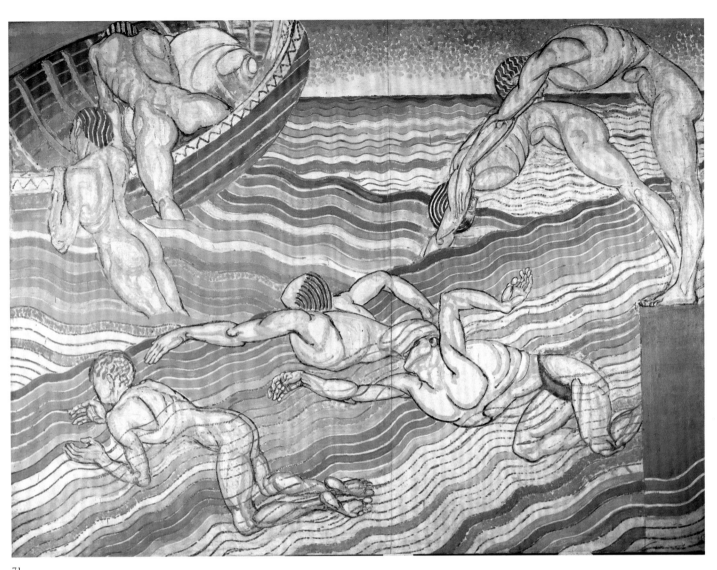

71

tion of a particular room and thus they form a collaborative prototype for the Omega Workshops which opened two years later. Basil Williams, a Cambridge friend of Fry, was Chairman of the House Committee of the Borough Polytechnic at the Elephant and Castle, south London. He approached Fry with the suggestion that the students' dining room might be decorated by a group of young Post-Impressionist artists, the cost of the enterprise to be kept to about £100. Fry selected Frederick Etchells and Bernard Adeney, as well as Grant and himself and later recruited Macdonald Gill and Albert Rothenstein (later known as Rutherston). The overall theme of the paintings was 'London on Holiday' and the work comprised *The Fair* (Etchells), *The Zoo* (Fry), *Sailing Boats* (on the Round Pond, Kensington Gardens, by Adeney), *Punch and Judy* (Gill), *Paddlers* (Rutherston) and Grant's two works inspired by bathing and football in Hyde Park (where nude bathing was allowed in the Serpentine). The paintings appear to have been carried out *in situ* and included a unifying repeated geometric border, probably devised by Fry, and a brightly coloured passage and stairs into the room.

When finished and inspected by the press, the murals received wide coverage and several reviewers picked out Grant's contribution for special praise (e.g. *The Times*, 19 September 1911, and J.B. in the *Spectator*, 11 November 1911); others described the room as a 'nightmare',

'travesties' likely to have a degenerate influence on the Polytechnic's working-class students (*National Review*, December 1911). The stylistic uncertainty shown by the six artists of the scheme was almost inevitable. Even so, Grant demonstrated to Etchells how they might all proceed by painting a single head in a simplified, slightly 'primitive' manner; this derivation from early Christian mosaics was acknowledged by reviewers at the time even though, years later, Grant denied any Byzantine influence (in conversation with David Brown, August 1972, typescript in TGA).

It is obvious that Grant's visit earlier in 1911 to Sicily where he saw the mosaics in the cathedral at Monreale and in the Cappella Palatina, Palermo, had an immediate impact on his work. The figure of Adam in the *Creation of Eve* mosaic in Palermo is remarkably similar to Grant's bather in muscular definition, in the ribbed pattern of each swimmer's hair and the way the colour darkens towards the contour. Furthermore, the border around all the paintings, as Collins has pointed out, is close to the similar patterned boundaries used in the Kariye Camii in Constantinople which Fry had visited a few weeks before the Polytechnic decorations were planned. Grant's return from Sicily took him through Rome where he visited the Sistine Chapel: Michelangelo's figures undoubtedly inform Grant's contemporary cockneys. After Rome, he moved on to Paris where he visited Matisse and may have

paid the first of several visits to Gertrude and Leo Stein and have seen their Picasso collection. All these references combined to form Grant's eclectic but increasingly personal style as found in *Bathing*. In London he employed a model for the swimmers and worked from photographs of him (fig.102). The final mural shows a single movement from right to left, the figure seen in seven postures from diving to swimming and clambering into the boat. This almost circular movement relates to Grant's mural for Keynes and to his two versions of *The Dancers* (see no.10) of 1910–11.

Prov: Borough Polytechnic, London; Tate Gallery purchase 1931
Exh: *Mural Decorative Paintings*, Whitechapel Art Gallery, 1935 (105); Tate 1975 (7); Barbican 1997 (101)
Lit: Mortimer 1944 (p.10); J. Rothenstein, *Modern English Painters*, 1956 (p.51); Shone 1976 (pl.34; pp.66–71); S. Wilson, *British Art*, 1979 (p.128, repr.); Watney 1980 (p.91; pl.82); Spalding 1980 (p.149); Collins 1983 (pp.11–17, pls.1, 2); Cork 1985 (pp.119–21, pl.149); Watney 1990 (p.31; pl.7); Shone, 1993 (pl.49; pp.63–7); Spalding 1997 (pp.110–12)

72 *The Tub* c.1913

Oil, wash and wax varnish on paper on canvas 76.2 × 55.9 (30 × 22)
Inscribed 'D Grant 1912' b.l. (later inscription)
Tate Gallery, London. Presented by the Trustees of the Chantrey Bequest 1965

Grant's almost hectic assimilation of influences in the period 1910–14 makes his output intractable in terms of precise dating and difficult to assess. In a number of works, rudimentary borrowings undermine his personal vision, no more obvious than in paintings indebted to certain stylistic hallmarks of Picasso's work of *c.*1907–8. In *The Tub*, however, that personal note is achieved, in spite of its many derivations – African sculpture, Picasso, Ravenna mosaics, Matisse. The mood, both grave and vernal, and the construction based on interlocking rhythmic phrases, show Grant in command of his repertory. Almost

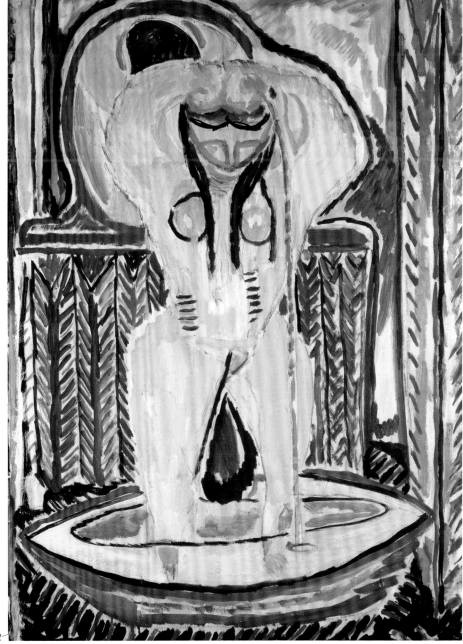

72

certainly this nude was inspired by Vanessa Bell bathing and belongs to the two artists' early intimacy (Bell told Fry in a letter of 29 September 1913, after Grant had been at Asheham with her for several days and returned to London, that it was 'very odd having my bath alone'). There are several drawings of Bell bathing and another painting of c.1915–16 which exists only in a later copy, the earlier version having been destroyed in a fire (fig.25); on this, Grant also based a woodcut (see no.107C). Although Grant, later, dated this work 1912 it more likely belongs to 1913 and shows similarities with Grant's *Adam and Eve*, fig.30, completed late that year (destroyed after 1929; the Tate Gallery's *Head of Eve* (fig.20) is a study for this work) and the hatched angularities of *Slops* (private collection) and *Nepi* (spring 1913; Bryan Ferry Collection).

The subject matter, a naked woman taking a bath, was not of course new (though Grant later denied any inspiration from Degas) but it was not common in England. Sickert's nudes in interiors are rarely washing, even though the washstand and mirror make many appearances in his work; very close in subject are Etchells's *The Hip Bath* (1911–12; Fry Collection, Courtauld Gallery) and Bell's Charleston decoration, *The Tub* of 1917 (fig.150).

Vanessa Bell acquired the work early on from Grant (though not in June 1912 as stated in Shone 1993, pl.62). It remained one of the artist's favourites among his works and in 1975 on the BBC radio programme *Desert Island Discs* he chose it as the painting by which he would like to be remembered.

Prov: Bt from the artist by V. Bell; to A.V. Garnett 1961; Chantrey purchase for Tate Gallery 1965
Exh: Wallace Collection 1940 (127); *Some 20th Century English Paintings & Drawings*, Arts Council, Wales, 1950 (48); Tate 1959 (21); Tate 1975 (9)
Lit: Cork 1976, 1 (p.21); Shone 1976 (pl.52); P. Roche, *With Duncan Grant in Southern Turkey*, 1982 (repr. opp. p. 56); Watney 1990 (pl.14); Shone 1993 (pl.62); Spalding 1997 (repr. btw. pp.144–7)

73

73 *Tents* 1913

Oil on hardboard 62.2 × 75.2 (24½ × 29½)
Inscribed 'D. Grant' b.l.
Private Collection

For a discussion of the context of this work in relation to Bell's painting *Summer Camp* and her Omega designs, see no.82. Grant painted two versions of *Tents*. The other one (Bryan Ferry Collection; repr. Shone 1993, pl.63) was probably painted in front of the motif – it is less conceptually coherent and has a more vivid, naturalistic range of colour. No.73 (the same size as the other version) may have been begun *in situ* and finished elsewhere. In spite of the patently Cézannian handling of the trees (e.g. *Le Grand Pin*, São Paulo Museum of Art, which had been in the 1910 exhibition *Manet and the Post-Impressionists*) and the Picasso-derived hatching of parallel brushstrokes in the foreground, Grant's own rhythms break through to establish his particular blend of understated wit and calligraphic invention.

Clive Bell persuaded Mary Hutchinson to buy no.73: 'Are you seriously on the look out for a Duncan? ... there is what I consider a very good one going – tents and trees; I suppose it costs about twenty pounds' (Clive Bell to Mary Hutchinson, 16 July 1914, Humanities Research Center, University of Texas).

Prov: Mary Hutchinson 1914; by descent to present owner
Exh: Wallace Collection 1940 (133); *40 Years of Modern Art. A Selection from British Collections*, Academy Hall, Oxford Street (an ICA exhibition), 1948 (pl.18); Tate 1959 (29)
Lit: Fry 1923 (pl.7); Mortimer 1944 (pl.2)

74 *Interior, 46 Gordon Square* 1914

Oil on wood panel 40 × 32.1 (15¾ × 12⅝)
Inscribed 'D. Grant 1914' b.r.
Tate Gallery, London. Purchased 1969

This is among Grant's earliest near-abstract paintings, based on the view between the front and back rooms on the first floor of the Bells' house at 46 Gordon Square, the front room being Vanessa Bell's studio. The painting contains elements recognisable as door frames, a chair, a sofa seen lengthways, canvases and windows, offering that interplay of verticals and horizontals that marks most of Grant's figurative work. Almost certainly it belongs to mid to late 1914 when Grant was frequently painting alongside Bell in this studio. The essential geometric scheme of the work is interrupted by the central sofa with its slim ellipse, a recurrent shape in Grant's work at this period (see the lemon in *The White Jug*, no.79); also the more loosely painted area of 'floor', with its irregular edge, provides counterpoint to the schematic architecture around it. The larger collage, no.75, was almost certainly made after the painting and provides a perfect example of Grant's habit of making at least two versions of a given motif. The papers used would have been painted beforehand. The collage technique demanded less detail than that found in the painting (e.g. the elimination of the chair legs) emphasising the rectilinear nature of the work yet retaining something of the double-interior which formed the basis of his inspiration.

Grant wished to show both nos.74 and 75 at his 1959 Tate Gallery retrospective as well as others of his more radical works such as *The Hat Box* (a collage of 1914; private collection), *The Modelling Stand* (no.49) and *Abstract* (unidentified); all were rejected by the selectors.

Prov: The artist from whom bt 1969
Exh: Edinburgh and Oxford 1975 (21); Tate 1980 (408); Barcelona 1986 (40, repr.); Liverpool 1996–7 (16, repr.)
Lit: Shone 1976 (pl.87); Watney 1980 (p.98, pl.87); Naylor 1990 (p.242, repr.)

75 *Interior at Gordon Square* c.1914–15

Collage of papier collé on board 60 × 72 (23⅝ × 28⅜)
Inscribed 'c.1915' b.l. (later inscription)
Private Collection

See no.74.

Prov: The artist; by whom sold to present owner 1968
Exh: Edinburgh (ex cat.) and Oxford 1975 (48); Barbican 1997 (112, repr.)

74

76 *Abstract Collage* c.1915

Paint, papier collé and fabric on board 63 × 45 (24¾ × 17¾)
Signed on back
Hoffmann Collection, Berlin

Grant maintained that designing for the Omega Workshops in 1913–15, far from curtailing his own studio painting, helped to generate ideas and induced a liberal attitude to materials. *Abstract Collage* takes the geometric basis of *Interior, 46 Gordon Square* (no.75) a step further by removing figurative references and flattening perspective to an extremely shallow spatial organisation, emphasised by the addition of printed fabric and marbled paper. Neither Grant nor Bell espoused the more hard-edged near-abstraction of contemporary work by Lewis or David Bomberg. Irregular edges and visible facture were essential to them in suggesting their more obviously sensuous and pacific approach; in a handful of works they dispensed entirely with figurative references but did not see these two styles as mutually exclusive. The inverted V-shape rising to the top of no.76 is a feature of another somewhat later painting-with-collage *In Memoriam Rupert Brooke* (fig.103).

Prov: The artist to d'Offay; to private collection 1987
Exh: d'Offay 1984 (68, repr.); d'Offay 1986 (no cat.); Barcelona 1986 (39, repr.); London and Stuttgart 1987 (26, repr.)
Lit: *Charleston Newsletter*, 17, 1986 (p.55, repr.); Watney 1990 (pl.17); Shone 1993 (pl.102)

75

fig.103 Duncan Grant, *In Memoriam Rupert Brooke*
1915, oil and collage on panel 55 × 30.5 cm. Yale
Center for British Art, New Haven

76

DUNCAN GRANT

DUNCAN GRANT

77 *Abstract Composition* 1915

> Papier collé on board 43.8 × 76.2 (17¼ × 30)
> *Hoffmann Collection, Berlin*

This work is listed in Vanessa Bell's inventory of paintings at Charleston (1951) as *Abstract* (and not as a design) and its dimensions given as 30 by 17 in. indicating it may have been conceived as a vertical painting. It is made up of broadly brushed cut papers, the blue border added last. Displayed in landscape-format, it suggests quick spatial recession; in vertical-format, there is a suggestion of an interior as in the collage version of *Interior, 46 Gordon Square* (no.75). Its lack of detail and more open composition almost certainly place it in 1915.

Prov: The artist to d'Offay by 1978; to private collection 1984
Exh: d'Offay 1984 (66, repr.)

78 *Abstract Kinetic Collage Painting with Sound* 1914

> Gouache, watercolour and collage of painted and cut papers on paper mounted on canvas 27.9 × 450.2 (11 × 177¼) laid on canvas 35.9 × 556.3 (14⅛ × 219)
> *Tate Gallery, London. Purchased 1973*

This is Grant's most ambitious, complex and surprising non-figurative work, entitling him to a place in the wider picture of the development of abstraction in its earliest stages. It was begun at Asheham House, Sussex, in August 1914, soon after the declaration of war, when Grant worked intensively, partly as a distraction from the consequences for himself of the impending conflict. Vanessa Bell wrote to Fry that '[Grant] has started on a long painting which is meant to be rolled up after the manner of those Chinese paintings and seen by degrees. It is purely abstract' (25 August 1914, TGA). He seems to

78

have continued with the work over the following weeks and it was in his studio at 22 Fitzroy Street when he showed it to D.H. Lawrence, E.M. Forster and others on 22 January 1915. It was never completely realised to his conception and remained rolled up and stored for nearly sixty years until acquired by the Tate Gallery. Originally it was intended to be seen through the aperture of a box as it passed, from right to left, through slots at the back by way of twin mechanical spools (see Grant's detailed drawing in Watney 1990, fig.30, which may suggest he first intended the scroll to move vertically rather than, as now shown, horizontally). The box was to be lit from within and the pace was to be dictated by a slow movement from one of Bach's Brandenburg Concertos. The roll is divided into seventeen sections of clustered, pasted or painted rectangles with painted additions; each cluster has its own individual configuration, carried out in colours selected from a repertory of six. Grey-blue *écriture* surrounds each cluster and areas of closely spotted or blobbed black paint at the edges of the rectangles add shallow relief throughout the length of the scroll which ends with three emphatic vertical chords. The work's musical conception was partly inspired by a newspaper report which Grant had seen announcing a performance of Scriabin's *Prometheus* which was to be accompanied by coloured lights (though this aspect of the performance did not in fact materialise at the concert held in March 1914 in London; see *Tate Gallery Biennial Report*, below). Grant's friend Saxon Sydney-Turner was an enthusiastic admirer of Scriabin's music which, however, was not to Grant's taste and had no influence on the formal execution of the work.

When D.H. Lawrence was shown the work it was the climax of a painful visit and though the writer reported to Lady Ottoline Morrell that he liked Grant very much, he asked her to 'Tell him not to make silly experiments in the futuristic line with bits of colour on moving paper'. Grant later remembered that Fry also was not encouraging. That these adverse opinions dissuaded Grant from fully realising the work is doubtful; a more likely reason is his unsettled existence during the early part of the war. When the Tate Gallery acquired the work, a film of it in motion was made and Grant selected, as the closest to the gravitas of his original conception, the slow movement of the First Brandenburg Concerto; the projected film-with-sound lasts four minutes and eighteen seconds.

Grant's scroll represents, in spite of its unrealised potential at the time, an extreme moment in European abstraction. Its musical inspiration links it to Walter Pater and James McNeill Whistler on the one hand, and on the other to contemporary French ideas on music and the visual arts such as those put forward by Apollinaire and Gabrielle

Buffet (Mme Picabia) with which Grant was familiar (see Watney 1990, p.39). Its formal disposition and variety of mark-making are in part indebted to Grant's first-hand knowledge of Picasso's and Braque's work in 1913–14 but, by eschewing any mimetic reference, he has taken his work into a realm of speculative abstraction unprecedented at that time.

Prov: The artist from 1914 to 1973; bt from d'Offay by Tate 1973
Exh: Tate 1975 (11); Oxford 1975 (46); Tate 1980 (407, repr.)
Lit: D. Garnett, *Flowers of the Forest*, 1955 (pp.34–7); *The Burlington Magazine*, 116, 1974 (fig.52, as recent Tate acquisition); *Tate Gallery Biennial Report 1972–74*, 1975 (pp.160–3, repr.); Shone 1976 (pp.142–3, pl.88, detail); Watney 1980 (pp.96–8, col. pl.11); *Letters of D.H. Lawrence*, ed. G.J. Zytarck and J.T. Boulton, 2, 1981 (p.263); Collins 1983 (pp.60, 113–14); Cork 1985 (p.171, pl.210); Watney 1990 (pp.39–41, pls.18, 19, figs.30, 31); Naylor 1990 (p.48, detail repr.); Shone 1993 (pl.104, detail)

78 (detail)

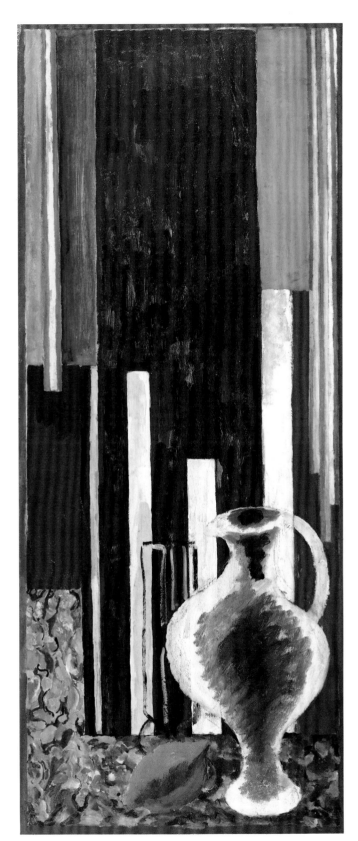

79

79 *The White Jug* 1914–18

Oil on panel 106.7 × 44.5 (42 × 17½)
Private Collection

A note on the back of a photograph of this work (taken down by the present author from Grant's comments on it, *c*. 1975) says that it was painted in London *c*. 1914, with later additions *c*. 1918. As originally conceived it was a severely geometrical non-figurative painting, its brightest colours towards the outer edge which is defined by a slim red framing device. Its strong vertical emphasis has suggested the influence of the work of Kupka but Grant maintained that he did not know that artist's work until several years later. Although there are purist reasons to regret the addition of the jug, lemon, fluted glass vase (?) and *écriture*, the painting assumes a symbolic resonance in its combination of rectilinear abstraction and figuration, of formal simplicity allied to decorative surface. The jug and lemon are frequent motifs in Grant's realist still lifes and elsewhere, shapes that lay deep in his visual memory and were summoned for a variety of purposes – for contour, volume, colour or allusive presence. The lemon closely relates, for example, to the sofa in *Interior, 46 Gordon Square* (no.74) and the jug is repeated in *Venus and Adonis* (no.118) painted at about the same time that Grant made his additions to no.79. The painting remained in the artist's possession and was unexhibited for fifty years; it was occasionally hung at Charleston and forms the background to a later still life by Vanessa Bell.

Prov: The artist; to d'Offay from whom bt by present owner 1976
Exh: Wildenstein 1964 (30); Edinburgh and Oxford 1975 (18); FAS 1976 (40); Tate 1980 (410, repr.); London and Stuttgart 1987 (28, repr.)
Lit: Shone 1976 (pl. 87); Shone 1977 (pl.66); Crafts Council 1984 (p.12); Cork 1985 (p.171, pl.209)

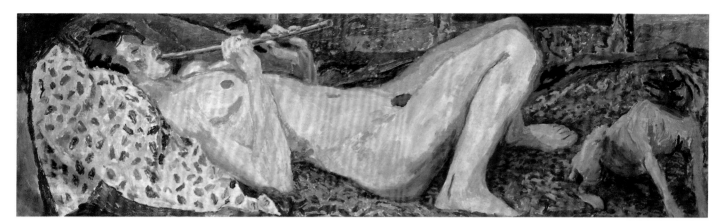

DUNCAN GRANT

80 *Nude with a Flute* 1914

Oil on panel 61.2 × 180 (24½ × 72)
Private Collection

At some point in 1913–14 Grant acquired four tall, narrow wooden panels with framed edges. On them he envisaged a group of paintings that would invest the human figure with exotic fantasy, partly through setting, partly through brilliant, emblematic colour. On one he painted a standing female nude accompanied by a blue bird (basing the figure on a photograph of Molly MacCarthy taken in early 1914; fig.104); the second is the present work; the third a version of this in which the figure is predominantly blue (private collection; see Watney 1990, pl.21); the fourth bears an unfinished standing nude. The two versions of a reclining nude woman playing a flute were modelled by Marjorie Strachey (for whom see no.7A), probably at Asheham House in 1914. The blue nude, unfortunately unavailable for loan, appears to be the last of the series. It is seen in part in the background of Bell's still life of 1915 (no.53) and shares similarities of colour and handling with Grant's portrait of David Garnett in profile, also of early 1915 (no.38). The painting, with the nude's awkward leg-splay and the alarmed expression of the pug dog, is characteristic of Grant's ludic treatment of a classic theme and may owe something to Titian's *Danaë* (in various versions) and to Piero di Cosimo's *Death of Procris* (as it was then called; National Gallery, London) a favourite work of Grant's which he later copied. Although not part of an Omega Workshops commission, it is certain that Grant's work there encouraged such comparatively large-scale semi-decorative panels as this and the others of the series. There is a possibility that this flute-playing figure was inspired by the memory of Nijinsky in the ballet *L'Après-Midi d'un Faune*, which Grant had seen in London in February 1913; the colouristic and gestural freedoms of the Russian Ballet continued to nourish Grant's work throughout the 1913–15 period.

Prov: The artist; sold Wildenstein to Vivien Leigh 1964; sold Christie's 9 June 1989 (292, repr.); bt Meredith Long, Houston, with d'Offay; to present owner 1990
Exh: Wildenstein 1964 (29); Meredith Long, Houston 1989
Lit: Watney 1990 (pl.22); Shone 1993 (pl.93)

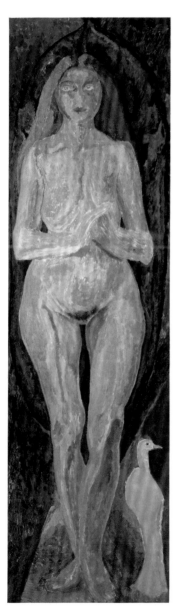

fig.104 Duncan Grant, *Standing Nude with Bird* 1914, wood 183 × 62.5 cm. Private Collection, USA

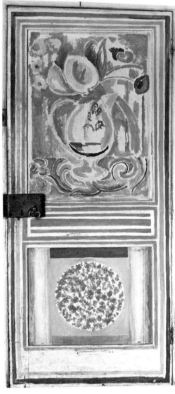

fig.105 Bedroom door at Charleston by
Vanessa Bell, 1918. Charleston Trust

DUNCAN GRANT

81 *Flowers in a Glass Vase* c.1917–18

Oil on board 58.4 × 54 (23 × 21¼)
Private Collection

This work may have been part of some now undiscoverable decorative
project (part of a slightly earlier decorative still life is on the back) but
whatever its intended status, it combines both stylised figuration with
two familiar aspects of Grant's non-figurative work – areas of geo-
metric abstraction and the imitation marbling or *écriture* that is found
in his output between 1914 and *c.* 1922 (e.g. in *The White Jug*, no.79,
and the *Kinetic Scroll*, no.78). The left-hand abstract area was extend-
ed over the main motif, cutting the flower at left and giving the com-
position an ambiguous spatial recession. The circle made by the glass
vase became, as Watney has pointed out, one of the most frequently
used devices in Grant's decorative work, as inclusive shape, as space-
filler and as counterpoint to surrounding geometric pattern. For Bell,
who frequently pulls ellipses towards the circular, particularly in her
still lifes, the circle assumes an almost symbolic role of containment,

exclusion or wholeness. Her decoration of the doors and fireplace in
Grant's bedroom at Charleston (early 1917) makes use of marbled cir-
cles and bands of colour to offset the exuberance of jugs of flowers in
the upper panels of the doors (fig.105). In contrast, Grant's sobriety of
palette in no.81 announces the more restrained note both of his deco-
rative work and of his easel paintings from 1917 onwards.

Prov: The artist; to d'Offay by whom sold to present owner 1987
Exh: d'Offay 1984 (76); d'Offay 1986 (no cat.); New York 1987 (131, repr.)
Lit: Watney 1990 (p.43, pl.26); Naylor 1990 (p.182, cropped)

82 *Summer Camp* 1913

Oil on board 78.7 × 83.8 (30 × 33)
Inscribed with artist's monogram 'VB', b.r.
Bryan Ferry Collection

This painting, Grant's *Tents* (no.73), Bell's screen (no.69) and her two Omega designs (nos.92 and 93) are all related and provide an extended illustration of the interchange of imagery between the artists' work for the Omega and their easel painting. In August 1913 a summer camp was organised at Brandon on the Norfolk-Suffolk border near Thetford. The core of the party were the Olivier sisters, Brynhild, Margery, Noel and Daphne, daughters of Sir Sydney Olivier, and central figures of the so-called Neo-Pagans (of whom Rupert Brooke, Ka Cox [see no.30] and the painters Jacques and Gwen Raverat were principal figures); Maynard Keynes stayed the full twelve days; others came and went more briefly, including Clive and Vanessa Bell, Duncan Grant, Adrian Stephen, Ka Cox, Gerald Shove (see no.29), Molly MacCarthy and Roger Fry. Three or four tents were set up at the edge of a field bordered by trees, cooking was done on site (often by Fry), and Vanessa Bell and one or two others stayed in a nearby farm. The holiday was recorded in many photographs and several paintings (there is an unfinished oil by Bell of one of the Oliviers, with a sketch on the back for the present painting, and an oil of Gerald Shove by Grant, both in a private collection, London). Bell surprisingly enjoyed this improvised holiday. 'Roger is a great success with the young women', Vanessa wrote to Clive Bell on 12 August; Noel Olivier wrote to Rupert Brooke that she 'liked to see Duncan & Vanessa at their pictures out in the field, Daphne absorbed in Dotztoyevsky [sic] & Maynard always busy with his writing' (see Harris 1991). Bell's view of the camp probably includes Keynes in a white sun hat at right. Simply and quickly stated in strong colour, her sketch nevertheless is firmly designed around the central figure and tent pole.

On her return to London, Bell painted a four-fold screen (no.69), boldly schematising the figures which she turns into green, naked women, substituting a single reclining figure for the two on the right of her painting. The geometry of the tents and arabesques of the trees

82

are dynamically interwoven, the predominent ochre of the summer grass pushing up to the top of her design which is firmly based on a triangular platform of venetian red. Bell draws on certain paintings by Matisse, particularly the 1912 Moroccan landscapes, and even anticipates in some aspects his *Bathers by a River* on which Matisse was working during the same months. She may also have been impressed by three sculptures by Brancusi, all of heads, exhibited in July 1913 at the Allied Artists Association, including the *Muse Endormie* and *Mlle Pogany* of which Fry owned a cast.

Two designs for the Omega were inspired by Bell's painted screen. The textile design (no.93) displays a similarly repeated geometrical pattern around a central axis and similar colour range (unfortunately Bell's design was never made up). Her *Design for an Omega Rug* (no.92) is also close in its colour scheme to the screen but is far bolder in its abstract grid of black lines, broken along the edge; it is one of Bell's most rigorous and successful Omega designs.

Prov: Artist's estate; with d'Offay by 1973; to present owner 1979
Exh: FAS 1976 (11); *Vanessa Bell: Paintings from Charleston*, Anthony d'Offay 1979 (ex cat.); Barbican 1997 (7)
Lit: Shone 1976 (pl.57); Collins 1983 (pl.32); *Song of Love: The Letters of Rupert Brooke and Noel Olivier*, ed. Pippa Harris, 1991 (p.248)

VANESSA BELL

83 *Abstract Painting* c.1914

> Gouache and oil on canvas 44.2 × 38.8 (17³⁄₈ × 15¼)
> *Tate Gallery, London. Purchased 1974*

Only four non-representational paintings by Bell have survived – two on canvas and two on paper. It is doubtful whether she attempted many more and Grant, in later years, said she had done very few (Grant to D. Brown, typescript, TGA). Only two paintings are listed as *Abstract* in her 1951 inventory of her work (no.83 and a large oil on canvas, now private collection); a large abstract painting owned by Roger Fry was accidentally destroyed by fire. In 1914 Bell had seen virtually no non-figurative work by other artists (save by Grant) and the 'abstract' works she knew by Wyndham Lewis and David Bomberg were only partially non-figurative. She had admired Kandinsky's work but it made no impact on her own practice. Abstraction for Bell evolved from a formal simplification of her own easel painting and her work as a designer for the Omega, especially when collage was involved (taken to its extreme in no.84). Her figurative painting became increasingly architectonic at this period with an emphasis on verticals at the margin; even the sitters in her portraits are seen against geometric abstract backgrounds (as in no.35). In this and related works she ruthlessly removes any figurative allusions (unlike Grant or Bomberg, for example). Intellectually she must have been convinced by her brief excursion into abstraction; but emotionally she found no compensation for what she regarded as the 'loss' of subject matter (as she explained years later to her son Quentin Bell). Although the uncertainty of her subsequent work in 1915–17 owed much to outward circumstances, her brief interest in abstraction chastened the natural flow of formalised representation.

In her inventory of 1951 Bell has added in parenthesis 'Test for chrome yellow' after the title *Abstract*.

Prov: A.V. Garnett; to d'Offay from whom bt 1975
Exh: d'Offay 1973 (14, repr.; pp.8–9); Tate 1975 (22); Edinburgh and Oxford 1975 (22); Tate 1980 (405, repr.); London and Stuttgart 1987 (no.24, repr.)
Lit: Cork 1976, 1 (p.276, repr.); Shone 1976 (pl.85); *Tate Gallery 1974–6. Illustrated Catalogue of Acquisitions*, 1978 (pp.52–3, repr.); S. Wilson, *British Art*, 1979 (p.125 repr.); Watney 1980 (pl.13); Naylor 1990 (p.102, repr.)

VANESSA BELL

84 *Composition* c.1914

> Oil and gouache on cut-and-pasted papers 55.1 × 43.7 (21³⁄₄ × 17¼)
> *Museum of Modern Art, New York, The Joan and Lester Avnet Collection*

See no.83.

Prov: David Garnett; A.V. Garnett; d'Offay; Joan and Lester Avnet; to Museum of Modern Art, New York 1978
Exh: Folio 1967 (48); New York 1980 (23); Dallas and London 1984 (5, repr.); Barbican 1997 (9, repr.)
Lit: Shone 1976 (pl.90); Collins 1983 (pl.76); Shone 1993 (pl.103); *Artforum*, Dec. 1997 (p.103, repr. fig.4)

VANESSA BELL

85 *By the Estuary* 1915

> Oil on canvas 47 × 63.5 (18½ × 25)
> *Private Collection*

Painted either at Eleanor House, West Wittering, in the spring of 1915 or nearby, in August, at The Grange, Bosham, both on the Chichester Estuary. The mast of a yacht appears above the central roof of a boatshed with farm buildings on either side. The geometrical abstraction that distinguished Bell's applied design for the Omega continued to inform her easel painting. Though landscape is relatively rare in her wartime painting, this modestly scaled example shows at its best her predilection for clarity of design in which bands and segments of contrasting but harmonious colour are undistracted by detail. The vertical elements of her composition (an obsessional characteristic) here punctuate the schematic arrangement of colour, transforming a comparatively mundane subject into one that, as Fry later wrote of her work, exemplifies 'her habitual mood of grave but joyous contemplation' (R. Fry, 'Vanessa Bell and Othon Friesz', *New Statesman*, 3 June 1922, pp.237–8).

No.85 appears as part of a studio still life by Duncan Grant, *Lime Juice Cordial*, 1915 (Government Art Collection), painted at Bosham.

Eleanor House (fig.87), on the edge of the village of West Wittering, was owned by St John and Mary Hutchinson; a boat house in the garden, adjoining the estuary, was frequently lent to the Hutchinsons' friend Henry Tonks, and used as a studio; in 1915, Grant, Bell and David Garnett spent several weeks at Eleanor, along with guests such as Lytton Strachey and Roger Fry. Grant's *Vanessa Bell at Eleanor* (fig.78; Yale Center for British Art) was painted in the house; his

83

84

85

86

Vanessa Bell Painting (Scottish National Gallery of Modern Art, Edinburgh) and his and Bell's portraits of David Garnett (nos.36 and 37) were painted in the boat house. Bell liked the area and later in the year rented The Grange in nearby Bosham.

Prov: Gift from the artist to David Garnett 1915; by family descent; D. Gage where bt by present owner 1995
Exh: Not previously exhibited

VANESSA BELL

86 *Nude with Poppies* 1916

Oil on canvas 23.5 × 42.5 (9¼ × 16¾)
Swindon Museum and Art Gallery

This work is a preliminary design for a bedhead which Bell painted for Mary Hutchinson (see no.35) in August 1916. In a letter of 2 August 1916 from Wissett Lodge, Bell mentions to Fry that she is at work on a decoration for Mary Hutchinson's bed: 'On one side is a woman asleep, rather like Flaming June by Lord Leighton, with poppies and waves (I think) all very symbolical' (TGA). It seems that Bell, after this trial run, painted the bedhead itself at Wissett for, three weeks later, she wrote to St John Hutchinson: 'Please tell Mary I've been painting her bed – I hope she won't be horrified to hear there's a nude figure of the most romantic description with poppies and waves – asleep – and bouquets of flowers and white satin ribbon – I don't think it's at all what she wanted' (VB to St John Hutchinson from Wissett, 24 August 1916; Humanities Research Center, University of Texas). The finished bed appears in a photograph in an article published in *Vogue* (Early February 1919, p.41) on Grant and Bell's decorations in the Hutchinsons' house at River House, Hammersmith, carried out in mid-1917 and in 1918. The subject matter was fairly standard (see Grant's *Nude with a Flute*, no.80) and Bell's oriental poppies (a favourite image) underline the mood of other-worldly somnolence. Nevertheless, the irony of Vanessa Bell painting a (single) bed for her husband's (married) lover would not have escaped Bloomsbury tongues, least of all Bell's own.

The head and foot boards of a bed were ideally suited to decoration by the Omega artists: Fry's bed for Mme Vandervelde (1916), in the Victoria and Albert Museum, also bears a reclining female nude on the headboard (and another on its reverse). In 1916–17 Grant painted a bed for Vanessa Bell (Charleston Trust) which shows on the headboard, Morpheus, God of Sleep, with outstretched wings, his nose, brow and forehead represented by two pieces of wood (fig.32); at the foot, two huge red poppies languish from a central glass vase. No other decorated beds from the Omega period seem to have survived though a number of projected designs are extant.

Prov: Artist's estate to d'Offay 1970 from whom bt 1973
Exh: Adams 1961 (15, as *Design for Bedhead* dated 1919); Sheffield 1979 (20); Canterbury 1983 (32); Crafts Council 1984 (P2, repr.)
Lit: Spalding 1983 (p.154); Naylor 1990 (repr. p.175); *The Swindon Collection of Twentieth Century British Art*, 1991 (pp.8–9)

ROGER FRY

87 *South Downs* 1913–14

Oil on board 45.1 × 61 (17¾ × 24)
Inscribed 'Roger Fry 1914' b.l.
Private Collection

Fry stayed at Asheham House, Sussex, in September 1913 and almost certainly painted this landscape on that visit. It apears to be a view from Asheham across the Ouse valley towards Iford Hill, among the Downs south of Lewes. It is one of his most vigorous assaults on the English countryside. 'I want clear-cut shapes and clear colours' he had written to G.L. Dickinson a few months before (Fry, *Letters*, 2, 1972, p.370), complaining of inky shadows and overcast skies. The increasing bareness, elimination of detail and angular faceting of his work (close in this respect to Bell at Asheham in 1912 [no.25] and Spencer Gore at Letchworth in the same year) reinvigorated his painting, aided by the heightened colour and freedom of form he had discovered in his applied design for the Omega Workshops.

South Downs was one of eleven paintings by Fry shown at the Second Grafton Group exhibition in January 1914 (which also included no.15 and 96 shown here). Save for the harsh criticisms of T.E. Hulme in *The New Age* (15 January 1914), they were surprisingly well received even by Sickert who, slightly maliciously, praised them at the expense of Fry's work as a critic and impresario of the modern movement (Letter, *The New Age*, 22 January 1914).

At this period Fry particularly admired the work of Derain (and owned his *Parc à Carrières*, Fry Collection, Courtauld Gallery): there are strong similarities between no.87 and, for example, Derain's landscape *Martigues* (fig.106).

Prov: Artist's estate; private collection; d'Offay from whom bt by present owner 1984
Exh: 2nd GG 1914 (cat. not traced); ?*Twentieth Century Art*, Whitechapel 1914; d'Offay 1983 (27)
Lit: Spalding 1980 (p.170; pl.60)

fig.106 André Derain, *Martigues* 1908, oil on canvas 73 × 91 cm. Kunsthaus, Zürich

87

ROGER FRY

88 *Ste Agnès, South of France* 1915

Oil on canvas 91.5 × 71 (36 × 28)
Inscribed 'Roger Fry 1915' b.l.
Jonathan Clark

See entry no.89.

Prov: ...; B. Meiselman, New York, by 1967; to private collection, New York, from which sold Sotheby's, London 2 May 1990 (49) where bt J. Clark Ltd; to present owner 1994
Exh: *Paintings by Roger Fry*, Alpine Club Gallery, 1915 (13); *Exhibition of Modern Paintings*, Jonathan Clark Ltd, Winter 1990 (p.6, p.7 repr.)
Lit: Shone 1993 (pl.106)

ROGER FRY

89 *Boats in Harbour, South of France* 1915

Oil on canvas 71.5 × 91 (28¼ × 36)
Wakefield Museums & Arts

In April 1915 Fry travelled to Northern France in order to help with the Quaker Relief Mission in the devastated area of the Marne and Meuse, the operations directed by his sister Margery Fry. Among various adventures, he was mistaken for a spy when trying to visit his friend Charles Vildrac, the poet and gallery-owner then on active service. He went on to Paris and continued south to Roquebrune to stay with Simon and Dorothy Bussy. His itinerary is sketchy and there are no letters to Vanessa Bell which at all other times provide a chronology of his movements. At Roquebrune his spirits were revived by the presence of Dorothy Bussy's sister Pippa (Philippa) Strachey (see Fry to P. Strachey, *Letters*, 2, 1972, pp.387–8). In his painting he was encour-

88

89

fig.107 Roger Fry, *The Quay, St Tropez* 1915, oil on paper on panel 62.2 × 47 cm. Private Collection

aged by Jan Vanden Eeckhoudt (1875–1945), the Belgian painter and close friend and neighbour of the Bussys. As a result, he lightened his palette, omitted half-tones and simplified forms. He painted prolifically, portraits and landscapes, the latter usually on small-sized board or card. After his return to London, several of these studies formed the core of his solo exhibition at the Alpine Club Gallery in November 1915. A study for the present painting, oil on card, is at Charleston, and a larger *The Quay, St Tropez*, in brilliant primaries echoing Derain at Collioure, was owned by the American Katherine Dreier of the Société Anonyme (fig.107). Another landscape, *Alpes Maritimes*, signed and dedicated to Pippa Strachey in 1915, is untraced.

From Roquebrune, Fry made excursions to Eze and into the hills to Ste Agnès with Pippa Strachey, painting her under a tree below the vertiginous, castle-topped village (no.88); it is not clear whether this vibrant landscape was executed on the spot or in London from studies. Fry obviously felt some satisfaction with the work for he later made a woodcut of it, printed in his *Twelve Original Woodcuts* (Hogarth Press, 1921).

After leaving the Bussys Fry travelled west by train along the French coast, stopping at several places in which, after the war, he painted frequently – St Raphael, St Maxime, St Tropez, La Ciotat and

Cassis. It is not clear which of these no.89 depicts; in his Alpine Club exhibition he showed *The Harbour, Cassis* (36, now Glasgow City Art Gallery) and *The Port, St Tropez* (30, probably the Dreier picture mentioned above). The present work is either *The Harbour, Cassis* (36) or *A Harbour* (49), probably the latter (the craggy hills around these small ports which years later Fry delineated in detail, are here radically simplified). The colouristic abandon of this French visit affected Fry's work over the next few years even when his modelling became more three-dimensional and he assumed a fuller statement of alternating volumes and planes (or *pleins et vides* as Fry himself would have said). *Boats in Harbour* attains an almost childlike simplicity and enjoyment in spite of its carefully wrought composition.

Prov: ...; Arthur A. Haley, Wakefield, by whom given to the present owner 1939
Exh: *Paintings by Roger Fry*, Alpine Club Gallery, 1915 (?49)
Lit: Morphet 1980 (pl.32); Naylor 1990 (p.90, repr.)

90 *Design for a Screen: Figures by a Lake* c.1912

Gouache on board 24.8 × 43.8 (9¾ × 17¼)
Inscribed 'Mrs Clive Bell' and 'VB' in Grant's hand on back
Mellon Bank, Pittsburgh

This design for a three-part screen is traditionally dated to 1912 and may have been Bell's exhibit *Design for Screen* shown at the February 1912 Friday Club exhibition (cat.no.11). If so, it predates by several months Bell's next applied art designs for the Grafton Group and the Omega Workshops. Under a red sky, nearly twenty naked women surround a blue pool below pine trees in a purple landscape. The inventive colour used here in her applied work was just beginning to be seen in Bell's contemporary easel painting (e.g. *Virginia Woolf*, no.23); a year later, such a distinction no longer remained. The motif of bathers under trees has a long history but Bell may have been more specifically influenced by Nabi paintings by Vuillard and Denis (who, along with Bonnard and others, had all painted screens in the 1890s and later).

Prov: Artist's estate; d'Offay from whom bt by present owner 1985
Exh: ?Friday Club, Feb. 1912 (11); ?*Exposition de quelques Indépendants anglais*, Galerie Barbazanges, Paris, July 1912 (5, as *Projet pour un écran*); d'Offay 1984 (1); Vassar 1984 (1); *In the Watercolor Tradition: British Works on Paper from the Mellon Bank Collection*, Carnegie Museum of Art, Pittsburgh, 1990 (1, pl.24)

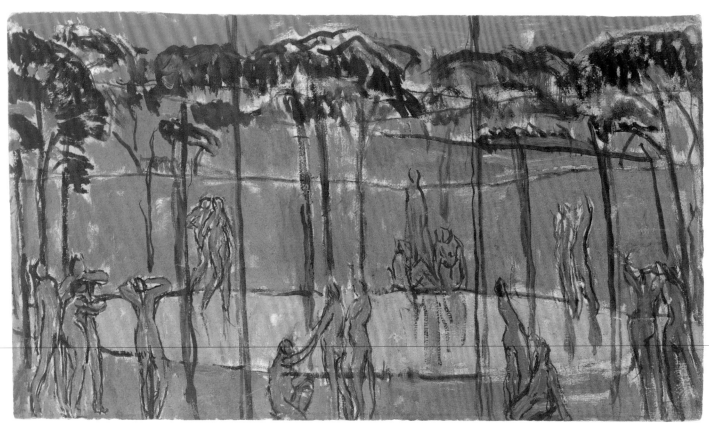

90

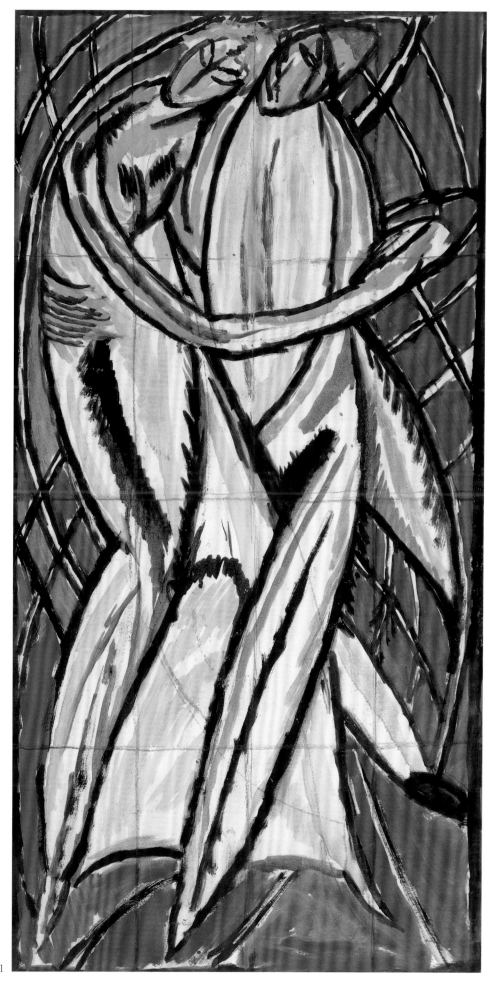

91

91 *Dancing Couple* 1914

Gouache and oil on paper 76.2 × 37.5 (30 × 14¾)
The Board of Trustees of the Victoria and Albert Museum

The pooling of anonymous designs at the Omega and the homogeneity of their imagery and handling has made it difficult to attribute individual works to one or another of the artists employed. Bell's dancing couple, in this squared-up design for a larger work on canvas, was long attributed to either Lewis or Grant; only when a letter from Bell to Fry (18 September 1913; TGA) was found to contain a small ink drawing for this work did it become clear that it is Bell's. The proposed painting was one of a pair destined for the two shallow rectangular niches either side of the main, first-floor window of 33 Fitzroy Square, the Omega's premises, and intended to proclaim the Post-Impressionist business being conducted within. From Bell's letter it seems that Fry had taken the two blank pieces of canvas (each over six feet by two feet nine inches) to Asheham House, Sussex, one for Grant and one for himself to paint on his next visit there: 'It's finer today,' she wrote on 17 September, 'and we have nailed up your canvas outside the house in front and have started on it. Duncan and I are each doing one. Do you mind? ... We are doing two modern dress dancing figures in each.' On the following day she continued: 'We have been working hard at the panels today and I think we should get them finished tomorrow ... The young lady is dressed in yellow, the young gentleman in dark blue, with a pale green shirt front, and the background is in venetian red ridges ... Marjorie [Strachey] thinks them hideous and we shall be stopped by the police, but I can't see what she means.' Neither panel has survived and there is no record of Grant's contribution.

A few weeks earlier Grant, Bell and Fry had each painted a panel for the main wall of the Omega's stand at the Ideal Home exhibition at Olympia in October: large nude dancing figures, each panel related in theme, drawing and colour, giving to the wall (known only from a colour photograph) what Richard Cork has described as 'an impressive confidence and unity of style' (Cork 1985, p.149). They appear to have been the most spectacular example of the Omega house style and if we did not know the authorship from contemporary evidence, it would be difficult to apportion them among Lewis, Etchells or the three Bloomsbury artists who in fact did paint them in August 1913. Bell's sketch of dancers (a subject treated by several avant-garde artists including William Roberts, Lewis and Bomberg) with its characteristic hatching, largeness of conception and felicitous choice of four colours and black and white is the best evidence that has survived of Omega mural painting at its most successful.

Prov: R. Fry; to P. Diamand by whom given to V & A 1955
Exh: The Omega Workshops, V & A 1964 (no. cat.); Crafts Council 1984 (D24, repr. front cover)
Lit: Q. Bell and S. Chaplin, 'The Ideal Home Rumpus', *Apollo*, 80, October 1964 (pl.x, fig.3); Cork 1976, 1 (p.87, repr. attrib. to Grant); Anscombe 1981 (pl.1); Collins 1983 (pl.20); Naylor 1990 (p.226, repr.); Marler 1993 (p.144 and drawing repr. p.145)

92 *Design for Omega Rug* 1914

Oil on paper 30.5 × 60.5 (12 × 23¾)
Inscribed with Omega symbol, b.r., stamped with Omega imprint twice in margins
Private Collection

In early 1914 Lady Hamilton, wife of General Sir Ian Hamilton, commissioned the Omega Workshops to decorate and provide furnishings for several rooms in her new London home at 1 Hyde Park Gardens. Besides painted friezes, inlaid furniture, mosaics and stained glass, a special rug for the entrance hall was designed by Bell. This was produced in enough quantities for four matching examples to be used in the Hamiltons' house, and further ones to be shown in June–July 1914 at the Omega display at the Allied Artists' Association, Holland Park Hall (fig.108). More than one preliminary design (e.g. Courtauld Gallery) is extant as well as this bolder and more finished design in oil on paper. With its thrusting black diagonals and sharp segments of blue and yellow, tautly contained within a red framework, this is certainly one of Bell's most exciting contributions to the Omega. The inspiration came from her screen (no.69) which in turn emerged from her easel painting *Summer Camp* (no.82), the rug omitting the figurative elements and sweeping curves of foliage found in the screen. With this and other designs by Bell and Grant in mind, it is difficult to justify Wyndham Lewis's claim in October 1913 that the Omega style was a debilitating exercise in mid-Victorian prettiness.

Prov: Artist's estate; to d'Offay Couper 1970; to private collection 1987
Exh: Vorticism 1974 (121); New York 1980 (20); d'Offay 1984 (8); *In Celebration of Charleston*, Anthony d'Offay Gallery, 1986 (5); Barcelona 1986 (41, repr.); New York 1987 (107, repr.)
Lit: Shone 1976 (pl.70; pp.116–7); Cork 1985 (pl.179, preliminary design); Shone 1993 (pl.89)

93 *Design for Omega Fabric* 1913

Gouache on paper 52.7 × 40 (20¾ × 15¾)
Inscribed 'VB' (estate stamp) b.r.
Yale Center for British Art, Paul Mellon Fund

The Omega's six printed linens, each available in more than one colour combination, were among the Workshops' most successful products; they were praised in the press and sold well. Fry may have thought of having further designs put into production (several unused designs exist) but the capital outlay may have proved too much of a strain on the business's finances; on the other hand, the outbreak of war in August 1914 would have interrupted relations with the French firm who had produced the original group of linens. Bell's design shown here remained unprinted. As with the rug (no.92), it relates to her painted screen (no.69), using a similar colour range but is more delicate and flexible in effect, as befits the fabric's close repeat.

Prov: Artist's estate; to d'Offay 1970; sold Spink 1992 to present owner
Exh: Vorticism 1974 (122); d'Offay 1984 (7); Barcelona 1986 (43, repr.); Spink 1991 (9, repr.).
Lit: Shone 1993 (pl.74)

92

fig.108 Omega Lounge at the Salon of the Allied Artists' Association, Holland
Park Hall, London, June–July 1914

93

94

94 *Omega Fabric Design (Maud)* 1913

Gouache on paper 47.9 × 68 (18⅞ × 26¾)
Jeremy Caddy

Of the Omega's six printed linens, two are definitely attributable to
Bell, *White* and *Maud*, for which no.94 is a preliminary design carried
out in early 1913. It may also have been intended to use the same
design for a rug or carpeting (as suggested in d'Offay 1984, n.6), the
graph paper indicating the individual knots for execution by the man-
ufacturer. The name Maud was given to the linen after Maud, Lady
Cunard, an early patron of the Omega.

Prov: Artist's estate; d'Offay Couper by 1970; to present owner 1991
Exh: Vorticism 1974 (123); New York 1980 (19); d'Offay 1984 (6); Vassar 1984
(6); Barcelona 1986 (42, repr.); Spink 1991 (12, repr.)
Lit: Cork 1976, 1 (p.89, repr.)

95 *Omega Pottery* 1914–16

Glazed earthenware
a) Two-handled Tureen
 White tin glaze 13.3 × 26.5 (5⅛ × 10½)
 Impressed with Omega mark on inside of foot
b) Dinner Plate
 White tin glaze diam. 30.4 (12)
 Impressed with Omega mark on back
c) Soup Plate
 White tin glaze diam. 28.5 (11⅛)
 Impressed with Omega mark on back
d) Two Dessert Plates
 White tin glaze diam. 24.5 (9½)
 Each impressed with Omega mark on back
e) Side Plate
 White tin glaze diam. 19 (7⅝)
 Impressed with Omega mark on back
f) Vase
 White tin glaze 20.5 × 10.3 (8 × 4)
The Charleston Trust
Prov: Nos.95 a to e: Mary Hutchinson; by descent; gift to Charleston Trust
1994; No.95 f: V. Bell to A.V. Garnett; to Charleston Trust 1984

g) Dessert Plate
 Blue glaze diam. 28.7 (11⅜)
h) Dinner Plate
 White tin glaze diam. 28.7 (11⅜)
Matthew Marks, New York
Prov: Fry family; to d'Offay by 1983 where bt by present owner 1987
Exh: d'Offay 1984 (150)
[Not illustrated]

j) Soup Plate
 Blue glaze diam. 28.5 (11⅛)
Frances Spalding
Prov: Private collection; Bloomsbury Workshop where bt by present owner
1993
Exh: *Piles of Plates*, Bloomsbury Workshop, 1993
[Not illustrated]

During the Omega years, Roger Fry's innate practicality and pleasure in designing and making entered a new phase when he became an impassioned potter: 'while his brain spun theories,' wrote Virginia Woolf, 'his hands busied themselves with solid objects' (V. Woolf, *Roger Fry*, 1940, p.197). Disliking most commercially produced ceramic wares, which he found lacking in sensibility and formal expressiveness, he decided to make his own. In the Omega's early months no specially made pottery was on sale although some commercially available plates and vases were painted over the glaze by artists such as Lewis, Grant and Fry. Through late 1913 to late 1914, Fry gradually acquired skills first at a workshop in Mitcham, south London, and then at the Camberwell School of Art and Crafts. The simple white tin-glazed pottery dates from late 1914 and was subsequently commercially produced from moulds by the firm of Carter's in Poole, Dorset. Blue glazed pottery was on sale in 1915 and black glazed pottery in 1916, also from Carter's: dinner and tea services as well as bowls and vases were then constantly available until the Omega closed in 1919. The pottery was widely advertised and sold well.

Fry's shapes are spare, simple and generous, surfaces enlivened by the inflections of his hand and the subtle glazes, particularly the white one with its grey-blue film. The best are undecorated and as such anticipate some of the plain though more smoothly regular ceramics of a later period. The dinner plates and tureens for vegetables and soup are among his most satisfying designs, the plates rising slightly to the centre and with wide edges for salt, mustard, etc. Several appear in Fry's own still lifes (e.g. fig.97) and the plain vase shown here (no.95f) can be seen in Grant's painting, no.115. The thickest and heaviest pottery seems to have been the first to be produced; items from 1916 onwards tend to be more thinly articulated. After the closure of the Omega Fry seems to have abandoned potting; Grant and Bell however, in their capacity as decorative designers went on to work closely with Phyllis Keyes, Foley China and A.J. Wilkinson, eventually working with Quentin Bell who established a kiln at Charleston.

95

96 *Group: Mother and Children* 1913

Painted wood 28.4 × 23.6 × 10.2 (11⅛ × 9¼ × 4)
Art Gallery of Ontario, Toronto. Purchase 1987

This is Roger Fry's only known sculpture, made in 1913 and based on a photograph almost certainly taken by Fry at Asheham, of Vanessa Bell with her two sons Julian and Quentin, although its origins go back to a traditional Madonna and Child with St John. The pose of the figures carries a suggestion of the *caritas* theme, obviously familiar to Fry, and was more than likely arranged as such; a woodcut by Fry on a Christmas card for December 1913 was a direct transcription of the sculpture. Two drawings by Grant (see no.103) also relate to this work. *Group* is a striking example of the Omega artists' desire to treat traditional iconography with a new-found freedom of form. Its rough-hewn surface and sharp rhythms relate it to contemporary work by Henri Gaudier-Brzeska whom Fry greatly admired and it has affinities with German Expressionist sculpture. (Fry tried to help the collector

Michael Sadler bring the 1913 *Blaue Reiter* exhibition to London but it proved impractical).

Diversification of activities at the Omega galvanised its artists into attempting new mediums and forms of expression. Fry himself learnt how to cut woodcuts, throw pots and design stage scenery and stained glass, and he even made toy wooden animals with movable limbs which were a conspicuous success. The sudden appearance in 1913 of this sculpture shows his enthusiastic response to another challenge.

Prov: ...; W. Posner; P. Diamand by 1979; d'Offay by whom sold to Art Gallery of Ontario 1987
Exh: Omega Workshops Sitting Room, Ideal Home Exhibition, Olympia, Oct. 1913; 2nd GG 1914 (48); *British Sculpture in the Twentieth Century*, Whitechapel Art Gallery, 1981 (42); d'Offay 1984 (26, repr.)
Lit: Omega Workshop brochure 1914 (repr.); D. Todd and R. Mortimer, *The New Interior Decoration*, 1929 (pl.75); P. Nash, *Room and Book*, 1932 (repr. opp. p.24); Spalding 1980 (p.170); Collins 1983 (p.83; pl.35); Cork 1985 (pls.195 and 196); *20th-Century British Art from the Collection of the Art Gallery of Ontario*, Toronto, 1987 (p.13; fig.7); R. Shone, '"Group"(1913): A sculpture by Roger Fry', *The Burlington Magazine*, 130, Dec. 1988 (pp.924–7, repr.); *Art Gallery of Ontario: Selected Works*, 1990 (p.172, repr.); Greenwood 1998 (p.61, fig.9)

96

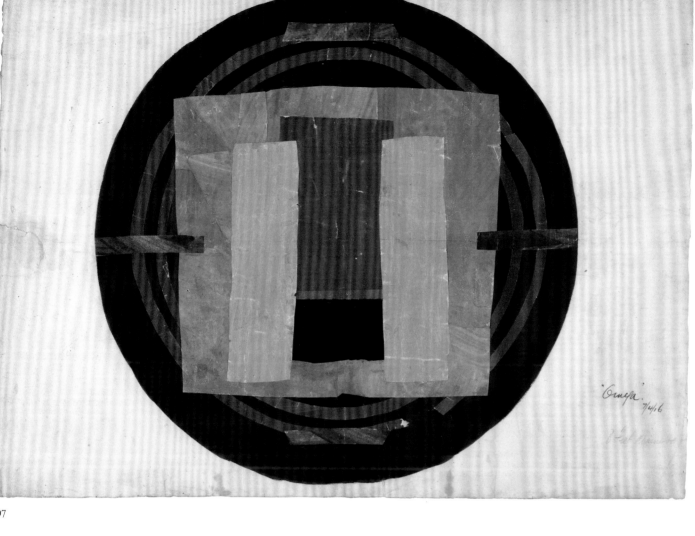

97

OMEGA / ROGER FRY

97 *Design for a Rug for Arthur Ruck* 1916

Ink and papier collé on paper 43.2 × 60.6 (17 × 23⅞)
Inscribed 'Omega 7.IV.16' b.r. and (below) '8 ft. diameter'
The Board of Trustees of the Victoria and Albert Museum

Fry's bold non-figurative carpet design gathers together some of the colours and forms found in the figurative murals he and other Omega artists painted in early 1916 at 4 Berkeley Street, London, for Arthur Ruck, a private picture dealer who advertised in *The Burlington Magazine*. We know the design is Fry's from a letter to Vanessa Bell in which he mentions it and draws its general idea in the margin of the page (April 1916; TGA). It was swiftly carried out and described in an article in *Colour* magazine (June 1916). The carpet and murals no longer exist. The inscription on this sheet is not in Fry's hand but is more likely to be that of the craftsman in charge of the manufacture of the carpet.

Prov: The artist; to P. Diamand by whom given to the V & A 1955
Exh: *Vorticism and its Allies*, Hayward Gallery, 1974 (127, where attributed to V. Bell); Norwich 1976–7 (70); Crafts Council 1984 (D9)
Lit: L. Gordon-Stables, 'On Painting and Decorative Painting', *Colour*, June 1916 (pp.187–8); Collins 1983 (p.134, pl.67); Cork 1985 (pl.180); Naylor 1990 (p.136, repr.)

98

99

OMEGA / DUNCAN GRANT

98 *Elephant Tray* 1913

Inlaid wood diam. 67.3 (26½)
Omega symbol on outside of rim
Private Collection

At least three marquetry trays were made for the Omega by the cabinet maker Joseph Kallenborn. One by Vanessa Bell was completely abstract in design (see fig.109), one by Henri Gaudier-Brzeska was based on a drawing of two dancers or wrestlers while the one by Grant shows a woman riding a small elephant. The origin of his design can be seen in the drawing shown here (no.103) in which Grant originally placed a howdah on the elephant's back.

Elephants were no strangers to Grant; he had seen and drawn them as a child in Burma. According to the artist, he carried out the initial design in cut, painted papers, which was then handed over to Kallenborn for fabrication. The tray was popular and copied several times; George Bernard Shaw bought a version and was told by Winifred Gill that Fry considered it the best article at the Omega. Shaw, who had invested money in the Workshops, replied: 'Would you very kindly tell him that I chose it myself without any prompting from you. He doesn't believe I've got any taste at all.' (V. Bell to Grant, 30 November 1913; TGA). The tray was available at the Omega by the end of November 1913.

Prov: R. Fry by 1914; by descent to P. Diamand; to O.B. Taber; to d'Offay; with Spink where bt by present owner 1991
Exh: Liverpool 1980 (25); d'Offay 1984 (129, repr.); Spink 1991 (11, repr.)
Lit: Collins 1983 (pl.VII); Shone 1993 (pl.82; p.104)

fig.109 Omega Workshops products with desk by Duncan Grant and abstract inlaid tray by Vanessa Bell

99 *Decorated Vase (Tunis)* 1914

Commercially available vase, painted and glazed, height 34.3 (13½)
The Charleston Trust

Grant visited Tunis in January–February 1914 from where he dis-
patched pots to the Omega Workshops and a box of oranges and
lemons to Vanessa Bell (see no.46). He found a village pottery and dec-
orated this vase with black-outlined nude female figures on both sides.
A second, smaller vase with similar, angular figures on it may also
have been executed in Tunis. Both vases remained in Grant's posses-
sion.

Prov: D. Grant; to A.V. Garnett 1978; to Charleston Trust 1984
Exh: Liverpool 1980 (12, repr.); Crafts Council 1984 (C15, repr.)

100

100 *Table Vase – Design for 'Macbeth'* 1913

Gouache on paper 50.8 × 38.1 (20 × 15)
Private Collection

The theatre producer and dramatist Harley Granville-Barker
(1877–1946) showed characteristic adventurousness when he chose
Grant as a possible stage designer for *Macbeth*, which he planned to
present at the Savoy Theatre in the autumn of 1912. For financial rea-
sons, the project was thwarted but revived in the spring of 1913 and
given at the Kingsway Theatre late that year. Grant worked hard on
costume and stage designs in April (a large sketchbook containing
many such designs is in the artist's estate) and Granville-Barker was
pleased with them; but the commission faltered in the summer, Grant
finding difficulty in squaring his own imaginative vision for the pro-
duction with the technical exigencies of a large theatre and the fact
that another artist, Norman Wilkinson, was by then involved in
aspects of the production. Eager also to return to his painting, Grant
resigned his role in June 1913 and allowed Granville-Barker free use of
his already completed designs. These included drawings for sumptu-
ously coloured Byzantinesque costumes and two large gouaches
(no.100 and another now at Charleston) of table ornaments for the
banquet scene (Act III, sc.iv). They were to have been freely painted,
flat cut-out boards ranged along the table. Grant's work for the
Omega, intensive in the early months of 1913, as he worked on *Mac-
beth*, provoked ideas about theatrical design and he was immediately
enthusiastic when Jacques Copeau (1879–1949), the great French
director and founder of the Théâtre du Vieux Colombier, asked him in
July to design the clothes and scant scenery for *Twelfth Night* (*La Nuit
des Rois*) to be given in Paris in May 1914. Copeau's revolutionary
approach to stage production in a specially created theatre was much
to Grant's taste and his entirely happy and successful collaboration
with Copeau made up for the disappointment of *Macbeth*. The pro-
duction used hand-painted costumes as well as Omega and other tex-
tiles, and a stage curtain (for which there is a design in the Fry
Collection, Courtauld Gallery) was of appliquéd materials. Grant
added costumes and some painted screens for later performances of
the play (in 1917 and 1920) and in 1917 designed a production of
Maeterlinck's *Pelléas et Mélisande* given by Copeau in New York and
Paris. A third collaboration, mooted in 1920, of André Gide's play *Saül*
(Gide was keen to have Grant design it) was eventually abandoned. By
then Grant was beginning to work in the London theatre, principally
as a designer of short ballets for Léonide Massine and Lydia Lopoko-
va, and for a production of Aristophanes's *The Birds* given in Cam-
bridge in 1924 as the University's Triennial Greek Play.

Prov: Artist's estate; to d'Offay from whom bt 1997
Exh: Liverpool 1980 (under no.93); d'Offay 1984 (44); d'Offay 1986 (no cat.);
Spink 1991 (7, repr.); *The Friday Club*, Michael Parkin Gallery, 1996 (31)

101

101 *Design for a Rug* 1913

Oil on paper 66 × 53.3 (26 × 21)
The Board of Trustees of the Victoria and Albert Museum

One of Grant's most successful works for the Omega was a large abstract carpet designed in mid-1913 and ready for the Ideal Home Exhibition that October. Examples of it are at the Courtauld Gallery (Fry Collection) and the Victoria and Albert Museum (which also owns the design for it, unfortunately unavailable for exhibition). It was among Fry's favourite Omega productions and, twenty years later, he praised it for its sensibility, its 'geometrical simplicity' and Grant's inclusion of the irregularities of the knotted wool as part of the overall effect (see R. Fry, *Last Lectures*, 1939, p.36, pl.12). The present design, less geometrically regular, approaches Grant's non-representational painting style but includes the hatched border found in the Ideal Home carpet and two further rug designs (Courtauld Gallery, Fry Collection). Neither of these nor no.101 reached the manufacturing stage but were pooled at the Omega for possible future use.

Exh: Not previously exhibited or recorded

102 *Tennis Player Design* 1913

Pencil, gouache and oil on paper 25 × 15.9 (9⅞ × 6¼)
Courtauld Gallery, London (Pamela Diamand Collection)

As this drawing was among the sheaf of designs from the Omega Workshops which Fry retained, it was presumably intended for some decorative purpose, perhaps a painted shutter or panel. It was almost certainly inspired by the dancer Vaslav Nijinsky in the Diaghilev ballet *Jeux*, whose ostensible action is a game of tennis; this was performed in London in June 1913 during which period Grant met Nijinsky, Leon Bakst and Sergei Diaghilev at Lady Ottoline Morrell's house in Bedford Square. In her memoirs, Lady Ottoline records Bakst and Nijinsky coming to her house one afternoon in July 1912 'when Duncan Grant and some others were playing tennis in Bedford Square garden – they were so entranced by the tall trees against the houses and the figures flitting about playing tennis that they exclaimed with delight: "Quel décor!"' (*The Early Memoirs of Lady Ottoline Morrell*, ed. R. Gathorne-Hardy, 1963, p.228). Though Debussy and Nijinsky were already at work on the music and choreography for *Jeux*, it is always presumed that this scene in Bedford Square inspired the ballet's décor and costumes designed by Bakst in 1913. Grant met Nijinsky on several occasions and found him charming and sympathetic to talk to: 'he was fond of pictures but could only speak indifferent French. He had what seemed in his clothes to be a slight torso, but his legs seemed full of muscle, as indeed they must have been and he is said to have had a double heel which made it possible for him to jump so high' (Grant to the author, 21 June 1965). Grant's admiration for Nijinsky found expression in several late paintings which include photographs of the dancer (fig.135).

Prov: R. Fry; to P. Diamand by whom given to Courtauld Gallery 1958
Exh: Liverpool 1980 (14); Crafts Council 1984 (D 34)

103 *Design for an Omega Christmas Card* 1913

Ink on paper 20.3 × 25.4 (8 × 10)
Art Gallery of Ontario, Toronto. Purchase 1987

This is essentially an Omega working drawing. To the left is a highly schematised elephant and howdah which is reminiscent both of Grant's inlaid *Elephant Tray* (see no.98), and one of the toy animals produced at the Workshops. On the right are a Madonna and two children flanked by angels, drawn in Grant's hatched, angular manner in late 1913. This relates to an Omega Christmas card, a woodcut by Fry based on Fry's own sculpture *Group* (no.96), the idea possibly suggested by Grant's drawing (see Greenwood 1998, p.61, repr.). No.103 is thus exemplary in the history of the Omega's collaborative spirit.

Prov: R. Fry; to P. Diamand; to d'Offay from whom bt by present owner 1987
Exh: Liverpool and Brighton 1981 (18)
Lit: R. Shone, '"Group" (1913): A Sculpture by Roger Fry', *The Burlington Magazine*, 130, Dec. 1988 (pp.924–7; fig.56)

102

OMEGA / DUNCAN GRANT

104 *Design for a Bookplate for Lady Strachey* 1914

Ink on paper 20 × 21.5 (7⅞ × 8½)
Dr R.A. Gekoski

Animal imagery occupies an important iconographical role not only in Grant's early work but in many productions of the Omega Workshops – for example, the small sculptures of Gaudier-Brzeska, Fry's inlaid giraffes on a cupboard and the woodcuts of Roald Kristian. Asses, birds, fish, sheep, cats, and an elephant all appear in Grant's applied designs and contemporaneous paintings. This is a preliminary design for a linocut, depicting a jumping animal of indeterminate genus and gender. The linocut was sent by Grant to his aunt Lady Strachey at Christmas 1913 (and is now at Charleston); presumably no.104 is a study for the linocut and was erroneously dated 1914 by Grant (see Greenwood 1998). No other impressions of the linocut are known. It relates to two versions of Grant's painting *The Ass* (Ferens Art Gallery, Hull, and private collection), to a gouache design *Reclining Horse and Sun* (Courtauld Gallery, Fry Collection) and to painted cushion covers for the Omega.

Prov: Artist's estate; to d'Offay; to present owner 1991
Exh: Liverpool 1980 (*22*, repr. as *Bookplate design for Lady Strachey*)
Lit: R.A. Gekoski. Catalogue 15, 1991 (*31*, repr.); Greenwood 1998 (p.99, fig.13)

103

DUNCAN GRANT

105 *Reclining Woman with Horse* c.1913

Ink on paper 26 × 35.6 (10¼ × 14)
The Bloomsbury Workshop

This characteristic *jeu d'esprit* combines two of Grant's obsessive motifs, the reclining female nude and a rushing horse. The figure is the ancestress of innumerable later Venuses (see no.118), Ledas, reclining nymphs and goddesses. Contrasting images of passivity and action are seen throughout Grant's work, sometimes in opposition, sometimes reconciled. The curvaceous female nude prefigures the hefty neoclassical nudes not only in Grant's work but in much painting and sculpture of the 1920s.

Prov: Artist's estate; d'Offay to present owner by 1994
Exh: Not previously exhibited or recorded

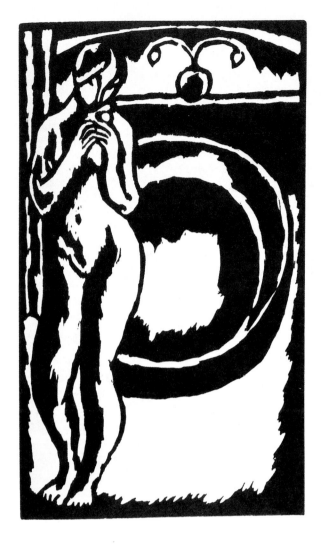

OMEGA WORKSHOPS

106 *Original Woodcuts by Various Artists* 1918

24.6 × 18 (9¾ × 7⅛)
32-page book containing 14 woodcuts printed for the Omega by Richard Madley of London (edition of 75)
Two copies
a) *British Museum, Department of Prints and Drawings*
b) *Belgrave Gallery, London*
Prov: a) Campbell Dodgson by whom bequeathed 1949; b) private collection
Exh: a) *Avant-Garde British Printmaking 1914–1960*, British Museum, 1990 (21)
Lit: a) and b) Greenwood 1998 (pp.22, 63, 100 passim)

Original Woodcuts by Various Artists was the fourth and last publication issued by the Omega Workshops and contains plates by Fry (2), Grant (2), Bell (2), Roald Kristian (2), Edward Wolfe (2) and one each from Mark Gertler, Simon Bussy and E. McKnight Kauffer. Three of these woodcuts are individually exhibited here (nos.107A–C) and no.106, copy b, is open at Vanessa Bell's *Nude*, based on Bell's large decoration *The Tub* (fig.150).

107A VANESSA BELL *Dahlias* 1918

Woodcut on paper 15.4 × 10.9 (6 × 4½) *Private Collection*

107B DUNCAN GRANT *The Hat Shop* 1918

Woodcut on paper 18.5 × 10.9 (7¼ × 4½) *Private Collection*

107C DUNCAN GRANT *The Tub* 1918

Woodcut on paper 11 × 18.5 (4⅜ × 7¼) Inscribed 'D Grant' b.r.
Private Collection

The full history of this publication is detailed in Greenwood 1998. 107A is a mantelpiece still life; 107B is based on a painting of a hat shop window of *c*.1914 (untraced) and 107C on a painting of *c*.1916 (fig.25) which Fry owned but which was later destroyed (and now exists only in a late copy by Grant; private collection). Grant's and Bell's woodcuts were carried out at Charleston in late 1918.

107A

107B

107C

Beginning Again

Paintings 1916–20

From early 1916, Bell and Grant were no longer London residents. As a conscientious objector, Grant was obliged to work on the land as part of his exemption from active service, first in Suffolk and later that autumn in Sussex as a farm labourer (alongside David Garnett, also a conscientious objector). Bell, wishing to be with Grant and to remove her two children from London, established her household at Charleston, a relatively remote farmhouse on the Firle estate, a few miles east of Lewes in the South Downs. Grant's painting was necessarily restricted and his and Bell's work for the Omega came to a halt.

Roger Fry (fig.111), who was fifty in 1916, remained based in London but was able to visit France in 1915 and again in the following year when he was shown recent work by both Matisse and Picasso. He continued to oversee the by then ailing business of the Omega, wrote for and edited *The Burlington Magazine*, organised the exhibition *The New Movement in Art* (1917, Birmingham and London) and concentrated on an extensive series of still lifes and portraits.

The changed circumstances of their lives led Grant and Bell to a closer personal relationship (their daughter was born at the end of 1918) partly based on their deepening sympathy as artists; they often painted the same models and still lifes and in their several decorative schemes were able to merge their identities. In their easel painting, however, they remained distinct, though both gradually abandoned the high colour key and free handling of paint of 1913–16. In the mid-1920s Bell was to reflect that her earlier concentration on colour inclined her 'to destroy the solidity of objects'; her return to sobriety and formal plenitude immediately after the war can be seen in such works as no.112 and fig.110. While her subject matter remained more restricted than Grant's, she achieved subtle tonal effects with a relatively limited palette. In late 1917 and 1918 Grant instigated a number of changes in his painting when, after a bout of ill-health, he was allowed to work part-time as a labourer. He began

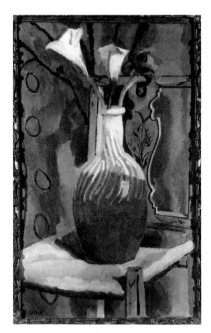

fig.110 Vanessa Bell, *Arum Lilies c.*1920, oil on canvas 73.6 × 45.7 cm. Courtauld Institute, London

fig.111 Roger Fry, *Self-Portrait* 1918, oil on canvas 79.8 × 59.3 cm. The Provost and Scholars of King's College, Cambridge

fig.112 Duncan Grant, *Man Seated by Window (Edward Wolfe)* 1919, oil on canvas 76 × 56 cm. Whereabouts unknown

opposite detail from Duncan Grant, *Juggler and Tightrope Walker c.*1918–19 (no.119)

to make use of preliminary drawings and studies (no.182 and fig.112), adopted a larger, more definitive drawing style, curtailed his former exuberance of brushwork and increased the richness of his colour. At the same time, vivid materiality of surface was fused with decorative fantasy (as in no.119).

Once European travel was again possible, something of the pre-war internationalism was resumed. The Bloomsbury artists played host in 1919 to Derain and Picasso, Mikhail Larionov, the conductor Ernest Ansermet and the dancer and choreographer Léonide Massine. Fry was in the South of France in late 1919; Grant and Bell in Rome in spring 1920 and in St Tropez in winter 1921–2. All three spent time in Paris where they saw Picasso, Dunoyer de Segonzac and the circle of painters and writers around Derain; all three showed recent work at the Galerie Vildrac in 1920 and Fry exhibited at the Salon d'automne. Their painting reflected the general sobriety of post-war European art, as indeed it had done for two years in the war-time isolation of Charleston and London. They pursued a personal representational style in their easel painting in line with many of their British and French contemporaries. Grant's first one-artist exhibition in London at the Carfax Gallery in 1920 (see nos.57, 113, 119 and 121) was a critical and commercial success, laying the foundations of his fame between the wars.

(*Beginning Again: An Autobiography of the Years 1911–1918*, by Leonard Woolf, 1964)

108 *Barns and Pond, Charleston* 1918

Oil on canvas 55.8 × 76.2 (22 × 30)
Inscribed 'Roger Fry/18' b.r.
Wakefield Museums & Arts

In mid-summer 1918 Fry and his two children spent a holiday at Bo-Peep Farm, Alciston, in the Sussex Downs not far from Vanessa Bell's household at Charleston. Hoping to regain some place in Bell's affections, Fry was in fact rebuffed and their friendship nearly ended. A persistent concentration on painting landscape was a solace even though the kind of synthesis he was searching for in his work eluded him. A little later in the year, he visited Charleston in more favourable circumstances and it was almost certainly then that he painted this late afternoon, late summer view of Charleston's farm. He set up his easel to the north-east side of the pond in front of the house to gain a full view of the imposing group of buildings reflected in the water; elm trees behind the barn, granary and cowsheds screen the height of Firle Beacon. It was exactly the kind of architectural landscape that Fry most relished and the still reflections in the pond of trees and buildings became a classic motif. The example of Cézanne's *Pool at the Jas de Bouffan* (1878, private collection), through which Fry had been alerted to the French painter's genius, lies behind a painting such as this with its close-woven planes, continuous near-central division between water and landscape and a 'pre-ponderance of right angles' offset by subtly judged diagonals from the wing of the barn at top right to the drifting punt in the water. But instead of the austerity Fry admired in the Cézanne painting (a winter landscape), he deploys a warm, autumnal palette, with touches of viridian and magenta, cooled by the blue blacks of the building's door and boarding.

No. 108 provides a stepping-stone in the slow development of Fry's painting. A certain innate puritanism had marked his earlier, more experimental work; a sense of duty infects even the successes of that phase. Although experiment answered his scientific temperament, to come through to a solution, to an 'inevitable synthesis' was his goal. *Barns and Pond* marks the beginning of this next phase in which attention to the unifying quality of light organises his composition in a more natural, less 'willed and deliberate' way. But in doing so he has exchanged the more bucolic aspects of the English countryside for the rich but sober earth colours of Provence. (The two quotations in this paragraph are from a letter to his sister Margery Fry of 2 June 1918 in *Letters*, 2, 1972, p.429.)

Prov: …; bt Wakefield Corporation 1937
Exh: *Landscape in Britain 1850–1950*, Hayward Gallery and ACGB tour, 1983 (103, repr.)
Lit: R. Fry, *Letters*, 2, 1972 (p.429); Naylor 1990 (p.214)

109 *The Pond, Charleston* 1916

Oil on canvas 30.5 × 35.5 (12⅛ × 14⅛)
The Charleston Trust

According to Duncan Grant, this was the first painting made by Bell at Charleston. In September 1916, when organising the move of herself and her household from Wissett Lodge, Suffolk, to her new home in Sussex found for her by her sister, she noticed at once the allure of the immediate landscape and 'the extraordinary peace and beauty of the place. The colour is too amazing now, all very warm, most lovely browns and warm greys and reds with the chalk everywhere giving that odd kind of softness' (V. Bell to Grant, 18 September 1916, quoted in Spalding 1983, p.155). No.109 shows the large, flint-walled farm pond in front of the house, bordered on the garden side with bushes and trees above which appears, at right, the dark roof of the granary; in the distance is Firle Beacon, the highest of the South Downs.

The remote tranquillity of Charleston, valued by Bell for the rest of her life, is captured in this small, perfectly organised painting, each of the warm colours of the landscape telling against the cooler geometry of the reflections in the water. The pond became a frequent subject in Bell's work; she particularly liked water in a landscape, taking pleasure in the repeated but different images it afforded, setting one kind of reality against another (e.g. *Tilton from the Pond*, 1937, fig.113, and *Charleston*, c.1950, Charleston Trust). Compare also Fry's painting made two years later (no.108).

Prov: Artist's estate; to A.V. Garnett; to Charleston Trust 1984
Exh: FAS 1976 (23, as *Landscape*); New York 1980 (31); Canterbury 1983 (35)
Lit: Naylor 1990 (p.247, repr.); *A Cézanne in the Hedge*, ed. H. Lee, 1993 (repr. front cover of paperback ed.)

fig.113 Vanessa Bell, *Tilton from the Pond* 1937, oil on canvas 50.8 × 61 cm. Private Collection

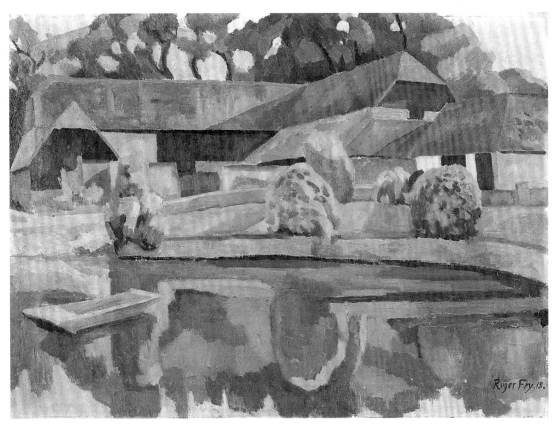

108

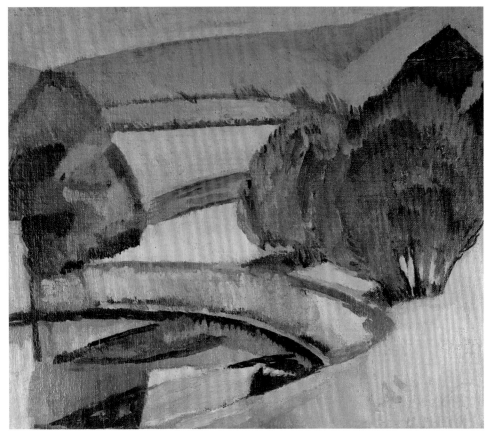

109

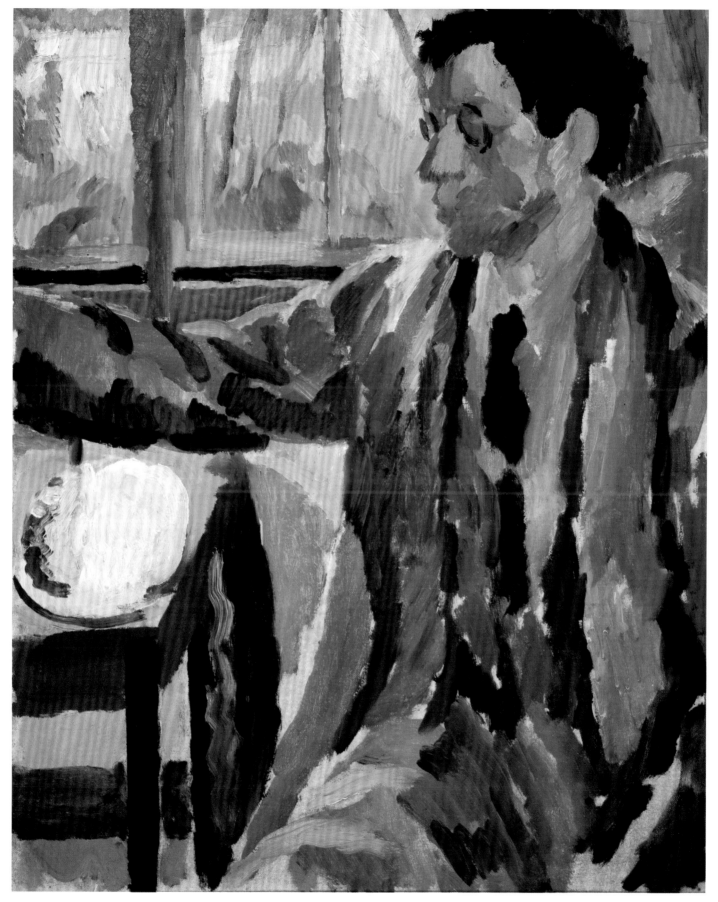

110

110 *Duncan Grant Painting* c.1920

Oil on canvas 49.8 × 39.2 (19⅝ × 15½)
Estate stamp on stretcher
Tatham Art Gallery, Pietermaritzburg

There are very few portraits of Grant by Bell and of the three belonging to her early period, one shows him painting alongside Henri Doucet at Asheham (fig.68) and another is unfinished (Watney 1980, pl.14). This one shows him seated at an easel with a work table nearby and wearing spectacles which he came to use for painting from c.1916–17 onwards. No.110 has been dated to c.1915 but should be placed in c.1920 for it shows Grant at work in a large army hut which, acquired in 1919, was transformed in summer 1920 into a studio in the orchard beyond the walled garden at Charleston. 'We have had a skylight put in and white washed it and it now makes a very good studio with a good north light and heaps of room for 2 or 3 painters. Also it's very nice being some way from the house, it's so quiet' (Bell to Fry, 15 August 1920; TGA).

The swift immediacy of Bell's image suggests the work was completed in one sitting. The colour scheme – ochre, umber, grey, mauve, black and white – is close to several landscapes by Bell from c.1920 and also relates to the oil sketches for the large figure decorations she and Grant were painting in their new studio, which were intended for Keynes's rooms in King's College, Cambridge; these were in progress in August 1920.

Prov: Artist's estate; d'Offay where bt by Pietermaritzburg 1983
Exh: Toronto 1977 (1, repr.); *Vanessa Bell 1879–1961*, Anthony d'Offay, 1983 (48); *Focus on Bloomsbury*, National Gallery of S. Africa, Cape Town, and tour 1987 (2; repr. front cover)
Lit: G. Greer, *The Obstacle Race*, 1979 (pl.26)

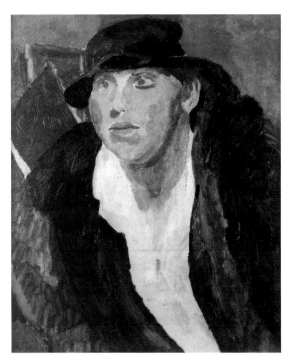

fig.114 Duncan Grant, *Dr Marie Moralt* 1919, oil on canvas
45.5 × 40.5 cm. Private Collection

111 *Woman in Furs (Dr Marie Moralt)* 1919

Oil on canvas 68.2 × 56.2 (26⅞ × 22⅜)
Inscribed 'VB/1919' b.l.
The Syndics of the Fitzwilliam Museum, Cambridge

Dr Marie Mathilde Alice Moralt came to Charleston in the crisis that followed the birth of Bell's and Grant's daughter on 25 December 1918. The baby had become ill and refused to gain weight; seeking another opinion, Bell contacted Noel Olivier who, unable to come to Charleston, sent her friend Marie Moralt. Both women had qualified as doctors in 1917 (LRCP). After an explosive scene with Bell's Lewes doctor, Moralt took charge, changed the baby's diet and improvement was immediate. Moralt stayed on at Charleston for two or three weeks: large, capable, genial, glad of a change of scene from London where she herself had been unwell and, according to Bell, 'wanting to know Bloomsbury, having never had any cultured friends of her own and longing to talk about Henry James, etc. I don't know how much one could supply that want' (Bell to Fry, 6 February 1919, in Marler 1993, p.230). She returned to Charleston in May and it was on this visit that she sat to Grant and Bell in the first-floor studio. 'She's simply wonderful to paint,' Bell reported to Roger Fry (who was already acquainted with Moralt); two vivid portraits resulted. Where Bell shows something of Moralt's inner dissatisfaction, Grant emphasises her physical vitality (fig.114) both of them using the more subdued palette of the post-war period. Moralt sat again to the two artists in December 1919 (there are several drawings of her by Grant) and remained in touch with them in a semi-professional capacity for several years. She rented Vanessa Bell's house at Cassis in 1930. She was in practice in St John's Wood and later in Great Bookham, Surrey, but disappears from medical directories after 1929.

Prov: Bt from Independent Gallery by Frank Hindley Smith, 1922, by whom bequeathed 1940
Exh: *Vanessa Bell*, Independent Gallery, 1922 (as *Portrait of Mrs M.*); *Contemporary British Art*, Bristol City Art Gallery, 1931; Fredericton 1976 (16, repr.); Sheffield 1979 (24); Canterbury 1983 (38); Crafts Council 1984 (P20); Barcelona 1986 (72 repr.)
Lit: R. Fry, 'Vanessa Bell and Othon Friesz', *New Statesman*, 3 June 1922 (pp.237–8); W. Sickert, 'Vanessa Bell', *The Burlington Magazine*, 41, July 1922 (pp.33–4, repr.); J.W. Goodman, *Fitzwilliam Museum, Cambridge: Catalogue of Paintings III: British School*, 1977 (p.14); Shone 1976 (pl.116); *Charleston Newsletter*, 24, 1989 (p.56, repr.); Shone 1993 (pl.143, pp.183–4)

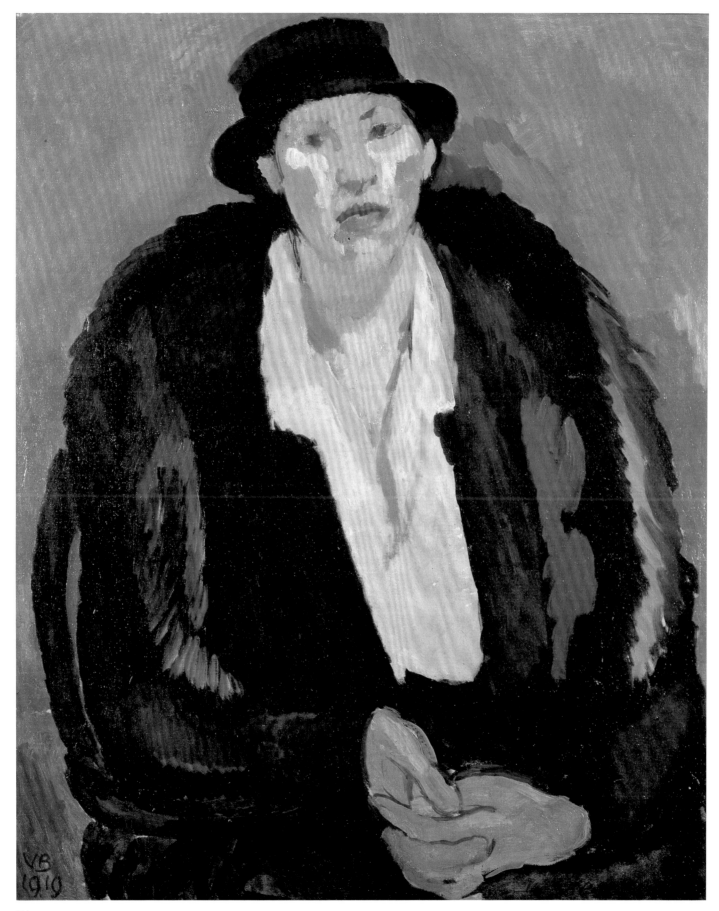

111

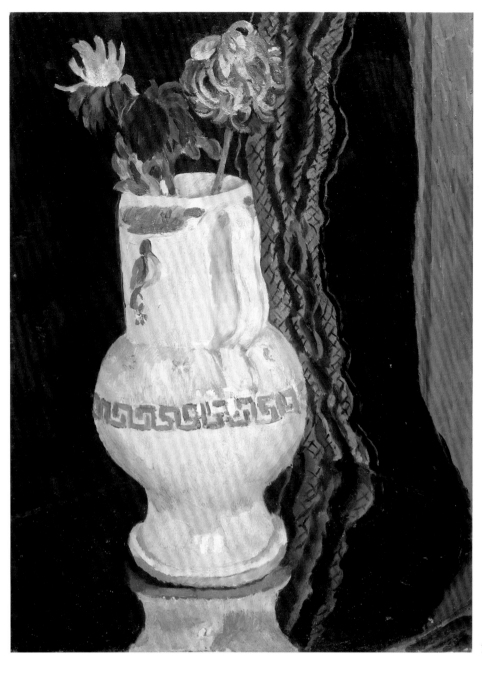

112

VANESSA BELL

112 *Chrysanthemums* 1920

Oil on canvas 61 × 46 (24 × 18)
Inscribed 'VB 1920' b.r.
Tate Gallery, London. Presented by the Contemporary Art Society 1924

Chrysanthemums encapsulates Bell's approach to still life in the immediate post-war years. It shows her preference in flower painting for a limited number of blooms, for an ample statement of the vessel itself and for a relatively simple arrangement of the principal objects against a printed textile. Whereas attention to the effects of light in her garden and landscape painting in the 1920s led to a certain undemanding pleasantness, her still lifes reveal a more concerted realisation of form, eliciting those aspects of blunt simplicity and detachment which characterise her best work.

The two-handled, decorated Italian vase, probably purchased in Italy in 1913, appears in several works by Grant and Bell (e.g. Grant's *Still Life*, 1914, Barclays Bank). No.112 was the first of Bell's works to enter the national collection at Millbank and the CAS continued to buy her paintings through the 1920s and 1930s, several entering public collections soon after purchase.

Prov: Bt from Independent Gallery by CAS 1923; presented to Tate Gallery 1924
Exh: *Paintings by Vanessa Bell*, Independent Gallery, London 1922 (11);
Exhibition of Paintings & Drawings, CAS, Grovesnor House, London 1923 (26);
ACGB 1964 (40)
Lit: *Contemporary Art Society Report 1919–24*, 1924 (pl.4); H. Hubbard, *A 100 Years of British Painting 1851 to 1951*, 1951 (pl.120); J. Rothenstein, *British Art Since 1900*, 1962 (pl.49)

113

113 *By the Fire* 1916–17

Oil on canvas 53.2 × 35.5 (21 × 14)
Inscribed 'D.G.' b.r.
The Charleston Trust

On various occasions in later years, Grant identified the interior depicted here as Wissett Lodge, as well as Charleston and 46 Gordon Square, at the same time denying that the seated figure by the fire was Vanessa Bell. Stylistically no.113 belongs to 1916 or early 1917 and thus 46 Gordon Square can probably be discounted. The fluted glass carafe appears in several Charleston still lifes of *c.*1917–20. Whatever the domestic circumstances of Grant's inspiration (and Vanessa Bell's figure and features by 1916 were becoming an ineradicable part of his visual subconscious), the interest of the painting lies in its inclusive spatial sweep – from the plate with two pears, precariously placed on the edge of the table, seen from above and almost parallel to the picture plane, through to the far side of the room where the figure appears the same size as the carafe. This spatial elasticity embodies the gently suggested mood derived from the bisecting curve of the table dividing human and aesthetic contemplation. It comes close to the atmosphere of Virginia Woolf's short story of 1917 'The Mark on the Wall' with its leaping juxtaposition of 'solid objects' and fireside reverie.

On the back of no.113 there is part of an earlier still life of flowers and a lamp; and the picture itself appears to have been painted over the whole or part of another painting.

Prov: V. Bell to A.V. Garnett 1961; to present owner
Exh: Edinburgh and Oxford 1975 (25)
Lit: Watney 1990 (p.48)

DUNCAN GRANT

114 *Vanessa Bell* *c.*1917–18

Oil on canvas 94 × 60.6 (37 × 23⅞)
National Portrait Gallery, London

This well-known portrait of Vanessa Bell, which exists in two versions, is difficult to date. Grant had first painted her in the same red paisley evening dress in September 1914, a full-length portrait (collection Olivier Bell) which includes paper collage and pasted fabric (the same as Bell's dress). A three-quarter length portrait, similar to no.114 (fig.115), also includes fabric collage and probably belongs to 1916, painted at Wissett Lodge, Suffolk, where some of the walls had been distempered blue, as seen in the background. No.114, almost certainly the second version, contains no collage elements and is painted in a more carefully realised manner. Bell's hair is closer to the head and longer at the nape but the composition is otherwise the same. The handling of paint is consistent with Grant's style of *c.*1918 in which definite patches of colour establish a solidity in, for example, the face and arms. Again the background is blue (Bell's upstairs studio at Charleston was briefly painted blue as can be seen in a Grant still life of *c.*1918–19, private collection, Scotland). The present work was in Grant's 1920 Carfax exhibition and listed by the artist as complete by

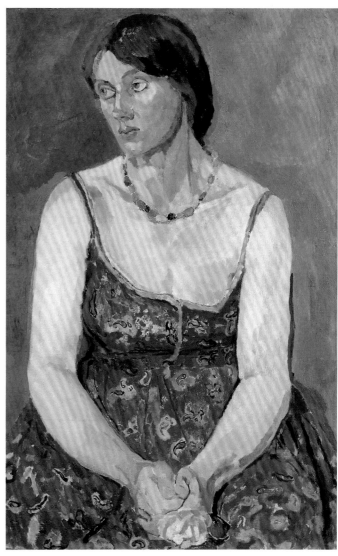

114

October 1919 (it was shown as *Portrait* and not *Portrait of a Lady* as suggested in Shone 1976, p.202). Although there is no direct confirmation, Grant may have been influenced in this work by the Master John portrait of Mary I (1544) in the National Portrait Gallery (fig.116).

Grant's image captures some of the qualities for which Bell was revered by her friends; she appears both seductive and monolithic, straightforward and mysterious. Contemporary with this painting is her sister's portrait of Vanessa as Katherine Hilbery in her novel *Night and Day* (1919) in which she writes of Katherine's 'dark oval eyes ... brimming with light on a basis of sadness, or, ... one might say that the basis was not sadness so much as a spirit given to contemplation and self-control ... Decision and composure stamped her'.

Prov: J.L. Behrend; bt from Leicester Galleries by NPG 1962
Exh: Carfax 1920 (8, as *Portrait*); *The J.L. Behrend Collection*, Leicester Galleries, London, 1962 (29, dated 1920); *Decade 1910–20*, Leeds and Arts Council tour 1965 (56, repr.); *Vision and Design* 1966 (33); Fredericton 1977 (14, repr.)
Lit: Q. Bell, *Bloomsbury*, paperback ed. 1974 (repr. btw. pp.64–5); J. Lehmann, *Virginia Woolf and her World*, 1975 (p.23); Naylor 1990 (p.171, repr.) F. Spalding, *The Bloomsbury Group*, NPG, 1997 (pp.24–6, repr.)

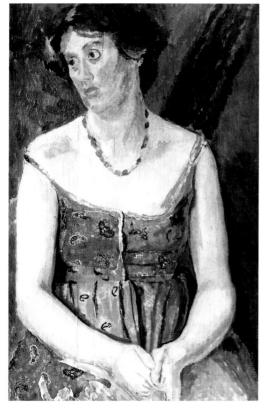

fig.115 Duncan Grant, *Vanessa Bell* c.1916, oil and fabric collage 91.5 × 61 cm. Mark Lancaster

fig.116 Master John, *Mary I* 1544, panel 71.1 × 50.8 cm. National Portrait Gallery, London

115 *Vanessa Bell at Charleston* 1917

Oil on canvas 127 × 102.2 (50 × 40¼)
National Portrait Gallery, London

According to the artist, this was the first portrait he made of Vanessa Bell at Charleston and can be dated to about May 1917. The setting is the downstairs sitting room (which became known as the garden room) with alcoves either side of the fireplace, a window facing onto the farm pond and French doors opening onto the walled garden. Bell is lying on a large upholstered sofa, with temporary bookshelves in the recess behind her; on the mantelshelf an Omega vase (see no.95f) contains a single oriental poppy. She is wearing a light summer dress, short waistcoat and beribboned sun hat. There is an oil sketch of her head and shoulders in these clothes by Roger Fry (formerly attributed to Grant; private collection). Fry seems to have been closer to the subject than Grant who, to gain the deep perspective needed to include the whole of Bell's figure, must have stood at his easel, his back close to the French doors. By raising his colour to the top of the spectrum, Grant attains brilliance throughout and is able to interweave areas of shadow and illumination with no dramatic shifts to darker colour: the relatively subdued hues of the sofa, for example, are in fact quite light, an impression reinforced by his aerated, loose handling of thinned pigment.

A charcoal drawing of Bell wearing the same clothes but a different hat and in the same pose as for no.115 is in a private collection (inscribed by Grant 1918 at a later date).

Bell, who was thirty-eight at the end of May 1917, appears both relaxed and watchful, a woman at the centre of a curious *ménage*. On a purely visual level, this Sussex farmhouse interior would have had few parallels; though Bell had rented Charleston to house temporarily herself, her two sons and two conscientious objectors working as farm labourers, her home quickly assumed a routine and look in which aesthetic considerations and the practical needs of two painters took precedence over respectable conformity. As Frances Spalding has noted, the house's relative isolation 'encouraged an existence entirely free of the usual social pressures' (Spalding 1983, p.164); and Virginia Woolf wrote of her sister, perhaps enviously, that she 'seems to have slipped civilization off her back' (V. Woolf to V. Dickinson, 10 April 1917, *Letters*, 2, 1976, p.147). Bell's new-found freedom, although it contained emotional tensions and domestic drudgery, was something she had long craved and Grant's resplendent image of her seems to celebrate her surprise and satisfaction in having found it.

Prov: The artist; d'Offay by 1975; Janet Hobhouse; Christie's 3 Nov. 1982 (80a; repr.in col. on addendum sheet) where bt by NPG
Exh: Tate 1959 (39); ACGB 1969 (20); *Modern British Painting*, Anthony d'Offay, London, 1975; FAS 1976 (43); New York 1980 (84); Dallas and London 1984 (18, repr.)
Lit: *The Burlington Magazine*, 117, Dec. 1975 (p.825, repr. fig.58); Shone 1976 (pl.VII); Naylor 1990 (p.238); Shone 1993 (pl.127); F. Spalding, *The Bloomsbury Group*, NPG, 1997 (pp.25–6, repr.)

115

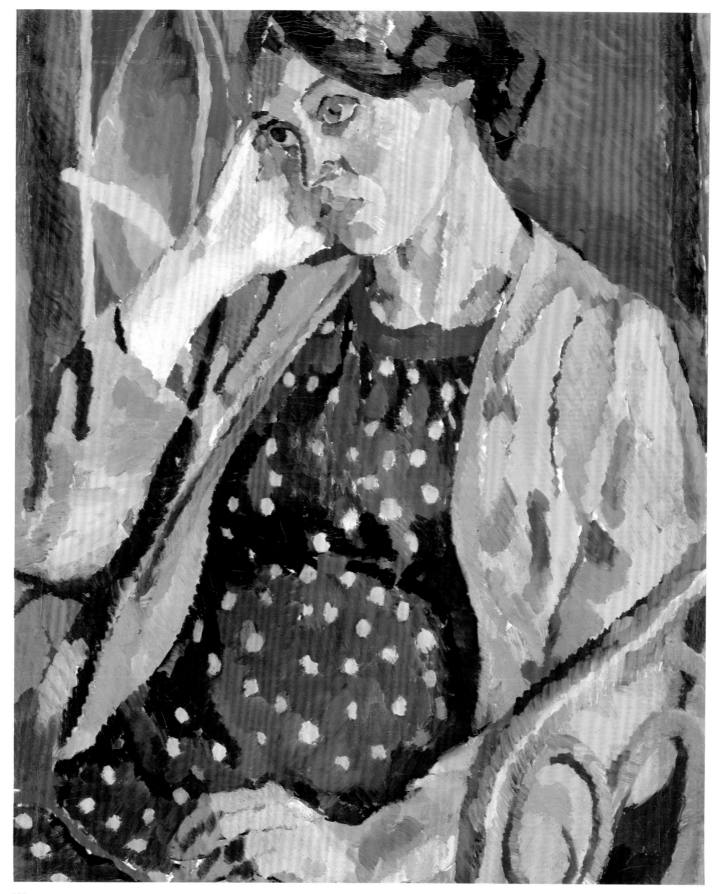

116

116 *Vanessa Bell Pregnant* 1918

Oil on canvas 49 × 40 (19¼ × 15¾)
Inscribed 'A Corner of the Crown Inn, King's Lynn' and 'D Grant' on
back of canvas
Mackelvie Trust Collection, Auckland Art Gallery, Tio o Tamaki

Vanessa Bell became pregnant in spring 1918 and her and Duncan Grant's daughter Angelica was born on Christmas Day at Charleston. This painting probably belongs to the early autumn when Bell had been advised by her doctor to rest, following a haemorrhage after a fall. It is one of the earliest secular depictions in British painting of an obviously pregnant woman, Augustus John having set a precedent with *Ida Pregnant* (*c*.1901, National Museum of Wales, Cardiff).

Behind Bell's figure there appears to be part of Grant's hanging signboard for the Omega Workshops, painted in May 1915, which contained two flowers in a vase on one side and the Omega symbol on the reverse. Whether it was actually hung, as intended, outside 33 Fitzroy Square, is not known; if it was, it must have been returned to Grant before no.116 was painted or there was another version of it at Charleston, long since lost or overpainted. Bell's yellow waistcoat is almost certainly the one made for her at the Omega by Kate Lechmere (see Bell to Grant, 6 August 1915 in Marler 1993, p.183).

No.116 only came to light in 1991 when it was discovered behind a much later and less interesting painting of a pub interior. Repaired stretcher marks around the edges are discernible. Grant often (and Bell occasionally) used the reverse of earlier canvases or boards for later works but it seems particularly regrettable that so forceful and intimate an image as this was lost for so long.

Prov: Agnew's July 1935 as *A Corner of the Crown Inn, King's Lynn*; to Mrs Marchant, French Gallery, London; ...; E.L. Franklin; by descent estate of Cyril Franklin, sold Christie's, 6 March 1992 (64) where bt Spink; bt Auckland City Art Gallery 1993
Exh: *Annual Exhibition of 20th Century British Art*, Spink, June 1992 as *Vanessa Bell Pregnant* (repr. in *Preview*)
Lit: *Charleston Magazine*, 5, Summer/Autumn 1992 (p.27, repr. p.29); Shone 1993 (pl.130)

117 *Lessons in the Orchard* 1917

Oil on canvas 45.6 × 50.6 (18 × 20)
Inscribed 'D. Grant' b.l., 'Lessons in the Garden by Duncan Grant' on
back in V. Bell's hand
The Charleston Trust

The scene is the orchard at the side of the walled garden at Charleston. Julian Bell (b.1908) is on the right, his brother Quentin (b.1910) on the left, either side of Mabel Selwood, who had worked for several years for Vanessa Bell as nurse and briefly as governess before leaving to marry in October 1917. The Bell boys were educated at home until soon after the end of the war and lessons were a regular feature of the household. The painting was probably carried out in late summer 1917. Its intimate charm lies in the perfect fusion of the directness of Grant's vision and the calligraphic ease with which he has conveyed it, establishing a set of gently echoing curves and correspondences of colour, the lightest and darkest tones balanced at the centre of the composition.

Prov: The artist to V. Bell; to A.V. Garnett 1961; to private collection
Exh: Tate 1959, (37, as *The Open-Air Lesson*, 1916); Bristol 1966 (3); Edinburgh and Oxford 1975 (26, as *The Open-Air Lesson*, *c*.1917)
Lit: Mortimer 1944 (pl.7); Naylor 1990 (pl.186); Shone 1993 (pl.116); Q. Bell and V. Nicholson, *Charleston*, 1997 (p.129, repr.)

118 *Venus and Adonis* *c*.1919

Oil on canvas 63.5 × 94 (25 × 37)
Tate Gallery, London. Purchased 1972

Venus and Adonis and Leda and the Swan were subjects to which Grant returned on more than one occasion in the period 1917–19 (and even to a composite *Venus and the Duck* on a linen chest at Charleston). In his Carfax exhibition there was a *Venus* (26) and the present work *Venus and Adonis* (29). The former may have been a painting begun in 1917, now untraced; *Venus and Adonis* belongs to 1919 and was a principal exhibit at his Carfax show, mentioned by most reviewers and called by Fry one of Grant's 'most striking and poetical inventions'. A number of drawings exist related to the figure of Venus against various backgrounds; in one (private collection), the figure of Adonis with bow is prominent, surveyed by Venus in massive profile, cut by the right edge of the paper; in another (fig.117) Adonis is absent. Grant later insisted that he was not following the story of the two lovers in any detail, it was 'not in any way an illustration of the subject, but a rhythm which *came out of* the subject' (Tate 1972, p.111). He seems chiefly to have been interested in seeing how far he could push a hot chromatic scale (the reds and magenta are unprecedented in English painting) without upsetting the rhythmic complexities of the whole. Though in general the painting's inspiration can be traced to Grant's experience of Titian and Poussin, the profile head, its rhythms continued into the light and dark clouds, draws directly on Piero di Cosimo's *Simonetta Vespucci* (Chantilly). Correspondences

117

of shape abound – from the billowing curtain echoing in reverse the goddess's swelling buttock and thighs to the handle of the white jug and Venus's right arm.

The enormous female figures which begin to populate Grant's painting from 1917–18 onwards are an original and early contribution to an aspect of Neo-classicism that became prevalent around 1920, particularly in the work of Picasso and Derain. During the First World War, Grant had been almost entirely cut off from continental art, in reality and in reproduction. Painting in relative isolation at Charleston he discovered his own *rappel à l'ordre*. Among his British contemporaries J.D. Fergusson had amplified his female figures before the war; after 1918–19, Mark Gertler pursued similar concerns resulting in his corpulent, hard-edged *Queen of Sheba* (1922, Tate Gallery) which contains several references to Grant's *Venus*. It is worth noting here that the young Henry Moore knew no.118 from his visits to Michael Sadler's house in Leeds in the early 1920s (as he told Grant in 1974).

Although Grant later stated that *Venus* was not modelled on Vanessa Bell (Grant to D. Brown, typescript, TGA), there is no doubt that the painting carries a personal undertone in its reference to a watchful, anxious goddess and a roving, far-off male – a situation often repeated in Grant's life with Vanessa Bell.

Prov: (?from Carfax 1920) Sir Michael Sadler; sold Christie's 30 Nov. 1928 (134) where bt Keynes (?on behalf of Strachey); Lytton Strachey by Feb. 1929; Dora Carrington (Partridge) 1932; Ralph Partridge; Frances Partridge by whom sold

fig.117 Duncan Grant, Study for *Venus and Adonis* c.1918, pencil on paper. Whereabouts unknown

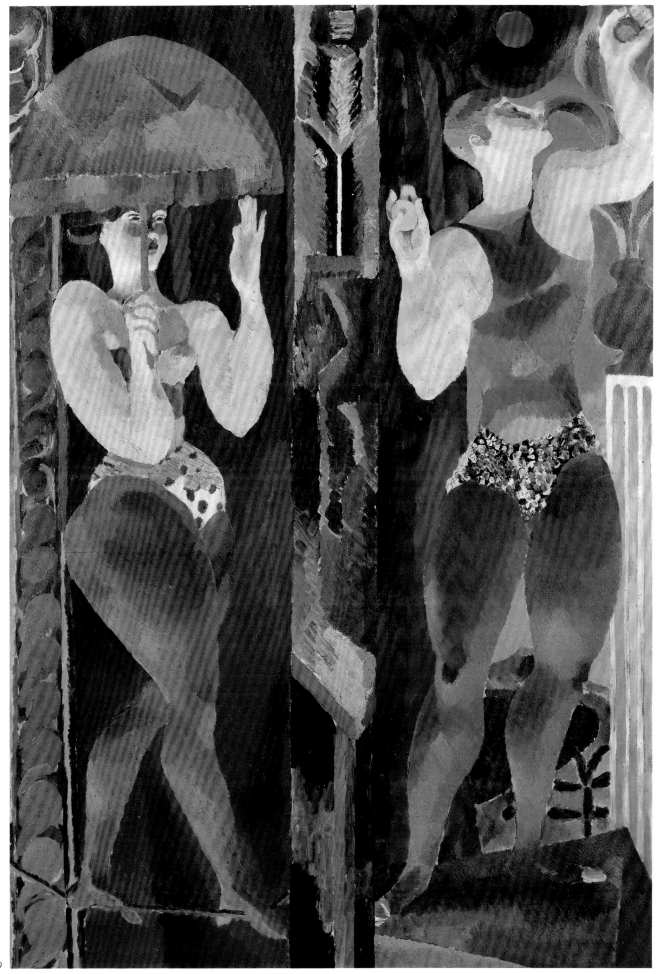

119

Sotheby's 13 Dec. 1961 (93); bt Roger Senhouse, Rye; sold Sotheby's, 12 May 1971 (32, repr.) where bt Stone Gallery, Newcastle-Upon-Tyne, where bt Tate 1972

Exh: Carfax 1920 (29); Guillaume Davis 1929 (9, lent by L. Strachey); Tate 1959 (43); Rye 1967 (87, lent by Senhouse); Tate 1975 (13); *British Sculpture in the Twentieth Century. Part One: Image and Form 1901–50*, Whitechapel Art Gallery, 1981 (p.86, repr.); London and Stuttgart 1987 (29, repr.)

Lit: R. Fry, 'Mr. Duncan Grant's Pictures at Patterson's [sic] Gallery', *New Statesman*, 21 Feb. 1920 (pp.586–7); *Art at Auction* 1970–71 (p.134, repr.); Fry, *Letters*, 2, 1972 (p.532, Fry to Bell 14 Feb. 1923); *The Tate Gallery 1970–72*, 1972, pp.110–11 (repr.); V. Woolf, *Letters*, I, 1976 (p.421, V. Woolf to Grant 11 February 1920); Shone 1976 (pl.124, p.202); Watney 1980 (pl.97, p.107); Watney 1990 (pl.42, p.37); Shone 1993 (pl.138)

DUNCAN GRANT

119 *Juggler and Tightrope Walker* c.1918–19

Oil on canvas 103.5 × 72.4 (40¾ × 28½)
Mrs Frances Partridge

In a letter to Keynes of late July 1918 Grant mentions that his painting of jugglers was in London ready to be photographed. Over a year later (October 1919) he made a note that he had to finish the 'Acrobat and Juggler' for his Carfax exhibition the following February. The two paintings may or may not be the same; there is evidence that he visited a circus in Dartford, Kent, in early autumn 1919 (Grant to V. Bell, quoted in Watney 1990, p.47) and no.119 may be the result of his obvious enjoyment: 'It was enchantingly traditional with clowns and exquisite horses and jugglers'. There are two preparatory studies on paper, no.181 and a pencil drawing in the artist's estate in which the tightrope walker carries cymbals (fig.118).

The human figure in action was a constant motif throughout Grant's career. The decades are punctuated by often large-scale compositions representing a variety of activities, from the *Bathing* and *Football* panels of 1911 (see no.71) through such works as the mid-1920s *Bathers* (National Gallery of Victoria, Melbourne), and the *Queen Mary* liner decorations to *The Arrival of the Italian Comedy* (1950–1; fig.43) and the *Gymnasium* (c.1965–9, destroyed). All these emerged from on-the-spot observations and studies from models and were developed in the studio through traditional compositional practice.

Roger Fry once wrote to Vanessa Bell of walking with Grant through London and noting 'how infinitely quick he is in his reaction to sight, how he misses the point of nothing' (24 November 1918, Fry *Letters*, 2, 1972, p.438). Grant not only made constant resort to his pocket sketchbooks but trained his memory to be able to translate onto a page the imagined figurative idea in his head. The drawings for no.119 were almost certainly made away from the motif: already the plan of dividing the composition vertically is in place. The tightrope walker with parasol is pictured indoors, the juggler on an outdoor platform, a purple curtain hanging behind both figures. The central abstract passage works as both physical division and surface decoration, some of the colours and rhythms of the figures either side being gathered together along its length. The painting has a paradoxical air of extreme weight and solidity and of dreamlike artificiality, a charac-

teristic of several paintings of this period including the *Venus and Adonis* (no.118). The landscape on the right contains a wry allusion to Piero, as Watney has pointed out; and already in the stage-prop plant on its classical column and the inventive repertory of mark-making we find the hallmarks of Grant's applied design of the following decade. When Fry reviewed Grant's 1920 exhibition he acknowledged the fantasy of Grant's imagination and the increased solidity of realisation in such works as no.119 but had reservations over his 'extended gamut of colour' which he felt was less resonant than in works of three or four years earlier. Claude Phillips in the *Telegraph* found it and other paintings unnecessarily distorted. But Lytton Strachey who had been distressed by Grant's Omega-period painting, was re-enchanted and bought the painting from Carfax for 60 guineas.

Prov: Sold by Carfax to L. Strachey 1920; to Dora Carrington (Partridge) 1932; to Ralph Partridge 1932

Exh: Carfax 1920 (21); *The Dial*, Nov. 1922 (repr. as *Acrobats*); *Exhibition of Contemporary Art, New York World's Fair*, 1939 (35); Tate 1959 (42); FAS 1976 (44)

Lit: R. Fry, 'Mr Duncan Grant's Pictures at Patterson's [sic] Gallery', *New Statesman*, 21 Feb. 1920 (pp.586–7); Fry 1923 (pl.11, left-hand figure only); J. Laver, *Portraits in Oil and Vinegar*, 1925 (pp.145–6); Shone 1976 (pl.122, pp.202, 205); Watney 1980 (p.48); Shone 1993 (pl.137); *Charleston Magazine*, 12, Autumn/Winter 1995, (p.17, repr.); Spalding 1997 (pp.224–5)

fig.118 Duncan Grant, Study for *Juggler and Tightrope Walker* c.1919, pencil on paper 32 × 22.6 cm. Estate of the Artist

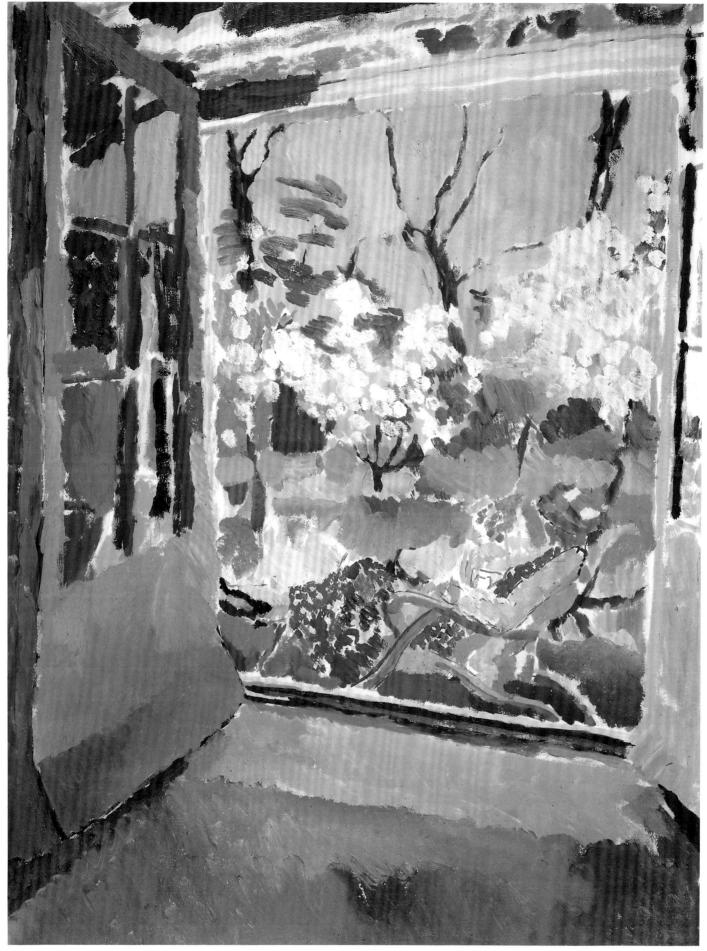

120 *Two Bathers* 1921

Oil on canvas 59.5 × 89.7 (23⅜ × 35½)
The Provost and Scholars of King's College, Cambridge

In December 1919, Grant persuaded Maynard Keynes to buy Seurat's oil study of 1884–5 of the standing couple featured towards the right in his *Sunday Afternoon on the Island of La Grande Jatte*. At Christmas 1919, Vanessa Bell gave Grant photographs of several late paintings by Renoir, who had recently died, nearly all of groups or single nude bathers in the open air. These two events were brought into focus in February 1921 when, on a visit to Paris, Grant saw further works by Seurat and went to see his old teacher, Jacques-Emile Blanche, where he was able to study Renoir's 'extraordinary' *Bathers* (1887, Philadelphia Museum of Art) which Blanche then owned. These events lie behind Grant's *Two Bathers*, the painting to which Vanessa Bell refers in a letter to Fry from Charleston (21 August 1921, TGA): 'Duncan is painting a picture of 2 nudes by a pond rather under the influence of Seurat I think – very odd pale relief. I hope he means to paint a large group out of doors from drawings'.

The setting is the farm pond at Charleston of which Grant had painted a whole series of views in 1920–21 (e.g. *Landscape, Sussex, 1920*, Tate Gallery); to people this luminous circle of water with bathing male nudes was one of Grant's abiding fantasies. The otherworldly, dreamlike quality of *Two Bathers* contrasts with the languorous note of erotic congress in *Bathers by the Pond* (no.121). The former suggests a more chaste and cooler vision than the high-keyed colour of the latter with its more adult figures and provocatively red bathing trunks. Both contain on the left a figure viewed from the back, seated at the edge of the water, echoing the seated nude at the left of Seurat's *Poseuses*. And in both Grant appears to have returned to a somewhat more layered version of his 'spotted' manner of painting of 1911–12 (even the foreground figure in *Two Bathers* is reminiscent of Virginia Woolf's pose in *On the Roof*, no.18). The moment passed and by the end of 1922 he had returned to a more smoothly integrated and solid manner of painting.

Prov: The artist; to J.M. Keynes *c*.1922 by whom bequeathed to the present owner 1946
Exh: Cambridge 1983 (27, repr.); on loan to Charleston, April–Oct. 1996
Lit: *The Burlington Magazine*, 125, 1983 (fig.56); Shone 1993 (pl.140)

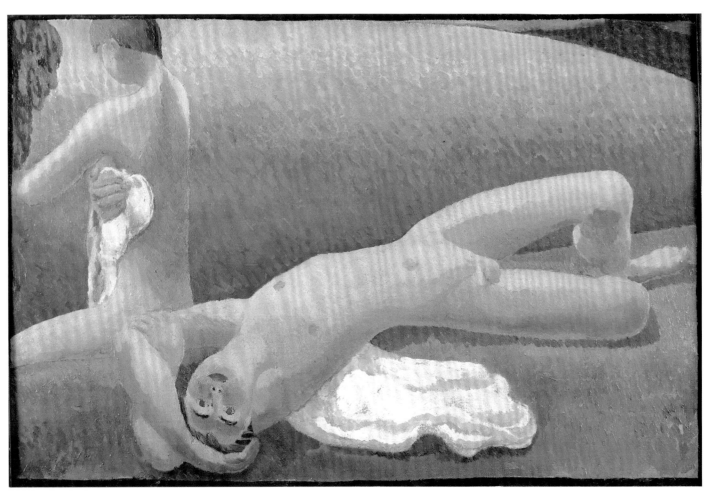

120

121 *Bathers by the Pond* c.1920–1

Oil on canvas 50.5 × 91.5 (20 × 36)
Hussey Bequest 1985, Pallant House, Chichester

Taking into account Grant's stylistic eclecticism in the immediate post-war period, it is difficult to date this work precisely. On the one hand its warm colour and exaggerated postures relate it to his *Venus and Adonis* (no.118) and *Juggler and Tightrope Walker* (no.119) of 1918–19. But Vanessa Bell's letter quoted in the previous entry (no.120) suggests that this work may have been the next step in Grant's evolution towards a major bathing scene. The segmented treatment of the surface of the pond is close to his pure landscape paintings of the pond in 1920–1. Both works have a painted border around the canvas edge.

It was only in 1926 that Grant again took up the idea of a large bathing scene by the pond, producing a rather unsuccessful painting of nine male figures, in and out of the water, in which the example of Cézanne wars with the homo-eroticism of Henry Scott Tuke. It was eventually finished in the early 1930s and is now in the National Gallery of Victoria, Melbourne. For further commentary on no.121, see previous entry.

Prov: The artist; Paul Roche from whom bt by Walter Hussey c.1977;
bequeathed to Pallant House, Chichester, 1985
Exh: FAS 1976 (48)
Lit: *The Fine Art Collections*, Pallant House, Chichester, 1990 (p.54)

122 *The Room with a View* 1919

Oil on canvas 76.2 × 57 (30 × 22½)
Private Collection
[Illustrated on p.201]

Charleston's walled garden is seen through the open French windows of the sitting room. Vanessa Bell, wearing what appears to be the same dress and jacket as seen in no.116, is seated on a reclining chair on the terrace. At that time, most of the garden, through war-time contingencies, was given over to vegetables and fruit trees, here seen in blossom. In spring 1919 Grant was mainly alone at Charleston and Bell, having by then established herself and her children in London, came to the house less frequently. The painting marks the first spring of Peace and is relaxed and lyrical in mood, similar to that of *Lessons in the Orchard* (no.117). It is Grant's first notable painting at Charleston of an interior/exterior view and the title he gave it (in his October 1919 list of pictures completed for his 1920 Carfax exhibition) may well be a conscious reference to E.M. Forster's novel *A Room with a View* (1908); Forster paid his first visit to Charleston in August 1919 (see no.162). The painting received several favourable press comments when shown at the Carfax and was bought by its director, Arthur Clifton, who had known Grant's work since the 1911 Camden Town Group exhibition at his gallery.

Prov: Bt from Carfax by Arthur Clifton 1920; to Mrs Clifton by whom sold to
Agnew's 1974; private collection from 1974
Exh: Carfax 1920 (12, as *The Room with a View*); *Modern British Paintings*,
Agnew's, summer 1974 (as *Landscape through a Window*)
Lit: C. Harrison, *English Art and Modernism*, 1981 (pl.72)

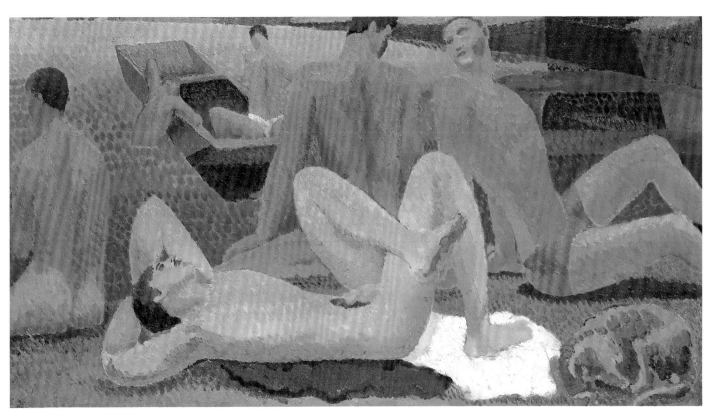

121

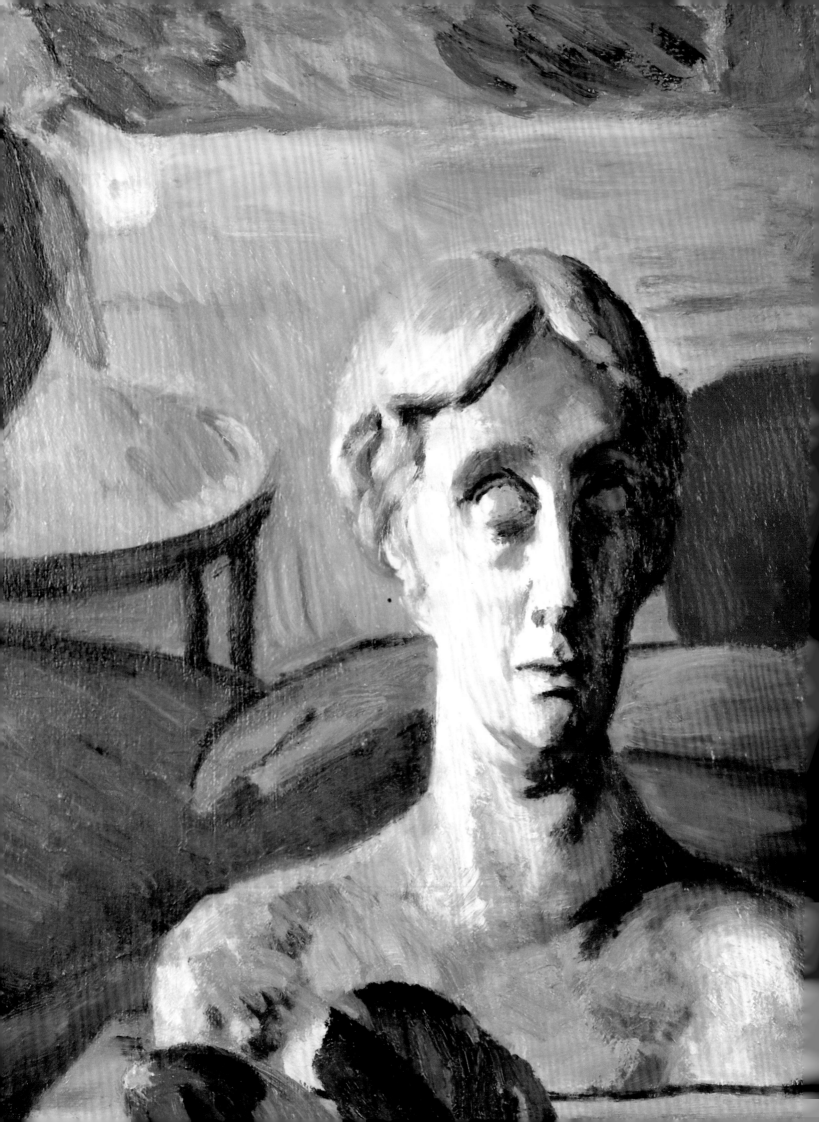

Transformations

Paintings post-1920

This last selection of paintings shows the mature and late styles of the three Bloomsbury artists and, by necessity, is highly abbreviated. Bell and Grant painted at Charleston, in their London studios (at 8 Fitzroy Street until 1939) and at their house, La Bergère, near Cassis, from 1928 to 1938. Fry spent much of each year in France (fig.120), finally sharing a house with French friends at St Rémy-de-Provence. Landscape painting was his overriding interest, practised with an increasing attention to light. He often favoured dramatic scenery as well as motifs celebrating the life of Provence, from small ports along the coast (no.126) to inland rural quietude (no.139). In the post-war years until his death in 1934, he became Britain's most famous writer on art, a popular lecturer and the author of *Vision and Design* (1920) and *Transformations* (1926), both collections of influential essays, as well as *Cézanne* (1927) and *Matisse* (1930). His occasional writings encompassed an enormous range, reflecting a lifetime's experience, from Far Eastern and Egyptian art, architecture and psychoanalysis, to commercial design, Mallarmé and Picasso, whom he described as 'one of the most sublime originators in the history of art'. Ironically, while he himself was considerably revising his views on the role of content in art, his earlier more rigid theoretical formalism came under attack.

Between the wars, Grant and Bell were among the best-known contemporary British artists, their work represented on several occasions in exhibitions such as the Venice Biennale and the Carnegie International, Pittsburgh, as well as throughout Britain. They developed a rich figurative style in which they left behind many of the audacities of their Post-Impressionist period in favour of a generally high-keyed polychromy, delineating their immediate world with slow-burning sensuousness. But by the 1930s they were no longer at the forefront. Their early work which prefigured aspects of the painting of artists such as Ben Nicholson and Ivon Hitchens, remained virtually unseen, and when Grant's large *Adam and Eve* (1913; fig.30) was shown at the 1928 London Group retrospective, it still caused derision and astonishment at the boldness of its idiom, especially in contrast to his more recent work.

fig.119 Vanessa Bell, *A Venetian Window* 1926, oil on canvas 86 × 67 cm. Leamington Spa Art Gallery

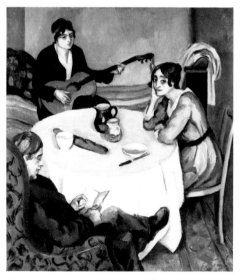

fig.120 Roger Fry, *Around the Table* [Marcel Gimond and his wife and, at right, Sonia Lewitska, in Vence] 1920, oil on canvas 75.6 × 69.2 cm. Courtesy Belgrave Gallery, London

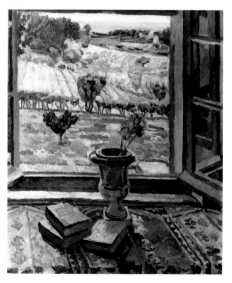

fig.121 Duncan Grant, *Window, Cassis* 1929, oil on canvas 66 × 54.6 cm. Private Collection

opposite detail from Duncan Grant, *Still Life with Bust of Virginia Woolf, Charleston* c.1955 (no.148)

Following the demise of the Omega Workshops in 1919, Fry rarely ventured again into applied design. Bell and Grant, on the other hand, were prolific designers between the wars carrying out many private commissions (nearly all of which have since perished or been disbanded), sets and costumes for several ballets and a huge range of pottery, fabrics, needlework and book illustration. They worked for Wedgwood, Royal Wilton, Shell and the Post Office. Grant's often elaborate mural decorations, drawing on mythological and Mediterranean imagery, ran parallel to his more closely realised easel paintings. Bell's decorative work is often bolder that Grant's in its manipulation of areas of flat colour and simple but suggestive motifs and is seen at its best in some of her bookjackets for the Hogarth Press.

During the Second World War, Grant's and Bell's reputations declined. Though their work continued to sell through several London dealers, it was met by critical silence. Bell, whose later years were overshadowed by the death of her son Julian in the Spanish Civil War and the suicide of her sister in 1941, became an increasingly isolated figure, content to follow, amidst her close family, the by now entrenched domestic and studio routine of Charleston. A number of later still lifes and self-portraits (e.g. nos.144 and 147), serene and contemplative, are telling vindications of a lifetime spent absorbed in the visual world. After Bell's death in 1961, Grant continued to live at Charleston, experiencing a revival of interest in his Post-Impressionist and Omega-period painting. At the same time, there was an exuberant flowering in his last work which, when shown at his ninetieth-birthday exhibition in 1975 at the Anthony d'Offay Gallery, was met with the kind of critical acclaim he had not received since the 1930s. In these paintings, of which three are shown here (nos.149–51), 'it seems', as Simon Watney has written, 'as if he was half consciously revisiting the themes and styles of his youth in a late flourish of passion for his craft' (Watney 1990, p.74).

(*Transformations*, by Roger Fry, 1926)

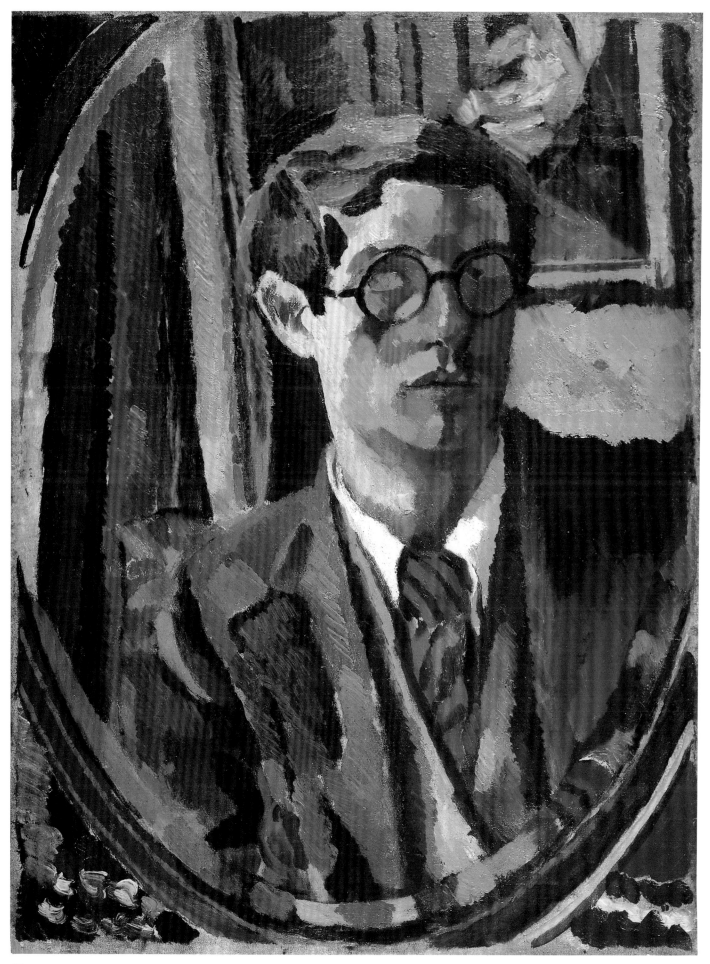

123

123 *Self-Portrait in a Mirror* 1920

Oil on canvas 61 × 45.8 (24 × 18)
Scottish National Portrait Gallery

Grant is looking at his reflection in a bevelled oval mirror in a room at 46 Gordon Square. Behind him is Matisse's *Seated Woman in an Armchair* (c.1917–18) which Maynard Keynes had recently bought (on Grant and Bell's advice) from Matisse's solo exhibition at the Leicester Galleries in November–December 1919 (in which several works included an oval dressing-table mirror). It seems likely that this self-portrait, therefore, was painted in early 1920, once the Matisse had entered Keynes's possession. The painting is a discreet homage to the living artist most profoundly admired in Bloomsbury; it finds Grant (who was thirty-five on 21 January 1920) coolly taking stock of himself at a critical period. The colour is warm yet subdued, the black and red stripes of Grant's tie reflected in the mirror's edge and echoed in the curtain on the left; ochre and Naples yellow and what he called French grey interweave in contrast across the picture plane. The image of himself that Grant projects here is altogether less self-conscious, more casually contemporary than that found in his self-portraits of a decade earlier (nos.9 and 27), the inclusion of the mirror itself emphasising an elusiveness in his character often noted by his friends. A year earlier, Virginia Woolf had observed him in a letter to Vanessa Bell: 'He is more and more like a white owl perched upon a branch and blinking at the light … a wonderful creature, you must admit, though, how he ever gets through life – but as a matter of fact he gets through it better than any of us' (16 February 1919, V. Woolf, *Letters*, 2, 1976, p.331).

Prov: The artist to d'Offay 1974; bt by SNPG 1980
Exh: d'Offay, 2, 1975 (no cat.); Barbican 1997 (115, repr.; p.159)
Lit: Watney 1980 (pl.9); Watney 1990 (pl.31); Naylor 1990 (p.101, repr.); *Concise Catalogue of the Scottish National Portrait Gallery*, 1990 (p.128, repr.)

VANESSA BELL

124 *Interior with a Table, St Tropez* 1921

Oil on canvas 54 × 64 (21¼ × 25¾)
Inscribed 'VB 1921' b.r.
Tate Gallery, London. Bequeathed by Frank Hindley Smith 1940

In the later nineteenth century St Tropez, a small port and ancient harbour on the southern French coast, east of Toulon, was a comparatively neglected town with poor road and rail communications. Painters were the first to 'discover' its unspoilt charm: Paul Signac had visited in 1892 and lived for many years at the Villa La Hune, attracting friends to the neighbourhood such as Maximilien Luce and Henri-Edmond Cross. A little later came the Fauvists and, along with Collioure, St Tropez ranks as a hallowed site of the movement, depicted by Matisse, Henri Manguin, Charles Camoin and Albert Marquet. After the First World War there was a changing international population of painters, several of them attracted by the genial presence of Dunoyer de Segonzac who had a house there for many years.

Through the Paris-based dealer Léopold Zborowski, Vanessa Bell heard that a house at St Tropez owned by Charles and Rose Vildrac was available for renting in the winter of 1921–2. La Maison Blanche was situated above and at the back of the town with extensive views over the port, the church and the Golfe de St Tropez. The house, relatively new in construction and recently furnished, had plenty of room for herself, her three children, two servants and Duncan Grant, he and Bell each having their own rooms in which to paint. When they arrived in October 1921, Roger Fry, an indefatigable explorer of Provence and its coastline, was already ensconced in the town. There were meetings with Charles Camoin (retelling his vivid memories of Cézanne), a visit from Moïse Kisling and excursions to see Simon and Dorothy Bussy at Roquebrune, Jean Marchand, and Gwen and Jacques Raverat at Vence. Fry left St Tropez in November and Bell and Grant returned to London in mid-January.

This is the finest of several paintings Bell completed at St Tropez, showing the view of the Golfe from one of the rooms of La Maison Blanche. The vase of flowers acts as a hinge between the sunlit autumnal landscape outside and the cooler tones of the interior, an interplay carried further in the blue reflections of the sky on the table's polished surface. The curves of the table and chair almost wittily counteract the more severe geometry of the window frame and curtains. A large painting of the same view but without the room and window (1921) was bought from the Independent Gallery in the following year by Maynard Keynes (now King's College, Cambridge). A small, vivid painting of sailboats in St Tropez harbour is at Charleston.

Before going to St Tropez Bell had become once more worried by her close painting partnership with Grant, similarities in their style being particularly noticeable when they shared the same motif or model. At La Maison Blanche they painted separately and purposely did not look at each other's work until the end of their stay. Bell was greatly relieved when Segonzac, to whom they showed their works in Paris, thought that they were fundamentally different and that any similarities were superficial. But the problem continued to nag her and from the 1920s there are fewer instances of their working from the same subject.

La Maison Blanche, hideously altered, still exists, in the suburban sprawl at the back of St Tropez.

Prov: Bt from Independent Gallery by Frank Hindley Smith 1922, by whom bequeathed to Tate Gallery 1940
Exh: *Paintings by Vanessa Bell*, Independent Gallery, June 1922 (17)
Lit: Watney 1980 (pl.104); Spalding 1983 (p.193; pl.6)

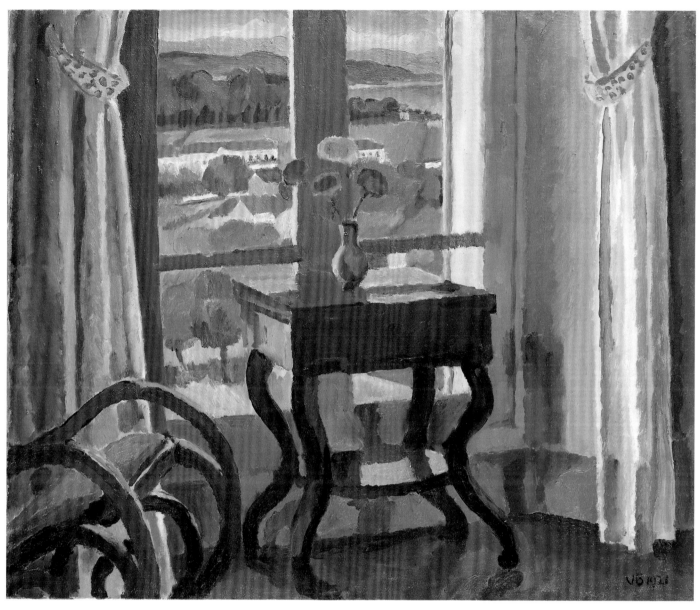

124

DUNCAN GRANT

125 *South of France* 1922

Oil on canvas 64.7 × 80.5 (25 ½ × 31 ¾)
Inscribed 'D. Grant / 22' b.l.
Tate Gallery, London. Presented by the Contemporary Art Society 1929

Grant's stay in St Tropez (see no.124) was highly productive and almost all the works produced there were landscapes. Although he had intermittently painted landscape since 1907–8, there had been little concerted effort to come to terms with the genre (unlike Fry and Bell) and it was only when he had lengthy periods at Charleston in 1919–20 that he painted out of doors with any regularity or sense of purpose. In St Tropez he found the landscape to his taste and took advantage of its variety – by turns mountainous, cultivated, panoramic and intimate. There were painting excursions to the port (e.g. *Boats, St Tropez*, Manchester City Art Galleries) but more often he chose his motifs not far from La Maison Blanche – farmbuildings, as here, or the trees and vineyards around the local Chapelle Ste Anne. Oil sketches were made on the spot, as well as drawn notations; the finished works were

painted either in Paris in February 1922 or later in London.

With these works – and *South of France* is outstanding among them – Grant allied himself with contemporaries such as Derain and Marchand, then equally involved in a cool reappraisal of landscape, notable for sober but warm colour, an elimination of detail, firm contour and a constructive emphasis on the contrast between architectonic interval and natural profusion. However, Grant never entirely suppresses an instinct towards surface elaboration, seen here in the linear organisation of leafless trees, furrowed fields and roofs, anchored by the shallow curve of the receding path.

The preliminary oil sketch for this work (24 × 35 cm; 1922) was with the Mayor Gallery, London, in 1983 and a working, charcoal drawing is in the artist's estate.

Prov: Bt from Independent Gallery by John Tattersall, Dundee, 1923; bt CAS 1926 and presented 1929 to Tate Gallery
Exh: Independent 1923 (4 or 10 or 13); *Some 20th Century English Paintings and Drawings*, Arts Council, Wales 1950 (50); Tate 1959 (46, repr. pl.6); Tate 1975 (16); on loan to Charleston Trust, April–Oct. 1998.
Lit: *The Dial*, Nov. 1922 (repr.); Shone 1976 (pl.153); Naylor 1990 (p.294, repr.); Watney 1990 (fig.45)

126 *View of Cassis* 1925

Oil on canvas 71.5 × 105 (28⅛ × 41¾)
Inscribed 'Roger Fry 1925' b.l.
Musée d'Orsay, Paris. Gift of Mrs Pamela Diamand, daughter of the artist, 1959

The small port of Cassis, east of Toulon, had attracted artists long before it was colonised by Bloomsbury (and before the Bells had first considered going there in late 1913). Derain had painted there in 1906 and 1907 and again in the 1920s with Othon Friesz; the Scottish colourists Samuel Peploe and F.C.B. Cadell had paid fruitful visits in 1913 and 1925–6 respectively. In between the wars Roland Penrose, Tristram Hillier, Wyndham Tryon, Robert Medley and Jessica Dismorr from England swelled the international community of artists. Roger Fry's delight in the town probably persuaded Leonard and Virginia Woolf to make the first of several visits in spring 1925 when they stayed in the modest Hôtel Cendrillon near to the port, finding there 'complete happiness'. Grant and Bell's small house, La Bergère, found in early 1927, was habitable by the following year. For Bell there were almost too many artists in Cassis; as Virginia Woolf noted of the visitors 'they are all painters; every street corner has an elderly gentleman on a camp stool' (*Letters*, 3, 1977, p.359)

Fry was fifty-eight when he painted *View of Cassis*; although he was continually in troubled health, his vitality was unceasing and each year he made for the South of France, Cassis and St Tropez becoming almost second homes. In a 'Letter from Paris' (*Apollo*, October 1926) by André Salmon, the French writer notes that in the summer the French Riviera is a 'prolongation of Montparnasse' and that 'nobody is surprised when they see Mr Roger Fry in a large vinedresser's hat, and very much at his ease in the blouse of a fisherman, appearing on the quai at St Tropez' talking to Segonzac, Luc-Albert Moreau or Charles Vildrac.

On 23 September 1925 Fry sent to Helen Anrep in London three ink drawings of the paintings on which he was working – a view of the port, the garden of his hotel and a view from 'a square a few yards off' (fig.122). He has chosen a narrow road which descends towards the port 'fringed with the pale coloured houses, very tall, shuttered, patched and peeled' and beyond 'the bare, bald grey mountains' (V. Woolf, *Diary*, 3, 1980, p.8, and *Letters*, 3, 1977, p.358).

A surprising aspect of the subject of many of Fry's Provençal paintings is his choice of some of the landscape's wildest or most obviously picturesque features, such as mountains, uninhabited ravines, castles (as here), rows of twisted olive trees, or a pool among rocks (e.g. *Windy Day, Beaumes de Venise*, Wakefield Art Gallery). Such topographically difficult subject matter is tempered by Fry's detachment and spare, dry brushwork. He is at his best, however, when the plain rural buildings of the area provide contrast with the spectacular terrain in which they sit, a conjunction he greatly admired in Cézanne. It

126

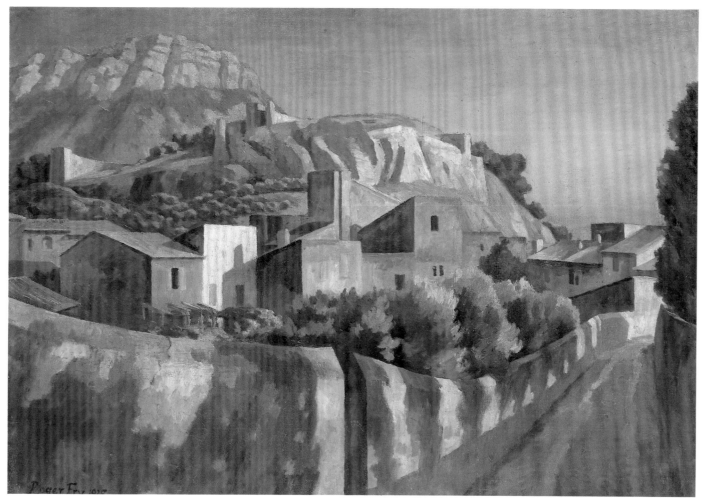

seems that Fry pushed himself as far as he dare in the matter of content to give himself maximum room for formal analysis. He began to recognise this predilection: 'I daresay my "taste" in landscape', he wrote to Vanessa Bell from St Rémy in 1927, 'is mixed with all sorts of irrelevant romanticisms and vague associations but [quoting Cézanne] it's plus fort que moi' (17 June 1927; TGA). At a time when the question of content was being revised in his writings, thus transforming his earlier formalist aesthetic, his painting began to benefit from a more personalised transcription of its subject.

Prov: P. Diamand by whom presented to Musée National d'Art Moderne 1959; transferred to Musée d'Orsay 1977
Exh: LAA, Leicester Galleries, London, May–June 1926 (9, as *Entrance to Cassis*); *Roger Fry 1866–1934*, Bristol Museum and Art Gallery, 1935 (41)
Lit: J. Lehmann, *Virginia Woolf and her World*, 1975 (p.104, repr.); *Musée d'Orsay: Catalogue Sommaire*, 1, 1990 (p.200, repr.)

fig.122 Roger Fry, Study for *View of Cassis*, in a letter to Helen Anrep sent on to Vanessa Bell, 12 September 1925. Tate Gallery Archive

fig.123 Duncan Grant, Study for *Bankside* c.1920, watercolour on paper 45.7 × 61 cm. Private Collection

127 *Bankside* 1920–22

Oil on canvas 100.5 × 79.5 (39⅝ × 31⅜)
Inscribed 'D. Grant 1920–22' b.r.
The Provost and Scholars of King's College, Cambridge

Grant has positioned himself on a short jetty on the south bank of the Thames in London, upstream from Blackfriars Bridge and a little to the west of the present Oxo Tower (the title of the painting is misleading, for Bankside, parallel with the river, runs further east at Southwark Bridge). On a boat moored alongside the river bank a man has pulled his hat over his face to take a midday nap (the painting was occasionally known as *Noon – Bankside*). In the middle distance another jetty partly obscures the arches of Blackfriars Bridge. A watercolour study (Christie's, 3 March 1989, 358) bears a contemporary signature and date of 1922 and shows a seated man from behind, either reading or sketching, in place of the present work's recumbent figure. Obviously the progress of the painting was interrupted at some point but brought to conclusion with the help of further studies in 1922 to be ready for the London Group exhibition that year where it was purchased by Maynard Keynes (along with Sickert's *Bar Parlour*, 1922) for his collection.

As far as is known, this is the first of Grant's many paintings of the Thames, nearly all of which are concentrated on the south side of the river between Waterloo and Tower Bridge (an exception is a view of Chelsea Bridge, 1933, National Gallery of Ireland, Dublin). He enjoyed the wide perspective of the subject, its warehouse architecture and the changing aspects and light of the water itself (e.g. *Thames Wharves*, c.1932, Southampton City Art Gallery). No British artist of his generation treated the subject so frequently and several works are a valuable record of a stretch of the Thames now almost totally altered; his last London works are of St Paul's Cathedral, painted just before and during the Second World War (Imperial War Museum, London, and Queen Elizabeth, the Queen Mother, Clarence House).

Bankside was widely praised in the press at its 1922 showing. It is notable for the clarity of its complex design, its fusion of light sober colour and buoyant spatial recession, taking us from the private world of the sleeping figure through the paraphernalia of work – cranes, boats, rigging – to the public world of declamatory flags and Sir Christopher Wren's cathedral dome. There is no doubt that Seurat's harbour scenes influenced Grant's composition. As noted at no.120, he had been looking at Seurat at this time, had been instrumental in Keynes's acquisition of the study for *La Grande Jatte* and, though he did not see the comprehensive 1920 Bernheim-Jeune exhibition, he did own Lucie Cousturier's 1921 book on Seurat in which several port paintings are reproduced.

Prov: Bt from LG by J.M. Keynes 1922; bequeathed to present owner 1946
Exh: LG, Mansard Gallery, Heal's, 1922 (43, as *St. Paul's*); LAA, Marie Sterner Galleries, New York, Dec. 1926 (20, as *Bankside*); Cambridge 1983 (33, repr.)
Lit: W. Gaunt, 'Duncan Grant', *Drawing and Design*, May 1927 (repr. p.135); W.G. Constable, *Duncan Grant*, 1927 (pl.2)

127

128

DUNCAN GRANT

128 *Still Life (with White Urn)* 1922

Oil on canvas 53.3 × 66 (21 × 26)
Inscribed 'D Grant 1922' b.r.
Southampton City Art Gallery

The objects and wallpaper shown here suggest that the painting was
carried out in February 1922 in Paris, a suggestion further confirmed
by the presence of the same distinctive white urn in a still life by Van-
essa Bell (1922, Fry Collection, Courtauld Gallery) almost certainly
painted in Paris at Bell's and Grant's studio, 33 rue de Verneuil.

Though Grant's palette was much reduced in brilliance by the early
1920s, it gained a new richness and luminosity and was subtler in its
patchwork of closely related tones. This is especially evident here
where the white urn retains its clean contrast with its surroundings
and the reality of the fruit remains undimmed by the patterns of plate,
textile and wallpaper around it. Also characteristic is the slightly
heightened viewpoint allowing a simple grid-like structure to underlie
the arrangement without undue emphasis.

Prov: Bt from the artist by Lytton Strachey, May 1922; Dora Carrington
(Partridge); Ralph Partridge; sold Frances Partridge, Sotheby's 13 Dec. 1961
(94); with Agnew's from whom bt by Southampton City Art Gallery 1972
Lit: *Charleston Newsletter*, 24, 1989 (p.50, repr.)

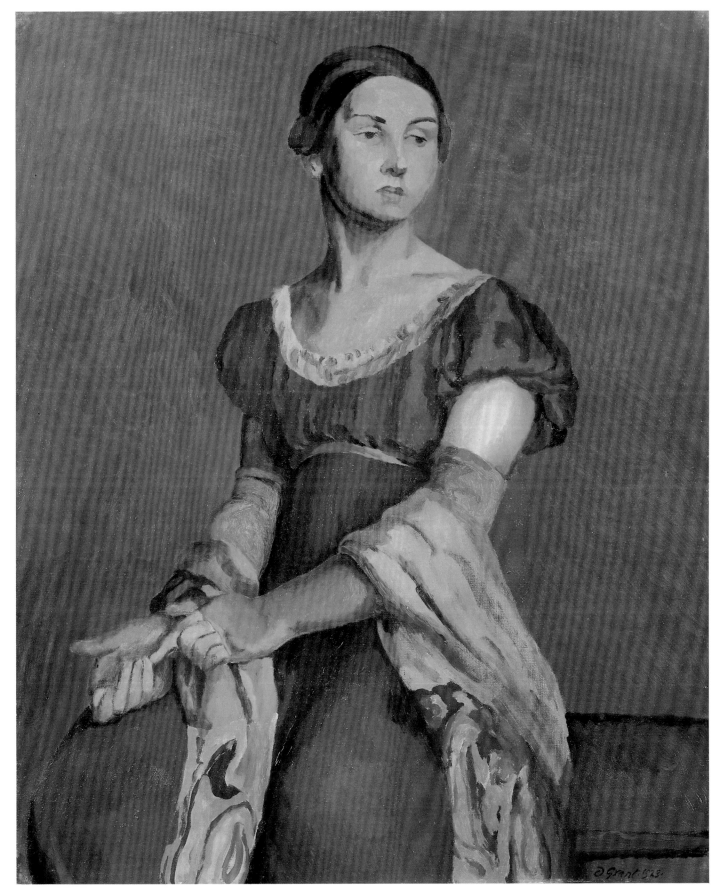

129

129 *Lydia Lopokova* 1923

Oil on canvas 72.6 × 60 (28⅝ × 23⅝)
Inscribed 'D Grant 1923' b.r.
The Provost and Scholars of King's College, Cambridge

By the time this portrait was painted, the great Russian dancer Lydia Lopokova (1892–1981) was living in Bloomsbury and conducting an affair with Maynard Keynes which surprised many of his old friends, a few of whom were even more dismayed when they were married in 1925 (fig.124). As a Diaghilev dancer, Lopokova had captivated English audiences with her astounding comic performance in 1919 in *La Boutique Fantasque*, partnered by Léonide Massine. When the two dancers left Diaghilev's company they and others formed their own and gave performances of short ballets, often as part of variety programmes at the Coliseum and the Royal Opera House. For several of these, Duncan Grant designed sets and costumes, most notably for *Masquerade* (1922), *Togo, or the Noble Savage* (1923) and *The Postman* (1925).

Grant and Roger Fry both painted Lopokova wearing a high-waisted dress designed for her by Grant in conscious emulation of Ingres's portrait of Mlle Rivière (1805, Louvre), including the long gloves and stole. The sittings took place over the winter of 1922–3 in 46 Gordon Square. Fry's portrait, (Fry family collection) shown at the Independent Gallery, April 1923 (no.17) was not well received, criticised as 'chocolate box' by Cecil Beaton and for its 'cloying prettiness' in the *Observer* (8 April 1923). Grant's painting shown at the Independent in June 1923 was warmly praised and it remains one of his most successful portraits, its subdued colour, enlivened by the patterned stole, suggesting something of the dancer's occasional melancholy as opposed to her more habitual high spirits, a combination of vivacity and childlike sincerity which, in her dancing, was unsurpassed. Vanessa Bell painted Lopokova at about the same time but at different sittings; the portrait, which was first exhibited at the April 1923 London Group show (no.8), unfortunately remains untraced (it is reproduced from an early photograph in M. Keynes 1983, pl.23). Grant made many drawings of Lopokova in the early 1920s and there is a later oval-format head-and-shoulders portrait, oil on canvas, in the National Portrait Gallery. See also nos.170 and 171.

Prov: J.M. Keynes, 1923, by whom bequeathed 1946 (but not transferred to King's until 1981)
Exh: Independent 1923 (20); ACGB 1969 (29); Cambridge 1983 (34, repr.)
Lit: Shone 1976 (pl.130); *Lydia Lopokova*, ed. M. Keynes,1983 (pl.22; p.198); *Lydia and Maynard*, ed. P. Hill and R. Keynes, 1989 (pl.16); Naylor 1990 (p.98, repr.); Shone 1993 (pl.132)

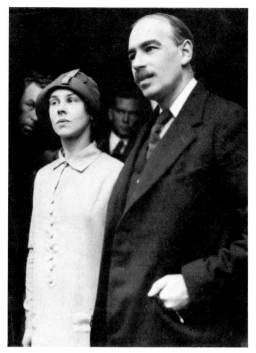

fig.124 Lydia Lopokova and J.M. Keynes on their wedding day, 4 August 1925, London

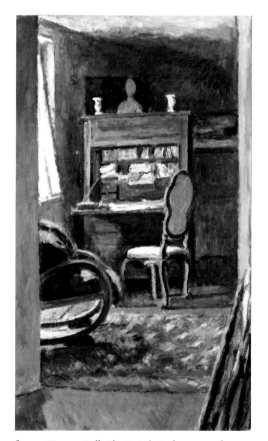

fig.125 Vanessa Bell, *The Artist's Desk* c.1945, oil on board 63.9 × 38.4 cm. Whereabouts unknown

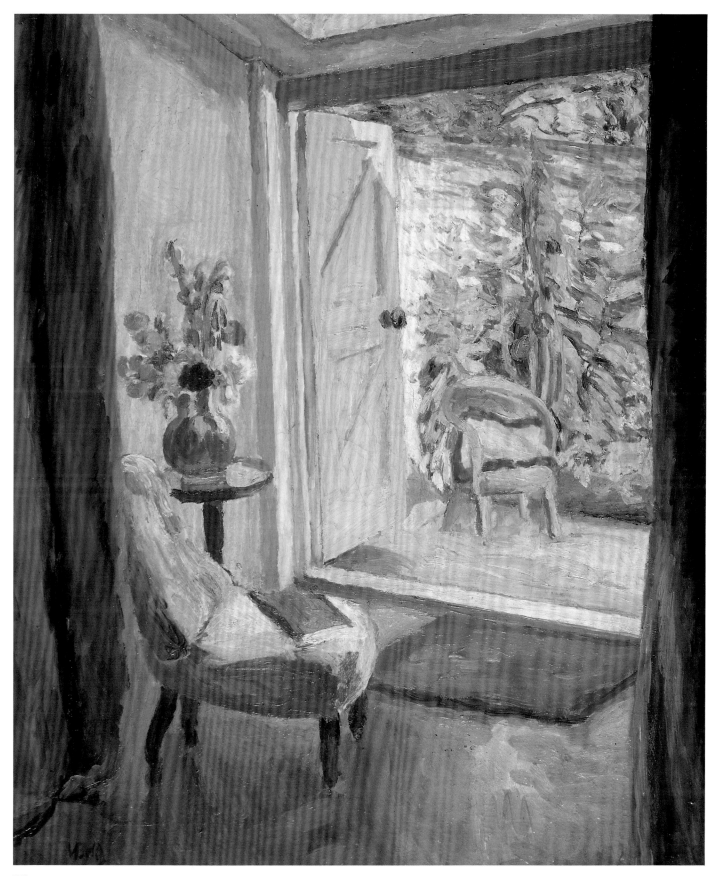

130

130 *The Open Door* 1926

Oil on board 75 × 62.3 (29½ × 24½)
Inscribed 'V Bell 1926' b.l.
Bolton Museum and Art Gallery

In 1925 a large, practical studio was built at Charleston, to Roger Fry's design, the object being 'to have as much room and spend as little money as possible' (Fry to H. Anrep, 18 April 1925, in *Letters, 2,* 1972, p.564). It benefited from both north and west light, was large enough to accommodate two or three painters and its principal feature was a handsome fireplace which Grant almost immediately decorated with male caryatids (see no.151). A small curtained alcove led, through double doors, onto the walled garden. The studio was used by both Grant and Bell until 1939 when Bell had an attic bedroom at the top of the house converted into her own studio.

Both Bell (no.130, p.217) and Grant (no.132, p.221) painted the view from the open doors to the garden across a small square terrace with a mosaic of a fish at its centre. Bell more closely suggests the continuity between interior and exterior, the two chairs making a formal mirror-image, the rectangle of the mat repeating that of the terrace, and the flowers in the vase becoming a miniature of the herbaceous border outside. Grant's luxurious calligraphy, characteristic of his work in the late 1920s, threatens to dissolve his whole composition, the framed view of the garden becoming almost a painting of a Grant painting. Where Bell's colour is warm but restrained, focused on the red-striped blue cushion, Grant's high-temperature, acidic yellow-greens in the foliage are checked by the red cloth over the chair.

The motif of an empty chair is recurrent in Bell's work but becomes especially frequent after *c.*1920, running from the woodcut for Virginia Woolf's story *A Haunted House* (1921) to later works such as *The Artist's Desk* (fig.125) and the painting of an interior at Asolo (fig.155). Something of Bell's intermittent melancholy (admitted to her sister: see V. Woolf, *Diary, 3,* 1980, p.242) is embodied in such chairs, resonant both of a sense of personal loss and a conscious withdrawal from human affairs.

Prov: Bt 1926 by Frank Hindley Smith by whom bequeathed to present owner 1940
Exh: Multi-National Exhibition, New Chenil Galleries, London 1926 (48, as *The Garden Door*); ACGB 1964 (44, as *View into the Garden*); *British Painting 1900–1960*, Mappin Art Gallery, Sheffield, and tour, 1975–6 (11); *Presents from the Past*, Greater Manchester Council Exhibition, 1978 (61, repr.)
Lit: Spalding 1983 (repr. btw. pp.272–3)

131 *Window, South of France* 1928

Oil on canvas 97.5 × 78.1 (39½ × 31¾)
Inscribed 'D. Grant/1928' b.l.
Manchester City Art Galleries

Grant and Bell's plans for spending time in the South of France, especially in the winter months, eventually came to fruition with their occupation from 1928 of a farm cottage, La Bergère. It was located on land attached to the seventeenth-century château of Fontcreuse, two kilometres to the north of Cassis, and set among vineyards and olive groves. Their landlord was Colonel Peter Teed, late of the Bengal Lancers, who lived in the château with his mistress Jean Campbell. As La Bergère was not large, some of the family and visitors (such as the Woolfs) stayed in rooms at the château or in the Hôtel Cendrillon in Cassis. The prime purpose of the house was as a refuge from increasingly busy London lives – a Charleston in France. Both painters had studios of their own: Grant's on the first floor looked south across the sloping landscape towards Cassis and its bay, a view he found irresistible and painted on several occasions between 1928 and 1930. One of the finest of the series *Arum Lilies*, was shown at the 1930 Carnegie International (cat no.99, untraced); a version similar to no.131, smaller in scale, is reproduced here (fig.121); another, comparable in size and composition, was in the collection of Mrs Russell Cooke, London, in 1959 (untraced). Vanessa Bell also painted the view either from Grant's studio or the terrace below (e.g. *The Well, c.*1929, Manchester City Art Galleries, and *Valley in Autumn,* 1930, South African National Gallery, Cape Town).

fig.126 The view from Duncan Grant's former studio at La Bergère, Cassis. Photograph by the author, 1999

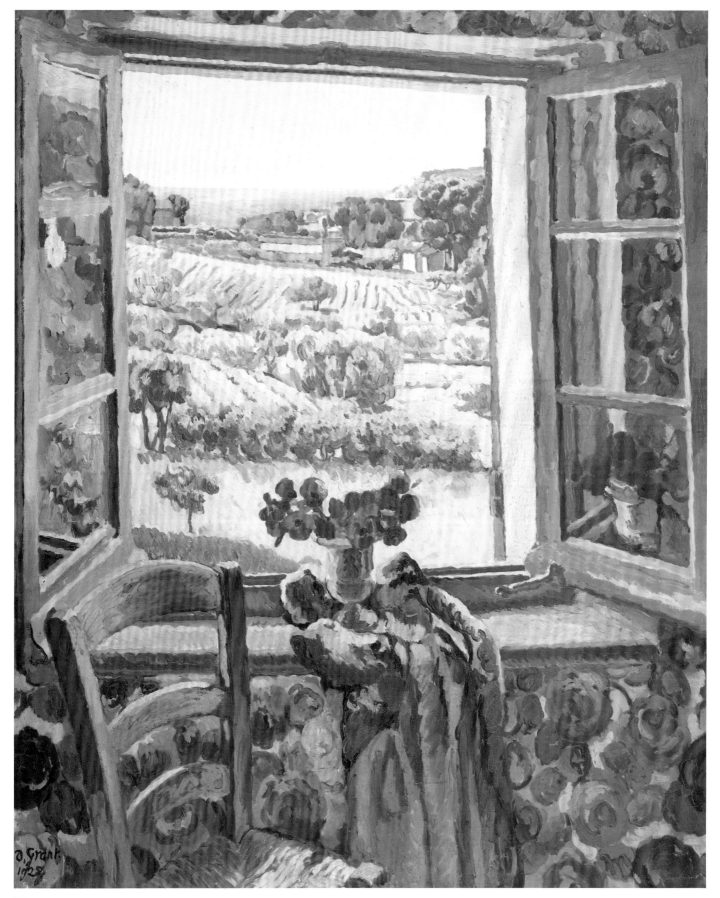

131

No.131 was probably painted in May or June 1928 towards the end of Grant's first prolonged visit to La Bergère. Grant tackles a dominant theme in modern French painting, particularly in the work of Matisse and Bonnard (though he had a special liking for Derain's *Window at Vers*, 1912, Museum of Modern Art, New York, shown in the Second Post-Impressionist Exhibition). One of his earliest treatments of the theme belongs to c.1915 (fig.91) and another is shown here, no.122. The firm realisation of the window demarcates the private, interior world of the studio from the blazing panorama outside. This classic, unspoilt Mediterranean view unfolds through fields and trees towards the sea whose strip of colour is returned to the interior through the electric blue of the window frame; the landscape is reflected in the panes on the left; the sill, with its urn of anenomes, in those on the right. In their turn, the flowers, gathered from outside, are echoed in the printed roses of the old–fashioned wallpaper around the window. The unchanging permanence of the landscape is contrasted with the palpable materials of still-life painting, the window reflections acting as buffers between the two.

The patterned wallpaper presents a problem; according to Grant his studio was painted plain grey-blue and buff pink and his daughter confirms that no such wallpaper existed at La Bergère (Angelica Garnett to the author, 5 February 1999). It is possible that Grant added it to the painting at a later date in London; inspection of the work tends to support this.

La Bergère was given up in 1938; the house, substantially the same, still exists at the centre of the successful vineyard of Fontcreuse and the view from Grant's studio window is little altered (fig.126).

Prov: CAS purchase (by Lord Sandwich) 1929; presented to Manchester City Art Galleries 1930
Exh: LG, New Burlington Galleries, Jan. 1929 (8, as *View from a Window*); Tate 1959 (53); *CAS 50th Anniversary Exhibition: The First Fifty Years 1910–1960*, Tate Gallery, 1960 (27); *50 Years of British Art*, Tate Gallery, 1964 (50); Edinburgh and Oxford 1975 (33); Dallas and London 1984 (21)
Lit: H. Hannay, 'Paintings by Duncan Grant', *London Mercury*, March 1929 (p.540); *CAS Report 1929* (p.7, repr.); *Manchester City Art Galleries Annual Report*, 1930; *British Paintings 1900–1930*, Manchester City Art Galleries 1954 (no.19, repr.); Shone 1976 (pl.154); *Concise Catalogue of British Paintings*, Manchester City Art Galleries, 1978, 2 (p.96); Watney 1990 (pl.44); Shone 1993 (pl.167)

132 *The Doorway* 1929

Oil on canvas 88 × 77.5 (34⅝ × 30½)
Inscribed 'D. Grant 1929' b.l.
Arts Council Collection, Hayward Gallery, London

See entry no.127.

A view of Charleston's garden through open doors (no.122) marked Grant's first settled period of painting after the First World War. *Door to the Garden* (fig.127), showing the same view as seen in no.132, was painted in May 1945 immediately after the end of the Second World War. Although it is improbable that Grant consciously painted such works in celebration of Peace, his sensitivity to a prevailing mood informs their vernal tranquillity.

Prov: ...; bt from Leicester Galleries, London by Arts Council of Great Britain, 1951
Exh: LG, New Burlington Galleries, Oct. 1929 (12); *British Painting before 1940*, Arts Council touring exhibition, 1967 (12, repr.)
Lit: A. Forge, 'The Arts Council Collection of Paintings and Drawings', *Studio*, 157, May 1959 (p.140, repr.); Shone 1976 (pl.134); *Arts Council Collection: Concise Illustrated Catalogue*, 1979 (p.110, repr.); Naylor 1990 (p.187, repr.)

fig.127 Duncan Grant, *Door to the Garden* 1945, oil on canvas 76.1 × 61 cm. Whereabouts unknown

132

133 *Still Life with Eggs* 1930

Oil on canvas 60.4 × 68.5 (23¾ × 27)
Inscribed 'D. Grant 30' b.r.
*Art Gallery of South Australia, Adelaide. South Australian Government
Grant 1956*

Ever since 1907 when Grant copied Chardin's still life known as *The
Butler's Table* in the Louvre, he had been enthralled by the French
painter's approach to the genre, above all by the simplicity of effect
achieved through complex means – the subtle adjustment of intervals,
the interplay of cool and warm colour, the contrast of ample form with
unfussy detail. Inevitably the example of other artists, particularly
Cézanne, inflected Grant's approach but no artist went so deep as
Chardin whose modesty and reticence in front of a few selected domes-
tic objects remained a permanent touchstone.

Still Life with Eggs is a classic example of Grant's still life from mid-
way between the wars. It was painted at La Bergère, Cassis, and con-
tains a decorated French plate (now at Charleston), a glass jar of pre-
served fruit, a speciality of Jean Campbell (for whom see no.131; bot-
tled fruit also appears in the Chardin mentioned above), two eggs, a
vase of foliage, printed cloth, all disposed on the steeply receding top
of an eighteenth-century French provincial chest of drawers (now at
Charleston). An exuberant weave of warm colour, cooled by touches
of black, grey-blue and white, is matched by the meandering linear
phrase of the scalloped edge of the plate through the floral pattern of
the cloth to the scrolled front of the chest. The density of the grouped
objects is allowed to breathe by the plunging space at the right. Grant
may not have made great formal discoveries in such still lifes but the
fertility of his handling and the probity of his vision give such paint-
ings their personal distinction. A more morose, earlier version of the
composition (1928) was at Christie's, 22 November 1994 (192).

Prov: Agnew's to Lefevre Gallery, Aug. 1933; bt from Lefevre by Art Gallery of
South Australia, 1956
Exh: *Bohemian London: Camden Town and Bloomsbury Paintings in Adelaide*,
Art Gallery of South Australia, Adelaide, 1997 (p.54; repr. p.55, where misdated
1920)

133

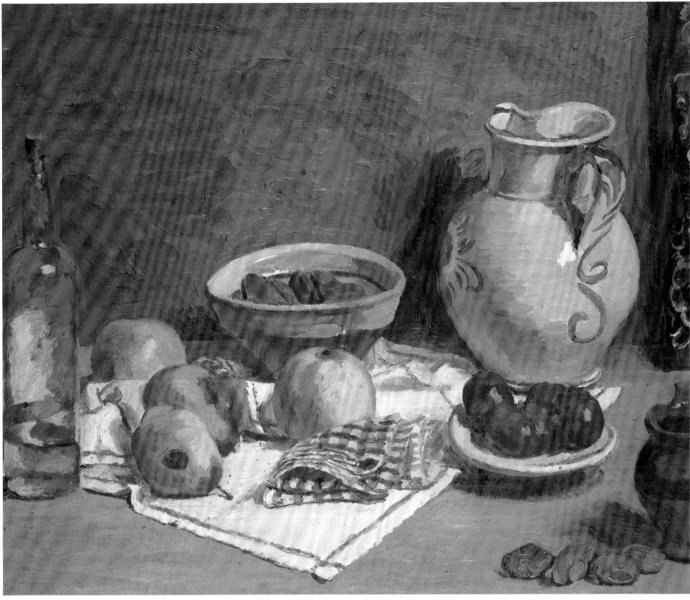

134

VANESSA BELL

134 *Still Life with Jug* c.1931–2

Oil on canvas 61 × 72.5 (24 × 28⅝)
Bradford Art Galleries and Museums

Bell's maturity as a painter in the 1930s is best experienced through a series of still lifes and a handful of interiors with figures. In her easel painting, her colour was gradually enriched, her handling became more succulent with a fuller suggestion of volume and an inclusive complexity of composition marks several of her ruminative interiors with figures (no.136). Later in this period a certain sweetness of conception enters her work so that painterly treatment and sentiment appear at odds. Her still lifes, however, were least affected by this.

No.134 was almost certainly painted in France, perhaps in the autumn of 1931 at La Bergère: the walls of Bell's studio there were grey, the napkins and jug appear to be French and it is not fanciful to sug-gest that the bottle contains the famous white wine of Cassis. In spite of Bell's display of 'the good things in life', her natural restraint invests the painting with an austerity of mood akin to Spanish bodegòn still lifes.

Cotton Lavender and Quinces (no.135) was painted in Bell's studio at 8 Fitzroy Street. The urn, made by the potter Phyllis Keyes and painted by Bell herself, holds cotton lavender (santolina), a border of which edges the lawn at Charleston; it is joined by a few everlasting flowers and quinces. The emphatic pattern of the cloth with its frontal drop across the width of the painting (a favourite device of Bell and Grant, e.g. no.150) increases the sense of recession beyond the beauti-fully judged reflection in the mirror. A portrait of Dora Morris (c.1936, Leeds City Art Gallery) shows the sitter reflected in the same mirror with the same cloth in front of it.

Prov: Alex. Reid & Lefevre from whom bt by Bradford City Art Gallery 1933
Exh: *Spring Exhibition*, Alex Reid & Lefevre, 1933

135

135 *Cotton Lavender and Quinces* 1934

 Oil on canvas 65.3 × 50.1 (25¾ × 19¾)
 Inscribed 'V. Bell 1934' b.r.
 Galerias Agustin Cristobal, Mexico

See entry no.134

Prov: Alex. Reid & Lefevre where bt Prof. H. Wilson; sold from his estate
Christie's, London, 12 July 1974 (329, repr.) where bt Cristobal; by descent to
present owner
Exh: ?Not previously exhibited
Lit: *Studio*, 504, March 1935 (repr. as col. frontispiece)

136 *Interior with the Artist's Daughter* c.1935–6

 Oil on canvas 73.7 × 61 (29 × 24)
 Dick Chapman and Ben Duncan

The artist's daughter, Angelica (b.1918), is reading in an armchair in
the studio at Charleston. Bell has placed herself in the alcove leading
out of the studio into the walled garden. In *The Open Door* (no.130),
the space beside the chair inside the room is close to the position where
she would have stood but, turning 180 degrees, she looks towards the
interior, her back to the garden. The two armchairs are covered in
Grant's textiles designed for Alan Walton Ltd; a striped kelim lies on
the woodblock floor in front of the stove, out of view on the right. In
the foreground, a vase holding four narcissi and some artichoke leaves
stands on the round table on which are placed scissors, cotton and an
open, illustrated book, echoed by the volume on Angelica's lap. This
consciously arranged still life fronts the absorbed intimacy of the fig-
ure which, Vuillard-like, is surrounded by patterned textiles and the
solid objects of still-life painting; this is the room that Angelica Gar-
nett later described as 'the sanctuary in which I spent the most trea-
sured hours of my life' (A. Garnett, *Deceived with Kindness*, 1984,
p.97).

 Bell's series of paintings in the 1930s of people in rooms began in
1934 with Duncan Grant (Williamson Art Gallery, Birkenhead), his
mother Mrs Grant (private collection) and Virginia Woolf (fig.128),
and continued with Leonard Woolf (NPG, London) and a double-por-
trait of Clive Bell and Duncan Grant in the sitting room at Charleston
(artist's estate on loan to Birkbeck College, University of London).

Prov: Artist's estate from which bt by present owners 1965
Exh: Not previously exhibited or recorded

fig.128 Vanessa Bell, *Virginia Woolf at 52 Tavistock Square*
1934, oil on canvas. Private Collection

136

137 *The Stove, Fitzroy Street* 1936

Oil on canvas 89.2 × 69.8 (35⅛ × 27½)
Inscribed 'D. Grant. 36' b.l.
Private Collection

The setting is a corner of Grant's studio at 8 Fitzroy Street, a large, high structure built out from the back of the house and reached by a labyrinthine corrugated iron passage from a half-landing in the hall. It was a famous old studio and among its earlier occupants had been Whistler, Augustus John and Sickert. Grant worked there from 1920 (though he retained accommodation in Gordon Square) and from later in the decade (when Vanessa Bell rented the adjoining studio) he lived there permanently. It was the frequent venue for parties and professional meetings and occasionally a showroom for Grant's and Bell's applied art. Virginia Woolf's play *Freshwater* was first performed in Vanessa Bell's studio on 18 January 1935 with Angelica Bell, just turned seventeen, taking the part of Ellen Terry. By the time Grant painted the present work, she was enrolled at the London Theatre Studio run by Michel Saint-Denis.

The studio had a mantelpiece and gas fire at one end, the space in front containing easels, a model's throne and all the paraphernalia of painting; at the other end, divided by standing screens, tables and chairs were arranged around a stove mounted, as seen here, on a tile-edged hearth. The small Victorian chair was given by Sickert to Grant (along with a sofa and fine oval mirror). To the left of the stove, in front of a Dutch mirror, is a stone torso (now at Charleston) by John Skeaping, on a marbled wooden plinth. Although Angelica Bell had a bedroom at the top of the house, she was frequently in her parents' studios where she posed on several occasions in the 1930s. For this work, it is unlikely she was asked to sit, and indeed she has no recollection of specifically posing for it (Angelica Garnett to the author, 21 January 1999); Grant would have seen her casually seated reading a picture paper and taken up his theme from there. It is often in such informal works that he is at his most revealing, accepting the visual facts of the scene with an approach both intimate and impartial.

Both studios were destroyed by fire during an air-raid in September 1940, soon after they had been vacated by William Coldstream and Victor Pasmore to whom they had been sublet (V. Pasmore to the author 12 December 1987). Vanessa Bell lost much early work (and was paid £1,200 in compensation) and Grant several more recent canvases (and was paid £1,700). Bell's full-length portrait by Charles Furse (NEAC, April–May 1902, no.85) was also destroyed.

Prov: Bt from Agnew's by E.L. Franklin, Nov. 1937; by descent to Cyril Franklin; Christie's 6 March 1992 (69, repr.) where bt by present owner
Exh: *Recent Work by Duncan Grant*, T. Agnew & Sons, 1937 (23); Wallace Collection 1940 (61); *Painters' Progress*, Whitechapel Art Gallery, 1950 (12, as *Girl by Stove*)
Lit: Mortimer 1944 (pl.14); Shone 1993 (pl.146)

138

138 *On the Table (Figures in a Glass Case)* 1938

Oil on canvas 59.7 × 48.3 (23½ × 19)
Birmingham Museums and Art Gallery

The principal object of this still life is a glass-domed case containing two Italian toy acrobats, one standing, one hoisted on a stick at the top of the glass, lent to the artist by the collector Sir Colin Anderson. On the wall behind it is the landscape painting *Peñiscola* (c.1932; Charleston Trust) by George Bergen (1903–84). There are two versions of the work, painted at 8 Fitzroy Street: the other one, *Acrobats*, taller in format, is in the Museum of Fine Arts, Montreal (bequeathed through the CAS by Sir Edward Marsh, 1954).

Objects seen through or reflected in glass occur throughout Grant's work (e.g. nos.55 and 123) eliciting subtle prismatic transformations and tonal changes. Here the glass decanter refracts the black base of the dome and picks up, towards the stopper, the russet colours of Bergen's landscape whose frame repeats, in turn, the black and gold ochre of the acrobat.

From early in Grant's career, commentators frequently referred to the wit of his invention. Fry, for example, saw it in paintings such as the *Juggler and Tightrope Walker* (no.119), Kenneth Clark in the mythological drawings and designs. It is an elusive quality and Grant never overplayed his hand. In a still life such as this, an unemphatic visual wit gently underlies his reactions to the composition and informs the harmonic correspondences of the whole.

Prov: Bt from the artist by Kenneth Clark 1938 and presented through the CAS to Birmingham City Art Gallery 1946
Exh: *Since Whistler*, National Gallery, London, 1940 (p.189); Edinburgh and Oxford 1975 (36)
Lit: Mortimer 1944 (11)

137

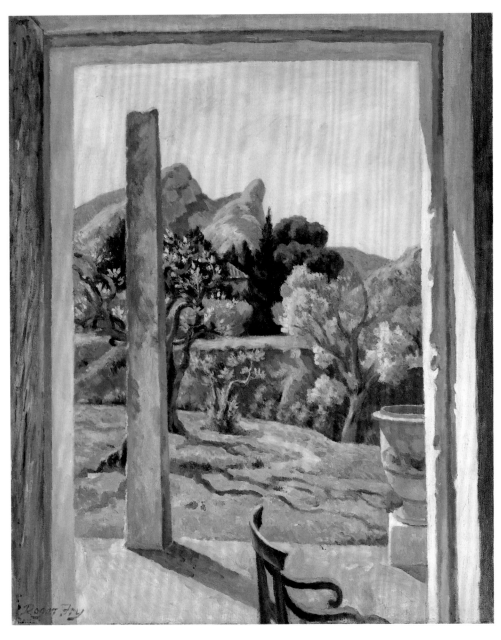

139

ROGER FRY

139 *Spring in Provence* 1931

Oil on canvas 79.6 × 65 (31⅜ × 25⅝)
Inscribed 'Roger Fry' b.l.
Vancouver Art Gallery Founders Fund

With his friends the writers Charles and Marie Mauron, Fry acquired the Mas d'Angirany in early 1931. It was (and still is, under the name Mas Gavon) a typical Provençal farmhouse on the outskirts of St Rémy near the celebrated Greco-Roman triumphal arch and mausoleum known as Les Antiques, the asylum of St Paul-de Mausole, where Van Gogh was confined in 1889–90, and the spectacular remains of the Hellenic Roman town of Glanum (see no.140). Visible from the terrace of the modest two-storey house, through olive, ilex and cypress trees, is the range of the Alpilles dominated by the pointed profile of Mont Gaussier. Fry furnished the house in April 1931 and wrote of developments to Vanessa Bell: '[Mauron] has picked up four great stone pillars which make the supports for the *treille* [vine arbour]

which will come when the vines grow. I got in Beaucaire two huge earthenware vases which stand between the pillars on either side of the great stone table which is in the centre. And the view is inconceivably lovely' (18 April 1931; TGA). Fry sent a drawing of the view in his letter to Bell and, later, some photographs (fig.129) of the house. These show the stone pillar and vase on the terrace as depicted by Fry from a doorway beyond the right of the photograph. The absence of the vine trellis from both no.139 and the photographs is evidence of a date of 1931 for the painting.

The framing device of doors and windows, here frankly espoused, is more frequent in Bell's and Grant's work than it is in Fry's. He preferred to go out into the landscape itself and was indefatigable in his search for the appropriate motif, greatly helped by his learning to drive in 1928. In his letters he often chides Bell for her relatively unadventurous attitude to landscape and she herself admitted that 'I don't think I'm nearly as enterprising as you (or Duncan) about painting anything I don't find at my door' (Bell to Fry, 16 September 1921; TGA). Richard Morphet has written of Fry's ability 'simultaneously to suggest both the immediate materiality and the endurance through

fig.129 View from the terrace of the Mas d'Angirany, St Rémy, showing the vase and pillars seen in no.139, c.1931, photographed by Roger Fry.
Tate Gallery Archive

extended time of the phenomena he represents' (see Morphet 1980, p.487). *Spring in Provence* perfectly encapsulates this in the most unaffected and accessible way as the viewer is drawn from the immediate here-and-now of the chair, through a succession of *repoussoirs* – pillars, trees, roof – to the outlandish silhouette of the distant mountains. The 'paradise' Fry found here, combining domestic life, creativity and timeless landscape was, however, short-lived. Professional obligations in London and elsewhere curbed the amount of time he was able to spend at the Mas d'Angirany before his unexpected death in 1934.

Prov: Bt from Agnew's by Vancouver Art Gallery 1933
Exh: *Pictures by Roger Fry*, Agnew's, 1933 (20); Fredericton 1977 (18, repr.)
Lit: 'Mr Roger Fry's Pictures at Messrs. Agnew's', *Apollo*, 18, Aug. 1933 (p.125)

ROGER FRY

140 *Excavations at St Rémy* c.1931–3

Oil on canvas 60.5 × 81.5 (23¾ × 32¹⁄₁₆)
Inscribed 'Roger Fry' b.r.
Manchester City Art Galleries

The excavations depicted here are those of Glanum close to Fry's home, the Mas d'Angirany (see no.139). During Van Gogh's time in the nearby asylum, these remains were mostly buried beneath olive groves as is shown in his *Olive Trees with the Alpilles in the Background* (1889, Museum of Modern Art, New York). In 1921, archaeological work began under the direction of Jules Formigé and Pierre Le Brun and was well underway when Fry became a regular visitor to St

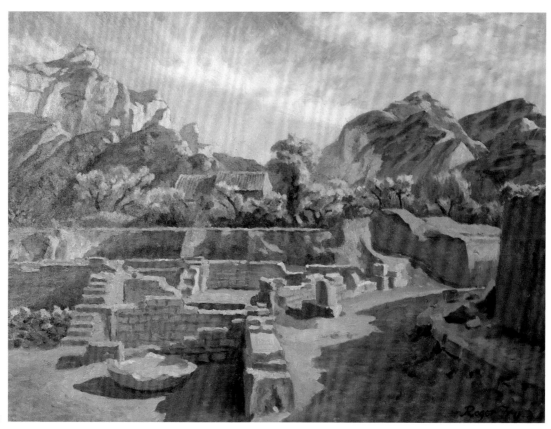

140

Rémy. Greek and Roman finds of enduring significance were uncovered including parts of the oldest dwellings in France. They soon became a tourist attraction, along with Les Antiques, and among the visitors were the Woolfs, the Bells and Duncan Grant, who made an excursion to see them from Cassis in 1928. In April 1933 Barbara Hepworth and Ben Nicholson were in St Rémy and both made drawings of Les Antiques and the Alpilles (fig.130) from a spot very close to Fry's House where he was, at that moment, in residence.

Although detailed topographical views, contrasting man-made structure and landscape, are found throughout Fry's work, no.140 is highly representative of his late style. An airy luminosity envelops the interplay of receding horizontals and verticals. The unearthed foundations of Glanum seem to stand for the very way in which Fry himself structured a painting, a metaphysical conceit embodied in many of his late works, enriched by a now more unbuttoned appreciation of the *genius loci*.

Prov: Given by Margery Fry to Manchester City Art Galleries 1935
Exh: *Pictures by Roger Fry*, Agnew's, 1933 (17)
Lit: *Concise Catalogue of British Paintings*, 2, Manchester City Art Galleries, 1978 (p.82, repr.)

fig.130 Barbara Hepworth, *St Rémy: Mountains and Trees I* 1933, pencil on paper 31.4 × 37.8 cm. Alan Bowness, Hepworth Estate

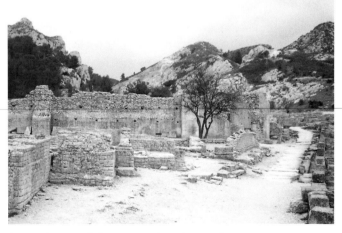

fig.131 The ruins of Glanum at St Rémy. Photograph 1999

ROGER FRY

141 *Self-Portrait* c.1930–2

Oil on canvas 59.7 × 49.5 (23½ × 19½)
National Portrait Gallery, London

From 1918 to a few months before his death Fry painted at least half a dozen self-portraits. Three show him nearly full-length in rooms indicative of his life as painter, collector and writer (e.g. fig.111). Another is a head-and-shoulders with his hand holding a paintbrush; and this one, perhaps the most austere, reveals the arc of his palette and edge of his canvas in the traditional manner of self-portraits. The eagerness to engage with the viewer, present in some of the earlier self-portraits, has been replaced by a resigned, steady gaze. No.141 is either a self-portrait of 1930 mentioned in a letter from Fry to Vanessa Bell (17 August 1930; TGA) or, more likely, the self-portrait painted at Charleston in July 1932 which Fry mentions in a letter to Kenneth Clark: 'I vary between thinking it a rather interesting image and a bloody business. Helen [Anrep] is solidly against it. Says it makes me a Calvinistic fanatic, says it's Flemish' (3 August 1932, *Letters*, 2, 1972, p.672). He tells Clark that he will probably paint another one (Clark wanted to purchase a self-portrait); his last image of himself was painted shortly before his death in 1934 and went to King's College, Cambridge, from Clark's collection.

Prov: Gift from Margery Fry to National Portrait Gallery 1952
Lit: L. Edel, *Bloomsbury: A House of Lions*, 1979 (repr. opp. p.161); F. Spalding, *The Bloomsbury Group*, NPG, 1997 (repr. p.33)

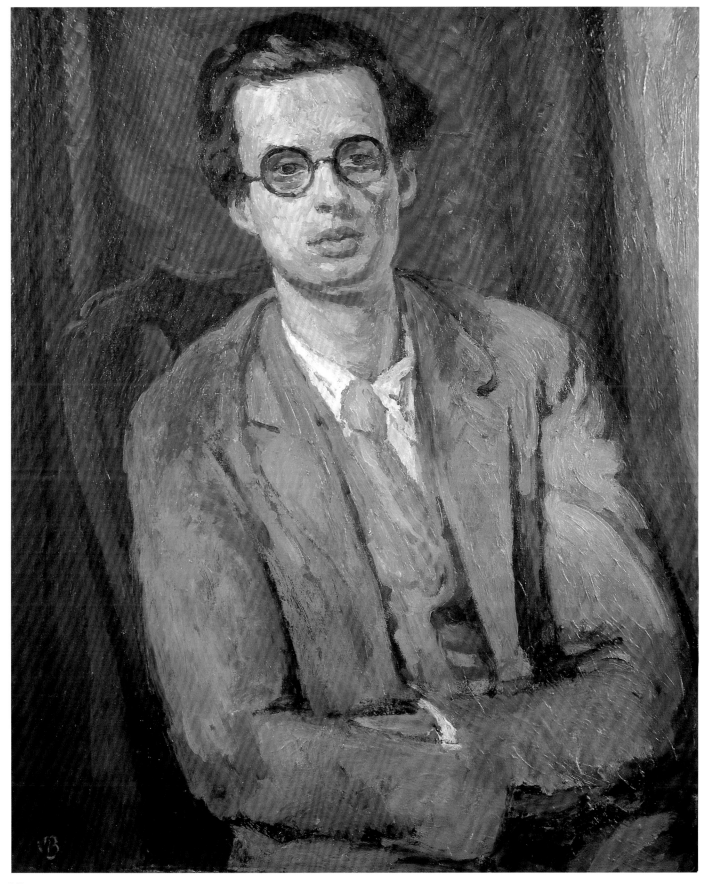

142

142 *Aldous Huxley* c.1931

Oil on canvas 71 × 56 (28 × 22)
Inscribed 'V.B.' b.l.
Bryan Ferry Collection

Little is known of the circumstances surrounding this portrait of the writer Aldous Huxley (1894–1963). Bell had known him slightly since the end of the First World War and had heard much of him from Clive Bell when they were fellow residents at Garsington in 1916–17. Huxley had a particular liking for Roger Fry: 'he remains a very good art critic', Huxley said in 1961, 'I mean he had extraordinary sensibility and great knowledge, and enthusiasms; and he was a genuinely *good* man, as well as immensely charming and interesting' (in S. Bedford, *Aldous Huxley*, I, 1973, p.69). Fry thought highly enough of the young man to offer him in 1919 the editorship of *The Burlington Magazine*, which Huxley refused, saying he knew nothing of art and that the salary was too small.

Fry and Bell together painted Huxley in London, Fry persuading Bell to try in her portrait the new oleo-resinous Maroger medium with her oil paint. Fry's enthusiasm for this medium dates to the autumn of 1931 (see Fry to J. Maroger, 14 November 1931, *Letters*, 2, 1972, p.664); and this period coincides with the peripatetic Huxley's three-month stay in London while he was working on an edition of D.H. Lawrence's letters. Earlier dates ascribed to the portrait (e.g. Shone 1993) can be discounted. But Bell obviously reworked the painting at a later date, for the 1935 reproduction in *Apollo* prominently shows Huxley's left hand and wrist resting on his right arm. Fry's portrait, which is untraced, was finished by 18 January 1932 for on that day Clive Bell wrote to Frances Marshall disparagingly: '[Fry] has now completed a very large portrait of Aldous which in horror surpasses anything he has ever painted before, and I think anything I have ever seen' (Frances Partridge).

Although perhaps not an acute likeness, Bell's portrait certainly suggests Huxley's attitude of gentle enquiry. The Argentinian publisher and editor Victoria Ocampo (1890–1979) met Huxley in November 1931 in London, almost certainly during the time he was sitting to Fry and Bell: '[He was] so courteous, distant – and tall ... He had, moreover, physical beauty, the kind which – like that of Virginia Woolf – is perdurable because it is produced by the structure of the bones ... I scrutinised the landscape of this noble and delicate face ... the slightly aquiline nose, the wide forehead, the generous mouth, the eyes, ... already threatened with ... blindness' (V. Ocampo in *Aldous Huxley: A Memorial Volume*, ed. J. Huxley, 1966, p.75).

Prov: Artist's estate; bt from Adams Gallery by J. Tayleur 1961; d'Offay where bt by present owner 1979
Exh: *Recent Pictures by Duncan Grant, Vanessa Bell and Keith Baynes*, Agnew's, 1932, (44); *Fifty Years of Portraits*, Leicester Galleries, London 1935; *British Painting 1925–1950*, ACGB touring exh., 1951 (7, dated 1931); Adams 1961 (19); ACGB 1964 (50, ill., pl.4); *Vanessa Bell. Paintings from Charleston*, Anthony d'Offay, 1979 (2); Sheffield 1979 (29)
Lit: *Apollo*, 22, July 1935 (p.43, repr.); M. Garland, *The Indecisive Decade*, 1968, (ill.opp.209); Spalding 1983 (p.266; repr. btw. pp.272–3); Shone 1993 (pl.150)

143 *Still Life with Bust and Flowers* 1947

Oil on canvas-board 55.9 × 45.7 (22 × 18)
Inscribed 'V. Bell 1947' b.r.
The Charleston Trust

See no.144.

Prov: A.V. Garnett; to Charleston Trust 1984
Exh: Bristol 1966 (60, repr); Dallas and London 1984 (11)

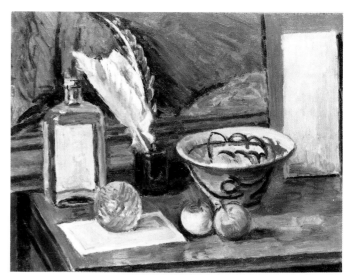

fig.132 Vanessa Bell, *Still Life with Quill Pens* c.1948–50, oil on canvas 35.5 × 45.7 cm. Bryan Ferry Collection

144 *Still Life with Bust by Studio Window* c.1950

Oil on canvas 68 × 61 (26¾ × 24)
Inscribed 'V.B.' (verso)
City of Aberdeen Art Gallery and Museums

These two still lifes were painted at Charleston in Bell's studio, converted from an attic room in 1939, overlooking the walled garden. Although Bell still painted alongside Grant in the downstairs studio (especially when family or friends sat for portraits), the small but practical top studio was the centre of her work until her death in 1961. Through the years, quantities of ceramics had accumulated at Charleston, many acquired abroad, many made by Quentin Bell in his pottery outside the downstairs studio; Bell also hoarded pieces of cotton or wool squares, remnants of dress materials 'ancient pieces of silk or velvet ... finding them, no matter how faded or threadbare, richly suggestive' (A. Garnett, 'The Earthly Paradise', *Charleston Past and Present*, 1987, pp.107–8). These pots and fabrics formed the changing repertory of her still lifes.

No.143 shows a bookshelf just inside the studio door; no.144 a portion of the high window with a view to fields beyond the garden below. The bust, common to both paintings, is a plaster cast from the antique acquired by Duncan Grant, along with several other casts, from Lewes Art School. In no.143 it is flanked on the left by a nineteenth-century

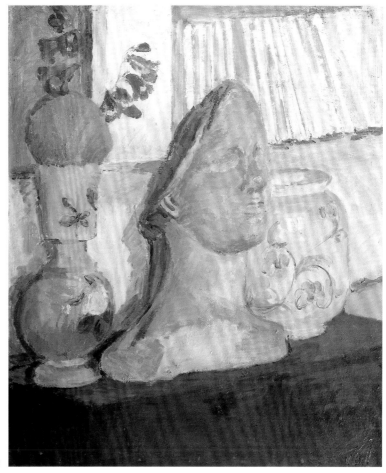

143

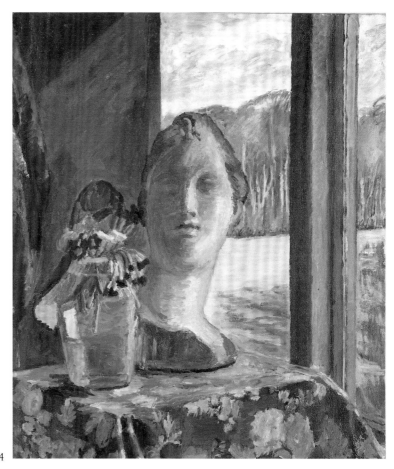

144

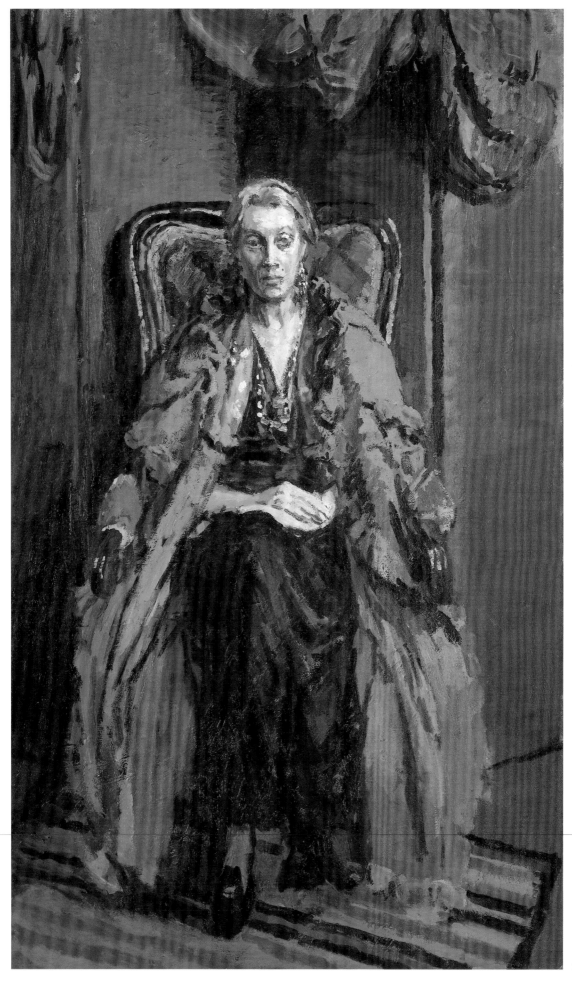

145

French opaline glass vase holding two penstemons and the vivid green leaf of a bergenia; to the right, an eighteenth-century faience polychrome drugs jar (both vases are still at Charleston). In no.144 the bust and glass holding primulas are placed on a piece of black and purple chintz, used for furnishings in the house.

Bell's tonal control rarely deserted her. Black, strong pinks and green with touches of yellow are common to both these works, enveloped in a cool north light. They have an exacting but heightened reality, are slow to deliver their message, eloquent without being wordy; both share an aloof timelessness emanating from the plaster bust.

Nos.143 and 144 are listed in Bell's inventory of paintings at Charleston, compiled in April 1951.

Prov: Artist's estate; to d'Offay; private collection 1986 from which sold Sotheby's 8 Nov. 1989 (82, rep.) where bt Aberdeen Art Gallery
Exh: d'Offay 1973 (33, repr.); *Vanessa Bell 1879–1961*, Anthony d'Offay 1983 (40); d'Offay 1986 (no cat.)
Lit: *Charleston Newsletter*, 24, 1989 (58, repr.); *Gallery*, Aberdeen Art Gallery, Sept. 1990 (repr.); Shone 1993 (pl.178)

DUNCAN GRANT

145 *Vanessa Bell* 1942

Oil on canvas 102 × 61 (40¼ × 24)
Tate Gallery, London. Purchased 1943

In 1942 Vanessa Bell was sixty-three years old. After the death of her son Julian in the Spanish Civil War, her appearance noticeably changed and she looked older than she was. Her withdrawal to Charleston during the Second World War coincided with her own gradual retreat into a more circumscribed world, compounded by her sister's suicide in 1941. She still impressed friends and visitors with her beauty and dignity; she could still surprise with her mordant humour and incisive remarks; her granddaughters (born to Angelica and David Garnett in the 1940s) knew her as amusing, attentive, loving and wise. To outsiders, however, she could appear distinctly chilly, varnishing her greeting with a wintry smile.

Nearly all Grant's portraits of Bell from *c.*1911 onwards capture her in relaxed and contemplative mood or absorbed at her easel. The pre-

146

sent work, painted at Charleston, finds her regally enthroned. This somewhat forbidding impression is strengthened by the cloud of purple drapery over the screen and by the high-backed chair with its suggestion, either side of Bell's head, of a winged, Elizabethan ruff. She is cross-legged, her hands on her lap, her eyes staring straight at the viewer, the pose is redolent of Bell's particular uncompromising integrity; her jewellery and oyster cloak with its deep pink lining and the claw-like arms of her chair accentuate this monarchal image.

There is deference in the portrait as well as psychological penetration, not so much through the delineation of Bell's features which are masked, immobile, but through the pose and arrangement of the whole. The ripe colour is pungent with the two painters' life together over thirty years.

Prov: Bt from the artist by the Tate Gallery 1943
Exh: *British Portraits*, RA, 1956–7 (806); Tate 1959 (74); ACGB 1969 (45, repr.); on loan annually to Charleston since 1993
Lit: Mortimer 1944 (pl.25); *The Windmill*, I, no.1, 1944 (p.38); A. Gwynne-Jones, *Portrait Painters*, 1950 (p.36, pl.152); H. Hubbard, *A Hundred Years of British Painting*, 1951 (p.274; repr.); J. Rothenstein, *Modern English Painters: Lewis to Moore*, 1956 (p.57); J. Rothenstein, *British Art Since 1900*, 1962 (pl.63); Shone 1976 (p.19; pl.1); Watney 1990 (pp.66–7; pl.56); Naylor 1990 (p.288, repr.); Shone 1993 (pl.7; p.15); Spalding 1997 (repr. opp. p.305)

DUNCAN GRANT

146 *Self-Portrait* 1956

Oil on board 48.9 × 38.1 (19¼ × 15)
Inscribed 'D.Grant/56' b.r.
Private Collection
[Reproduced on p.235]

There are several late self-portraits by Grant, invariably showing him in a straw hat against a plain background and painted, as was this, in his studio at Charleston. The precedent for these works is the self-portrait of the mid-1920s, once in the collection of Kenneth Clark (see Shone 1993, pl.153). In no.146 the original background was somewhat darker and Grant lightened it after he had completed the subtly modelled image of himself. The last self-portraits (from 1969–72; one is in Aberdeen Art Gallery) record the inevitable decay of old age, the painter touched with melancholy, diminished in physique. Here, aged seventy-one, Grant projects a gently robust image, the direct gaze of the eyes partially occluded by the spectacles and the shadow of his hat. Almost certainly Grant's late self-portraits are unconsciously modelled on the pastel self-portraits of Chardin in old age.

Prov: The artist to the present owner 1970
Exh: Dallas and London 1984–5 (ex. cat., London only); *Bloomsbury Portraits*, Bloomsbury Workshop, 1994 (no cat.)
Lit: Shone 1993 (pl.174)

VANESSA BELL

147 *Self-Portrait* c.1958

Oil on canvas 48.3 × 39.4 (19 × 15½)
The Charleston Trust

Vanessa Bell left six extant self-portraits, all sounding a chord that is both resolute and withdrawn. The earliest (c.1915, Yale Center for British Art, New Haven) is a ruthless self-examination, while another of the mid-1920s (private collection, USA) shows her in middle age, lugubriously unadorned. Four further ones belong to the last decade of her life; they are equally revealing and all purvey a feeling of isolation. They were painted in her attic studio, two of them almost featureless, ghostly figures amid the attributes of the painter – easel, paintings, brushes, light (fig.133). No.147 is the most famous of the group, a head-and-shoulders against a plain background, in which she wears a straw hat, spectacles and spotted shawl. It is lightly painted, the background dark yet warm, the touch infinitely delicate. Its formal simplicity embodies those qualities of 'discretion, reserve and modesty' that Dunoyer de Segonzac felt were dominant features of her art. He saw this self-portrait as 'a token of farewell … steeped in emotion deep but contained and pervaded by a moving sense of resignation' (Adams 1961).

Prov: Bt Adams by Kenneth Clark 1961; Sotheby's, Lord Clark sale, 27 June 1984 (36, repr.) where bt Charleston Trust
Exh: Adams 1961 (61, repr.); ACGB 1964 (85, repr.); Rye 1967 (63, repr.); *The Word and the Image: The Bloomsbury Group*, National Book League, 1976 (27, repr.); *British Painting 1952–1977*, RA 1977 (34, repr.); New York 1980 (77); Dallas and London 1984–5 (13, repr.)
Lit: Shone 1976 (pl.161); Spalding 1983 (repr. opp. p.145); Naylor 1990 (p.298, repr.); Shone 1993 (pl.173)

fig.133 Vanessa Bell, *Self-Portrait* c.1952,
oil 40.5 × 30.4 cm. Private Collection

147

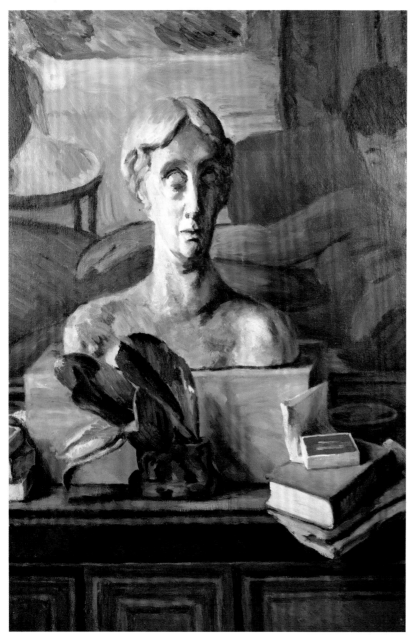

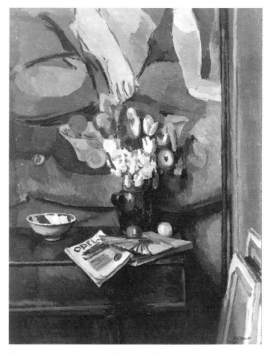

fig.134 Duncan Grant, *Still Life with Opel* 1937, oil on canvas 91.5 × 71 cm. Reader's Digest Collection, USA

DUNCAN GRANT

148 *Still Life with Bust of Virginia Woolf, Charleston*
*c.*1955

Oil on board 76 × 50.7 (30 × 20)
Bryan Ferry Collection

The principal object in this still life is Stephen Tomlin's bust of Virginia Woolf (see no.195). Part of a large painting by Vanessa Bell, *The Other Room* (private collection) fills the background – for a number of years it was in Grant's Charleston studio propped against the wall on top of an Italian chest of drawers, one of the room's chief pieces of furniture (containing sketchbooks and works on paper). An ink well holds several fleshy leaves of the magnolia grandiflora which grows against the front of the house. A book, papers, a bowl and a cigarette packet complete the ensemble, highly characteristic of Grant's later still lifes (e.g. fig.134, an 8 Fitzroy Street interior showing part of Grant's huge decorations for the *Queen Mary* liner).

It is unlikely that Grant conceived the painting as a homage to Virgina Woolf but it is inescapable that the section of Bell's painting shows a seated young woman reading a book, with a view into a garden through French windows, an archetypal Woolfian image. And the green of the foreground book is almost exactly the green of the uniform edition of Woolf's works as published by the Hogarth Press. Tomlin's bust is, as Quentin Bell asserted, far more like the sitter than any photograph; with its blank eyes and rough, animated surface, its character changes frequently in various lights – silent, intimate, aloof or, by lamplight, sending a volley of excited words across the room. Woolf is seen caught between the world of solid objects and the imaginative realm of her sister's painting. So too Grant fuses the daily materials of still life and the inspiration that other works of art always gave him, thereby creating an almost palpable sense of progression through nature and art, the present and the past.

Prov: The artist to d'Offay from whom bt by present owner 1980
Lit: J. Lehmann, *Virginia Woolf and her World*, London 1975 (p.89, repr.)

149 *Flowers against Abstract* 1969

Oil on canvas 74.3 × 59.6 (29¼ × 23½)
Inscribed 'D. Grant/69' b.r.
The Villis-Rock Collection

See no.150.

Prov: Bt from the artist by present owner 1969
Exh: Not previously exhibited or recorded

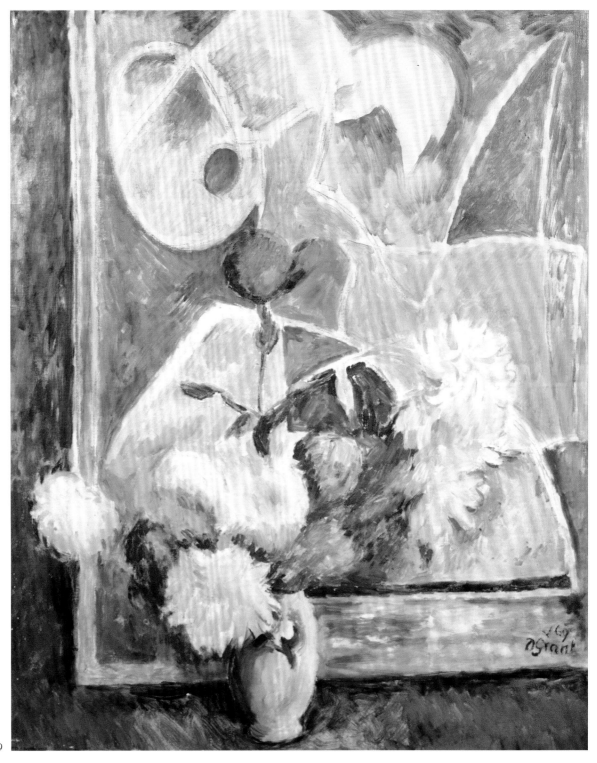

149

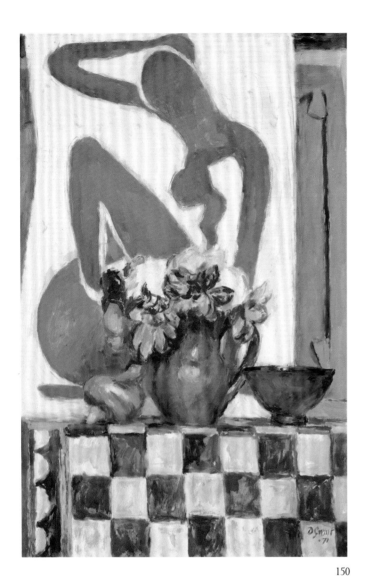

150

and from the Bonnard he took a more open sense of composition. Underneath the renewed gaiety of surface, however, there lay a considerable subtlety of structure. The apparent casualness of no.151, for example, showing the left side of the decorated studio fireplace seen from below, is notable for its carefully judged formal intervals and its interplay of light and dark colours. No.150 is more carefully planned, the terracotta jug of single dahlias seeming to emerge from the lower half of the reproduction of Matisse's cut-out *Blue Nude I* (pinned to the back of a stretched canvas). No.149, one of the earliest in the series, contains an Omega vase holding red and white chrysanthemums against a large abstract painting of *c.*1930 by Grant (Charleston Trust), again juxtaposing material nature with continued abstraction. It is not coincidental that during the period in which these works were painted, Grant had looked again at many early paintings stored at Charleston where, by this time, dealers, collectors and art historians were constant visitors. *The Mantelpiece* of 1914 (no.48) was acquired by the Tate Gallery in 1971 and its similarities to his mantelpiece paintings of 1971–3 are hardly fortuitous. As in the work of many artists in old age, early themes returned, transformed or recontextualised, such as the sloping shelf or table top, the architectonic uprights of canvases, objects intruding into a composition and left unexplained, the presence of other works of art. All these Grant now wove into a modest but lyrically directed finale.

Prov: Bt by present owner, King's Lynn, 1973
Exh: *Recent Paintings by Duncan Grant*, Fermoy Art Gallery, King's Lynn, 1973 (14); Dallas and London 1984–5 (26; repr. cover)
Lit: P. Roche, *With Duncan Grant in Southern Turkey*, 1982 (frontispiece); Watney 1990 (pl.61); Shone 1993 (pl.185); Spalding 1997 (p.476)

DUNCAN GRANT

150 *Still Life with Matisse* 1971

Oil on board 55.9 × 36.8 (22 × 14½)
Inscribed 'D. Grant/71' b.r.
Queen Elizabeth, The Queen Mother

This still life and nos.149 and 151 belong to the period when Grant was in his eighties, living alone at Charleston, his painting mostly confined to still life and portraits of friends. A large figure painting, *The Gymnasium*, on which he had been intermittently at work for some years, had become onerous and unresolved. He turned to his immediate surroundings and produced what in fact became a quite extensive series of still lifes and studio interiors which were more random in their choice of viewpoint and less consciously arranged than his still lifes of the preceding decade. Nearly all contain other works of art — his own earlier paintings, studio decorations, photographs (of Nijinsky for example, fig.135), a piece of textile printed with a woodblock by Sharaku, an Omega box by Etchells. His colour became lighter and purer, his touch less emphatic, more ruminative. He had been greatly moved by the Royal Academy's Bonnard retrospective in 1966 and by two Matisse exhibitions, in London in 1968 and in Paris two years later. These almost certainly encouraged a lightening of his palette

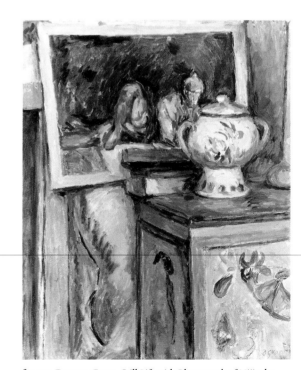

fig.135 Duncan Grant, *Still Life with Photograph of Nijinsky* *c.*1972, oil on canvas 51 × 40.8 cm. Private Collection

151

DUNCAN GRANT

151 *The Mantelpiece at Charleston* 1972

Oil on canvas 50.8 × 40.7 (20 × 16)
Inscribed 'D. Grant/72' r.c.
Private Collection

See no.150.

Prov: d'Offay where bt Stephen Spender 1975
Exh: d'Offay 2, 1975 (no cat.); Edinburgh and Oxford 1975 (43)
Lit: Watney 1990 (pl.62); Shone 1993 (pl.187)

Works on Paper
and Sculpture

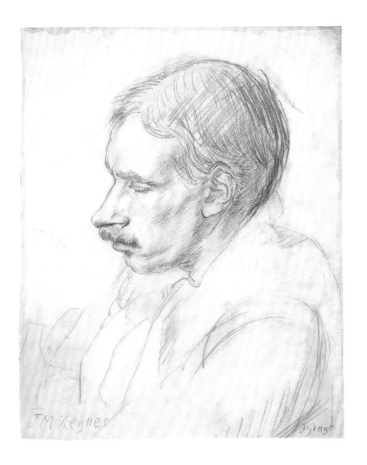

DUNCAN GRANT

DUNCAN GRANT

152 *John Maynard Keynes* c.1908

> Pencil on paper 25 × 19 (9¾ × 7½)
> Inscribed 'J M Keynes' b.l. and '. Grant' b.r.
> *Dr Milo Keynes*

For Keynes's relations with Grant see no.6. This was probably drawn when the two friends were in the Orkneys in summer 1908 and is a good example of Grant's fine early drawing style. At about this time he made several such portrait drawings – of J.T. Sheppard (King's College, Cambridge), Cecil Taylor (Clifton College, Bristol) and his father Bartle Grant (Charleston Trust).

Prov: J.M. Keynes; by descent to present owner
Lit: Shone 1976 (pl.19); Shone 1993 (pl.39)

153 *Self-Portrait* c.1909

> Pencil on paper 32 × 24.5 (12⅝ × 9⅝)
> *Private Collection*

For a discussion of Grant's early self-portraits, see nos.9 and 27.

Prov: Roger Fry; to P. Diamand; …; Spink from whom bt by present owner 1987
Exh: *Annual Exhibition of 20th Century British Paintings, Watercolours and Drawings*, Spink, June 1987 (no cat.)
Lit: Fry, *Letters*, I, 1972 (pl.60)

HENRY LAMB

HENRY LAMB

154 Clive Bell *c.*1909–10

> Pencil on paper 34 × 24 (13⅜ × 9½)
> *The Charleston Trust*

Lamb made two drawings of Bell, this and one now in the Fitzwilliam Museum, Cambridge. He also caricatured Bell and Lytton Strachey looking at works of art (K. Clements, *Henry Lamb*, 1985, repr. btw. pp.146–7). Further details of Lamb's relations with Bloomsbury are given in nos.42 and 43.

Prov: Clive Bell; Quentin Bell; to Charleston Trust 1984
Exh: *Henry Lamb 1883–1960*, Manchester City Art Gallery and tour, 1984 (14, repr.)

155 *Lytton Strachey* *c.*1912

> Pencil on paper 28.7 × 22.6 (11⅜ × 8⅞)
> Inscribed by the artist 'Lytton Strachey for Fitz.portrait' b.r.
> *The Board of Trustees of the Victoria and Albert Museum*

This is a study for the head-and-shoulders portrait of Strachey of 1912–13 in the Fitzwilliam Museum, Cambridge. In April 1912 Strachey grew his inimitable tawny beard and a little later, in imitation of Augustus John, began to wear an earring; metal spectacles replaced his earlier *pince-nez*. This unforgettable look (almost sinister when augmented by black cloak and hat) lasted until about 1916. By then, Strachey was well into the writing of *Eminent Victorians* (1918), which remains his most famous book.

Prov: Artist's estate; bt by Victoria and Albert Museum 1962

156 *Lytton Strachey at Work* 1904

Pastel on paper 53.3 × 43.1 (21 × 17)
Inscribed 'Simon Bussy' b.l.
National Portrait Gallery, London

This portrait was drawn in April 1904 when Strachey stayed with Simon and Dorothy Bussy in their house, La Souco, in Roquebrune for just over three weeks. He is seen working on his Cambridge Fellowship dissertation on Warren Hastings that he had begun in the previous autumn (and which was rejected in 1905). This image of scholarly absorption and others of the same period by Bussy had a profound impact on Duncan Grant's early painting (see the portrait of J.M. Keynes, no.6); figures reading or writing in interiors remained a constant feature of his work.

Prov: The Strachey family; given by Alix Strachey to the NPG 1967
Exh: *Simon Bussy*, Leighton House 1907 (4); *Simon Bussy et Ses Amis*, Musée des Beaux-Arts, Besançon 1970 (5, repr.); *Simon Bussy (1870–1954)*, Musée départemental de l'Oise, Beauvais, and tour 1996 (26, repr.)
Lit: Holroyd, 1, 1967 (frontispiece); L. Norton, 'Simon Bussy, Channel Painter', *Apollo*, Sept. 1970 (p.221; repr.); J. Lehmann, *Virginia Woolf and her World*, 1975 (p.16, fig.4); L. Edel, *Bloomsbury: A House of Lions*, 1979 (repr. opp. p.129); *Complete Illustrated Catalogue: National Portrait Gallery*, 1981 (p.545, repr.)

157 *George Mallory* c.1909–10

Pastel on paper 29.2 × 22.9 (11½ × 9)
Inscribed 'Simon Bussy' b.l.
National Portrait Gallery, London

George Leigh Mallory (1886–1924), a Cambridge graduate, schoolmaster at Charterhouse, and one of the greatest of all mountaineers, was taken up by Lytton Strachey and Maynard Keynes for his good looks and genial character. During 1911–12 he posed on several occasions for Duncan Grant, notably for a portrait now at the National Portrait Gallery and for a seated nude (c.1911–12, repr. Shone 1976, pl.60; untraced). Grant and Mallory's good-natured, intermittent affair more or less ended with Mallory's marriage in 1914. They remained friends until Mallory's death in 1924 when he and his fellow-climber Irvine, probably the first men to reach the summit of Everest, disappeared near the top in still unexplained circumstances. (Mallory's body was finally recovered in May 1999, but the camera he carried, which may still reveal photographic evidence that the pair had completed the ascent and were on their way down when they died, has not been located.) After a climbing fall in 1909 Mallory went to convalesce as a paying guest of Simon and Dorothy Bussy at La Souco, Roquebrune, staying for several weeks in the winter of 1909–10; it was then that Bussy drew 'le beau Mallory'.

Prov: Artist's estate; bt by NPG 1954
Exh: *Simon Bussy*, Galerie Charpentier, Paris, 1948 (3); *Simon Bussy (1870–1954)*, Musée départemental de l'Oise, Beauvais, and tour, 1996 (32, repr.)
Lit: *Complete Illustrated Catalogue: National Portrait Gallery*, 1981 (p.370, repr.); O. Garnett, 'Simon Bussy: An Anglo-French Painter', *Charleston Magazine*, Winter/Spring 1992–3 (pp.14–21; repr.)

157

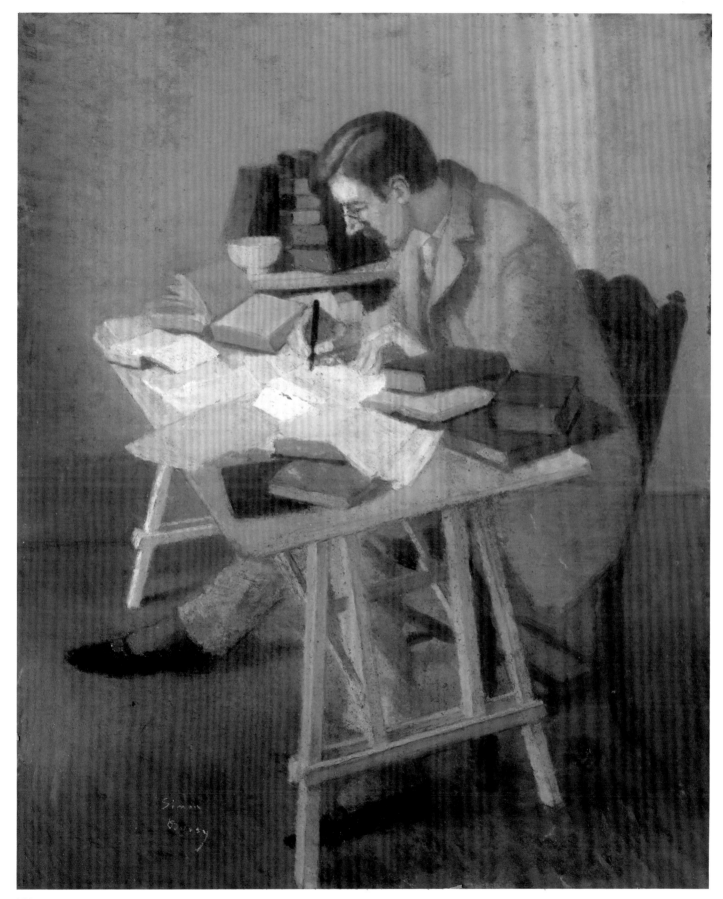

156

DUNCAN GRANT

DUNCAN GRANT

158 *Vanessa Bell in Profile* *c.*1911

Oil and pencil on newsprint 31 × 28.3 (12³/₁₆ × 11⅛)
Inscribed 'VB' b.l. and 'DB' b.r. (late inscription)
Mark Lancaster

This is almost certainly the first extant image of Bell by Grant, the beginning of a long series of portraits that ended with Bell's death in 1961 (when Grant drew her on her deathbed). Grant occasionally worked on newsprint, especially swiftly drawn figure compositions, but this is his only known portrait on this support. The page of *The Times* is from 7 August 1911. At that time Grant was mainly in London finishing his murals at the Borough Polytechnic; Bell was still semi-convalescent after a miscarriage and subsequent illness earlier that spring. The spotted application of paint, described by Bell as Grant's 'leopard technique', is consistent with his style of mid to late 1911.

Prov: Artist's estate; d'Offay; to Davis & Langdale where bt by present owner 1984
Exh: *British Drawings and Watercolors 1889–1947*, Davis & Langdale, New York, Nov. 1984 (12)

159 *Vanessa Bell* *c.*1918

Charcoal on paper 31.1 × 45.7 (12¼ × 18)
Inscribed 'Duncan Grant *c.*/16' b.c. (late inscription)
British Museum, Department of Prints and Drawings

This drawing, although dated *c.*1916 by Grant in later years, almost certainly belongs to *c.*1918 and was probably drawn in the sitting room at Charleston, showing the bookshelves seen in the painting of Bell in the same room (no.115). A later date for no.159 is preferred because of its more articulated drawing style, the Cézannian tilt of the figure and the existence of other, similarly fully worked drawings in charcoal datable to *c.*1918–19.

Prov: Artist's estate; to d'Offay from whom bt by British Museum 1981
Exh: d'Offay 1981 (9, repr.)

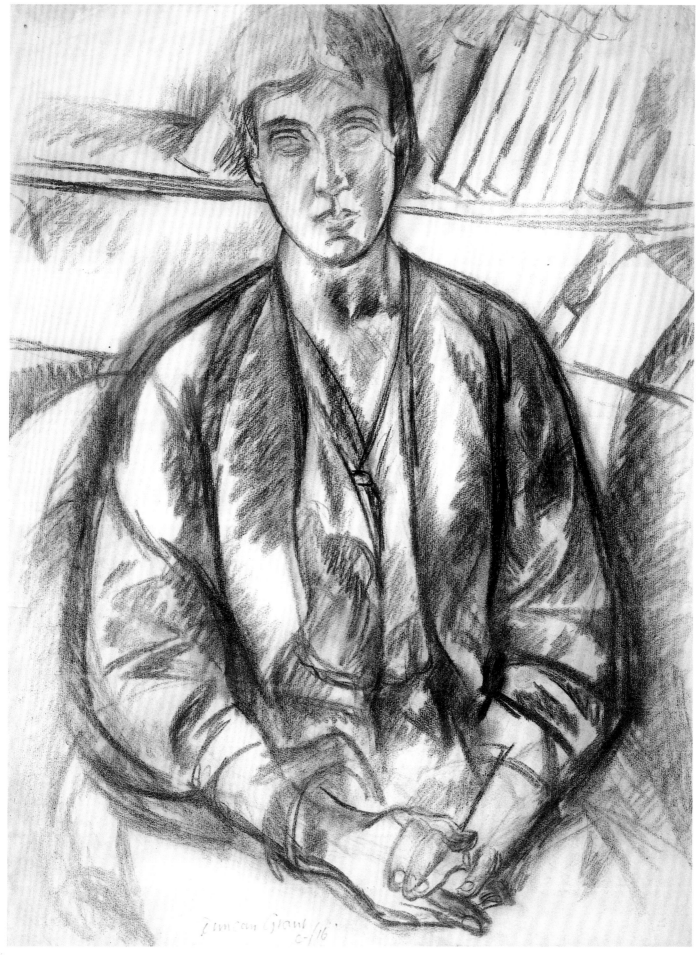

159

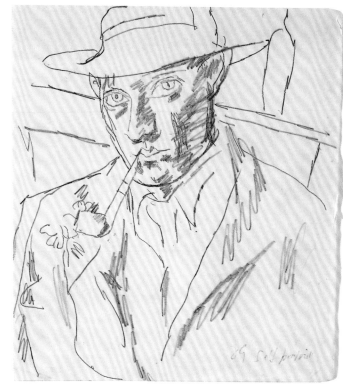

FRANCIS DODD

DUNCAN GRANT

160 *Virginia Woolf* 1908

Charcoal on paper 27.9 × 17.8 (11 × 7)
Inscribed 'Dodd/Miss Stephen 1908' centre
Holland R. Melson, Jr, New York

Francis Dodd (1874–1949), painter, etcher, member of the NEAC and
a trustee of the Tate Gallery (1928–35), was introduced to the Stephens
and Bells by Henry Lamb; he made occasional appearances at the Fri-
day Club and lived, at the time of this portrait, at 13 Fitzroy Street with
his lifelong companion Miss Isabel Dacre. He made three known
drawings preparatory to an etching of Virginia Stephen between
autumn 1907 and mid-1908; one drawing is in the National Portrait
Gallery; another (untraced) was in the collection of Benjamin Sonnen-
berg, New York (see Lehmann 1975, p.19, repr.). None is a satisfacto-
ry likeness but they are the only extant portraits of Virginia Stephen,
other than photographs, from when she was writing the early chapters
of her first novel *The Voyage Out* (1915).

Dodd exhibited a painting entitled *Virginia* at the April–May New
English Art Club exhibition in 1905 (74) but it is unlikely it was a por-
trait of the present sitter.

Prov: Artist's estate; London art market; Maas Gallery; to present owner by
1965
Lit: New York Times Book Review, 5 November 1972 (p.1, repr.)

161 *Self-Portrait with Pipe* c.1918

Pencil on paper 27.2 × 24.2 (10¾ × 9½)
Inscribed 'DG Self portrait' b.r. (late inscription); drawing of a hand and
two designs for Omega hats (verso)
Art Gallery of Ontario, Toronto. Gift of Gary Michael Dault 1998

The designs for Omega hats on the back of this drawing place it in
c.1918–19 rather than the date of 1916–17 as previously published. It
was almost certainly made at Charleston and is Grant's only known
drawn or painted record of himself between c.1910 and 1920.

Prov: The artist to d'Offay; private collection, Toronto; to Art Gallery of Ontario
1998
Exh: Duncan Grant: Watercolours and Drawings, d'Offay Couper Gallery 1972
(7, repr.); FAS Edinburgh 1975 (5); *Artists of the Bloomsbury Group*, Morris
Gallery, Toronto (21, repr.)
Lit: Orbit, March 1975 (front cover); Watney 1990 (frontispiece)

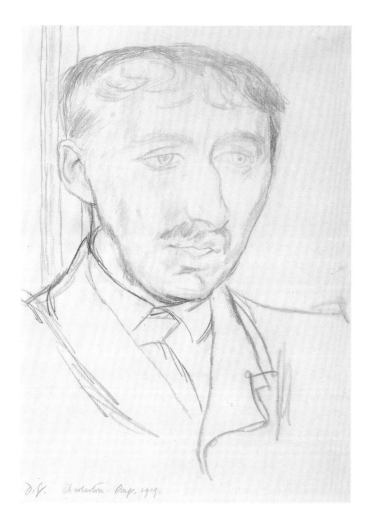

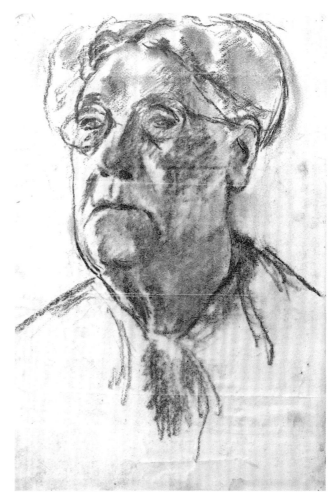

DUNCAN GRANT

VANESSA BELL

162 *E.M. Forster* 1919

> Pencil on paper 32.4 × 22.9 (12¾ × 9)
> Inscribed 'D.G. Charleston Aug.1919' b.l.
> *National Portrait Gallery, London*

E.M. Forster (for whom see no.45) stayed at Asheham House with Virginia and Leonard Woolf between 22 and 25 August 1919 and from there he made his first visit to Charleston where this drawing was made. In 1969 Grant drew Forster (then aged ninety) asleep in the Senior Combination Room at King's College, Cambridge (the sketchbook is unfortunately untraced): this was his last meeting with the writer with whom he had maintained a warm if intermittent friendship for over half a century. In between these two drawings, he had painted Forster in 1940, alongside Vanessa Bell at Charleston (Bell's painting in the oval format that she and Grant adopted for a series of portraits of members of the Memoir Club, is reproduced in Beauman 1993, p.289; Grant's is untraced).

Prov: Roger Fry; to P. Diamand; to d'Offay from whom bt by NPG 1982
Exh: *British Drawings and Watercolours 1890–1940*, Anthony d'Offay, 1982 (31, repr.)
Lit: *Illustrated Report 1982–3*, NPG, 1983 (p.12; fig.21); N. Beauman, *Morgan: A Biography of E.M. Forster*, 1993 (p.289, repr.)

163 *Lady Strachey* 1922

> Charcoal on paper 28.5 × 25 (11¼ × 9⅞)
> *Private Collection*

This is a preliminary study of Lady Strachey's head for a three-quarter length portrait of her (Charleston Trust; Naylor 1990, repr. p.293) painted at 51 Gordon Square where Lady Strachey lived with some of her children until her death in 1928. She was a formidable link with the past while remaining intellectually alert, interested in the careers of her children and their friends, humorous and uncensorious. By the time this drawing was made she was already losing her sight. Old age brought blindness, but her mind remained unimpaired and she could still recite from memory a mass of English poetry including Milton's *Lycidas* 'without hesitating over a word' (L. Woolf, *Sowing*, 1960, p.189). The portrait was probably carried out at the same time as Grant was drawing a charcoal study of Lady Strachey and her family intended for a large painting which was never executed (see *Duncan Grant: Works on Paper*, Anthony d'Offay, 1981, 27, repr.)

Prov: The artist's estate to present owner 1961
Exh: Folio 1967 (39)
Lit: Shone 1976 (pl.13); Shone 1993 (pl.27)

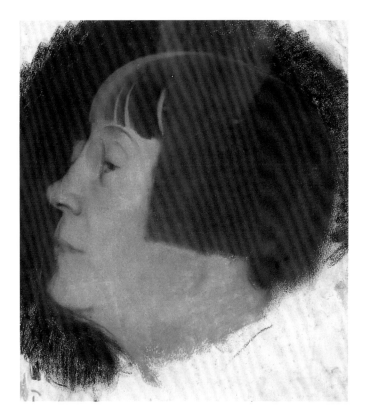

164

VISION VOLUMES AND RECESSION

165

164 *Dorothy Strachey* c.1920–5

Pastel on paper 30 × 26.5 (11⅞ × 10½)
Private Collection

Dorothy Bussy (née Dorothea Strachey 1866–1960) was one of the foremost links between Bloomsbury and France. She and her husband spent half the year at their home at Roquebrune and half in England. Her marriage to Bussy helped bring together several French and English painters and writers, notably André Gide whose accredited English translator she became and whose published correspondence with her reveals her passionate attachment to him from 1918 to Gide's death in 1951. She was a friend of T.S. Eliot and introduced him to Matisse in London in 1937. Besides Gide, she translated several French writers, notably the short book on Velázquez (1904) by Auguste Bréal and Paul Valéry's *L'Ame et la danse* (1951) and published anonymously her autobiographical *Olivia* in 1949 (the last two books both having jackets designed by her cousin Duncan Grant). The Bussys and their daughter Janie on their annual visits to England were an integral part of the social life of Bloomsbury. An early portrait of Dorothy by Bussy is in the Ashmolean Museum, Oxford, and there is a late study of her in her garden at La Souco by Vanessa Bell (1954, Charleston Trust). The painter Jan Vanden Eeckhoudt (for whom see no.89) wrote of her: '…elle était faite … d'une étonnante propension à comparer les faits et les idées, à chercher à saisir les rapports, les liaisons entre les différentes manifestations de la sensibilité, de la pensée et de l'activité créatrice des hommes' ('she had … an amazing tendency to compare facts and ideas, to seek to seize upon the connections, the links between the different manifestations of people's sensibility, thought and the creative activity.' 'Quelques souvenirs sur Dorothy Bussy', *Bulletin des Amis d'André Gide*, 17, 1989, p.337).

Prov: Artist's estate; London saleroom where bt by present owner
Exh: *Simon Bussy (1870–1954)*, Musée départemental de l'Oise, Beauvais, and tour, 1996 (28, repr.)

165 *Vision Volumes and Recession* c.1923; published 1929

Etching on paper 20 × 11.1 (7 7/8 × 4⅜)
Inscribed 'Sickert' in plate b.r. and title
Private Collection

This etching is based on an ink drawing of c.1911–12 (Islington Public Libraries, Sickert Collection) of Roger Fry lecturing. Sickert's friendship with Fry began in the 1890s when Fry attended Sickert's short-lived school in The Vale, Chelsea. Later, with Fry's advocacy of the Post-Impressionists, Sickert felt usurped as the aesthetic mentor of a younger generation of British painters. But while they might publicly disagree, there was a fundamental friendship between the two men, lasting until Fry's death. In this famous image, Sickert pokes fun at Fry's proselytising presence as lecturer and, in the title, at the formalist language in which his appreciation of Cézanne and Matisse was couched. In a memorable phrase in a letter to Cecily Hey (19 Sep-

tember 1934, ten days after Fry's death), Sickert wrote of Hey's recently exhibited portrait of Fry: 'Roger looks like an ecstatic carp, which he did, poor dear, to the joy of us all' (see Bath 1990).

With Grant and Bell, Sickert was on the warmest terms from *c.* 1911 onwards and though neither was particularly influenced by him (though he was forever giving them advice), they and Clive Bell owned several works by him and admired him above all living British artists (until *c.* 1930–2 when his *Echoes*, based on Victorian illustrations, struck Vanessa Bell, for example, as feeble). In print Sickert praised Vanessa Bell in a review in *The Burlington Magazine* (July 1922, pp.33–4) and Grant in the *Nation and Athenaeum* (February 1929, collected in O. Sitwell (ed.), *A Free House*, 1947, pp.292–4). Sickert called him the 'grand young man' of British painting who luckily had paid little attention to the theories of Fry and Clive Bell. 'In his sleep I am convinced that neither the overworked word "vision", nor "volumes" ... has passed his lips. Nor does he, even in dreams, give to ... perspective ... the consecrated name of "recession"'. These words of 1929 coincided with the publication by the Leicester Galleries of the etching shown here.

Prov: Bt from Lumley Cazalet, London, by present owner 1985
Exh: *From Beardsley to Beaverbrook: Portraits by Walter Richard Sickert*, Victoria Art Gallery, Bath, 1990 (25; pp.22–3)

MAX BEERBOHM

166 *Significant Form* c.1920–1

Pencil and watercolour on paper 32.5 × 21.5 (13 × 8½)
Inscribed 'Max' b.c. and with title and caption: 'Significant Form. Mr. Clive Bell: "I always think that when one feels one's been carrying a theory too far, then's the time to carry it a little further." Mr. Roger Fry: "A little? Good heavens, man! Are you growing old?"'
Private Collection

Max Beerbohm's cartoon of the two foremost apologists of aesthetic formalism shows the widespread fame Fry and Bell had achieved by 1920. Such drawings as this (and the cartoons of Henry Tonks) perpetuated the legend that Fry was a wholehearted convert to Bell's theory of significant form as propounded in *Art* (1914). Fry's review of it, however, and later pronouncements show he had several reservations and misgivings. Max Beerbohm (1872–1956) maintained cordial relations with several members of the Bloomsbury circle. He caricatured Roger Fry in 1913 (King's College, Cambridge) and Lytton Strachey in 1921 (National Gallery of Victoria, Melbourne), felinely named his cat 'Strachey', and delivered the Rede Lecture in Cambridge on Strachey in 1943. Iris Tree (no.34) was the daughter of his half-brother, Sir Herbert Beerbohm Tree.

Prov: ...; Ronald Searle by 1956; to Agnew's where bt Barbara Bagenal; by descent to present owner
Exh: *Caricatures by Max Beerbohm*, Leicester Galleries, May 1921 (2); *Vision and Design* 1966 (14); Rye 1967 (90); *Clive Bell at Charleston*, Harvane Gallery, 1972 (53); *Word and Image: The Bloomsbury Group*, National Book League, 1976 (34, repr.)
Lit: C. Bell, *Old Friends*, 1956 (repr. frontispiece and jacket); Q. Bell, *Bloomsbury*, 1968 (p.46, repr.) and paperback ed. 1974 (repr. btw. pp.48–9)

166

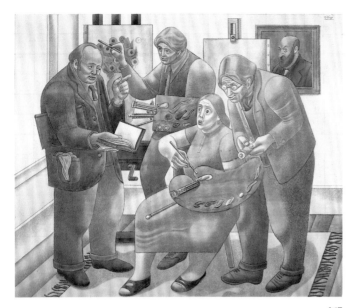

167

WILLIAM ROBERTS

167 *No! No! Roger, Cézanne did not use it* 1934

Pencil and watercolour on paper 35.6 × 43.2 (14 × 17)
Inscribed with title on separate paper b.c., and 'William Roberts' t.r.
Sheffield Galleries & Museums Trust

Clive Bell instructs from a book (his own *Since Cézanne* perhaps);
Duncan Grant paints a flowerpiece; Vanessa Bell holds her palette
onto which Roger Fry is about to squeeze paint from a tube. A self-por-
trait by Cézanne is on the wall behind. Roberts's gentle satire on the
Bloomsbury artists' personal relationships and their veneration for
Cézanne was probably prompted by the death of Roger Fry in Sep-
tember 1934. Roberts had known Fry, Grant and Bell only slightly
when he worked briefly for the Omega Workshops in 1913–14; he also
exhibited with them at the second Grafton Group show in January
1914. Later, as a member of the London Artists' Association he was
again a fellow exhibitor of the Bloomsbury painters and benefited
from the friendly patronage of Maynard Keynes in the 1930s (see
no.6).

No.165 belongs to a group of works in which Roberts wrily com-
mented on the art world of his time, including Sickert's use of pho-
tographs, Hampstead Bohemians, unprincipled dealers and 1960s
abstraction.

Prov: Bt Wilfred Evill 1942; to Honor Frost; bt Sheffield City Art Galleries 1966
Exh: *William Roberts*, Redfern Gallery, 1942 (27); *Pictures from the Collection of
Wilfred A. Evill*, Leicester Galleries, 1952 (38); *The Wilfred Evill Collection*,
Brighton Art Gallery, 1965 (155); *William Roberts RA*, Arts Council, Tate
Gallery and tour 1965–6 (157); *Thirties*, Hayward Gallery, 1979–80 (5.29)
Lit: *Concise Catalogue of Works by British Artists Born after 1850*, Sheffield City
Art Galleries, 1981 (p.44; repr. p.64, no.21)

168

VANESSA BELL

168 *Roger Fry* c.1932

Pencil on paper 38.7 × 27 (15¼ × 10⅝)
Inscribed 'VB' on back
Art Gallery of Ontario, Toronto. Gift of Dr Mary Rowell Jackman 1992

One of two pencil studies of Roger Fry in profile drawn at Charleston
in preparation for Bell's painting *Roger Fry and Julian Bell Playing
Chess* (King's College, Cambridge) variously dated to c.1930–3. A
pencil drawing for the composition is reproduced in Shone 1976
(pl.158). Fry's head is strongly lit from the left by a lamp that stands
between the two players.

Prov: Artist's estate to d'Offay; bt from Morris Gallery by Dr Mary Rowell
Jackman and presented to Art Gallery of Ontario 1992
Exh: *Artists of the Bloomsbury Group*, Morris Gallery, Toronto (2, repr.)

ANDRÉ DERAIN

169 *Clive Bell* c.1919–20

> Pencil on paper 17.7 × 10 (7 × 4)
> Inscribed 'à Mon Cher Clive Bell / A Derain'
> *The Charleston Trust*

André Derain (1880–1954) was Clive Bell's closest friend among the many artists he knew in Paris (see Bell's chapter 'Paris in the "Twenties"', *Old Friends*, 1956, pp.170–95). Derain had been much admired in Bloomsbury since 1910 when he was included in *Manet and the Post-Impressionists* and both Fry and Keynes owned paintings by him. For several weeks in 1919 he lived in Vanessa Bell's flat in Regent Square while working for the Russian Ballet and over the years saw much of the Bells and Duncan Grant in London and Paris. But even by 1924 Vanessa Bell thought him 'too much of an old master' (V. Bell to Fry, 6 July 1924; TGA); Grant regarded him with qualified admiration as 'the Dr Johnson of painting' (Grant to the present author, 6 May 1969). Bell's most measured account of Derain's work was published in *Formes*, I, February 1930 (pp.5–6). For a fuller account of Derain's relations with Fry and Bell, see James Beechey's essay above.

Prov: Clive Bell; to Quentin Bell 1964; to Charleston Trust 1984
Exh: *Clive Bell at Charleston*, Harvane Gallery 1972 (54)

PABLO PICASSO

170 *Lydia Lopokova* 1919

> Pencil on paper 35.6 × 25.1 (14 × 9⅞)
> Inscribed 'Picasso / Londres 1919'
> *The Syndics of the Fitzwilliam Museum, Cambridge*

Lydia Lopokova (for whom see no.129) came to know Picasso in 1918–19 (they had met in Rome in 1917), particularly during the summer 1919 season of the Diaghilev company in London. Picasso stayed at the Savoy Hotel, working on the sets and costumes of *Le Tricorne* in the stage-painting studio in Floral Street, Covent Garden, and attending ballet rehearsals where he drew Lopokova in action several times. A more formal sitting at the Savoy resulted in this and a very similar drawing (Christian Zervos, *Pablo Picasso*, 1932–78, 3, 299; Thaw Collection, Pierpont Morgan Library, New York). These were made between 25 May when Picasso arrived in London and c.9 July when Lopokova sensationally fled from the Savoy and the Diaghilev company. She greatly admired but did not entirely trust Picasso, finding his attentions to several members of the *corps de ballet* 'semi-scandalous', especially as he was married to Olga Koklova, Lopokova's friend and confidante – 'luckily Olga was present' at the portrait sittings (Lopokova in conversation with the author, August 1971). Thus the drawing was made during Lopokova's immense acclaim in London for her roles in *Les Femmes de Bonne Humeur* and *La Boutique Fantasque*. It was then, too, that she came to know the Bloomsbury circle, though it seems she did not then renew her brief acquaintance with her future husband, J.M. Keynes: he was in Paris for the Peace Treaty negotiations from early January to June 1919. By 1921 Lopokova was reunit-

169

ed with Diaghilev and installed at 50 Gordon Square with Keynes living two doors away at number 46.

It was during this three-month stay in London in 1919 that Picasso saw a great deal of Clive Bell and was entertained at 46 Gordon Square as well as at Roger Fry's house and at Garsington Manor. In the autumn Bell was in Paris for several weeks and it was on 21 November that Picasso made the well-known drawing of his wife, Cocteau, Satie and Bell (fig.53). Picasso last saw Lopokova on his visit to England in 1950.

Prov: ...; Cyril Beaumont; Sacheverell Sitwell; Francis Sitwell; bt Fitzwilliam Museum 1990
Exh: *The Diaghilev Exhibition*, Edinburgh and London, 1954 (no.486)
Lit: *Lydia Lopokova*, ed. M. Keynes, 1983 (pl.14; p.145; and back jacket); D. Cooper, *Picasso Theatre*, New York 1987 ed. (pl.157); *Lydia and Maynard*, ed. P. Hill and R. Keynes, 1989 (pl.18); D. Scrase, 'Picasso's Lydia Lopokova', *NACF Review*, 1990 (pp.128–33, repr.)

WILLIAM ROBERTS

171 *Lydia Keynes* c.1932

Pencil on paper 42.5 × 32.5 (16¾ × 12⅞)
Inscribed 'W Roberts' b.r.
The Provost and Scholars of King's College, Cambridge

This study of Lydia Keynes for a double-portrait of herself and her husband (1932–3; fig.136) was a direct result of Keynes's patronage of William Roberts (1895–1980), an artist he greatly admired and who was a member of the London Artists' Association from 1927 until its disbandment in 1933. The four guarantors of the LAA, which held its first exhibition in 1926, were Keynes, Samuel Courtauld, F. Hindley Smith and L.H. Myers. The artists were guaranteed a certain income a year, the Association taking a 30 per cent commission; the guarantors made up any shortfall for an artist's annual income. Grant, Bell

and Fry along with Bernard Adeney, Frederick Porter, Keith Baynes and Frank Dobson (see no. 192) were the original members and over the next few years a wide range of artists were full or probationary members – Edward Wolfe, Paul Nash, William Coldstream, Ben Nicholson, Ivon Hitchens, Cedric Morris, Geoffrey Tibble, Robert Medley and Victor Pasmore. In July 1931, Grant, Bell, Fry and Baynes resigned from the LAA after disagreements with Keynes. From then onwards Grant and Bell were handled by Alex. Reid and Lefevre and by Agnew's with whom they greatly increased their sales and incomes. Keynes continued to help Roberts, commissioning the double-portrait, buying several works and arranging with Lefevre a solo exhibition in 1937.

By the early 1930s Lydia Keynes was an important figure in the establishment of British ballet and though her own days as a dancer were ending, a new career as an actress kept her in the public eye. After Keynes's unexpected death in 1946, she gradually retired from the world, living at Tilton House near Charleston.

Prov: ? Gift from artist to J.M. Keynes; by whom bequeathed to King's College 1946
Exh: Cambridge 1983 (93, repr.)

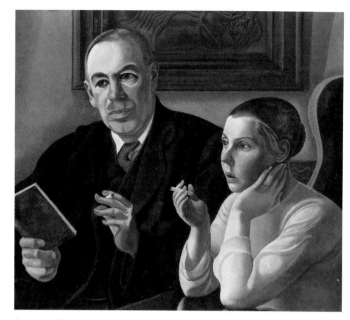

fig. 136 William Roberts, *Mr and Mrs J.M. Keynes* c. 1932, oil on canvas 72.5 × 80 cm. National Portrait Gallery, London

171

173 *Mary Hutchinson* 1936

Charcoal on paper 66 × 50 (26 × 19¾)
Inscribed 'Henri Matisse 36' b.l.
Private Collection

Matisse made two drawings of Mary Hutchinson (for whom see nos.35 and 172) in his Paris studio in June 1936. The sitting was arranged through Matisse's son-in-law Georges Duthuit, the writer on art. He was a friend of the Bells and Duncan Grant, a visitor to Charleston and a temporary tenant in 1931 of Grant's London studio. Matisse retained one drawing for sale (R. Escholier, *Henri Matisse*, 1937, p.169 repr., collection M. Vaux); Mary Hutchinson bought the more worked second drawing (see Shone 1993 below, for further details of the commission).

Matisse remained the living French painter most admired in Bloomsbury: Fry and Keynes owned works by him as did St John and Mary Hutchinson (a Nice interior now in St Louis Art Museum, see fig.58); Fry's short book on Matisse was published in 1930. Matisse was especially grateful to Clive Bell for a review of his drawings exhibition at the Leicester Galleries in 1936 (C. Bell, 'Black and White', *New Statesman*, 15 February 1936, pp.226–7). Bell visited Matisse on several occasions in the South of France after the Second World War (once, in 1948, with Mary Hutchinson at Vence).

Prov: The sitter by descent to present owner
Exh: Not previously exhibited
Lit: R. Shone, 'Matisse in England and Two English Sitters', *The Burlington Magazine*, 135, July 1993 (pp.479–84; fig.38)

172

DUNCAN GRANT

172 *Mary Hutchinson* c.1917

Pencil on paper 40.5 × 27.9 (16 × 11)
Private Collection

Mary Hutchinson (for whom see no.35) stayed at Charleston in April 1917 and Grant and Vanessa Bell persuaded her to sit to them for 'sketches and drawings from which we mean to paint' (Bell to Fry, early May 1917; TGA). This arresting full-face study is almost certainly one of these drawings; no subsequent portrait materialised. Bell incorporated Mary Hutchinson's features in her large decoration *The Tub* (fig.150) and took several photographs of her (fig.86).

Prov: Artist's estate; Bloomsbury Workshop; to present owner 1994
Exh: *Bloomsbury Portraits*, Bloomsbury Workshop 1994 (no cat.)

174

173

ROGER FRY

ROGER FRY

174 *Chair with Bowl and Towel* c.1916–18

Ink and watercolour on paper 20 × 22.3 (7⅞ × 8⅞)
Sheffield Galleries & Museums Trust

It is uncertain whether this small, compact watercolour was made as a study for the painting exhibited here, no.59, or as a record of it afterwards.

Prov: Artist's estate; to P. Diamand; to d'Offay from whom bt Sheffield City Art Galleries 1982
Exh: Vision and Design 1966 (100, repr.)

175 *Nude on a Chair (Nina Hamnett)* 1917

Pencil on paper 35.9 × 23.9 (14⅛ × 9⅜)
Inscribed 'July 1917' by the artist b.r.
Private Collection

Nina Hamnett (1890–1956), painter and Bohemian, was frequently employed at the Omega Workshops and collaborated with Fry and others on several schemes of interior decoration. She lived briefly with her Norwegian husband Edgar de Bergen, another artist employed at the Omega, who worked under the name Roald Kristian; their gloomy marriage is captured in Sickert's painting *The Little Tea Party* (c.1916, Tate Gallery). Hamnett's affair with Fry seems to have lasted from 1916 to early 1918 during which time Fry painted her on several occasions, notably the portraits in the Courtauld Gallery (Fry Collection)

175

fig.136A Roger Fry, *Nina Hamnett* 1917, oil on canvas
81 × 60.9 cm. Courtauld Gallery, London

(fig.136A), and the University of Leeds Art Gallery (both unavailable for this exhibition). The latter collection also contains many line drawings of her by Fry (and drawings by Hamnett herself); this study of her slim figure was probably preparatory for a now lost painting. She was the model for Gaudier-Brzeska's equally slender *Torso* in the Victoria and Albert Museum – hence the name of her autobiography, *Laughing Torso*, 1932.

Hamnett was a close associate of the Bloomsbury artists during the First World War and showed her paintings alongside them on several occasions. She is known for careful, often penetrating portraits (e.g. *Ossip Zadkine*, private collection), sturdy still lifes in the manner of Marchand and Fry and for her fluent line drawings influenced by her friend Modigliani. But her chief claims to fame were her incurable Bohemianism in London and Paris, her predilection for sailors and boxers and, in later years, the resilience she showed in the face of alcoholism and poverty.

Prov: The artist's estate to P. Diamand; to d'Offay from whom bt by present owner 1982
Exh: Vision and Design 1966 (97, repr.); Rye 1967 (8, repr.); *British Drawings and Watercolours 1890–1940*, Anthony d'Offay, 1982 (20, repr.)
Lit: Shone 1993 (113)

ROGER FRY

176 *Seated Woman* 1922

> Charcoal on paper 58 × 36.5 (23 × 14⅜)
> Inscribed 'Roger Fry 1922' b.r.
> *British Museum, Department of Prints and Drawings*

Fry's preferred medium for works on paper was ink or pencil, often combined with watercolour. Chalk and charcoal, in sanguine or black, was usually reserved for life drawing and occasional figure studies as here. Fry was a prolific draughtsman influenced early on by English topographical watercolourists (Fry's watercolours tend to be coloured drawings) and later by Cézanne. He had little obvious fluency or personal grace of line (though he wrote exceptionally well on that quality in his 'Line as a Means of Expression in Modern Art', *The Burlington Magazine*, December 1918, pp.201–8, and February 1919, pp.62–9); in the 1920s, however, he achieved a more monumental style and his drawings relate more closely to his work as a painter in their transcription of light and volume. The model for this drawing is almost certainly Mela Muter, a Polish Jewish painter, whom Fry met in St Tropez in 1921; he painted her portrait in spring 1922 (Rieff Collection, USA; Spalding 1980, pl.88) in which she appears to be wearing the same or a similar low-necked dress.

Substantial groups of works on paper by Fry are in the collection of the University of Leeds and the Louvre's Département des Arts Graphique.

Prov: Frank Hindley Smith c. 1923–4 by whom bequeathed to the British Museum 1940
Exh: *Recent Paintings by Roger Fry*, Independent Gallery 1923 (as *Portrait Study*; no cat.)
Lit: 'Mr Roger Fry's Pictures', *The Burlington Magazine*, 42, May 1923 (pp.254–9, repr.)

176

177

177 *Still Life with Flask* c.1912–13

Watercolour on paper 35.6 × 24 (14 × 9½)
Mr and Mrs Craufurd D. Goodwin

Very few works on paper by Bell exist from before *c.*1913 (and these in the main relate to her role as a designer for the Omega Workshops). But we know that in early 1913, working at Asheham House, she painted a number of watercolours: '[They] are my one delight for I see it doesn't matter the least what one does. One has to turn it into something quite different and any bit of the room or still life may become fascinating. One is quite released from any necessity of imitation and has to invent all the time' (Bell to Fry, 24 January 1913; TGA). This still life almost certainly belongs to this moment, clearly showing her indebtedness to Cézanne in the fusion of firm statement and mobility of surface, broken contour and the superimposition of transparent patches of colour. A sizeable group of Cézanne's watercolours was added to the Second Post-Impressionist Exhibition in January 1913 and may well have provided an impetus to Bell's use of the medium.

Prov: Artist's estate; Bloomsbury Workshop; to present owner 1998
Exh: *Christmas Exhibition*, Bloomsbury Workshop, 1997 (repr. on card)

178

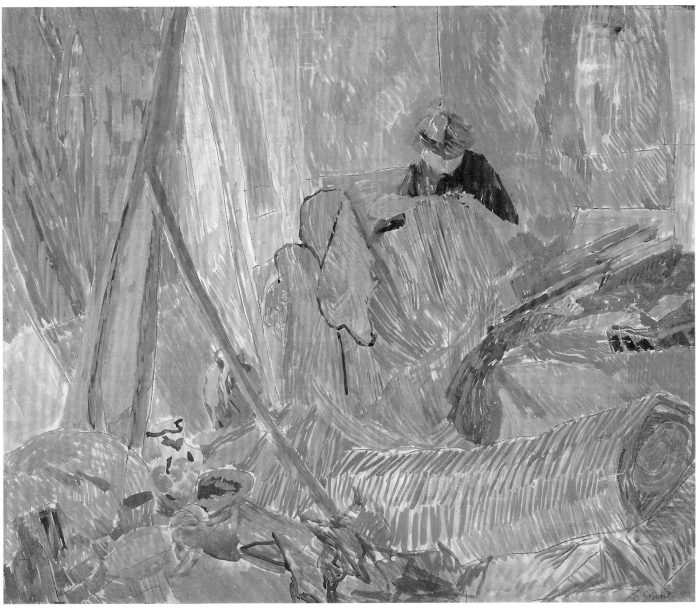

179

VANESSA BELL

178 *The Coffee Tray* c.1914–15

> Watercolour on paper 28 × 40 (11 × 15¾)
> Inscribed 'V.B.' b.r.
> *Private Collection*

A label on the back of this work (a piece of board cut down from a painting by Bell) records the title, price (£5), the artist's Charleston address and 'no 3' which probably refers to a mixed exhibition at the Omega Workshops in 1917–18. The white cups appear in still lifes by Grant painted in late 1914 at Asheham House and this watercolour, with its limpid washes and succinct suggestion of volume, may also belong to that period.

Prov: Artist's estate; A.V. Garnett; Magdalene Street Gallery, Cambridge; to present owner 1971
Exh: ?Omega Workshops 1917–18; Folio 1967 (59); *Modern English Pictures from Local Collections*, Clare College, Cambridge, 1970 (17)

DUNCAN GRANT

179 *Matting* 1913

> Gouache and pencil on board 61 × 74 (24 × 29⅛)
> Inscribed 'D. Grant 1913' b.r.
> *Sheffield Galleries & Museums Trust*

The setting for this gouache has not been established. The work predates the opening of the Omega Workshops, but may reflect its preparatory activities; it is unlikely to have been Grant's studio at 38 Brunswick Square, yet on the floor (centre) is part of a painting of a head of Vanessa Bell by Grant (c.1911–12; Tatham Art Gallery, Pietermaritzburg) and the jugs and bottle are familiar props from some of Grant's still lifes. The background on the left suggests tree trunks against a blue sky, either a window view or part of a large painting leaning against the wall. The figure is seated in an armchair and the roll of matting seems to be partly on the floor, partly on a chair or sofa (on the right). Grant has transformed the whole scene with vibrant

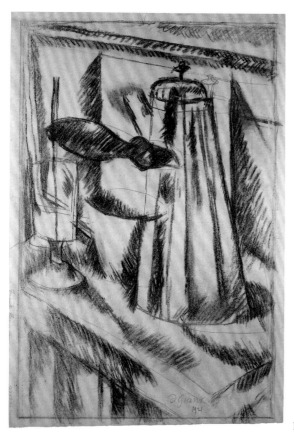

180

181

hatching similar to other works of 1912–13 (particularly his *Blue Sheep Screen* also shown in the first Grafton Group Exhibition in March 1913). Hatching, as with Grant's earlier adaptation of a pointillist application of paint, was a short-lived phase in which all-over animation was sought by binding together the elements of a composition through a free and rhythmically varied calligraphy.

Prov: ...; Middleton; Christie's 4 Nov. 1983 (98, repr.); D. Woolf; Sotheby's 13 Nov. 1985 (74, repr.) where bt Sheffield City Art Galleries
Exh: 1st GG 1913 (8)
Lit: Naylor 1990 (p.97, repr.)

DUNCAN GRANT

180 *Study for 'The Coffee Pot'* c.1918

Charcoal and pencil on paper 52.7 × 34.9 (20¾ × 13¾)
Inscribed 'D. Grant 1921' b.c.r. (late inscription)
Trustees of the Cecil Higgins Art Gallery, Bedford

At the time no.178 was acquired by Bedford (on the recommendation of the late Ronald Alley shortly before Grant's 1959 Tate retrospective), Grant inscribed it with the date 1921, one of his habitual late misdatings. It is in fact a study for *The Coffee Pot* (no.57) and belongs to a group of studies in pencil and charcoal made in preparation for several still life paintings of c.1918–19. All are notable for a strong constructive sense and eschew the lyrical fluency of earlier and later still-life drawings.

Prov: The artist, from whom bt Cecil Higgins Museum 1959
Exh: Tate 1959 (96, repr.)

DUNCAN GRANT

181 *Study for 'Juggler and Tightrope Walker'* c.1918

Pencil on paper 33 × 22.9 (13 × 9)
Inscribed 'DG' b.r. (late inscription)
Sandra Lummis Fine Art, London

One of two known studies for the painting shown here, no.119. The other drawing (fig.118) shows the left-hand figure holding cymbals rather than a sunshade; here all the elements for the final work are in place.

Prov: Artist's estate to d'Offay; with S. Lummis by 1990
Exh: d'Offay 1981 (11)
Lit: Watney 1990 (fig.39)

182

DUNCAN GRANT

182 *Edward Wolfe Sketching* 1919

Pastel and charcoal on paper 62.2 × 47.8 (24½ × 18¾)
British Museum, Department of Prints and Drawings

The setting is an upper window at 36 Regent Square, a flat rented by Vanessa Bell in 1919. Neither the house nor the neo-classical church of St Peter's (seen here across the square) has survived. The South African-born painter Edward Wolfe (1897–1982) was introduced to the Omega Workshops in 1917 by Nina Hamnett (for whom see no.175). He was an enthusiastic convert to Bloomsbury Post-Impressionism

after the rigours of Professor Tonks's teaching at the Slade School of Art. He exhibited paintings at the Omega and through Fry's intervention, painted Arnold Bennett, his first important portrait commission. He was at Charleston in 1919 (where two early paintings by him still hang). His friendship with Grant was maintained until the latter's death, though frequently interrupted by Wolfe's extended sojourns abroad.

This is a study for an oil painting shown in Tate 1959 (41) and sold at Sotheby's 25 June 1975 (lot 56, bt Crane Kalman (fig.112)).

Prov: The artist; Browse and Darby where bt by British Museum 1981

183 *Portrait of a Negro* c.1918–19

Pastel and charcoal on paper 44.5 × 29.7 (17⅝ × 11¾)
Birmingham Museum and Art Gallery

This portrait study of a professional model may relate to a large unfinished painting of the same model made in c.1915 in Grant's studio at 22 Fitzroy Street (artist's estate). But the style of the work places it later, especially as Grant's first substantial group of pastels belongs to c.1918–20. In a letter to Mary Hutchinson (3 October 1918), Clive Bell mentions that Grant is painting a negro. Grant told the author that West Indian models were rare in London but they would occasionally 'knock on studio doors in and around Fitzroy Street asking for work'.

Prov: Bt Leicester Galleries 1944 by Birmingham City Art Galleries
Exh: *Pastels*, Leicester Galleries 1944 (7, as *A Coloured Gentleman*)
Lit: T. Cox, 'City of Birmingham Art Gallery', *Studio*, 134, October 1947 (p.101, repr.)

DUNCAN GRANT

184 *Seated Male Nude* 1922

Charcoal on paper 52 × 38 (20½ × 15)
Inscribed 'DGrant 1922' b.r.
Bradford City Art Galleries and Museums

See entry no.185

Prov: Bt from the artist by Bradford City Art Galleries 1934
Exh: Not previously exhibited or recorded

DUNCAN GRANT

185 *Semi-nude Woman, Seated* 1920

Charcoal on paper 60.5 × 43 (23⅞ × 16⅞)
Inscribed 'D. Grant / 20' b.r.
Private Collection

When in 1920 Grant established himself in Sickert's former studio at 8 Fitzroy Street, his greater financial security enabled him to hire professional models, something he had not done with any regularity since before c.1912. Drawing from the model, either as an independent activity or as preparation for a specific composition, occupied Grant to the end of his life. The models for these two drawings have not been identified but there is a possibility that Ralph Partridge posed for no.184 and was drawn by his future wife Dora Carrington on the same occasion. Further drawings of the female model with her distinctive coil of hair, are in the artist's estate. The example of Sickert hovers over the drawing – from the woman's characterful head to the placing of the figure at an angle to the wall behind. A reproduction of no.185 appears in a photograph c.1974 of the studio at Charleston.

Prov: Vint Collection; by descent
Exh: Not previously exhibited or recorded

184

185

183

186 *Harlequin and Columbine* c.1924–5

Gouache on paper 74 × 54.5 (29⅛ × 21½)
Doncaster Museum and Art Gallery, Doncaster Metropolitan Borough Council

The underlying inspiration for this work was Grant's experience of seeing Karsavina and Nijinsky in 1911 in the Russian Ballet's *Le Carnaval* (a ballet that remained in the company's repertoire for many years). He shared the European fascination with the characters of the Commedia dell' Arte – Harlequin, Columbine and Pierrot – as seen in works by Picasso, Derain, Severini and in Arnold Schoenberg's *Pierrot Lunaire*, which Grant heard performed in London in 1923. He used this particular image on several occasions, notably in a three-panelled painted screen of c.1924–6 in which the two figures dance under the moon between a Pierrot playing a violin, on the right, and three contemporary women, as though in a theatre box, looking at the scene from the left. The screen was shown at the London Group in 1929 and is now in a private collection. Grant also made an easel painting of the subject (untraced) for he mentions in a letter that Matthew Smith had visited him and made useful criticisms about his picture (Grant to V. Bell, 15 April 1926; TGA); this painting was shown at Paul Guillaume Gallery, London, 1929 (22). Related studies include an early preliminary design in pencil (Watney 1990, fig.29), *Pierrot Lunaire* (watercolour; *Duncan Grant. Watercolours and Drawings*, Anthony d'Offay, 1972, 27, repr.) and a gouache (Spink 1991, 48, repr.) in which the Harlequin's traditional costume is in black, white and red. It is often in preliminary studies such as no.186 that Grant reveals his buoyant lyricism rather than in the final painting which tends to be solidly over-realised, the densely painted surface smothering the original conception.

Prov: Artist's estate; to Roy Miles from whom bt by present owner 1984
Lit: *Spring 1984*, Roy Miles, London (repr. in 4-page brochure)

186

fig.137 Duncan Grant, *The Contortionists* c.1945, oil on canvas on board 49.5 × 39.4 cm. Whereabouts unknown

187

188

187 *Four Dancers* c.1925–6

Oil and charcoal on paper 56 × 76.3 (22 × 30⅛)
Bryan Ferry Collection

From the early 1920s Grant was involved with the ballet as set and costume designer working with Massine and Lopokova, Rupert Doone and, in the early 1930s, with the Camargo Ballet. This activity is reflected in many paintings and decorative works of dancers in action. Nothing is known of the origins of this vital, swiftly executed composition. It may have been based on notes made at a theatre (as was Grant's frequent practice; fig.137), with its figures lit by footlights from below. More likely, it was an entirely spontaneous invention.

Prov: Artist's estate to d'Offay from whom bt by present owner 1981
Exh: d'Offay 1981 (38)
Lit: Watney 1990 (pl.43 and front jacket)

189

188 *Farmhouse and Trees, near Cassis* 1928

Pastel and pencil on paper 46.7 × 62.2 (18⅜ × 24½)
Inscribed 'D Grant / 28' b.l.
Whitworth Art Gallery, University of Manchester

This was drawn at Cassis in April or May 1928 near to the artist's house, La Bergère. Grant made several paintings and drawings of the farmhouses and cottages around the Château de Fontcreuse, its surrounding vineyards and olive groves, the most closely related to no.188 being *Farmhouse among Trees* (1928, National Gallery of Scotland, Edinburgh). Grant's first prolonged stay at Cassis was highly productive, giving him a new range of subject matter and uninterrupted peace. Much of his work from this stay is in a fluent, calligraphic manner, the paintings carried out in a loose web of turpentine-thinned brushwork, the drawings and pastels in heightened colour (the electric blue of the trees here) and with vigorous passages of rhythmic cross-hatching.

Prov: Gift from A.E. Anderson to Whitworth Art Gallery 1929

189 *The Orange Bandeau* 1933

Pastel on paper 54 × 35.6 (21¼ × 14)
Mr and Mrs Julian Agnew

This was one of a large group of pastel studies of nude female and male models, carried out in Grant's studio in the early 1930s. Several were shown at an Agnew's exhibition in 1933 for which Kenneth Clark wrote the preface. He commended no.189 (which he purchased) and others as the outcome of Grant's efforts to fuse weight and substance with 'his natural charm of colour and handling … These are not merely good drawings tinted up; they are drawn in colour from the first stroke'. In the following year Grant's drawing from the model intensified as he worked towards three large decorative panels for the new liner the RMS *Queen Mary*. Kenneth Clark also owned another study of the same female model (Mortimer 1944, pl.20), part of his large collection of works by Grant and Bell (see nos.138 and 147).

Prov: Bt from Agnew's by K. Clark 1933; Sotheby's 10 June 1981 (68); MacMillan & Perrin Gallery, Toronto; Christie's 4 March 1983 (99) where bt by present owner
Exh: *Drawings by Duncan Grant*, Thomas Agnew & Sons, June 1933 (25); *British Drawings*, Bucharest 1935–6
Lit: Mortimer 1944 (pl.21, as *Nude Study*, 1935)

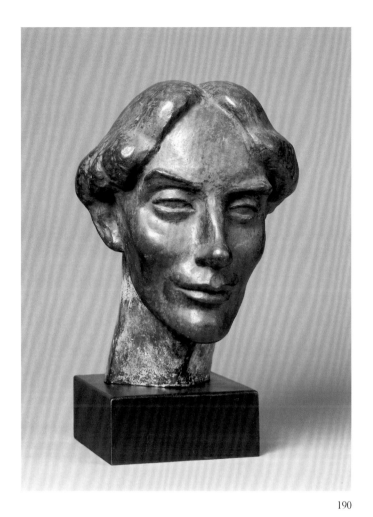

190

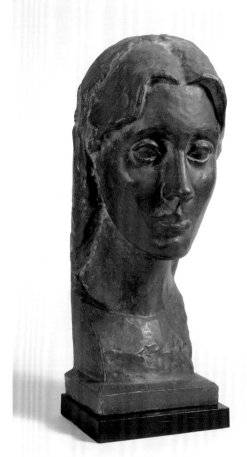

191

MARCEL GIMOND

MARCEL GIMOND

190 *Roger Fry* 1920

Lead h. 34.3 (13½)
National Portrait Gallery, London

In 1919 Marcel Antoine Gimond (1891–1961), a pupil of Maillol, became an assistant to Renoir, helping him with his sculpture and making a bust of him shortly before he died in Cagnes in December that year. Gimond remained in the South of France and in the following spring was introduced by Jean Marchand to Roger Fry in Vence. Fry asked him to London where this head was made: 'He has also begun my portrait, which I find interesting – it looks a bit of a crétin, but they assure me not more than I do in real life. But it's a rather spiritual crétin so I don't complain' (Fry to Marie Mauron, 13 July 1920, in *Letters*, 2, 1972, p.484). Fry painted an interior of Gimond and his wife, and Sonia Lewitska (Mme Jean Marchand) around a table (fig.120). Gimond's sculpted heads of the later 1920s have close affinities with Maillol and Dobson.

Prov: R. Fry; to P. Diamand 1934 from whom bt by National Portrait Gallery 1981
Exh: Vision and Design 1966 (17)
Lit: *Report of the Trustees 1981–2*, NPG 1983 (p.23, pl.18)

191 *Vanessa Bell* c.1920

Lead h. 47 (18½)
Richard Garnett

No documentation exists for this head. When Gimond came to London in summer 1920 he made busts of Fry (no.190) and his daughter Pamela. Almost certainly it was during this stay, in which Fry actively sought commissions for Gimond, that this portrait of Bell was made. At about the same time Grant acquired a plaster head by Gimond which appears in several still lifes of the 1920s and in a Bell still life of c.1945 (the head is now at Charleston along with three drawings by Gimond). The original plaster for no.191, once owned by Fry (see fig.144), is in a private collection, Sussex; there is a cast in the National Portrait Gallery, London, and a third cast at Charleston.

Prov: D. Garnett; by descent to present owner

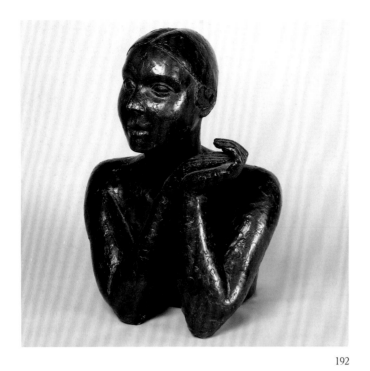

192

FRANK DOBSON

192 *Lydia Lopokova* 1924

> Bronze 47 × 36 × 35 (18½ × 14⅛ × 13¾)
> Inscribed 'Dobson 2/2' b.r.
> *Arts Council Collection, Hayward Gallery, London*

J.M. Keynes commissioned this sculpture of Lydia Lopokova in late 1923, eighteen months before the economist and the dancer were married. Lopokova is caught in characteristic pose as though airily talking at the table on which she rests her elbows. This was one of Keynes's most successful acts of patronage and though the fee to Dobson was comparatively hefty (about £160), artist, sitter and patron were delighted with the result. Dobson was highly praised in the 1920s by Fry and Clive Bell as a classic sculptor in the line of Maillol; Fry felt that in this work Dobson had finally put his apprenticeship behind him, fusing 'a clearly balanced formal system' with an appreciation of 'a definite and unique personality' (see Fry 1926). Dobson showed alongside Grant and Vanessa Bell in the London Group and was a founder member with them of the London Artists' Association in 1925.

Two further casts of no.192 are known, one in the Keynes family and another in Glasgow City Art Gallery (not numbered), a gift of the CAS in 1933.

Prov: Lady Herbert; Sotheby's 9 March 1949 where bt Arts Council
Exh: LG, Mansard Gallery, Heal's, April 1924 (130); *Ten Decades: A Review of British Taste 1851–1951*, ICA, 1951 (210); Vision and Design 1966 (52, London only); *Frank Dobson: Memorial Exhibition*, ACGB touring exhibition 1966 (19; pl.7); *Frank Dobson: True and Pure Sculpture*, Kettle's Yard, Cambridge, and ACGB tour, 1981–2 (37); *Head First: Portraits from the Arts Council Collection*, ACGB touring exhibition 1998–9 (13, repr.; pp.9–10)
Lit: R. Fry, 'London Sculptors and Sculptures', *Transformations*, 1926 (Keynes cast repr. opp. p.155); R. Mortimer, *Frank Dobson*, 1926 (pl.7); T.W. Earp, *Frank Dobson: Sculptor*, 1945 (pl.19); Arts Council Collection, 1979 (p.81, repr.); *Lydia Lopokova*, ed. M. Keynes, 1983 (p.201); N. Jason and L. Thompson-Pharoah, *The Sculpture of Frank Dobson*, 1994 (pp.53–5; no.36, p.128, repr.)

193

STEPHEN TOMLIN

193 *Duncan Grant* 1924

> Bronze 38 × 23.5 × 31 (15 × 9¼ × 12¼)
> *Richard Garnett*

Stephen Tomlin (1901–1937), son of Lord Justice Tomlin, worked with Frank Dobson (see no.192) in the early 1920s before establishing himself as a sculptor primarily of portrait heads and large-scale figures. He also worked briefly on ceramic heads with the London potter Phyllis Keyes, a close colleague of Grant and Bell. He was introduced to Bloomsbury by David Garnett, one of his earliest sitters, and caused emotional havoc among several of its men and women. His marriage in 1927 to the writer Julia Strachey lasted about five years; he died aged thirty-five from blood-poisoning and pneumonia, having gained some reputation through exhibitions at the Leicester Galleries and the London Group.

At the instigation of Garnett and J.M. Keynes, this bust was made in autumn 1924 in Tomlin's Fulham studio; another cast is with the Keynes family.

Prov: David Garnett; by descent to present owner

194

195

STEPHEN TOMLIN

194 *Lytton Strachey* 1929

> Bronze 46 × 25.5 × 28 (18⅛ × 10 × 11)
> *Tate Gallery, London. Presented by Brinsley Ford (later Sir Brinsley Ford)
> 1932*

Tomlin was a close friend of Lytton Strachey and Carrington and a frequent visitor to Ham Spray House, both before and after his marriage to Strachey's niece Julia. This bust was commissioned by Strachey in late 1928, carried out at Ham Spray in August 1929 and cast in bronze in an edition of three; the original plaster is in a private collection, London, a bronze cast was owned by David Garnett and another (Strachey's own) is on loan to Charleston. Strachey wrote to George Rylands: 'I sit all day to Tommy who is creating what appears to me a highly impressive, repulsive, and sinister object' (Holroyd 1968). This sympathetic portrait reveals something of the dignified and sagacious presence of the writer noted by many who met him in the last years of his life.

Prov: Bt from Leicester Galleries by Brinsley Ford and presented by him to the Tate Gallery 1932
Lit: Tate 1964, 2 (pp.726–27; repr. pl.46); Holroyd, 2, 1968 (p.644, repr.)

STEPHEN TOMLIN

195 *Virginia Woolf* 1931

> Plaster h. 38.4 (15⅛)
> *The Charleston Trust*

The six sittings for this bust took place in July 1931 and caused great distress to Virginia Woolf and disappointment for Tomlin. Woolf had just finished a final rewriting of *The Waves* and, though buoyant from her husband's verdict, delivered on the day before the first of her sittings for Tomlin, that it was a masterpiece, she was apprehensive over the arrival of the proofs of her novel and, as was usually the case, hated being pinned down and scrutinised in Tomlin's studio (even though Vanessa Bell reassuringly attended the sittings). Nevertheless, this is Tomlin's 'masterpiece', remaining an impressive and affecting portrayal of the exhausted yet volatile writer, owing part of its impact to its unfinished state, for after six sittings, Woolf refused to continue.

Bronze casts were made soon afterwards, one of them acquired by Vita Sackville-West (and now at Sissinghurst Castle), another by David Garnett; a third is in the National Portrait Gallery and a fourth in the garden of Monk's House, Rodmell. A further edition of seven bronzes was issued in 1973 and a single bronze cast was made in 1998 for the British Library. For Grant's 'portrait' of the bust see no.148.

Prov: V. Bell to A.V. Garnett; to Charleston Trust 1984
Exh: *Treasures from Sussex Houses*, Brighton Museum, 1985 (198)
Lit: Q. Bell, *Virginia Woolf*, 2, 1972 (pp.160–1, NPG cast repr.)

Photographs and Books

The following photographs and books will be included in the exhibition at the Tate Gallery: the displays at the other venues will vary. Additional documentary material will also be exhibited at each venue.

Photographs are listed chronologically; books are listed alphabetically by author.

PHOTOGRAPHS

[photographer unknown]
Sir Richard Strachey c.1850–5
National Portrait Gallery, London

Julia Margaret Cameron
Julia Jackson (Mrs Leslie Stephen) c.1867
National Portrait Gallery, London

Julia Margaret Cameron
Julia My Neice April 1867
National Portrait Gallery, London

Julia Margaret Cameron
Leslie Stephen 1870s
Henrietta Garnett

George Beresford
Leslie Stephen and Virginia Stephen 1902
Harvard Theatre Library, Harvard University, Cambridge, Massachusetts

George Beresford
Sir Leslie Stephen 1902
National Portrait Gallery, London

George Beresford
Thoby Stephen c.1902–3
National Portrait Gallery, London

Elliott & Fry
Sir Edward Fry and *Lady Mariabella Fry* c.1905
Private Collection

Graystone Bird of Bath
Lady Strachey and her five daughters c.1893
National Portrait Gallery, London

Graystone Bird of Bath
The Strachey Family c.1893
National Portrait Gallery, London

Messrs Stearn, Cambridge
Clive Bell 1899
Tate Gallery Archive

Alice Boughton
Roger Fry c.1900
National Portrait Gallery, London

George Beresford
Virginia Stephen (Woolf) 1902
National Portrait Gallery, London

George Beresford
Virginia Stephen (Woolf) 1902
National Portrait Gallery, London

George Beresford
Vanessa Stephen c.1902–3
Private Collection

Vanessa Bell
Leonard and Virginia Woolf at Asheham House c.1912
Tate Gallery Archive

Vanessa Bell
Duncan Grant and J.M. Keynes at Asheham House c.1912
Tate Gallery Archive

Omega Workshops sitting room at Allied Artists Association exhibition, Holland Park June 1914
Tate Gallery Archive

[photographer unknown]
Advertisement for Omega Pottery 1916
The Burlington Magazine

A.C. Cooper
Roger Fry 28 February 1918
National Portrait Gallery, London

[photographer uncertain]
Vanessa Bell at Charleston c.1925–6
Tate Gallery Archive

[photographer uncertain]
Vanessa Bell and Duncan Grant at Cassis c.1928–30
Tate Gallery Archive

Vanessa Bell
Duncan Grant at Cassis c.1929
Tate Gallery Archive

[photographer unknown]
Duncan Grant painting Mary Coss, Rome April 1930
Fitzwilliam Museum, Cambridge

? Dora Carrington
Lytton Strachey at Ham Spray c.1930
National Portrait Gallery, London

? Roger Fry
Vanessa Bell at Charleston c.1930–2
Tate Gallery Archive

? Vanessa Bell
Roger Fry at Charleston c.1930–2
Tate Gallery Archive

Ramsay & Muspratt
Roger Fry 1932
National Portrait Gallery, London

Ramsay & Muspratt
Clive Bell 1932
National Portrait Gallery, London

Pearl Freeman Studios
Duncan Grant c.1932
Charleston Trust

Man Ray
Virginia Woolf 1934
National Portrait Gallery, London

Man Ray
Virginia Woolf 1934
Harvard Theatre Library, Harvard University, Cambridge, Massachusetts

? Leonard Woolf
Vanessa Bell, Angelica Bell, Clive Bell, Virginia Woolf, J.M. Keynes (l. to r.) at Monk's House, Rodmell c.1935
Harvard Theatre Library, Harvard University, Cambridge, Massachusetts

Ramsay & Muspratt
John Maynard Keynes c.1937
National Portrait Gallery, London

Howard Coster
E.M. Forster 1938
National Portrait Gallery, London

[photographer uncertain]
Vanessa Bell and Duncan Grant at Cassis 1938
Tate Gallery Archive

Gisèle Freund
Virginia Woolf 1939
National Portrait Gallery

Gisèle Freund
Virginia and Leonard Woolf 1939
National Portrait Gallery

Beck and MacGregor
John Maynard Keynes and Lydia Lopokova 1925
Reproduction from *Vogue*, late 1925

[photographer unknown]
A room at the first retrospective of the Omega Workshops, Miller's Gallery, Lewes, Sussex 1946
Private Collection

Barbara Bagenal
Clive Bell and Pablo Picasso outside the bullring at Arles c.1958
Tate Gallery Archive

Barbara Bagenal
Clive Bell with Picasso in a mask, La Californic c.1959 60
Tate Gallery Archive

?Angelica Garnett
Edward le Bas, Barbara Bagenal, Clive Bell, Vanessa Bell, Peter Morris, Duncan Grant at Roquebrune 1960
Private Collection

Olivier Bell
Vanessa Bell at Charleston 1960
Charleston Trust

Christopher Morphet
Duncan Grant in the Studio, Charleston 1970
Private Collection

Various photographers
Stephen family photograph album
Tate Gallery Archive

Stella (Duckworth) Hills
Hills family photograph album
New York Public Library, Berg Collction

BOOKS

CLIVE BELL
Art, Chatto & Windus 1914
Private Collection
Since Cézanne, Chatto & Windus 1922
Private Collection

BIRRELL AND GARNETT
Some Contemporary English Artists, Birrell and Garnett 1921
Private Collection

T.S. ELIOT
Poems, Hogarth Press 1919
Victoria University Library, Toronto
The Waste Land, Hogarth Press 1923
Stanford University Libraries
Homage to John Dryden, Hogarth Press 1924
Private Collection

E.M. FORSTER
A Passage to India, Edward Arnold 1924
Private Collection

SIGMUND FREUD
Autobiographical Study, trans. James Strachey, Hogarth Press 1936
Private Collection

ROGER FRY
Duncan Grant, Hogarth Press 1923
Victoria University Library, Toronto
Cézanne: A Study of his Development, Hogarth Press 1927
Private Collection
Vision and Design, Chatto & Windus 1920
Private Collection

ROBERT GRAVES
The Feather Bed, Hogarth Press 1923
Victoria University Library, Toronto

HENRY GREEN
Loving, Hogarth Press 1943
Daniel Moynihan
Back, Hogarth Press 1946
Daniel Moynihan

CHRISTOPHER ISHERWOOD
The Memorial, Hogarth Press 1932
Victoria University Library, Toronto

JOHN MAYNARD KEYNES
The Economic Consequences of the Peace Macmillan 1919
Dr Milo Keynes

WILLIAM PLOMER
Sado, Hogarth Press 1931 [2nd ed, 1960]
Private Collection

WILLIAM SANSOM
The Equilibriad, Hogarth Press 1948
Private Collection

GERTRUDE STEIN
Composition as Explanation, Hogarth Press 1926
Private Collection

LYTTON STRACHEY
Eminent Victorians, Chatto & Windus 1918
Stanford University Libraries

EDWARD UPWARD
Journey to the Border, Hogarth Press 1938
John Byrne

LEONARD WOOLF
Quack, Quack!, Hogarth Press 1937
Victoria University Library, Toronto
Hunting the Highbrow, Hogarth Press 1927
Victoria University Library, Toronto

VIRGINIA WOOLF
Kew Gardens, Hogarth Press 1919
Victoria University Library, Toronto
Monday or Tuesday, Hogarth Press 1921
Stanford University Libraries
Monday or Tuesday, Hogarth Press 1921
Private Collection
Mrs Dalloway, Hogarth Press 1925
Victoria University Library, Toronto
To the Lighthouse, Hogarth Press 1927
Victoria University Library, Toronto
Three Guineas, Hogarth Press 1938
Victoria University Library, Toronto
Walter Sickert: A Conversation, Hogarth Press 1934
Private Collection

WU CH'ÊNG-ÊN
Monkey, trans. Arthur Waley, Folio Society 1968
Private Collection

Chronologies

These chronologies are based on those published in *Letters of Roger Fry*, ed. D. Sutton (1972), and in *Bloomsbury Portraits*, R. Shone (1993 ed.). They have been fully revised with the help of Frances Spalding's three biographies of Fry, Bell and Grant and include new archival material. They are necessarily selective, particularly in the case of Roger Fry. His many public lectures, particularly in relation to the series of important inter-war exhibitions at the Royal Academy, London, and which were hugely popular, have not been included; most of the lectures appear in his later publications on Flemish, French and British art. His Slade lectures, incomplete at the time of his death, appear in *Last Lectures*. Additionally, many group exhibitions of a more ephemeral nature in which the artists were represented have been omitted.

CB: Clive Bell RF: Roger Fry
VB: Vanessa Bell DG: Duncan Grant

ROGER FRY

1866

14 December: Roger Eliot Fry born at 6 The Grove, Highgate, north London, both his parents of distinguished Quaker families. His father Sir Edward Fry eventually became Lord Justice of Appeal (1883); his mother was Mariabella Hodgkin, granddaughter of the meteorologist Luke Howard. There was another son, Portsmouth, and five daughters including Margery, later Principal of Somerville College, Oxford, and a leading proponent of penal reform.

1872

Fry family moves next door to 5 The Grove.

1877–81

Attends Sunninghill Preparatory School, Ascot.

1881–5

At Clifton College, Bristol, near the Fry family's home Failand House; J.E. McTaggart, the future philosopher, is also a pupil.

1885–8

Awarded exhibition to King's College, Cambridge: reads Natural Sciences (First Class in Part I, 1887, and in Part II, 1888). McTaggart also at King's and their circle includes Nathaniel Webb, C.R. Ashbee and Goldsworthy Lowes Dickinson, the latter remaining one of RF's closest friends.

1887

Elected to the Apostles, the Cambridge *conversazione* society; this later formed a link between RF and younger members of Bloomsbury such as Leonard Woolf and Lytton Strachey who were Apostles at the turn of the century.

1888

To his father's regret, decides to study painting rather than follow a scientific career; encouraged by J.H. Middleton, Slade Professor.

1889

January: Attends Francis Bate's progressive art school in Hammersmith, west London; lives with his parents at 1 Palace Houses, Bayswater, but finds he is frequently in conflict with his father.

1890

Continues to work under Bate; growing interest in the history of art.

fig. 138 Sir Edward and Lady Mariabella Fry, *c.* 1905. Courtesy Annabel Cole

fig. 139 Roger Fry, *Landscape with Shepherd, near Villa Madama, Rome* 1891, oil on canvas 36 × 46.4 cm. Tate Gallery

fig. 140 Helen and Roger Fry, Failand House, near Bristol, *c.* 1897. Tate Gallery Archive

1891

February–early June: First visit to Italy; travels extensively and stays in Rome, Naples, Sicily, Florence and Venice; paints near Rome (fig. 139).

1892

January–February: In Paris with G.L. Dickinson and studies at Académie Julian.
Spring: Shares a house with Cambridge friend and poet R.C. Trevelyan at 29 Beaufort Street, Chelsea.
Summer: Painting at Blythburgh, Suffolk (see no. 1).

1893

Attends evening classes (with William Rothenstein and others) at Walter Sickert's Chelsea Life School (1 The Vale); encouragement from Sickert and the start of their long if prickly friendship.
April: Exhibits portrait of G.L. Dickinson at New English Art Club (NEAC) of which he is elected a member.

1894

Paints *Edward Carpenter* (National Portrait Gallery), exhibited at spring NEAC exhibition.
Summer: Painting at La Roche Guyon.
Autumn: In Italy with Augustus Daniel (later Director of National Gallery).
Designs furniture for McTaggart's Cambridge rooms; begins lecturing on art for Cambridge Extension Movement.

1895

Summer: Continues lecturing for Cambridge Extension Movement; portrait painted by Sickert (untraced).
July–August: Painting at La Roche Guyon and in Seine valley (shows *La Roche Guyon* at NEAC spring 1896); paints mural for C.R. Ashbee's mother's house in Chelsea.

1896

Paints mural at parents' house at Failand.
Autumn: Organises an exhibition of 'progressive' art at Bijou Theatre, Cambridge, with works by Steer, Tonks, Rothenstein, MacColl and RF.

3 December: Marriage to Helen Coombe (1864–1937), painter and designer affiliated to A.H. Mackmurdo's Century Guild; honeymoon in France and North Africa returning to London in early spring 1897.

1897

Late spring to late summer: With Helen in Italy; returns with Helen to Italy in late autumn, painting in Ravello.

1898

In Rome by spring and on to Florence; preparing lectures on Venetian art to be given in Cambridge and elsewhere; commissioned to write *Giovanni Bellini*, a pioneering monograph (1899); meets and is encouraged by Bernard Berenson in Florence; this influential relationship gradually sours (see 1903 below).
Summer: Helen Fry's first bout of mental illness.

1899

Autumn: Temporarily recovered, Helen accompanies RF on German and Italian tour; meets Wilhelm von Bode in Berlin.

1900

Frys move to Ivy Holt, Dorking, Surrey.
Elected to NEAC; on selecting jury; exhibits in most of its shows (usually two a year) to November 1907.
Important essays on Giotto in *Monthly Review*, December 1900 and February 1901

1901

Birth of son Julian.
February: Begins regularly reviewing for the *Athenaeum*

1902

Birth of daughter Pamela.
September: In Bruges to see *Primitifs Flamands et d'Art Ancien*.
Autumn: In Italy (Vicenza, Mantua, Verona, Venice).

1903

Frys move to 22 Willow Road, Hampstead; visited by Vanessa Stephen.
On the founding consultative committee of *The Burlington Magazine*; involved in disputes over articles with Berenson; helps stave off magazine's financial crisis in autumn.
April: First one-artist exhibition, Carfax Gallery, London.
Winter: Helen very ill; they go, with his sister Margery and a nurse, to Lyme Regis; slow recovery through 1904.
On selecting jury for NEAC exhibition (November–December) where he shows five works; is on Executive Committee for 1905 and 1906 spring exhibitions.

1904

June: Rejected as Slade Professor of Fine Art, Oxford.
Visits Paris.

1905

January: Visits United States to raise funds for *The Burlington Magazine*; the offer of post of Assistant Director at Metropolitan Museum breaks down with the refusal of President of Trustees, J. Pierpont Morgan, to agree to RF's financial requirements; in Boston visits Isabella Stewart Gardner and meets Denman Ross (Harvard) and Matthew Prichard (MFA). Meets John G. Johnson of Philadelphia and begins to advise on his collection (now Philadelphia Museum of Art).
Summer: European tour looking at old masters (possibly for American collectors).
Edits and introduces *Discourses of Sir Joshua Reynolds* (Seeley, London).

1906

January: Accepts position as Curator of Paintings, Metropolitan Museum of Art, New York.
8 February to late spring: In New York.
July: Exhibition of work (mostly watercolours) at Alpine Club Gallery.
Late summer and autumn: In Europe on behalf of the Metropolitan.
October: Returns to New York until 19 December.

fig.141 Roger Fry, *c*.1918. Courtesy Annabel Cole

fig.142 Durbins, Guildford, *c*.1918. Courtesy Annabel Cole

fig.143 Roger Fry, *Landscape, South of France* 1913, oil on canvas 34.3 × 53 cm. Whereabouts unknown

1907

Post at Metropolitan changed to European Advisor; buys Renoir's *La Famille Charpentier* for the Museum.
Summer: In Italy with Pierpont Morgan; they visit Berenson at Villa I Tatti, Florence.
November–December: In New York.

1908

Summer: Acquires land outside Guildford and designs his house Durbins (fig.142); garden planned with Gertrude Jekyll; living nearby at Chantry Dene, Guildford.
Winter: Severe mental illness of Helen Fry; hospitalised.

1909

April: Publishes his influential 'Essay in Aesthetics' in *New Quarterly*.
September: Joint-Editor of *The Burlington Magazine*.
Early winter: Moves into Durbins which remains his principal home to 1919; his sister Joan Fry is housekeeper; Helen Fry increasingly ill.

1910

January: Meets Clive and Vanessa Bell, Cambridge railway station; beginnings of close friendship.
Translates and introduces Maurice Denis's *Cézanne* for *The Burlington Magazine* (January and February issues).
February: Position with Metropolitan terminated.
21 February: Lectures to Friday Club.
6 June: Visits Matisse at Issy-les-Moulineaux.
8 November: *Manet and the Post-Impressionists* opens at the Grafton Galleries, London (and runs to 15 January 1911); organised by RF with help from critic Desmond MacCarthy entailing visits to Paris, Munich and Holland, over 25,000 people visit it.

1911

Turkey with CB, VB and H.T.J. Norton; love affair with VB begins.
February: Exhibits two landscapes at Friday Club.
Exhibits for last time with NEAC (Summer and Winter exhibitions).
October: In France with CB and DG, visiting Romanesque churches and painting (see no.13).

1912

January: *Paintings and Drawings by Roger Fry* (Alpine Club Gallery).
July: Organises and is included in *Exposition de quelques Indépendants anglais*, Gallery Barbazanges, Paris.
5 October: Second Post-Impressionist Exhibition opens at Grafton Galleries (until end January 1913); French, Russian and English sections selected by, respectively, Fry, Boris Anrep, CB; includes outstanding works by Matisse, Derain, Picasso and Braque; RF shows five paintings.
December: Fund-raising for proposed Omega Workshops (£1,500 raised by February 1913).

1913

March: Member of and shows in first Grafton Group exhibition (Alpine Club Gallery).
April–May: In Italy with CB, VB and DG (Ravenna, Siena, Pisa, etc.).
8 July: Press day for opening of Omega Workshops, 33 Fitzroy Square; RF shows watercolours.
5 October: After altercation with RF, Wyndham Lewis with Cuthbert Hamilton, Frederick Etchells and Edward Wadsworth walk out of Omega and later, while RF is in France, accuse Fry of mismanagement in a round robin letter sent to patrons and press.
c.11 October: Leaves London for painting holiday in Avignon with Henri Doucet (see no.15 and fig.143).
9–25 October: Omega sitting-room at Ideal Home Exhibition, Olympia.
14 November: Gives first of six lectures on 'Some Principles of Design' at Slade School of Art where he has lectured for some years.
Autumn: With DG and VB decorates room for Henry Harris in (?) Bedford Square.

1914

January: Shows in second Grafton Group exhibition (Alpine Club Gallery) – mostly landscapes.
Mid-January: In Paris with VB, CB and Molly MacCarthy; visits, Matisse, Picasso, Gertrude Stein.
April: Omega decorates and furnishes 1 Hyde Park Gardens.
June: Omega lounge at Allied Artists' Association exhibition, Holland Park Hall.

August: Omega decorates and furnishes Cadena Café, Westbourne Grove.
(?) Winter: Takes rooms and studio at 21 Fitzroy Street.

1915

April: In Northern France working with Quaker War Victims Relief mission; painting in South of France in June (see nos.88 and 89).
November: *Paintings by Roger Fry* (Alpine Club Gallery).

1916

Late June–early July: In Paris with Lalla Vandervelde; meets Diego Rivera; Maria Blanchard; visits Matisse and Picasso.
August: At Bosham, near Chichester.
October: Omega decorates and furnishes Chelsea flat for Lalla Vandervelde (see no.63); and for Arthur Ruck, 4 Berkeley St.; several paintings of Nina Hamnett, with whom he has an affair.

1917

April: Exhibits with London Group for first time and each year until his death.

1918

September: Paints André Gide (fig.88) at Durbins.
18 October: Death of Sir Edward Fry.
Supervises production of and contributes to *Original Woodcuts by Various Artists* (Omega).

1919

Sells Durbins and buys 7 Dalmeny Avenue, Holloway, shared with Margery Fry; takes attic rooms at 18 Fitzroy Street.
Summer: Closure of Omega Workshops, with clearance sale, 23 June–9 July.
Entertains Picasso and Derain in London.
October: To Paris and on to Aix, Avignon and Les Baux.

1920

April: Exhibits with DG and VB at Galerie Vildrac, Paris.
June–July: one-artist exhibition, Independent Gallery, London.
August–September: In Brittany with Pamela Fry and paints at Auray in the Morbihan.
28 September: In Paris and visits Matisse to see his recent work; visits Maillol.
Represented in the Salon d'Automne.
December: *Vision and Design* (Chatto & Windus).

1921

March: In Paris where Picasso shows him his recent work.
May: Organises *Nameless Exhibition of Modern British Painting*, Grosvenor Gallery, in which works of several 'schools' are shown anonymously.
Visits South of France.
July: *Architectural Heresies of a Painter* (Chatto & Windus).
October–November: In St Tropez; DG and VB staying nearby at La Maison Blanche.
Represented in the Salon d'Automne.
December: *Twelve Original Woodcuts by Roger Fry* (Hogarth Press).

1922

April: Visits Brancusi in Paris.
June: In Cornwall painting Bertrand Russell (NPG, London).
Late summer: In South of France, mainly at St Tropez; attends the clinic at Nancy of Dr Coué on a course of auto-suggestion to cure his persistent internal pains.

1923

February: To Southport to paint the collector Frank Hindley Smith; visits his wife Helen at The Retreat in York and Michael Sadler in Leeds.
April: One-artist exhibition, Independent Gallery, London;
May–June: In France at Dr Coué's clinic; on to Spain, meeting VB and DG; returns unwell to Nancy; returns to Spain and makes landscape drawings for his *Sampler of Castille* published in November by Hogarth Press.

fig.144 Sitting room in Roger Fry's house, 48 Bernard Street, c.1934. Courtesy Annabel Cole

fig.145 Roger Fry writing, St Rémy, c.1928. Tate Gallery Archive

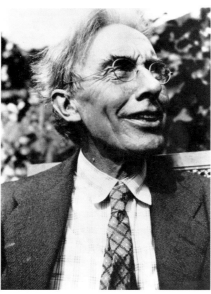

fig.146 Roger Fry at Charleston, c.1932. Tate Gallery Archive

Paints Robert Bridges.
Autumn: In Paris; gives evidence in Hahn *vs.* Duveen over the former's *Belle Ferronière* by Leonardo denounced as a copy by the latter; continues a difficult affair with Josette Coatmellec met in 1922 at Nancy; she commits suicide end March 1924.
February: *Duncan Grant* issued (dated 1923; Hogarth Press).
Much of the year after May spent in France – with the Maurons at St Rémy (paints Charles Mauron) and then at Souillac in the Lot.
September–October: In St Tropez.
November: *The Artist and Psycho-Analysis* (Hogarth Essays, no.2).
Winter: Meets Helen Anrep (née Maitland; 1885–1965) wife of the mosaicist Boris Anrep; the following year she leaves her husband to live with Fry for the rest of his life.

1925

January: One-artist exhibition at Joseph Brummer Gallery, New York.
Spring: In Paris seeing the Pellerin collection of Cézannes; on to St Rémy; to Cassis.
Autumn: Returns to paint in Cassis.

1926

March: *Art and Commerce* (Hogarth Essays, no.16).
May: Exhibits ten works in the first exhibition of the London Artists' Association, of which he is a founder member, Leicester Galleries.
September–October: In Spain followed by touring in France; sees Gide in Dieppe.
On return to London moves from 7 Dalmeny Avenue into 48 Bernard Street, Bloomsbury, shared with Helen Anrep.
October: Contributes essay, alongside another by Virginia Woolf, to *Victorian Photographs of Famous Men and Fair Women by Julia Margaret Cameron* (Hogarth Press).
November: *Transformations* (Chatto & Windus).

1927

March: Translates and introduces C. Mauron's *The Nature of Beauty* (Hogarth Press).
Spring: Shares exhibition with Frederick Porter and Bernard Meninsky, Lefevre Galleries.
Early summer: In St Rémy and Cassis translating into English his *Cézanne: A Study of his Development* from his original French (published in *L'Amour de l'Art*, 7, December 1926) for publication by Hogarth (November).
July: *Flemish Art* (Chatto & Windus).
September: Takes a health cure in Vichy; on to Paris; stays with Ethel Sands and Nan Hudson at Château d'Auppegard; in Dieppe with Helen Anrep.

1928

March–April: Included in London Group retrospective, New Burlington Galleries; contributes introduction to catalogue.
April: Lectures in Menton, staying with the Bussys at La Souco, Roquebrune; paints Simon Bussy; continues to St Rémy and Arles.
May: Brief return to London before a long tour with Helen Anrep of Germany and Austria, visiting Frankfurt, Munich (joined by Quentin Bell), Dresden, Vienna and returning via Berlin.
August: Helen Anrep buys Rodwell House, near Ipswich, Suffolk, shared with Fry; learns to drive.
Autumn: In poor health in Brantôme and Paris.

1929

Hon. Doctor of Laws, Aberdeen University.
March: In Paris.
June: Again in Paris; visits Chantilly; paints in Cluny.
September: In Venice with his sister Margery (now Principal of Somerville College, Oxford) and Lowes Dickinson; returns via Holland.
Autumn: Gives six weekly broadcasts on BBC radio on 'The Meaning of Pictures'.

1930

January: BBC broadcast on the Royal Academy's *Italian Exhibition*.

Spring: In Provence with Margery; paints in St Rémy, Carpentras and Beaumes-de-Venise.
June: Health cure in Royat; to Autun.
July: Death of Lady Mariabella Fry, aged ninety-eight.
August: *Henri-Matisse* (Zwemmer).
Autumn: Painting in the Vaucluse.
October: *Ten Architectural Lithographs* (Architectural Press).

1931

February: Retrospective exhibition held at Cooling Galleries. BBC talk on Persian art at the Royal Academy.
March–April: Acquires the Mas d'Angirany on the outskirts of St Rémy, which is shared with the Maurons.
May: From France goes to Italy; visits Pisa, Rome (seeing DG, VB and family) and the Berensons at I Tatti.
Summer: In Paris and Royat; on return paints economist Mary Paley Marshall for University of Cambridge.
December: BBC talk on French art at the Royal Academy.

1932

Spring: To Greece with the Woolfs and Margery Fry; returns via Italy; death of his close friend Lowes Dickinson.
September: *The Arts of Painting and Sculpture* (Gollancz).
November: *Characteristics of French Art* (Chatto & Windus).

1933

February–March: With Helen Anrep in Morocco; on to Spain; in St Rémy by early April.
July: Exhibition of recent paintings at Agnew's; Vancouver buys *Spring in Provence* (no.139).
Summer: In London and Rodwell; visits Charleston (Aug.).
18 October: Inaugural lecture 'Art-History as an Academic Study' as Slade Professor of Fine Art, Cambridge.

1934

March: *Reflections on British Painting* (Faber).
August: Last contribution to *The Burlington Magazine* (on a National Gallery Corot); last broadcast (on Rembrandt's *Bathsheba*); in St Rémy; in Royat for health-cure.
9 September: After a fall in his Bernard St house, fracturing his pelvis, dies from heart failure in Royal Free Hospital.

1935

July–August: *Roger Fry* memorial exhibition opened by Virginia Woolf, Bristol Museum and Art Gallery.
C. Mauron's *Aesthetics and Psychology*, trans. RF and K. John (Hogarth Press).

1936

His translation of *Poems* by Stéphane Mallarmé published (Chatto & Windus).

1937

His wife Helen Fry dies in York.

1939

Last Lectures, ed. Kenneth Clark.

1940

Virginia Woolf, *Roger Fry: A Biography*.

1952

Roger Fry: Paintings and Drawings (Arts Council touring exh.).

1966

Vision and Design: The Life, Work and Influence of Roger Fry (Arts Council touring exh.).

1972

Letters of Roger Fry ed. D. Sutton, 2 vols.

1976

Portraits by Roger Fry (Courtauld Institute; Mappin Art Gallery Sheffield).

1980

Frances Spalding, *Roger Fry: Art and Life*.

VANESSA BELL

1879

30 May: Vanessa Stephen born at 22 Hyde Park Gate, London, the oldest of the four children of Leslie Stephen (1832–1904), editor of the *Dictionary of National Biography*, literary critic and mountaineer and his second wife Julia (née Jackson; 1846–95), niece of the photographer Julia Margaret Cameron. Stella, George and Gerald, her mother's three children by her first marriage to Herbert Duckworth, also form part of the household. Stephen's first wife was W.M. Thackeray's daughter. Harriet; family friends include George Meredith, Thomas Hardy, G.F. Watts and Henry James.
Educated at home.

1880

Birth of Thoby Stephen.

1882

Birth of Virginia Stephen.

1882–94

Annual summer visits to Talland House, St Ives, Cornwall, which were later to inspire her sister Virginia's novel *To the Lighthouse* (1927).

1883

Birth of Adrian Stephen.

1894

February: With Virginia stays in Guildford, Surrey, with G.F. Watts, who painted and drew several members of the Stephen family and was to influence her early work.

c.1894–6

Studies drawing under Ebenezer Cooke, follower of Ruskin.

1895

5 May: Death of her mother.

1896–1900

Studies under Sir Arthur Cope RA, at his school in Pelham Street, South Kensington.

1897

Death of her half-sister Stella Hills (19 July); Vanessa assumes onerous domestic responsibilities and comes into conflict with her father.

1899

Thoby Stephen enters Trinity College, Cambridge, and comes to know Lytton Strachey (1880–1932), Leonard Woolf (1880–1969), Clive Bell (1881–1964) and others.

1900

April: Visits Paris for a week.

1901

Submits drawings to the Royal Academy Schools and is accepted for September: taught by J.S. Sargent whose instruction she finds valuable.

1902

April: Visits Rome and Florence with George Duckworth. Her portrait is painted by C.W. Furse and exhibited at the NEAC (it was destroyed in the Blitz in 1940).
June: Leslie Stephen is knighted.

1903

March: Again visits G.F. Watts whose work she now finds unsympathetic.

1904

22 February: Death of Sir Leslie Stephen.
April–May: The Stephen children take a spring holiday in Italy (Venice and Florence); Vanessa and Virginia stay in Paris during return journey where they meet CB; they visit Rodin's studio.

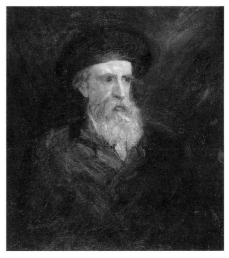

fig.147 Vanessa Bell, *Sir Leslie Stephen* c.1902–3, oil on canvas 66 × 59 cm. Private Collection

October: Moves with Virginia, Thoby and Adrian to 46 Gordon Square, Bloomsbury; 22 Hyde Park Gate is let; leaves the Royal Academy Schools.
Autumn: Brief attendance at the Slade School where she feels 'crushed' by the teaching of Henry Tonks.

1905

February: Beginning of the Stephens' 'Thursday Evenings' at Gordon Square to which come Thoby's Cambridge friends such as Walter Lamb, CB, Lytton Strachey and Saxon Sydney-Turner; her first commission, *Portrait of Lady Robert Cecil*, exhibited at the Summer Exhibition, New Gallery.
August: Refuses proposal of marriage from CB.
Summer: Organises the Friday Club for annual exhibitions, discussions, and lectures on art; it holds its first exhibition in November; friendship with Henry Lamb begins.

1906

January: First meeting with Duncan Grant at a Friday Club evening, introduced by Pippa Strachey.
April: Paints Lord Robert Cecil.
31 July: Refuses second marriage proposal from Clive Bell.
September–October: With Adrian, Virginia, Thoby and Violet Dickinson she journeys to Greece; is seriously ill.
20 November: Death in London of Thoby Stephen from typhoid contracted in Greece.
22 November: Agrees to marry CB.

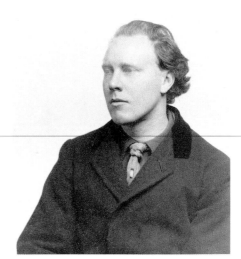

fig.148 Clive Bell, c.1910. Tate Gallery Archive

1907

7 February: Marries CB.
April: Honeymoon in Paris; Adrian and Virginia also there; meets Duncan Grant again, then working in Paris at the Atelier La Palette.

1908

4 February: Birth of son Julian.
June–July: Exhibits three paintings at Friday Club Exhibition, Baillie Gallery, London.
July: Exhibits *Portrait* at the Allied Artists' Association, Albert Hall, London.
September: In Italy with CB and Virginia, staying in Siena and Perugia and visiting Assisi and Pavia; in Paris in last week of September.

1909

April–May: With CB in Florence; paints Rezia Corsini, a Stephen family friend.
Summer: Exhibits *Iceland Poppies* (no.3) at the NEAC summer exhibition; has encouragement from Walter Sickert.
September–October: At Studland, Dorset.

1910

January: Chance meeting with Roger Fry at Cambridge railway station brings him into the Bells's circle.
March–April: At Studland; exhibits *London Morning*, a nude study, at NEAC Summer Exhibition.
June: Exhibits two still lifes at Friday Club Exhibition, Alpine Club Gallery.
19 August: Birth of second son, Quentin.
September: At Studland.

1911

February: Exhibits *Apples: 46 Gordon Square* (no.4) and other works at Friday Club, Alpine Club Gallery; at Little Talland House, Firle, Sussex, with Virginia who has rented the house for a year.
April: Visits Turkey with CB, RF and H.T.J. Norton; miscarriage and illness; begins affair with RF which lasts to c.mid-1913.
Summer: Mainly at Millmead Cottage, Guildford (near RF's home Durbins), recovering from illness and painting little.
September: At Studland.
October: Visits Paris with CB and RF; they buy Picasso's still life *Pots et Citron* (fig.51) and a Vlaminck landscape.

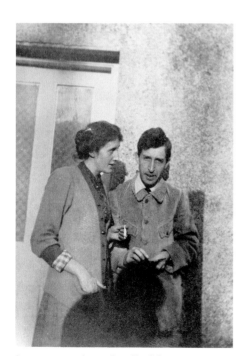

fig.149 Virginia and Leonard Woolf, Asheham House, *c.*1912. Tate Gallery Archive

1912

January: In Niton in the Isle of Wight with RF (whose portrait she paints; fig.8).
February: Exhibits four pictures (including *Design for Screen*, no.90) at Friday Club, Alpine Club Gallery; at Asheham House, Sussex (rented by Virginia) and pays many visits there in the next two years.
May: In Italy with CB and RF; paints in Siena and Pisa.
July: Exhibits *Monte Oliveto* (no.21) at Allied Artists' Association, Albert Hall; represented by six paintings at *Exposition de quelques Indépendants anglais*, Galerie Barbazanges, Paris, an exhibition organised by RF.
August: Sells *The Spanish Model* to the Contemporary Art Society (CAS) for five guineas (Leicester Museum and Art Gallery); attends the Cologne 'Sonderbund' exhibition of recent art with CB and RF.
10 August: Virginia marries Leonard Woolf; the Bells, DG, RF and others are wedding guests.
Summer: At Asheham House painting landscapes and figures in interiors including visitors such as Frederick and Jessie Etchells (no.24) and Henri Doucet (fig.79); begins to take substantial groups of photographs recording her children, family and friends.
October–December: Exhibits four paintings in the English section of the Second Post-Impressionist Exhibition, Grafton Galleries, London. During early winter preparations are underway for the Omega Workshops.

1913

January–February: At Asheham House painting and designing for the Omega's opening exhibition planned for July. Exhibits at first Grafton Group exhibition, Alpine Club Gallery, along with Lewis, Fry, Grant, Picasso and Kandinsky.
February: Meets Gertrude Stein in London.
May: In Italy with CB, RF and DG; visits Rome, Viterbo, Ravenna and Venice; returns via Paris.
8 July: Opening of the Omega Workshops at 33 Fitzroy Square, London; VB is co-director with RF and DG.
August: Attends summer camp at Brandon, Thetford, Norfolk, with RF, DG, J.M. Keynes and others; paints *Summer Camp* (no.82) which is later used as the basis for several Omega designs and for her *Screen* (no.69).
September–October: painting at Asheham House, including portrait of Lytton Strachey (no.33). RF and DG are there and also paint Strachey.
September: Virginia Woolf attempts suicide.
October: Takes charge of the Omega while RF is in Provence and deals with the crisis that occurs when Wyndham Lewis, Frederick Etchells, Cuthbert Hamilton and Edward Wadsworth leave abruptly in protest against RF's administration of the Workshops and its aesthetic direction.

1914

January: Exhibits five paintings and a screen at the second Grafton Group exhibition, Alpine Club Gallery.
Mid-January: In Paris with CB, RF and Molly MacCarthy; meets Picasso and is profoundly impressed with the work she sees in his studio; visits Gertrude Stein and Michael Stein; the Bells buy a Gris and a Vlaminck; resigns from Friday Club.
May: In Paris with DG with whom she is in love.
May–June: Five pictures in *Twentieth Century Art*, Whitechapel Art Gallery, London.
August–September: At Asheham House and paints dancers panel (see no.91) for façade of Omega Workshops. Adrian Stephen marries Karin Costelloe, Bernard Berenson's step-daughter.

1915

Paints several portraits including those of Iris Tree (no.34) and Mary Hutchinson (no.35).
Office work in London for the No Conscription Fellowship.
Spring: Takes Mary and St John Hutchinson's house Eleanor, West Wittering, Sussex; paints still lifes and a portrait of David Garnett (no.36) who stays there with her and DG.
Exhibition of clothes she has designed at the Omega Workshops.

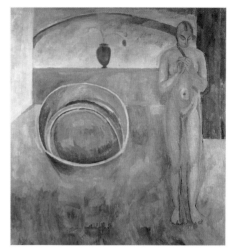

fig.150 Vanessa Bell, *The Tub* 1917, oil and gouache on canvas 180.3 × 166.4 cm. Tate Gallery

August: At The Grange, Bosham, Sussex, with DG and David Garnett; visits from RF, CB, J.M. Keynes and James and Lytton Strachey.

1916

January: Holds her first solo exhibition of paintings, Omega Workshops.
March: At Wissett Lodge, Halesworth, Suffolk, with her children, and DG and David Garnett; as conscientious objectors to conscription they are working as fruit-farmers; many visitors and little painting; CB works on the land 1916–18 at Garsington Manor, Oxford, home of Philip and Lady Ottoline Morrell.
October: Rents Charleston, a farmhouse near Firle, Sussex, on the Gage family estate, where she moves with her children, DG and Garnett who have found work locally as farm labourers.

1917

May: Sends five copies to the Omega Workshops *Copies* exhibition.
September–October: Eight paintings in *The New Movement in Art*, Mansard Gallery, Heal & Sons (a modified version of the exhibition previously at the Royal Birmingham Society of Artists) where Michael Sadler buys her *Triple Alliance* (no.52).
November: Exhibits with others at the Omega Workshops. Paints *The Tub* (fig.150) intended as a wall decoration for Charleston.

1918

8–28 August: Six pictures in *Englische Moderne Malerei* at the Kunsthaus, Zürich.
September–October: With DG decorates sitting room for J.M. Keynes at 46 Gordon Square in which house the Bells retain accommodation.
November: Woodcuts for *Kew Gardens* by Virginia Woolf, published by Hogarth Press, the publishing business founded by the Woolfs; exhibits with others at Omega Workshops.
25 December: Birth of her and DG's daughter Angelica at Charleston.

1919

March: Takes Alix Sargant-Florence's flat at 36 Regent Square, London, for one year but spends time at Charleston; paints Dr Marie Moralt (no.111).
Summer: Meetings with Picasso and Derain in London; Derain occupies her London flat for a month in May–June.
November: Exhibits with the London Group (and almost annually until her death).

1920

May: In Rome with J.M. Keynes and DG ; afterwards they stay with the Berensons at Villa I Tatti, Florence; with DG

visits Picasso in Paris on return journey; moves with her family to 50 Gordon Square until 1923.
Spring: Exhibits with RF and DG at the Galerie Vildrac, Paris.
June: Exhibits watercolours with DG at the Chelsea Book Club.
With DG paints decorations for J.M. Keynes's rooms at Webb's Court, King's College, Cambridge (finished 1922).
November: Exhibits sixteen watercolours at the Independent Gallery, an exhibition of works on paper shared with DG and Robert Lotiron.

1921

March: Represented in *Some Contemporary English Artists* at the Independent Gallery.
May: Visits Paris with DG, seeing Derain and Picasso; meets Satie, Braque and Kisling.
October: At La Maison Blanche, St Tropez, with her family and DG, remaining there until January 1922; RF is a visitor; she makes excursions to see Simon and Dorothy Bussy and Gwen and Jacques Raverat and meets Jean Marchand; paints several landscapes.

1922

February: Joins DG in Paris for a month.
June: One-artist exhibition held at Independent Gallery which attracts admiring reviews from Sickert, Fry, A. Clutton-Brock and others.

1923

May: In Spain with DG, joined by RF.
Decorations (with DG) for Leonard and Virginia Woolf at 52 Tavistock Square (destroyed in Second World War).
Moves back to 46 Gordon Square.

1924

May–June: In Paris with DG. Meetings with Picasso, Derain, Matthew Smith and Segonzac, who becomes her life-long admirer. Paints several views of the city.

1925

Moves with her children and DG to 37 Gordon Square.
January: Decorations with DG for Peter Harrison at Moon Hall, Gomshall, Surrey.
May: In Paris; visits Pellerin Collection of Cézannes with DG and RF.
March–April: Decorations with DG for Raymond Mortimer's flat, 6 Gordon Place, London (decorations now in the Victoria and Albert Museum, London).
Summer at Charleston where a large studio, designed by RF, is added to the house.
For many years during summer months at Charleston VB is host to numerous guests who include the Woolfs, the MacCarthys, RF, Lytton Strachey, Frances Marshall, Raymond Mortimer, Angus Davidson and more occasional visitors such as E.M. Forster, T.S. Eliot, Lowes Dickinson, the Bussys, Georges Duthuit, Edward Wolfe, Vita Sackville-West, Dame Ethel Smyth, Frederick Ashton and Jane and Kenneth Clark.
October: Contributes to *Modern Designs in Needlework*, Independent Gallery.

1926

May–June: Included in first exhibition of London Artists' Association (LAA) at Leicester Galleries, London; Keynes, Samuel Courtauld, F. Hindley Smith and L.H. Myers are the guarantors of the organisation which acts as her principal agent until 1931. Her paintings now enter several private collections (Spencer Churchill, Hugh Walpole, Courtauld, Kenneth Clark, Hindley Smith and others) and are bought by the CAS.
May–June: In Venice with DG and Angus Davidson; visits Ravenna, Padua and Ferrara; represented in the XV Venice Biennale.
October: With DG decorates CB's flat at 50 Gordon Square; represented in LAA exhibitions in Berlin and New York.

fig.151 Sitting room at 37 Gordon Square: at left, Gimond's bust of Vanessa Bell (no.191) in front of Grant's *Elephant Tray* (no.98); at right on mantelpiece Grant's Tunis vase (no.99); far right, Picasso's *Pots et Citron* (fig.51). Photograph from D. Todd and R. Mortimer, *The New Interior Decoration*, Batsford 1929, pl.21

fig.152 Vanessa Bell, *Provençal Landscape* 1928, oil on canvas 81.5 × 65.5 cm. Private Collection

fig.153 Vanessa Bell at Charleston, c.1932. Tate Gallery Archive

1927

January–May: Takes the Villa Corsica in Cassis, France; discovers La Bergère, Fontcreuse, just outside the town, and rents it for ten years from her English landlord Colonel Teed.
Illustrations for Virginia Woolf's *Kew Gardens* (Hogarth Press).
August: With DG decorates the garden loggia at Ethel Sands's and Nan Hudson's house, Château d'Auppegard, near Dieppe.
Autumn: Three paintings in the Carnegie International Exhibition, Pittsburgh.

1928

January–May: First visit to La Bergère which has been renovated and extended, providing studio space for her and DG.
October: Brief visit to Cassis.
November: Represented at the Marie Sterner Galleries, New York, in *Modern English Pictures* (LAA).

1929

January–February: To Germany, Vienna and Prague with DG; in Berlin they meet the Woolfs, Harold and Vita Nicolson and Edward Sackville-West.
April–July: At La Bergère; mainly at work on panels commissioned from VB and DG by Lady Dorothy Wellesley to decorate dining room of her home Penns-in-the-Rocks, Withyham, Sussex (finished 1931).
Takes studio at 8 Fitzroy Street, adjoining DG's; it remains her London base until 1939.
October: In Paris with DG; impressed with a Chardin exhibition.

1930

February–March: One-artist exhibition through the LAA of twenty-seven paintings at the Cooling Galleries, 92 New Bond Street, London, with catalogue introduction by Virginia Woolf.
Autumn: At La Bergère.
Three paintings in the Carnegie International Exhibition, Pittsburgh.
December: Wins third prize for interior design for 'Lord Benbow's Apartment', a competition set by the *Architectural Review*; her collaborators are John Skeaping, Humphrey Slater, Robert Medley and DG.

1931

May–June: In Rome with DG; travels back through Italy.
July: Resigns from LAA and thereafter her work is sold through Agnew & Sons and Reid & Lefevre.
December: Included in exhibition of Allan Walton textiles at the Cooling Galleries; she produces several textiles over the following years as well as painted pottery made by Phyllis Keyes.

1932

21 January: Death of Lytton Strachey.
March–April: At La Bergère, her last visit for several years.
Designs decor for *High Yellow* given by the Camargo Ballet, with choreography by Ashton and Bradley, music by Spike Hughes, costumes by William Chappell.
June–July: *Recent Paintings by Duncan Grant, Vanessa Bell and Keith Baynes*, Agnew & Sons.
December: Opening of a Music Room decorated and furnished by VB and DG, installed at Lefevre Galleries.

1933

January: Decor and costumes for Sadler's Wells Ballet production of *Pomona*, with choreography by Ashton, music by Constant Lambert.
Autumn: Two paintings in Carnegie International Exhibition, Pittsburgh (and exhibits one painting in each of its annual exhibitions from 1936–9).
Illustrations for Virginia Woolf's *Flush* (Hogarth Press).

1934

Decor for Ethel Smyth's ballet *Fête Galante*, with choreography by Dolin.
March: *Recent Paintings by Vanessa Bell* at Lefevre Galleries, with catalogue preface by Virginia Woolf.
9 September: Death of Roger Fry.
October: Designs a dinner-service for Wilkinson's Bizarre range directed by Clarice Cliff.

1935

End April–end July: In Rome with her family where joined by DG; paints several views of the city near her studio at 33 via Margutta; she and DG work on their respective decorations for RMS *Queen Mary*, commissioned by Cunard.
Summer: At Charleston spending time with her son Julian who leaves for China for nearly two years on 29 August.

1936

End January: Brief visit to Paris with Quentin.
May: Again in Paris.
Member of the Artists International Association.
Summer: Painting at Charleston.
Involved in aid for Spanish Civil War victims' relief and attends anti-fascist meetings.

1937

January–February: Included in *British Contemporary Art*, Rosenberg & Helft, London.
May: *Recent Paintings by Vanessa Bell*, Lefevre Galleries. In Paris with DG and Quentin; they visit Picasso working on *Guernica*.
June–July: *Contemporary British Artists*, Coronation Exhibition at Agnew's, chosen by VB, DG and Keith Baynes; younger artists such as Roger Hilton, Robert Medley and William Coldstream are included.
18 July: Julian Bell killed in Spain as ambulance driver for Republicans in Civil War; profoundly affected by his death and paints little during rest of year.
Summer: Convalescent at Charleston.
Autumn: Involved in establishment of Euston Road School.
Christmas: At Château de Fontcreuse, Cassis (La Bergère is let) with Angelica.

1938

Carries out decorations for Ethel Sands's house with DG, in Chelsea Square, London (destroyed).
July: Entertains Sickert at 8 Fitzroy Street; teaching at the Euston Road School.
Garden in April in Salon d'Automne, Paris.
Autumn: With her family and DG at La Bergère (returning in mid-November), her last visit to the house.

1939

Charleston considerably altered in readiness for country, war-time existence; VB makes own studio in attic; lets 8 Fitzroy Street studio (destroyed in Blitz in 1940).
Elected member of Society of Mural Painters.

1939–45

Living at Charleston with DG, CB and Quentin. Begins work in 1940 on two large panels for interior of Berwick Church, Sussex; paints Leonard Woolf (NPG).

1941

March 28: Virginia Woolf commits suicide.
June–July: Exhibition of recent work at Leicester Galleries.

1942

May: Angelica marries David Garnett; their children are Amaryllis (1943–1973), Henrietta (b. 1945) and twins Frances and Nerissa (b. 1946); paints her granddaughters on numerous occasions through the 1950s.

1943

June: Represented in *Robert Colquhoun and Notable British Artists* at Lefevre Galleries; paints Desmond MacCarthy at Charleston.
October: Ceremony to mark completion of murals at Berwick Church which she has undertaken with DG and Quentin.

fig.154 Angelica Bell in costume at Charleston, *c.*1935. Tate Gallery Archive

fig.155 Vanessa Bell, T*he Window at Asolo* 1955, oil on canvas 61 × 51 cm. Private Collection

fig.156 Vanessa Bell at Charleston, photograph by Olivier Bell, 1960. Courtesy Charleston Trust

1944

February: Unveiling (by J.M. Keynes) of decorations with DG for the Children's Restaurant, Devonshire Hill School, Tottenham, on story of Cinderella (destroyed).
September: Mastectomy operation; convalesces at Charleston.

1946

21 April: Death of J.M. Keynes at Tilton, close to Charleston.
Decorative panels for *Britain Can Make It* exhibition.
September: In Dieppe with DG and Edward le Bas; visits Ethel Sands and Nan Hudson at Auppegard; repaints damaged loggia decorations made in 1928.

1947

Autumn: Visits Paris with DG and Edward le Bas; sees Segonzac, Georges and Marguerite Duthuit and Pierre and Line Clairin.

1948

3 May: Death of her brother Adrian Stephen.
Autumn: Visits Venice with DG, le Bas and Angelica.

1949

On the committee (until 1959) of the Edwin Austin Abbey Memorial Trust Fund for Mural Painting.
September: In Lucca with DG.

1950

April: Contributes to first exhibition of Society of Mural Painters (founded 1939), Arts Council of Great Britain.
Summer: Touring in France with DG and Angelica; paints at Auxerre.
Exhibits one painting at Carnegie International Exhibition, Pittsburgh.

1951

Contributes *The Garden Room* to Arts Council's Festival of Britain exhibition *Fifty Paintings for '51*.

1952

February: Marriage of Quentin Bell to Olivier Popham; their children are Julian, Virginia and Cressida.
London *pied-à-terre* at 26a Canonbury Square, Islington (to mid-1955).
June: In Perugia with DG and visits Cortona, Arezzo and Florence.
October: In Venice with DG and Edward le Bas.

1953

On jury of Prix de Rome awards to young artists.
With DG visits Quentin and family in Newcastle-upon-Tyne and visits Edinburgh.
August–September: Exhibition by past members of LAA, Ferens Art Gallery, Hull.
Autumn: Auxerre with DG.

1954

March: Stays with Dorothy and Simon Bussy at Roquebrune; visits Antibes and Vence.
Elected member of Royal West of England Academy, Bristol, and shows at its annual exhibitions.

1955

Spring: In Asolo with DG, Edward le Bas and Eardley Knollys at rented villa La Mura (fig.155); visits Venice.
Summer: Takes flat at 28 Percy Street, London, with DG, although her visits to London become infrequent.

1956

February: One-artist exhibition at Adams Gallery, London.
March: Meets Benjamin Britten, Peter Pears and Mary Potter at Aldeburgh.

1957

Contributes to a BBC radio broadcast portrait of Virginia Woolf.
October: In Venice with DG, CB, Barbara Bagenal and Eardley Knollys.

1958

Designs the last of her many jackets for Virginia Woolf's books (*Granite and Rainbow*, Hogarth Press).

1959

Mostly at Charleston in frail health.

1960

January–April: At Roquebrune, staying in the Bussys' home, La Souco, with DG; later Angelica, Peter Morris, Edward le Bas, Barbara Bagenal and CB are in the neighbourhood; returns via Paris, her last visit.
Autumn: Sees Picasso retrospective at Tate Gallery. Offered an exhibition at the Adams Gallery for the following year.

1961

7 April: Dies at Charleston and is buried (12 April) in Firle village churchyard.
October: Memorial Exhibition at Adams Gallery, with catalogue foreword by Segonzac.

1964

March: Memorial Exhibition at Arts Council Gallery, London, and tour.
16 September: Death of Clive Bell.

1966

Paintings by Duncan Grant and Vanessa Bell, Royal West of England Academy, Bristol.

1967

November: *Drawings and Designs*, Folio Fine Art Ltd, London.

1973

November–December: *Paintings and Drawings*, Anthony d'Offay Gallery, London, which shows for first time several of her Post-Impressionist period paintings.
Tate Gallery purchases *Abstract Painting* (1914; no.83).

1979

July–August: *Vanessa Bell: Paintings from Charleston*, Anthony d'Offay, London.
September–November: *Vanessa Bell 1879–1961* (centenary exhibition), Sheffield City Art Galleries and at Portsmouth Art Gallery.

1980

April–May: *Vanessa Bell: A Retrospective Exhibition*, Davis & Long, New York.

1983

August–September: *Vanessa Bell 1879–1961*, Anthony d'Offay, London, marking publication of Frances Spalding's biography *Vanessa Bell*.

1984

September–October: *Vanessa Bell 1879–1961*, an exhibition of paintings, works on paper and book jackets, Vassar College Art Gallery, Poughkeepsie, New York 1993.
December–January 1985: *The Charleston Artists*, Meadows Museum, Dallas, Texas (autumn) and Sotheby's, London.

1993

Publication of *Selected Letters of Vanessa Bell*, ed. R. Marler.

1996

May–July: *Vanessa Bell & Virginia Woolf: Disegnare la vita*, Palazzo Massari, Ferrara.

1998

Publication of her autobiographical essays (written for the Memoir Club) *Sketches in Pen and Ink*, ed. L. Giachero.

DUNCAN GRANT

1885

21 January: Duncan James Corrowr Grant born at The Doune, Rothiemurchus, Inverness, only child of Bartle Grant and of his wife Ethel (née McNeil), of Scottish and Irish descent. Bartle's sister Jane is married to Richard Strachey. Early years in India and Burma where his father is a Major in the VIII Hussars; holidays every two years at The Doune, the Grant family home.

1894–9

Hillbrow Preparatory School, Rugby; Rupert Brooke and James Strachey, his cousin, are fellow pupils.

1899–1902

St Paul's School, West Kensington; living with Strachey family at 69 Lancaster Gate, London.

1899–1900

Winter: With his mother in Bruges.

1900

Christmas at Menton.

1901

Summer: At Rothiemurchus.
Attends Westminster School of Art while still at St Paul's; also receives lessons from Louise Jopling; is influenced by Beardsley and Burne-Jones.

1902

January: His parents, encouraged by Lady Strachey, remove him from St Paul's for full-time attendance at Westminster School of Art; continues to live with Strachey family.

1903

January–February: In Menton staying with his aunt Lady Colvile.
April: His cousin Dorothy Strachey marries the French painter Simon Bussy from whose advice and encouragement DG greatly benefits.
Whitsun: On a visit to Lytton Strachey in Cambridge is introduced to Clive Bell and Thoby Stephen.
Summer: At Streatley-on-Thames; painting holiday in Holland.

1904–5

Winter: In Florence with his mother; copies Masaccio (*Expulsion of Adam and Eve*, Brancacci Chapel) and Piero della Francesca (*Federigo da Montefeltro*, Uffizi); his school acquaintance Rupert Brooke is in Florence. Visits Arezzo, Siena and, with his cousin Harry Strachey, writer on art and author of *Raphael*, stays in Rome.

1905

Leaves Westminster School of Art.
Summer: In France and Wales.
Autumn: Lives with his parents, now permanently in England, at 143 Fellows Road, Hampstead; takes studio in Upper Baker Street.

1906

January: Attends Friday Club and meets Vanessa Stephen for the first time.
February: On recommendation of Simon Bussy, attends Jacques-Emile Blanche's school La Palette in Paris.
Summer: Painting holiday at Rothiemurchus with Arthur Hobhouse.
Autumn: Abandons La Palette and enrolls at the Slade School of Art, London.

1907

January: Returns to La Palette, now in Montparnasse, living at 22 rue Delambre.
February: Meetings in Paris with Wyndham Lewis.
March: Introduced to Augustus John by Henry Lamb; visits Salon des Indépendants; visits Gwen John; copies Rubens and Rembrandt in the Louvre and studies

fig.157 Simon Bussy, *Dorothy Strachey* c.1902, pastel on paper 47 × 58 cm. Ashmolean Museum, Oxford

Poussin's drawings; is greatly impressed by Degas's *Le Viol* at Durand-Ruel.
April: Moves to Atelier 45, 9 rue Campagne Première, Montparnasse; paints still lifes influenced by Chardin; visited by the Bells and Virginia and Adrian Stephen.
June: Leaves La Palette; in Florence and Certaldo, near Siena. Meets Berenson and family at I Tatti.
Summer: At Rothiemurchus painting portrait of the laird, John Peter Grant (Scottish National Portrait Gallery, Edinburgh).
November–December: Exhibits two pictures at United Arts Club, Grafton Galleries: *South Porch, Chartres* and *Walnut Trees*.

1908

Summer term at Slade School of Art.
August–September: At Melsetter in the Orkneys, staying with friends; later on Hoy with J.M. Keynes who sits for his portrait; their affair lasts about a year and they remain lifelong friends.
October: At Rothiemurchus on his return south.
December: Takes studio at 19 Belgrave Road, London, which is also Keynes's *pied-à-terre*; paints Pernel Strachey.

1909

April: With J.M. Keynes in Paris and Versailles; visits Salon des Indépendants and visits Leo Stein, whom he met in Florence in 1907.
July: Meets Lady Ottoline Morrell.
Summer: Painting at Burford, near Oxford; his work still highly realist and as yet uninfluenced by recent French art; meets Henry James in Cambridge; engaged on a succession of portraits in interiors.
Exhibits two watercolours at Winter Exhibition of the NEAC, and (ex cat.) a portrait of James Strachey (no.8).
November: Takes rooms with Keynes at 21 Fitzroy Square; growing friendship with the Bells and Virginia and Adrian Stephen.

1910

7 February: Takes part in the 'Dreadnought Hoax' with Adrian and Virginia Stephen, Horace Cole, and others.
March: To Greece and Turkey with Keynes.
June: Three pictures, including *The Lemon Gatherers* (bought by VB) (fig.158), at the Friday Club Exhibition.
Summer: At Burford finishing portrait of Cecil Taylor.
Autumn: Renews acquaintance with Roger Fry.
Exhibits *Study* at Winter Exhibition, NEAC.
November–December: Several visits to *Manet and the Post-Impressionists*, Grafton Galleries, and stays with RF at Durbins, Guildford.

1910–11

Mural for Keynes's rooms at Webb's Court, King's College, Cambridge, showing influence of recent French art.

1911

February: Exhibits *Idyll* at Friday Club.
April: In Sicily and Tunis with Keynes; returns via Naples and Rome; visits Matisse at Issy-les-Moulineaux, Paris, with introduction from Simon Bussy.

Summer: working on *Bathing* (no.71) and *Football* murals for Borough Polytechnic, London.
July: Attends performances by the Russian Ballet and meets Nijinsky and Bakst at Lady Ottoline Morrell's; painting holiday at Grantchester staying with Jacques Raverat and Rupert Brooke; paints Katherine Cox.
October: In France with RF and CB; visits Romanesque churches.
November: Moves with J.M. Keynes to 38 Brunswick Square, a house shared with Adrian and Virginia Stephen, Gerald Shove and Leonard Woolf.
December: As a member, exhibits *Parrot Tulips* (no.11) at the Second Camden Town Group Exhibition, Carfax Gallery (bought by Edward Marsh).

1912

December–January: *Idyll* and *Lemon Gatherers*, in exhibition of CAS at City Art Gallery, Manchester, and tour.
February: Exhibits *The Red Sea – decoration* and *Still Life* at the Friday Club.
Spring: Paints *Queen of Sheba* (no.20) and other pointillist-influenced works.
July: Represented by six works in *Exposition de quelques indépendants anglais*, Galerie Barbazanges, Paris.
Summer: At Everleigh, Marlborough, and (September) Asheham House, Sussex; paints portrait of Henri Doucet.
October–December: Six pictures in the English section of the Second Post-Impressionist Exhibition, Grafton Galleries, including *Queen of Sheba* and *Pamela* (no.17). Commissioned by H. Granville-Barker to design production of *Macbeth*, a project abandoned in 1913.
End of year: Already working on designs for the Omega Workshops, which open in July 1913.

1913

March: Exhibits at first Grafton Group Exhibition, Alpine Club Gallery.
Visits Snowdonia as guest of George Mallory; paints Lady Ottoline Morrell (no.31).
7 April: Meets Severini.
April: Italy with CB, VB and RF; visits Venice and Ravenna.
8 July: Opening of Omega Workshops Ltd, 33 Fitzroy Square, London, of which he is co-director with VB and RF; attends summer camp at Brandon, Norfolk, with VB, RF, J.M. Keynes and others; paints *Tents* (no.73).
September: At Asheham House.
Autumn: With RF and VB decorates room for Henry Harris in (?)Bedford Square.
October: In Paris to see Jacques Copeau who has commissioned costumes and scenery for *Twelfth Night*, to be produced at his Théâtre du Vieux Colombier.
15 November: Attends founding meeting of the London Group but is not elected until 1919.
Winter: Working on large painting *Adam and Eve* commissioned by CAS (fig.30).

1914

January: Exhibits at second Grafton Group Exhibition, including his controversial *Adam and Eve*.
January–February: In the South of France and Tunis.
February–March: In Paris working for Copeau; several meetings with Picasso and attends Gertrude Stein's salon.
May: VB joins him in Paris for premiere of *Twelfth Night*.
May–June: Four pictures in *Twentieth Century Art*, Whitechapel Art Gallery.
Summer: First collage and abstract paintings.
August–September: At Asheham working on *Abstract Kinetic Collage Painting* (no.78).
Autumn: Leaves Brunswick Square and briefly takes a room in the Bells' house at 46 Gordon Square; studio at 22 Fitzroy Street.

1915

January: D.H. Lawrence visits his studio (with Frieda Lawrence, E.M. Forster and David Garnett; see no.37).
February: Makes marionettes for performance of Racine's *Bérénice* at Omega Workshops.
Spring: With VB and David Garnett at Eleanor, West

fig.158 Duncan Grant, *The Lemon Gatherers* 1910, oil on board 56.5 × 81.3 cm. Tate Gallery

fig.159 Duncan Grant at Asheham House, photographed by Vanessa Bell, 1912. Tate Gallery Archive

Wittering, Sussex, country cottage of his cousin Mary and her husband St John Hutchinson.
June: Exhibits three works by invitation at the Vorticist Exhibition, Doré Galleries, London. Pays first visit to the Morrells' home Garsington Manor, near Oxford.
August: In Dorset and with VB at The Grange, Bosham, Sussex.
Christmas and New Year at Asheham House.

1916

March: As conscientious objector, does agricultural work in Suffolk, living at Wissett Lodge, Halesworth, with David Garnett and VB and family.
May: Receives exemption from combatant service and undertakes farm-work for the rest of the war.
October: Moves with VB and Garnett to Charleston, Firle, Sussex, and works on a nearby farm; painting restricted to Sundays.

1917

May: Four works in Omega *Copies* exhibition.
Summer: Designs costumes for Copeau's Paris production of Maeterlinck's *Pelléas et Mélisande*; decorations with VB for St John and Mary Hutchinson's house in Upper Mall, Hammersmith.
September–October: Nine paintings in *The New Movement in Art*, Mansard Gallery, Heal & Sons (shown previously at the Royal Birmingham Society of Artists).
November: Exhibits with others at Omega Workshops, including *The Kitchen* (1914–17) and *The Tub* (1916).

1918

Pelléas et Mélisande performed in New York; also *Twelfth Night* with additional scenery by DG.
8–28 August: Six pictures in *Englische Moderne Malerei* at the Kunsthaus, Zürich, a CAS exhibition.
22 September: Meets Lydia Lopokova and Léonide Massine.
September–October: With VB decorates sitting room for J.M. Keynes at 46 Gordon Square.
11 November: Attends Peace celebrations in London.
November: Exhibits with others at Omega Workshops. Dines with T.S. Eliot.
Grant and Garnett released from farm-labouring; continues living at Charleston and uses Fry's studio at 21 Fitzroy Street.
25 December: Birth of his and VB's daughter, Angelica, at Charleston.

1919

Lives at Charleston with visits to London.
June–July: Sees Derain and Picasso (both in London) on several occasions.
November: Exhibits with the London Group (and continues to do so almost annually until the late 1950s).

1920

Takes a studio (previously Sickert's) at 8 Fitzroy Street (until 1940).
February: First one-artist exhibition at Carfax Gallery, St James's, London: financial and critical success.
May: In Rome with VB and Keynes; stays with Berensons at I Tatti; visits Picasso in Paris on return journey.
Spring: Exhibits with VB and RF at the Galerie Vildrac, Paris.
Summer: Charleston; with VB paints eight panels for J.M. Keynes's rooms at Webb's Court, King's College, Cambridge (finished 1922), replacing his earlier decoration.
November: Exhibits twenty watercolours at the Independent Gallery, Grafton Street, London, an exhibition shared with VB and Robert Lotiron.

1921

February: Visits Paris and sees André Gide to discuss production of *Saul* (project abandoned); visits his old teacher Jacques-Emile Blanche; represented at Salon des Indépendants.
March: Represented in *Some Contemporary English Artists* at the Independent Gallery.
May–June: In Paris; meetings with Derain, Picasso, Satie, Braque and Kisling.
October: At La Maison Blanche, St Tropez, with VB and her family; several landscapes (no.125).

1922

January: To Paris from St Tropez; takes a studio for a month; sees Gide, Copeau and Jean Cocteau and English painters in Paris including Keith Baynes and Edward Wolfe; visits Picasso with VB after her arrival in February.
Summer: Painting in London and at Charleston.
Winter: Begins portrait of Lydia Lopokova (no.130).

1923

22 January: Designs *Togo, or the Noble Savage*, music by Milhaud, choreography by Massine, with Lopokova, Massine and Sokolova among the dancers, for Cochran review at Royal Opera House, Covent Garden.
April: Sees Sickert and Thérèse Lessore on several occasions.
May–June: In Spain with VB, joined by RF; returns alone to Paris; sees Picasso; attends premiere of Stravinsky/Nijinska/Goncharova ballet *Les Noces*; meets James Joyce.
June: *Recent Paintings and Drawings* at Independent Gallery. Designs *Masquerade* for Lopokova and others at Coliseum (premiere 20 November).
September: At Charleston; greatly impressed by Eliot's *The Waste Land* read aloud by Desmond MacCarthy to DG and CB.
Designs costumes for Aristophanes's *The Birds* staged in Cambridge in February 1924.

1924

February: Hogarth Press issues *Duncan Grant* with essay by RF.
16 April: Death of his father Bartle Grant.
April: Costumes for Lopokova and Idzikowski in Coliseum divertissement *Soldier and Grisette*.
May–June: In Paris with VB with fortnight's visit alone to Berlin in June to stay with the painter Franzi von Haas; visits Potsdam and Dresden.
29 June: Scenery for *The Pleasure Garden* by Beatrice Mayor, produced by the Incorporated Stage Society, Regent Theatre, London.
Winter: In Châlon-sur-Saône and Beaune.

1925

January: Decorations with VB for Peter Harrison, Moon Hall, Gomshall, Surrey.
March–April: Large mural and decorations with VB for Raymond Mortimer's flat at 6 Gordon Place, London.
May: In Paris; visits Pellerin Collection of Cézannes with RF and VB.
Designs decor for ballet *The Postman* at Coliseum with Lopokova and Woizikowski.
July: Designs sets and costumes for *The Son of Heaven* by Lytton Strachey; premiere on 12 July at the Scala Theatre, London.
Summer: At Charleston; large studio, designed by RF, added to house.
October: Exhibition of *Modern Designs in Needlework*, Independent Gallery; designs by DG, VB, RF and Wyndham Tryon.

1926

May–June: First exhibition of London Artists' Association (LAA) at Leicester Galleries – works by Grant, Bell, Fry, Baynes, Porter, Adeney, Dobson.
May–June: Represented at XV Venice Biennale.
Travels via Switzerland to Venice; later joined by VB and Angus Davidson; they visit Ravenna, Padua, Ferrara.
August–September: At Charleston.
October: With VB decorates CB's flat at 50 Gordon Square.
Represented in LAA exhibitions in Berlin and New York; one painting in Carnegie International, Pittsburgh.
In Paris and sees Derain.

1927

January–May: At Cassis with his mother; falls seriously ill and is joined by VB.
April–May: *Paintings by Duncan Grant* at the LAA, 163 New Bond Street, London.
August: With VB at Ethel Sands and Nan Hudson's house, Château d'Auppegard, near Dieppe, decorating the garden loggia.
October: To Cassis with David Garnett and oversees renovation of VB's cottage, La Bergère; returns via Paris and sees Derain and Larionov.
Three paintings in Carnegie International, Pittsburgh.

1928

January–May: At La Bergère; paints landscapes and *Window, South of France* (no.131).
Summer: At Charleston.
October: To Cassis, returning alone via Paris; visits Picasso, Segonzac and Marchand; several meetings with Robert Medley and Rupert Doone.
November: Scenery for George Rylands's production of Milton's *Comus*, first given at A.D.C. Theatre, Cambridge, and later at 46 Gordon Square, with Michael Redgrave and Lydia Lopokova; represented at Marie Sterner Galleries, New York, in exhibition of *Modern English Pictures* (LAA).

1929

January–February: To Germany, Vienna and Prague with VB meeting the Woolfs, the Nicolsons and Edward Sackville-West in Berlin.
February–March: Retrospective exhibition of paintings 1910–29 at Paul Guillaume, Brandon Davis Ltd, 73 Grosvenor Street, London.

fig.160 Duncan Grant, *Self-Portrait*, 1923, pencil on paper 20.2 × 15.2 cm. Private Collection

fig.161 Duncan Grant at La Bergère, Cassis, 1928. Tate Gallery Archive

fig.162 Duncan Grant painting, Rome, 1931. Courtesy The Syndics of the Fitzwilliam Museum, Cambridge

April–July: At La Bergère with VB and her family; working on panels commissioned by Lady Dorothy Wellesley to decorate the dining room of Penns-in-the-Rocks, Withyham, Sussex (finished 1931).
October: To Paris and La Bergère with his mother.

1930

Summer: Shows work at XVII Venice Biennale.
Autumn: At La Bergère with the Bells and George Bergen; RF and Helen Anrep visit.
Three paintings in Carnegie International, Pittsburgh.

1931

May–June: In Rome with Vincent Sheean at the Palazzo Lovatelli; joined by VB and family.
June–July: *Recent Paintings by Duncan Grant*, LAA, Cooling Galleries; catalogue preface by David Garnett. Resigns from LAA; Agnew's become his main dealer. Meets Charlie Chaplin at Lady Ottoline Morrell's.
December: Exhibition of Allan Walton textiles at Cooling Galleries; fabrics designed by Grant, Bell, Baynes, Morris, Dobson, Walton and others.

1932

21 January: Death of Lytton Strachey.
March–April: At La Bergère.
March: Scenery and costumes for *The Enchanted Grove* produced originally for Camargo Ballet, given by Vic-Wells Ballet, London, with Dolin and de Valois, choreography by Rupert Doone, music by Ravel.
June: Scenery and costumes for second act of *Swan Lake*, Camargo Ballet; scenery from designs by Inigo Jones.
June–July: *Recent Paintings by Duncan Grant, Vanessa Bell and Keith Baynes*, Agnew's. Represented at the XVIII Venice Biennale.
August: Painting visit to King's Lynn with George Bergen.
December–January 1933: Opening of a music room decorated and furnished by DG and VB, installed at Lefevre Galleries.

1933

June: *Drawings by Duncan Grant*, Agnew's; catalogue preface by Kenneth Clark.
Represented in International College Art Association Exhibition, New York.
October: Represented at Carnegie International, Pittsburgh, and annually thereafter to 1939 (and once more in 1950).

1934

May: *Recent Paintings by Duncan Grant*, Lefevre Galleries. Painting visit to Falmouth.
9 September: Death of Roger Fry.
October: Pottery for Foley China exhibited at Harrods, London, in 'Modern Art for the Table'.
November–December: *Gainsborough to Grant*, Agnew's.

1935

Three decorative panels commissioned by Cunard Steamship Company for RMS *Queen Mary*.
May–June: Joins VB and family in Rome and works on *Queen Mary* decorations; visited by Leonard and Virginia Woolf.
September: Leaves Rome for London.

1936

February: *Queen Mary* decorations rejected by Cunard.
April: In Spain and Mallorca; paints in Seville and Granada.
May: In Paris with VB.
Autumn: Charleston.

1937

January–February: Included in *British Contemporary Art*, Rosenberg & Helft, London.
May: In Paris with VB and Quentin Bell; they visit Picasso working on *Guernica*; continues alone to Toulon to paint; visits Cassis, Cagnes and Nice.
June–July: *Contemporary British Artists*, Coronation Exhibition at Agnew's, chosen by DG, VB and Keith

Baynes; wins Medal of Merit at Paris International Exhibition, for Walton textile *Apollo and Daphne*. November–December: *Recent Works by Duncan Grant*, Agnew's, including the *Queen Mary* panels and studies which are widely praised in the press.
Christmas in Paris with his mother; joins VB and Angelica at Château de Fontcreuse (La Bergère is let); in January 1938 goes alone to paint at Villefranche.

1938

With VB carries out decorations for Ethel Sands's house in Chelsea Square, London. Teaching at Euston Road School with which he and VB are closely involved.
Autumn: At La Bergère with VB and family (last visit).

1939

January–February: Member of Advisory Committee of Artists' International Association for 'Unity of Artists for Peace, Democracy and Cultural Development'; contributes to fourth annual exhibition, Whitechapel Art Gallery, London; represented in *Contemporary British Art*, World's Fair, New York.
Gives up studio at 8 Fitzroy Street which is destroyed by fire in September 1940; moves to Charleston where he becomes member of local Home Guard.

1940

May: *Drawings and Sketches by Duncan Grant*, Calmann Gallery, London.
Thirty-nine paintings chosen for the XXII Venice Biennale; the consignment was not sent owing to the war and was instead shown at Wallace Collection.
Living and painting in Plymouth, on commission from War Artists' Advisory Committee (WAAC); begins work on large painting and other decorations for Berwick Church, Sussex; local opposition overcome through Consistory Court hearings.

1941

June: Royal Designer for Industry, Royal Society of Arts.
Paints St Paul's Cathedral amidst ruins for WAAC (Imperial War Museum); becomes involved in arranging a series of exhibitions held during the War at Miller's, Lewes.

1942

Elected to Art Advisory Panel of the Council for the Encouragement of Music and the Arts (later the Arts Council of Great Britain) and is regularly in touch with J.M. Keynes over its proceedings and with his fellow advisers Henry Moore and Tom Monnington.
April: Paints in Lyme Regis.

1943

June: Represented in *Robert Colquhoun and Notable British Artists*, Lefevre Galleries.
October: Ceremony to mark the completion of murals at Berwick Church, by DG, VB and Quentin Bell, painted at Charleston (1940–2; completed 1944).

1944

February: Decorations with VB for the Children's Restaurant, Devonshire Hill School, Tottenham, on the story of Cinderella (destroyed).
April: Publication of Raymond Mortimer's *Duncan Grant* (Penguin Modern Painters).

1945

June: Visits Denmark and Sweden with his mother; paints in Copenhagen.
June–July: *Recent Paintings by Duncan Grant*, Leicester Galleries, London. Reputation in decline.

1946

21 April: Death of J.M. Keynes.
Summer: Meets Paul Roche.
Autumn: With VB and the painter and collector Edward le Bas, painting in Dieppe.
VB takes a room in Marjorie Strachey's flat at 1 Taviton Street, London, which DG also uses; often works in London at 53 Bedford Square, the house of Edward le Bas.

fig.163 Vanessa Bell and Duncan Grant at La Bergère, 1938. Tate Gallery Archive

1947

June: *Duncan Grant and Vanessa Bell*, Gainsborough Galleries, Johannesburg.
Autumn: In Paris with VB and Edward le Bas; sees Segonzac, the Clairins and Georges and Marguerite Duthuit.

1948

January: Death of his mother in Twickenham.
Autumn: In Venice with VB, Edward le Bas and Angelica.

1949

September: Visits Lucca with VB.

1950

April: As member of Society of Mural Painters contributes to its first exhibition, Arts Council of Great Britain.
Summer: Touring in France with VB and Angelica; paints in Auxerre.
October: Five works in *Mostra Internazionale del Disegno*, Bergamo.

1951

Contributes *The Arrival of the Italian Comedy* (fig.43) to *Fifty Paintings for '51*, Arts Council's Festival of Britain exhibition.

1952

June: Painting in Perugia with VB; visits Arezzo, Cortona and Florence.
October: Visits Venice with VB and Edward le Bas. Moves to 26a Canonbury Square, Islington, with VB.

1953

August–September: In exhibition by past members of the LAA, Ferens Art Gallery, Hull.
Autumn: Auxerre with VB.

1955

In Asolo with VB, Edward le Bas and Eardley Knollys. With VB moves to flat at 28 Percy Street, London.

1956

Designs scenery and costumes for John Blow's *Venus and Adonis*, first given at Aldeburgh Festival on 15 June, and in September and October at Scala Theatre, London.

1957

May: Forty new paintings exhibited at the Leicester Galleries.
October: With VB, Eardley Knollys, CB and Barbara Bagenal in Venice.

1958–9

Murals for the Russell Chantry Chapel, Lincoln Cathedral.

1959

May–June: *Duncan Grant: A Retrospective Exhibition*, Tate Gallery; poorly received.

1960

January–April: With VB at La Souco, Menton; visits from Angelica, Eardley Knollys, Edward le Bas, CB, Barbara Bagenal and Peter Morris.

1961

7 April: Death of Vanessa Bell at Charleston; profoundly affected DG paints little until the autumn.
June: In France with Edward le Bas.
September: Fortnight in Venice; moves to rooms in 24 Victoria Square, Leonard Woolf's London house.

1962

December 1961–February: With Edward le Bas painting near Cadiz; to Morocco; returns home via Madrid.

1963

April: Retrospective exhibition at the Minories, Colchester.
September: With Angelica and David Garnett in their house in St Martin de Vers, Cahors.
Represented in retrospective of Omega Workshops, Victoria and Albert Museum, London.

1964

Spring: Painting in Marbella with Edward le Bas.
16 September: Death in London of Clive Bell.
Lives alone at Charleston with frequent visits from family and friends.
November: Large retrospective *Duncan Grant and his World* at Wildenstein, selected and catalogued by Denys Sutton, begins revival of reputation.

1965

May–June: Visits Morocco.
Illustrates Folio Society edition of Arthur Waley's translation of Wu Ch'êng-ên's *Monkey*.

1966

With Segonzac to see Bonnard retrospective at Royal Academy, London.
Illustrates Virginia Woolf's children's story *Nurse Lugton's Golden Thimble* (Hogarth Press).
April–May: *Paintings by Duncan Grant and Vanessa Bell*, RWEA, Bristol, opened by John Betjeman.
October: Visits United States and stays in New York with George Bergen; visits Boston, Philadelphia and Washington.

1967

February: Short visit to Paris and visits Bonnard retrospective at l'Orangerie.
May: To Greece with Paul Roche.
June–August: Twenty-seven works in *Artists of Bloomsbury*, Rye Art Gallery, Sussex.
September: Publication of Michael Holroyd's first volume of *Lytton Strachey*, detailing much of DG's early life.
Autumn: With Angelica at St Martin de Vers.

1968

Illustrates *In an Eighteenth Century Kitchen* (Cecil & Amelia Woolf, London).
Summer: In Tangier; takes a studio in Fez for two months; joined by Angelica.

1969

Recorded by BBC television for a portrait of Virginia Woolf.
Series of Charleston studio still lifes continues for several years (nos.149–151).
November: Visits Amsterdam for the Rembrandt exhibition.
Fifty-six works from 1908 to 1969 in *Portraits by Duncan Grant*, Arts Council exhibition, Cambridge, and tour.

1970

Pied-à-terre in 3 Park Square West, London, the home of Patrick Trevor-Roper.
Spring: Visits Cyprus, staying with John Haylock.
May: Visits Cambridge, draws E.M. Forster. Visits Matisse centenary exhibition, Paris.
Duncan Grant at Charleston, film by Christopher Mason.
Awarded Honorary Doctor of Letters, Royal College of Art, London.

1971

Anthony d'Offay becomes his dealer.
Picasso sends him a drawing and fond remembrances.

1972

January–February: Visits Portugal and paints in Cascais.
April–May: *Watercolours and Drawings by Duncan Grant,* d'Offay Couper Gallery, London; begins double portrait of Gilbert and George (fig.165).

1973

January: *Recent Paintings,* Fermoy Art Gallery, King's Lynn, including several studio still lifes.
July: Honorary Doctor of Letters, University of Sussex.
Autumn: Visits Turkey with Paul Roche.

1974

Autumn: To Scotland with Paul Roche; visits his birthplace at Rothiemurchus; stays on Skye.

1975

Ninetieth-birthday exhibitions include:
January–February: *Recent Paintings,* Anthony d'Offay Gallery, London.
February: *Paintings and Drawings by Duncan Grant,* Southover Gallery, Lewes, Sussex.
February–March: *Ninetieth Birthday Exhibition,* Tate Gallery; *A Homage to Duncan Grant,* Gallery Edward Harvane, London; *Early Paintings,* Anthony d'Offay Gallery.
April: *Duncan Grant* (works on paper), Davis & Long, New York.
May–June: Retrospective exhibition *Duncan Grant,* Scottish National Gallery of Modern Art, Edinburgh, and (July–September), Museum of Modern Art, Oxford.
June: *Duncan Grant and Bloomsbury,* Fine Art Society, Edinburgh.
October: In Tangier with Paul Roche; seriously ill with pneumonia.

1976

April: Returns to Charleston from Tangier.
November: *Bloomsbury Painters and their Circle,* Beaverbrook Art Gallery, Fredericton, New Brunswick (and Canadian tour 1976–7).

fig.164 Duncan Grant at Charleston, 1970. Publicity still for Christopher Mason's film *Duncan Grant at Charleston.* Courtesy Charleston Trust

fig.165 Duncan Grant, *Gilbert and George* c.1973. Pencil, gouache and oil on paper 54 × 40 cm. Private Collection

October: *Recent Water Colours and Pastels,* Southover Gallery, Lewes, Sussex.
November: Visits loan exhibition of works by DG, VB, RF and others at Fine Art Society, London, to mark the publication of Richard Shone's *Bloomsbury Portraits.*

1977

Mainly at Charleston.
Spring: *Paintings, Watercolours and Drawings,* Rye Art Gallery, Sussex.
October: *Artists of the Bloomsbury Group,* Morris Gallery, Toronto.

1978

April: Visits Paris with Paul Roche to see *Cézanne: The Late Work*; already frail, he contracts pneumonia.
9 May: Dies at Aldermaston, Berkshire, the home of Paul and Clarissa Roche; buried at Firle, Sussex, near to Vanessa Bell.
27 June: Memorial Service, St Paul's Cathedral, London, with address by Kenneth Clark.

1981

November–December: *Duncan Grant: Works on Paper,* Anthony d'Offay, London.

1982

With Duncan Grant in Southern Turkey by Paul Roche.

1984

The Charleston Artists, Meadows Museum, Dallas, Texas (autumn) and Sotheby's, London (December 1984–January 1985).

1985

Charleston opens to the public.

1987

Duncan Grant and the Bloomsbury Group by Douglas Blair Turnbaugh.

1989

July–August: *Duncan Grant: Watercolours and Drawings,* Bloomsbury Workshop, London.

1990

The Art of Duncan Grant by Simon Watney.

1991

June–July: *Duncan Grant,* Bloomsbury Workshop, London.

1997

Duncan Grant: A Biography by Frances Spalding.

Bibliography

GENERAL ABBREVIATIONS

NEAC: New English Art Club

AAA: Allied Artists' Association

CAS: Contemporary Art Society

LG: London Group

LAA: London Artists' Association

ACGB: Arts Council of Great Britain

FC: Friday Club

CTG: Camden Town Group

NPG: National Portrait Gallery

RA: Royal Academy

SNGMA: Scottish National Gallery of Modern Art

TGA: Tate Gallery Archive

EXHIBITIONS: SHORT REFERENCES

ACGB 1952: *Roger Fry: Paintings and Drawings*, Arts Council Gallery, London, 1952

ACGB 1964: *Vanessa Bell: Memorial Retrospective*, Arts Council, London and tour, 1964

ACGB 1969: *Portraits by Duncan Grant*, Cambridge and tour, 1969

Adams 1961: *Vanessa Bell (1879–1961): Memorial Exhibition*, Adams Gallery, London, 1961

Barbican 1997: *Modern Art in Britain 1910–1914*, Barbican Art Gallery, London, 1997

Barcelona 1986: *El Grupo de Bloomsbury*, Caixa de Pensions, Barcelona, 1986

Bristol 1935: *Roger Fry: Memorial Exhibition*, Bristol City Art Gallery, 1935

Bristol 1966: *Paintings by Duncan Grant and Vanessa Bell*, Royal West of England Academy, Bristol, 1966

Cambridge 1983: *Maynard Keynes: Collector of Pictures, Books and Manuscripts*, Fitzwilliam Museum, Cambridge, 1983

Canterbury 1983: *Vanessa Bell: Paintings 1910–1920*, Royal Museum, Canterbury, 1983

Carfax 1920: *Paintings by Duncan Grant*, Carfax Gallery, London, 1920

Colchester 1959: *Roger Fry: Paintings, Watercolours and Drawings*, The Minories, Colchester, 1959 (and at Luton Museum, 1960, with slight variations)

Colchester 1963: Duncan Grant retrospective exhibition, The Minories, Colchester, April 1963

Columbus 1971: *British Art 1890–1928*, Columbus Gallery of Fine Arts, Columbus, Ohio 1971

Crafts Council 1984: *The Omega Workshops 1913–19: Decorative Arts of Bloomsbury*, Crafts Council Gallery, London, 1984

Dallas and London 1984–5: *The Charleston Artists*, Meadows Museum, Dallas, Texas, 1984–5

d'Offay 1973: *Vanessa Bell: Paintings and Drawings*, Anthony d'Offay, London, 1973

d'Offay 1975 (1): *Recent Paintings by Duncan Grant*, Anthony d'Offay, London, 1975

d'Offay 1975 (2): *Early Paintings by Duncan Grant*, Anthony d'Offay, London, 1975

d'Offay 1979: *Vanessa Bell: Paintings from Charleston*, Anthony d'Offay, London, 1979

d'Offay 1981: *Duncan Grant (1885–1978): Works on Paper*, Anthony d'Offay, London, 1981

d'Offay 1984: *The Omega Workshops: Alliance and Enmity in English Art 1911–1920*, Anthony d'Offay, London, 1984

d'Offay 1986: Exhibition to mark public opening of Charleston, Anthony d'Offay, London, 1986

Edinburgh and Oxford 1975: *Duncan Grant: 90th Birthday Exhibition of Paintings*, Scottish National Gallery of Modern Art, Edinburgh, and (with changes) Museum of Modern Art, Oxford, 1975

FAS 1976: *Bloomsbury Portraits*, exhibition to mark publication of Richard Shone's *Bloomsbury Portraits*, Fine Art Society, London, 1976

FAS Edinburgh 1975: *Duncan Grant and Bloomsbury*, Fine Art Society, Edinburgh, 1975

1st GG 1913: First Grafton Group Exhibition, Alpine Club Gallery, London, 1913

1st PIE: *Manet and the Post-Impressionists*, Grafton Galleries, London, 1910

Folio 1967: *Vanessa Bell: Drawings and Designs*, Folio Fine Art, London, 1967

Fredericton 1976: *Bloomsbury Painters and their Circle*, Beaverbrook Art Gallery, Fredericton and Canadian tour, 1976–7

Guillaume Davis 1929: *Duncan Grant: Retrospective Exhibition (1910–29)*, Paul Guillaume and Brandon Davis, London, 1929

Independent 1923: *Duncan Grant: Recent Paintings and Drawings*, Independent Gallery, London, 1923

Liverpool 1980: *Duncan Grant: Designer*, Bluecoat Gallery, Liverpool, and Pavilion Art Gallery, Brighton, 1980

Liverpool 1996–7: *Characters and Conversations: British Art 1900–1930*, Tate Gallery Liverpool 1996–7

London and Stuttgart 1987: *British Art in the 20th Century*, Royal Academy, London, and Neue Staatsgalerie, Stuttgart, 1987

Luton 1960: see Colchester 1959

New York 1980: *Vanessa Bell: A Retrospective Exhibition*, Davis & Long, New York, 1980

New York 1987: *British Modernist Art 1905–1930*, Hirschl & Adler, New York, 1987–1988

Norwich 1976–7: *A Terrific Thing: British Art 1910–1916*, Norwich Castle Museum and tour 1976–7

Portraits 1976: *Portraits by Roger Fry*, Courtauld Institute Galleries, London, and Mappin Art Gallery, Sheffield, 1976

Rye 1967: *Artists of Bloomsbury*, Rye Art Gallery, 1967

2nd GG 1914: Second Grafton Group Exhibition, Alpine Club Gallery, London, 1914

2nd PIE: Second Post-Impressionist Exhibition, Grafton Galleries, London, 1912

Sheffield 1979: *Vanessa Bell 1879–1961* (centenary exhibition), Sheffield City Art Galleries and Portsmouth Art Gallery, 1979

Spink 1991: *Duncan Grant and Vanessa Bell: Design and Decoration 1910–1960*, Spink & Sons, London, 1991

Tate 1959: *Duncan Grant: A Retrospective Exhibition*, Tate Gallery, London, 1959, and ACGB tour

Tate 1975: *Duncan Grant: A Display to Celebrate his 90th Birthday*, Tate Gallery, London, 1975

Tate 1980: *Abstraction: Towards a New Art: Painting 1910–20*, Tate Gallery, London, 1980

Toronto 1977: *Artists of the Bloomsbury Group*, Morris Gallery, Toronto, 1977

Vassar 1984: *Vanessa Bell 1879–1961*, Vassar College of Art, Poughkeepsie, New York, 1984

Vision and Design 1966: *Vision and Design: The Life, Work and Influence of Roger Fry*, Arts Council Gallery, London, Nottingham University Art Gallery, and tour, 1966

Vorticism 1974: *Vorticism and its Allies*, Arts Council, Hayward Gallery, London, 1974

Wallace Collection 1940: *XXth Biennale International*, Wallace Collection, London, 1940 (where Grant's group of paintings intended for Venice was shown)

Whitechapel 1914: *Twentieth Century Art*, Whitechapel Art Gallery, London, 1914

Wildenstein 1964: *Duncan Grant and his World*, Wildenstein & Co. Ltd., London, 1964

Zürich 1918: *Englische Moderne Malerei*, Kunsthaus, Zürich, 1918

LITERATURE: SHORT REFERENCES

Anscombe 1981: Isabelle Anscombe, *Omega and After: Bloomsbury and the Decorative Arts*, Thames & Hudson, London 1981

Bell 1986: Quentin Bell, *Bloomsbury* Weidenfeld & Nicolson, London 1986 (revised and pictorially enlarged ed. of 1968 publication)

Collins 1983: Judith Collins, *The Omega Workshops*, Secker & Warburg, London 1983

Constable 1927: W.G. Constable, *Duncan Grant*, British Artists of To-day (VI), Fleuron, London 1927

Cork 1976: Richard Cork, *Vorticism and Abstract Art in the First Machine Age*, 2 vols., Gordon Fraser, London 1976

Cork 1985: Richard Cork, *Art Beyond the Gallery in Early 20th Century England*, Yale University Press, New Haven and London 1985

Fry 1923: Roger Fry, *Duncan Grant*, Hogarth Press, London, 1923 (new ed. 1930)

Greenwood 1998: Jeremy Greenwood, *Omega Cuts*, Wood Lea Press, Woodbridge 1998

Holroyd 1967, 1968: Michael Holroyd, *Lytton Strachey: A Critical Biography*, 2 vols., London 1967, 1968

Lehmann 1975: John Lehmann, *Virginia Woolf and her World*, Thames & Hudson, London 1975

Marler 1993: *Selected Letters of Vanessa Bell*, ed. Regina Marler, Bloomsbury, London 1993

Morphet 1980: Richard Morphet, 'Roger Fry: The Nature of his Painting', *The Burlington Magazine*, 928, July 1980, pp.478–88.

Mortimer 1944: Raymond Mortimer, *Duncan Grant*, Penguin Modern Painters, Penguin Books, Harmondsworth 1944

NPG 1981: K.K. Yung, *National Portrait Gallery: Complete Illustrated Catalogue*, National Portrait Gallery, London 1981

Naylor 1990: *Bloomsbury: The Artists, Authors and Designers by Themselves*, ed. Gillian Naylor, Octopus/Amazon 1990

Reed 1996: *A Roger Fry Reader*, ed. Christopher Reed, University of Chicago Press 1996

Shone 1976: *Bloomsbury Portraits: Vanessa Bell, Duncan Grant and their Circle*, Phaidon, London and Oxford 1976

Shone 1977: *The Century of Change: British Painting since 1900*, Phaidon, Oxford 1977

Shone 1993: revised, expanded and newly illustrated paperback edition of Shone 1976, Phaidon, London 1993

Spalding 1980: Frances Spalding, *Roger Fry: Art and Life*, Elek/Granada, London 1980

Spalding 1983: Frances Spalding, *Vanessa Bell*, Weidenfeld & Nicolson, London 1983

Spalding 1986: Frances Spalding, *British Art since 1900* Thames & Hudson, London 1986

Spalding 1997: Frances Spalding, *Duncan Grant: A Biography*, Chatto & Windus, London 1997

Sutton 1972: *Letters of Roger Fry*, ed. Denys Sutton, 2 vols., Chatto & Windus, London 1972

Tate 1964: Mary Chamot, Dennis Farr and Martin Butlin, *Tate Gallery: The Modern British Paintings, Drawings and Sculpture*, 2 vols., Oldbourne Press, London 1964

Watney 1980: Simon Watney, *English Post-Impressionism*, Studio Vista, London 1980

Watney 1990: Simon Watney, *The Art of Duncan Grant*, John Murray, London 1990

Woolf Diary: *The Diary of Virginia Woolf*, ed. Anne Olivier Bell, 5 vols., Hogarth Press, London 1977–84

Woolf Letters: *The Letters of Virginia Woolf*, ed. Nigel Nicolson with Joanna Trautmann, 6 vols., Hogarth Press, London 1975–80

The author wishes to acknowledge the immense usefulness of *A Bloomsbury Iconography* by the late Elizabeth P. Richardson (1989) during the writing of this catalogue. Further publications, not cited, but frequently helpful have included Robert Skidelsky's *John Maynard Keynes* (2 vols., 1983, 1992), Hermione Lee's *Virginia Woolf* (1993), S.P. Rosenbaum's *A Bloomsbury Group Reader* (1993), Jane Dunn's *Virginia Woolf and Vanessa Bell: A Very Close Conspiracy* (1990) and Diane Gillespie's *The Sisters' Arts* (1988). Many articles in *The Charleston Newsletter* and its successor *The Charleston Magazine* have been fruitful. Invaluable as first-hand evidence are the conversations and written interviews between Duncan Grant and David Brown in typescript now in the Tate Gallery Archive.

Lenders

PHOTOGRAPHIC CREDITS

COPYRIGHT CREDITS

Index

Ways of Giving

The Tate Gallery attracts funds from the private sector to support its programme of activities in London, Liverpool and St Ives. Support is raised from the business community, individuals, trusts and foundations, and includes sponsorships, donations, bequests and gifts of works of art. The Tate Gallery is an exempt charity; the Museums & Galleries Act 1992 added the Tate Gallery to the list of exempt charities defined in the 1960 Charities Act.

TRUSTEES

David Verey (Chairman)
Professor Dawn Ades
Victoria Barnsley
The Hon. Mrs Janet de Botton
Sir Richard Carew Pole
Prof. Michael Craig-Martin
Peter Doig
Sir Christopher Mallaby
Sir Mark Richmond
John Studzinski
Bill Woodrow

DONATIONS

There are a variety of ways through which you can make a donation to the Tate Gallery.
Donations All donations, however small, will be gratefully received and acknowledged by the Tate Gallery.
Covenants A Deed of Covenant, which must be taken out for a minimum of four years, will enable the Tate Gallery to claim back tax on your charitable donation. For example, a covenant for £100 per annum will allow the Gallery to claim a further £30 at present tax rates.
Gift-Aid For individuals and companies wishing to make donations of £250 and above, Gift-Aid allows the gallery to claim back tax on your charitable donation. In addition, if you are a higher rate taxpayer you will be able to claim tax relief on the donation. A Gift-Aid form and explanatory leaflet can be sent to you if you require further information.
Bequests You may wish to remember the Tate Gallery in your will or make a specific donation In Memoriam. A bequest may take the form of either a specific cash sum, a residual proportion of your estate or a specific item of property, such as a work of art. Certain tax advantages can be obtained by making a legacy in favour of the Tate Gallery. Please check with the Tate Gallery when you draw up your will that it is able to accept your bequest.
American Fund for the Tate Gallery The American Fund was formed in 1986 to facilitate gifts of works of art, donations and bequests to the Tate Gallery from the United States residents. It receives full tax exempt status from the IRS.

INDIVIDUAL MEMBERSHIP PROGRAMMES

Friends

Friends share in the life of the Gallery and contribute towards the purchase of important works of art for the Tate. Privileges include free unlimited entry to exhibitions; tate: the art magazine; private views and special events; 'Late at the Tate' evening openings; exclusive Friends Room. Annual rates start from £24.
Tate Friends Liverpool and Tate Friends St Ives offer local events programmes and full membership of the Friends in London. The Friends of the Tate Gallery are supported by Tate & Lyle PLC.
Further details on the Friends in London, Liverpool and St Ives may be obtained from: Membership Office, Tate Gallery, Millbank, London SW1P 4RG
Tel: 0171-887 8752

Patrons

Patrons of British Art support British painting and sculpture from the Elizabethan period through to the early twentieth century in the Tate Gallery's collection. They encourage knowledge and awareness of British art by providing an opportunity to study Britain's cultural heritage.
Patrons of New Art support contemporary art in the Tate Gallery's collection. They promote a lively and informed interest in contemporary art and are associated with the Turner Prize, one of the most prestigious awards for the visual arts.
Privileges for both groups include invitations to Tate Gallery receptions, an opportunity to sit on the Patrons' executive and acquisitions committees, special events including visits to private and corporate collections and complimentary catalogues of Tate Gallery exhibitions.
Annual membership of the Patrons is £650, and funds the purchase of works of art for the Tate Gallery's collection.
Further details on the Patrons may be obtained from: Patrons Office, Tate Gallery, Millbank, London SW1P 4RG
Tel: 0171-887 8754

CORPORATE MEMBERSHIP PROGRAMMES

Membership of the Tate Gallery's two Corporate Membership programmes (the Founding Corporate Partner Programme and the Corporate Membership Programme) offer companies outstanding value-for-money and provide opportunities for every employee to enjoy a closer knowledge of the Gallery, its collection and exhibitions.Membership benefits are specifically geared to business needs and include private views for company employees, free admission to exhibitions, out-of-hours Gallery visits, behind-the-scenes tours, exclusive use of the Gallery for corporate entertainment, invitations to VIP events, copies of Gallery literature and acknowledgment in Gallery publications.

Tate Gallery London: Founding Corporate Partners

AMP (UK) plc
CGU plc
Clifford Chance
Energis
Freshfields
Goldman Sachs International
Lazard Brothers & Co Limited
London Electricity
Paribas
Pearson plc
Prudential
Railtrack plc
Reuters Limited
Rolls-Royce plc
Schroders
Warburg Dillon Read

Tate Gallery London: Corporate Members

Partners
Bank of America
BP
Ernst & Young
Freshfields
Merrill Lynch Mercury
Prudential
Associates
Alliance & Leicester plc
Channel Four Television
Credit Suisse First Boston
Drivers Jonas
The EMI Group
Global Asset Management
Goldman Sachs International
HUGO BOSS
Lazard Brothers & Co Limited
Linklaters & Alliance
Manpower PLC
Morgan Stanley Dean Witter
Nomura International plc
Nycomed Amersham plc
Robert Fleming & Co. Limited
Schroders
Simmons & Simmons
UBS AG

Tate Gallery Liverpool: Corporate Members

J Blake & Co Ltd
BT
Hitchcock Wright and Partners
Littlewoods
Liverpool John Moores University
Manchester Airport PLC
Pilkington plc
Tilney Investment Management
United Utilities plc

CORPORATE SPONSORSHIP

The Tate Gallery works closely with sponsors to ensure that their business interests are well served, and has a reputation for developing imaginative fund-raising initiatives. Sponsorships can range from a few thousand pounds to considerable investment in long-term programmes; small businesses as well as multi-national corporations have benefited from the high profile and prestige of Tate Gallery sponsorship.

Opportunities available at Tate Gallery London, Liverpool and St Ives include exhibitions (some also tour the UK), education, conservation and research programmes, audience development, visitor access to the Collection and special events. Sponsorship benefits include national and regional publicity, targeted marketing to niche audiences, exclusive corporate entertainment, employee benefits and acknowledgment in Tate Gallery publications.

Tate Gallery London: Principal corporate sponsors

(alphabetical order)
BP
1990–2000, *New Displays*
1998–2000, Campaign for the Creation of the Tate Gallery of British Art
Channel Four Television
1991–9, *The Turner Prize*
Ernst & Young
1996, *Cézanne**
1998, *Bonnard*
Magnox Electric plc
1995–8, The Magnox Electric Turner Scholarships
1997, *Turner's Watercolour Explorations*
1998, *Turner and the Scientists*
Prudential
1996, *Grand Tour*
1997, *The Age of Rossetti, Burne-Jones and Watts: Symbolism in Britain 1860–1910*
1999, *The Art of Bloomsbury*
Tate & Lyle PLC
1991–2000, Friends Marketing Programme
1997, *Henry Tate's Gift*
Volkswagen
1991–6, The Volkswagen Turner Scholarships

Tate Gallery London: Corporate sponsors

(alphabetical order)
Akeler Developments Ltd
1997–8, Art Now Programme
American Airlines*
1999, *Jackson Pollock* (in kind)
1999, *Chris Burden, 'When Robots Rule': The Two Minute Airplane Factory*
Aon Risk Services Ltd in association with ITT London & Edinburgh
1998, *In Celebration: The Art of the Country House*
L'Association Française d'Action Artistique
1999, *Abracadabra*
AT&T
1997, *Piet Mondrian*
CDT Design Ltd
1995–6, *Art Now*
Classic FM
1995–6, Regional tour of David Hockney's *Mr and Mrs Clark and Percy* (in kind)
Coutts Group
1998, *Per Kirkeby*
Coutts Contemporary Art Foundation
1997, *Luciano Fabro*
Danish Contemporary Art Foundation
1998, *Per Kirkeby*
The German Government
1997, *Lovis Corinth*
Glaxo Wellcome plc

1997, *Turner on the Loire*
1999, *Turner on the Seine*
The Guardian
1999, *Jackson Pollock* (in kind)
Häagen-Dazs Fresh Cream Ice Cream
1995–6, *Art Now*
The Hiscox Group
1995–9, Friends Room
HUGO BOSS
1997, *Ellsworth Kelly*
Lombard Odier & Cie
1998, *Turner in the Alps*
Morgan Stanley Dean Witter
1998, *John Singer Sargent*
1998, *Constructing Identities*
1999, *Visual Paths: Teaching Literacy in the Gallery*
Pro Helvetia
1997, *Art Now – Beat Streuli*
Romulus Construction Limited
1996, *Bill Woodrow: Fools' Gold*
Spink-Leger Pictures
1997, *Francis Towne*
Tarmac Group plc*
1995–9, *Paintings Conservation*
The EMI Group
1997, *Centre Stage* education project

Tate Gallery of Modern Art: Corporate Sponsors
(alphabetical order)
Ernst & Young
1997–2000, Tate Gallery of Modern Art Visitor Centre

Tate Gallery Liverpool: Corporate Sponsors
(alphabetical order)
Girobank plc
1998, *Great Art Adventure* (education programme)
The Littlewoods Organisation PLC
1998, *EYOPENERS* (education programme)
Manchester Airport and Tilney Investment Management
1998, *Salvador Dalí*
MOMART plc
1991–9 The Momart Fellowship

Tate Gallery St Ives: Corporate Sponsors (alphabetical order)
Marks & Spencer
1998–9, Education Events and Workshops
Northcliffe Newspapers in Education*
1995–7, Education Programme

* denotes a sponsorship in the arts recognised by an award under the Government's 'Pairing Scheme' administered by Arts & Business.

TATE GALLERY FOUNDING BENEFACTORS (date order)
Sir Henry Tate
Sir Joseph Duveen
Lord Duveen
The Clore Foundation
Heritage Lottery Fund

TATE GALLERY PRINCIPAL BENEFACTORS (alphabetical order)
American Fund for the Tate Gallery
The Annenberg Foundation
Calouste Gulbenkian Foundation
Friends of the Tate Gallery
The Henry Moore Foundation
The Kreitman Foundation
Sir Edwin and Lady Manton
National Art Collections Fund

National Heritage Memorial Fund
The Nomura Securities Co., Ltd
Patrons of New Art
Dr Mortimer and Theresa Sackler Foundation
St Ives Tate Action Group
The Wolfson Foundation and Family Charitable Trust

TATE GALLERY BENEFACTORS
(alphabetical order)

The Baring Foundation
Bernard Sunley Charitable Foundation
Gilbert and Janet de Botton
Mr and Mrs James Brice
Mr Edwin C.Cohen
The Eleanor Rathbone Charitable Trust
Esmée Fairbairn Charitable Trust
Foundation for Sport and the Arts
GABO TRUST for Sculpture Conservation
GEC Plessey Telecommunications
The Getty Grant Program
Granada Group plc
The Paul Hamlyn Foundation
Horace W. Goldsmith Foundation
John Hughes
The John S.Cohen Foundation
The John Ellerman Foundation
John Lewis Partnership
John Lyon's Charity
The Leverhulme Trust
Museums and Galleries Improvement Fund
Ocean Group plc (P.H. Holt Trust)
Patrons of British Art
The Paul Hamlyn Foundation
The Paul Mellon Centre
Peter Moores Foundation
The Pilgrim Trust
Mr John Ritblat
The Sainsbury Family Charitable Trusts
Samsung Foundation of Culture
The Stanley Foundation Limited
Save and Prosper Educational Trust
SRU Limited
Weinberg Foundation

TATE GALLERY DONORS
(alphabetical order)
London
Professor Abbott
Howard and Roberta Ahmanson
The Andy Warhol Foundation for the Visual Arts, Inc
The Fagus Anstruther Memorial Trust
Mr and Mrs Halvor Astrup
Lord Attenborough CBE
The Austin and Hope Pilkington Charitable Trust
BAA plc
Friends of Nancy Balfour OBE
Balmuir Holdings
The Hon. Robin Baring
B.A.T. Industries plc
Nancy Bateman Charitable Trust
Mr Tom Bendhem
Mr Alexander Bernstein
Anne Best
David and Janice Blackburn
Blackwall Green Limited
Michael and Marcia Blakenham
George and Mary Bloch
Miss Mary Boone
Frances and John Bowes
The Britwell Trust
Mr and Mrs Donald L. Bryant, Jr
Mrs Melva Bucksbaum
Mr and Mrs Neville Burston
Card Aid
Carlsberg Brewery

Mr Vincent Carrozza
Mrs Beryl Carpenter
Cazenove & Co
Charlotte Bonham Carter Charitable Trust
Christie, Manson & Woods Ltd
The Claire Hunter Charitable Trust
The Clothworkers Foundation
Mrs Elisabeth Collins
Mr Christopher Cone
Ricki and Robert Conway
Giles and Sonia Coode-Adams
Mrs Dagny Corcoran
Cognac Courvoisier
Mr Edwin Cox
Paula Cussi
Gordon and Marilyn Darling
Antony d'Offay Gallery
Mr and Mrs Kenneth Dayton
Mr Damon and The Hon. Mrs de Laszlo
Baron and Baroness Elie de Rothschild
Madame Gustava de Rothschild
The Leopold de Rothschild Charitable Trust
Baroness Liliane de Rothschild
Deutsche Bank AG
Sir Harry and Lady Djanogly
Miss W.A. Donner
Mr Paul Dupee
Mrs Maurice Dwek
Elephant Trust
Eli Broad Family Foundation
Elizabeth Arden Ltd
Mr and Mrs Georges A. Embiricos
The Essick Foundation
European Arts Festival
Evelyn, Lady Downshire's Trust Fund
Roberto Fainello Art Advisers Ltd
First Boston Corporation
Mr and Mrs Donald G. Fisher
The Flow Foundation
Foreign & Colonial Management Limited
Miss Kate Ganz
Mr Henry Geldzahler
Ms Laure Genillard
Mr and Mrs David Gilmour
The German Government
Goethe Institut
Jack Goldhill
Sir Nicholas and Lady Goodison Charitable Settlement
David and Maggi Gordon
Mr William Govett
Mr and Mrs Richard Grogan
Gytha Trust
Mr and Mrs Rupert Hambro
Miriam and Peter Haas
Mrs Sue Hammerson
Harry Kweller Charitable Trust
The Hon. Lady Hastings
The Hedley Foundation
Hereford Salon
Mr and Mrs Michael Heseltine
Mr Rupert Heseltine
Mr Robert Hornton
Mr and Mrs Michael Hue-Williams
Hurry Armour Trust
Idlewild Trust
The Italian Government
Lord and Lady Jacobs
Mrs Gabrielle Keiller
James and Clare Kirkman Trust
Knapping Fund
Dr Patrick Koerfer
Mr and Mrs Richard Knight
Mr and Mrs Richard Kramlich
Mr and Mrs Jan Krugier
The Kirby Laing Foundation
The Lauder Foundation-Leonard and Evelyn Lauder Fund
The Leche Trust
Robert Lehman Foundation,Inc
The Helena and Kenneth Levy Bequest

Mr and Mrs Gilbert Lloyd
Mr and Mrs George Loudon
Mr and Mrs Lawrence Lowenthal
Mail on Sunday
Mr Alexander Marchessini
Marsh (Charities Fund) Ltd
The Mayor Gallery
Penny McCall Foundation
Midland Bank Artscard
Mr and Mrs Robert Mnuchin
Mr and Mrs Peter Nahum
Mr and Mrs Philip Niarchos
Fondation Nestlé pour l'Art
Dr Andreas Papadakis
The Paradina Trust
Mr William Pegrum
Philips Fine Art Auctioneers
The Earl of Plymouth
Old Possum's Practical Trust
The Hon. Mrs Olga Polizzi
Paul Nash Trust
Peter Samuel Charitable Trust
Mr Jean Pigozzi
Ptarmigan Trust
The Radcliffe Trust
Sir Gordon Reece
Reed International P.L.C.
Richard Green Fine Paintings
Mrs Jill Ritblat
Rothschild Bank AG
Kathy and Keith Sachs
Mrs Jean Sainsbury
The Hon. Simon Sainsbury
Salander-O'Reilly Galleries LLC
Fondazione Sandretto Re Rebaudengo per l'Arte
The Scouloudi Foundation
Sebastian de Ferranti Trust
Schroder Charity Trust
Mr and Mrs D M Shalit
Ms Dasha Shenkman
South Square Trust
Mr A. Speelman
Standard Chartered Bank
The Swan Trust
Sir Adrian and Lady Judith Swire
Mr and Mrs Louis A. Tanner
Mr and Mrs A. Alfred Taubman
Mrs Barbara Thomas
Time-Life International Ltd
The 29th May 1961 Charitable Trust
Lady Juliet Townsend
Laura and Barry Townsley
The Triangle Trust
U.K. Charity Lotteries Ltd
Visiting Arts
Mr and Mrs Leslie Waddington
Waley-Cohen Charitable Trust
Mr Mark Weiss
Mr and Mrs Gérard Wertheimer
Weltkunst Foundation
Mrs Alexandra Williams
Graham and Nina Williams
Willis Faber plc
Mr Andrew Wilton
Thomas and Odette Worrell
The Worshipful Company of Goldsmiths
Mrs Jayne Wrightsman
and those donors who wish to remain anonymous

Friends Benefactors and Life Members 1958–1998
The André Bernheim Charitable Trust
Dr and Mrs David Cohen
Mrs Isobel Dalziel
Mr and Mrs Charles Dickinson
Lady Gosling
Miranda, Countess of Iveagh
Lord and Lady Jacobs
Mr and Mrs A.G.W. Lang

Sir Sydney and Lady Lipworth
The Sir Jack Lyons Charitable Trust
Mr Michael Rose
Lieutenant Commander and Mrs Shilling
Mrs Jack Steinberg
Mr John B. Sunley
Mr and Mrs Terry Willson

Tate Gallery of Modern Art
Arthur Andersen (pro-bono)
The Annenberg Foundation
The Arts Council of England
Lord and Lady Attenborough
The Baring Foundation
David and Janice Blackburn
Mr and Mrs Anthony Bloom
Mr and Mrs John Botts
Frances and John Bowes
Mr and Mrs James Brice
Donald L. Bryant Jr Family
Mrs Melva Bucksbaum
Monsieur Alain Camu
The Carpenters' Company
Cazenove & Co
The Clore Foundation
Mr Edwin C. Cohen
Ronald and Sharon Cohen
The John S. Cohen Foundation
Giles and Sonia Coode-Adams
Gilbert de Botton
Sir Harry and Lady Djanogly
The Drapers' Company
English Heritage
English Partnerships
Ernst & Young
Esmée Fairbairn Charitable Trust
Doris and Donald Fisher
Richard B. and Jeanne D. Fisher
The Fishmongers' Company
The Foundation for Sport and the Arts
Friends of the Tate Gallery
The Worshipful Company of Goldsmiths
Noam and Geraldine Gottesman
GJW Government Relations (pro-bono)
The Worshipful Company of Haberdashers
Hanover Acceptances Limited
André and Rosalie Hoffmann
The Horace W. Goldsmith Foundation
Lord and Lady Jacobs
Irene and Hyman Kreitman
Leathersellers' Company Charitable Fund
Edward and Agnes Lee
Mr and Mrs George Loudon
McKinseys & Co (pro-bono)
David and Pauline Mann-Vogelroel
The Mercers' Company
The Meyer Foundation
The Millennium Commission
The Monument Trust
Mr and Mrs M.D. Moross
Guy and Marion Naggar
Maja Oeri and Hans BodenmannThe Nyda
 and Oliver Prenn Foundation
The Quercus Trust
The Rayne Foundation
The Dr Mortimer and Theresa Sackler
 Foundation
The Salters' Company
Stephan Schmidheiny (pro-bono)
Belle Shenkman Estate
Simmons & Simmons
London Borough of Southwark
The Starr Foundation
Lord and Lady Stevenson
Hugh and Catherine Stevenson
Miss M.F. Stevenson
Mr and Mrs Ian Stoutzker
John Studzinski
David and Linda Supino
The Tallow Chandlers' Company
Laura and Barry Townsley

Townsley & Co
The 29th May 1961 Charitable Trust
The Vintners' Company
Robert and Felicity Waley-Cohen
The Weston Foundation
Graham and Nina Williams
The Worshipful Company of Grocers
Poju and Anita Zabludowicz
and those donors who wish to remain
 anonymous

**Tate Gallery of Modern Art:
Collections Benefactor**
Janet Wolfson de Botton

Tate Gallery of British Art
The Annenberg Foundation
The CHK Charities Limited
The Clore Foundation
Sir Harry and Lady Djanogly
The D'Oyly Carte Charitable Trust
The Dulverton Trust
Maurice and Janet Dwek
Friends of the Tate Gallery
Sir Paul Getty, KBE
Heritage Lottery Fund
Lloyds TSB Foundation for England
 and Wales
Sir Edwin and Lady Manton
The P.F. Charitable Trust
The Polizzi Charitable Trust
Lord and Lady Sainsbury of Preston
 Candover
Mrs Coral Samuel CBE
Tate Gallery Centenary Gala
The Trusthouse Charitable Foundation
The Duke of Westminster OBE TD DL
Sam Whitbread
The Wolfson Foundation
and those donors who wish to remain
 anonymous

Tate Gallery Liverpool
Association for Business Sponsorship of the
 Arts (Arts & Business)
Arrowcroft Group Plc
Arts Council of England
The Australian Bicentennial Authority
Barclays Bank PLC
The Baring Foundation
BASF
The Bernard Sunley Charitable Foundation
Boddingtons plc
British Alcan Aluminium plc
BG plc
BT
Calouste Gulbenkian Foundation
Coopers & Lybrand
Mr and Mrs Henry Cotton
Cultural Relations Committee
David M Robinson Jewellery
Deloitte & Touche
The Eleanor Rathbone Charitable Trust
The John Ellerman Foundation
English Partnerships
The Esmée Fairbairn Charitable Trust
European Arts Festival
European Regional Development Fund
The Foundation for Sport and the Arts
Friends of the Tate Gallery
Girobank plc
The Granada Foundation
Granada Television Limited
The Henry Moore Foundation
The Henry Moore Sculpture Trust
Heritage Lottery Fund
Mr John Heyman
Higsons Brewery plc
Ian Short Partnership
IBM United Kingdom Limited
ICI Chemicals & Polymers Limited

The John Lewis Partnership
The John S. Cohen Foundation
The Laura Ashley Foundation
The Littlewoods Organisation PLC
Liverpool John Moores University
Mr & Mrs Jack Lyons
Manchester Airport PLC
Manor Charitable Trust
Marconi Communications
Merseyside Development Corporation
Mobil Oil Company Ltd
MOMART plc
The Moores Family Charitable Foundation
The Museums and Galleries Improvement
 Fund
The Nigel Moores Family Charitable Foun-
 dation
NSK Bearings Europe Ltd
P & P Micro Distributors Ltd
Parkman Group Ltd
PH Holt Charitable Trust
The Pilgrim Trust
Pilkington plc
Pioneer High Fidelity (GB) Ltd
Rio Tinto plc
Royal & Sun Alliance
Royal Liver Assurance
Sainsbury Family Charitable Trusts
Samsung Electronics (UK) Limited
Save & Prosper Educational Trust
Scottish Courage Limited
Stanley Thomas Johnson Foundation
The Summerfield Charitable Trust
Tate Friends Liverpool
Tilney Investment Management
Trinity International Holdings plc
The TSB Foundation for England and Wales
The Trustees of the Tate Gallery Liverpool
Unilever plc
United Biscuits (UK) Limited
United Utilities plc
The University of Liverpool
Vernons Pools Ltd
Visiting Arts
Volkswagen
Whitbread & Company PLC
The Wolfson Foundation
and those donors who wish to remain
 anonymous